AMERICAN
SHOWCASE

ILLUSTRATION

AMERICAN SHOWCASE

VOLUME 7

American Showcase, Inc.
New York

President and Publisher:
Ira Shapiro

Production Manager:
Fiona L'Estrange

Director of Marketing and New Projects:
Chris Curtis

Operations/Credit Manager:
Wendl Kornfeld

Distribution and Advertising Sales Manager:
Julia Morris

Book Sales Manager:
Chuck Novotny

Production Assistant:
Kyla Kanz

Grey Pages:
Julia Bahr

Bookkeeper:
Cathy Arrigo

Assistant Operations Manager:
Daria Dodds

Sales Representatives:

New York:
**John Bergstrom, Deborah Darr, Stacey Gold,
Kate Hoffman, Donna Levinstone, Wendy Saunders.**

West Coast:
Bob Courtman, Ralph Redpath.

Book Design:
Weeks & Toomey, Inc., NYC

Mechanical Production:
The Mike Saltzman Group, NYC

Typesetting:
**Ultra Typographic Services, Inc., NYC
Automatech Graphics Corporation, NYC**

Color Separation, Printing and Binding:
Dai Nippon Printing Co. Ltd., Tokyo, Japan

U.S. Book Trade Distribution:
Van Nostrand Reinhold Co. ▨
135 West 50th Street, New York, New York 10020

Published by
American Showcase, Inc.
724 Fifth Avenue, 10th Floor
New York, New York 10019
(212) 245-0981

CONTENTS

ILLUSTRATION

GRAPHIC ARTS ORGANIZATIONS

PHONE LISTINGS

VIEWPOINTS

INDEX

GERALD & CULLEN RAPP

WE BELIEVE WE SELL MORE QUALITY ILLUSTRATION THAN ANYONE ELSE IN THE WORLD!

HERE'S WHY:

EXCLUSIVE REPRESENTATIVES FOR

MICHAEL DAVID BROWN

LON BUSCH	ALLAN MARDON
KEN DALLISON	ELWYN MEHLMAN
JACK DAVIS	MARIE MICHAL
BOB DESCHAMPS	ALEX MURAWSKI
BILL DEVLIN	LOU MYERS
RAY DOMINGO	GARY OVERACRE
GINNIE HOFMANN	JERRY PINKNEY
LIONEL KALISH	CHARLES SANTORE
SHARON KNETTELL	ROBERT TANENBAUM

BARRY ZAID

—— GRAPHIC DESIGN ——
MDB COMMUNICATIONS INC.

FREE FILE BOX

The field's best reference source for contemporary
advertising illustration. Write to us on
your company letterhead and we will send you our file box.
It's packed with miniature color portfolios of our artists' work.

GERALD & CULLEN RAPP, INC.
108 E. 35 ST. (#1), NEW YORK CITY 10016 PHONE: (212) 889-3337

Airstream

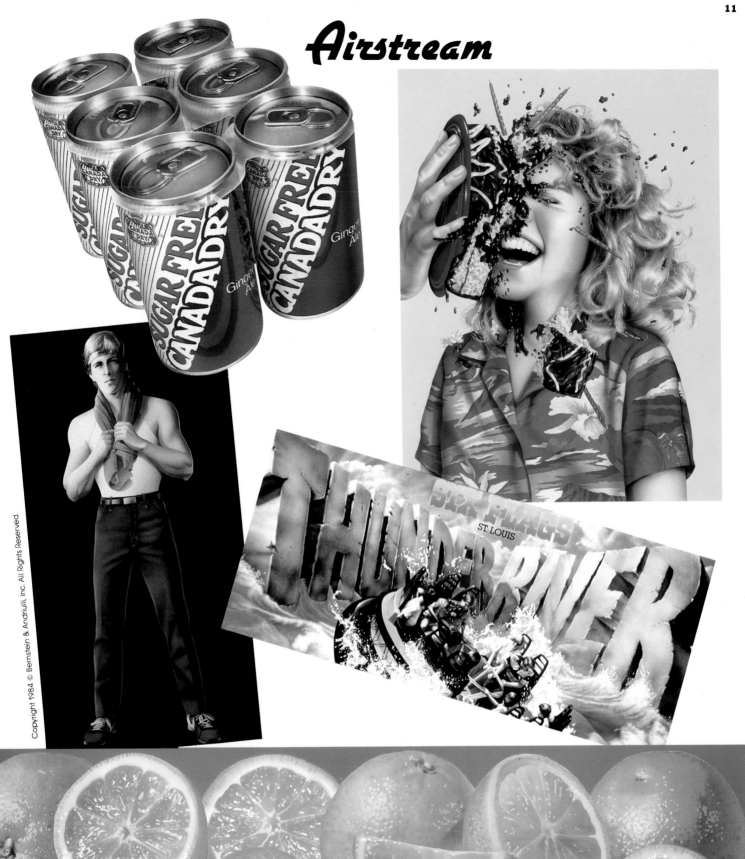

Airstream is represented by Bernstein & Andriulli, Inc. 60 East 42nd Street New York, N.Y. 10165 (212) 682-1490

Tony Antonios

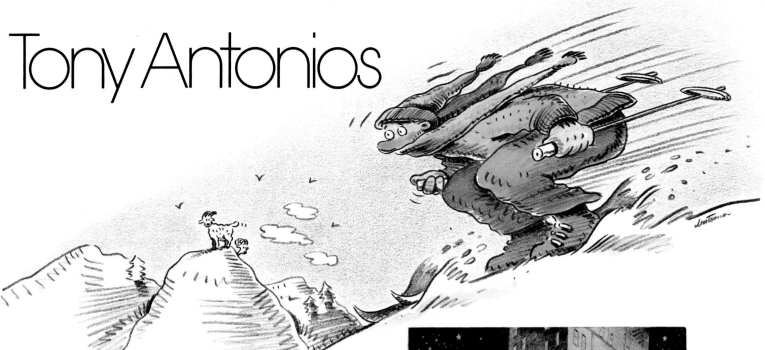

ARE THE MONEY MARKET PEOPLE OVERREACTING?

Let's face it, things have not been going too well for the money market funds lately.

It all started November 15, the day federal regulators first outlined details of the new Money Market Account. Ever since then, money has been pouring out of the money market funds by the millions.

And into The Provident.

But their loss isn't just our gain. It's yours. Because now you have an investment alternative that *outperforms money market funds in several important ways.*

MONEY MARKET RATES

Your Provident Money Market Account pays interest rates that are competitive with, if not higher than, money market funds. And you can open it with as little as $2,500.

FDIC INSURANCE

At The Provident your Money Market Account is backed by the Federal Deposit Insurance Corporation, a benefit you can't get in any money market fund.

TAX BENEFITS

The Provident also gives you a tax break. Under Massachusetts law, interest from your Money Market Account will be taxed at only half the rate of money market fund dividends: 5.375% versus 10.75%.

LIQUIDITY

Your Money Market Account at The Provident lets you write up to three checks per month. And unlike money market funds, you can write them in any amount. You can also make deposits in any amount once your account is opened. And in addition to writing checks, you can make unlimited withdrawals at no charge.

TALK TO A PROFESSIONAL

We've already given you four good reasons why you should withdraw whatever money you may now have in a money market fund and send it to The Provident today. But there's one more.

Because unlike money market funds, we give you a real person to talk to. Instead of a P.O. Box.

In fact, our Money Market Account is so superior to money market funds, it's something even the money market people might want to look into. Before they leap.

The Provident
617-423-9600 Member FDIC, DIFM

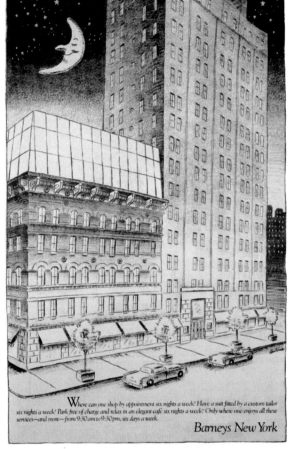

Where can one shop by appointment six nights a week? Have a suit fitted by a custom tailor six nights a week? Park free of charge and relax in an elegant café six nights a week? Only where one enjoys all these services—and more—from 9:30am to 9:30pm, six days a week.

Barneys New York

Tony Antonios is represented by Bernstein & Andriulli, Inc. 60 East 42nd Street New York, N.Y. 10165 (212) 682-1490

Garie Blackwell

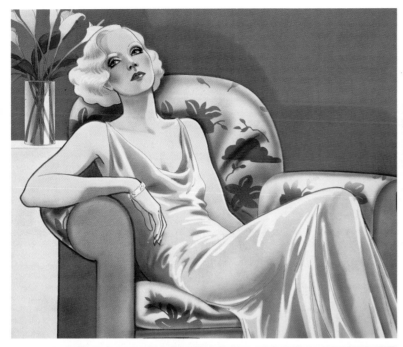

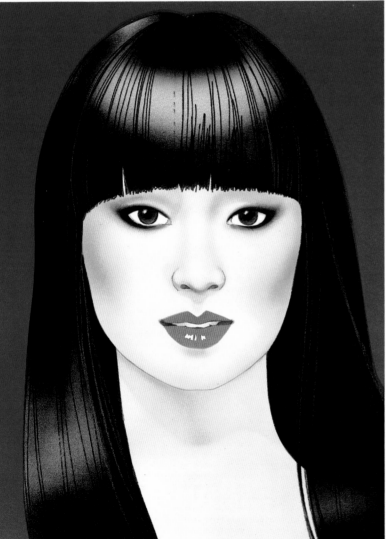

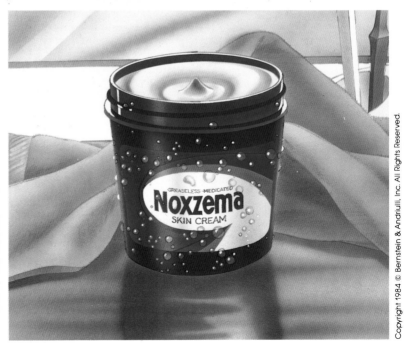

Garie Blackwell is represented by Bernstein & Andriulli, Inc. 60 East 42nd Street New York, N.Y. 10165 (212) 682-1490

Deeter

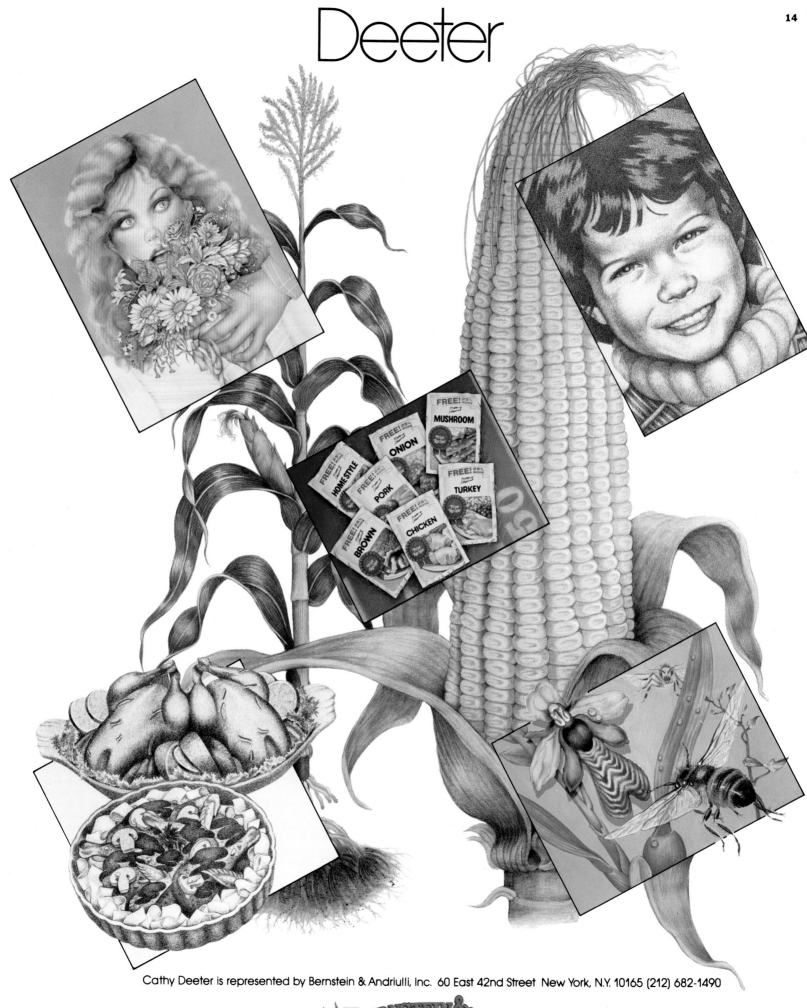

Cathy Deeter is represented by Bernstein & Andriulli, Inc. 60 East 42nd Street New York, N.Y. 10165 (212) 682-1490

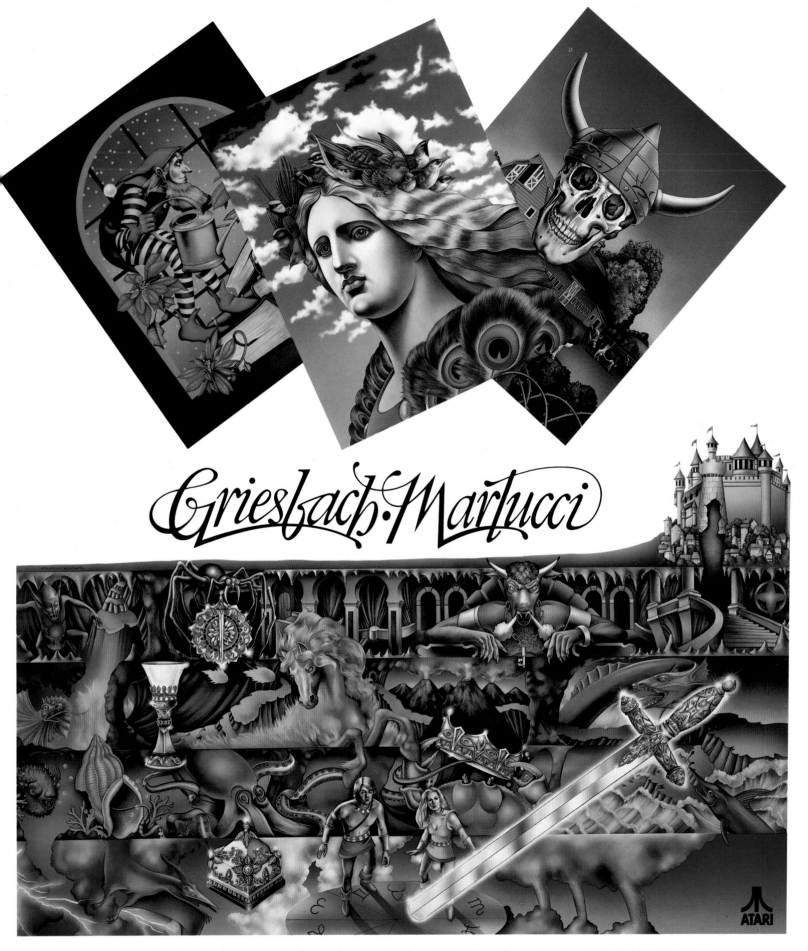

Griesbach·Martucci

Griesbach/Martucci is represented by Bernstein & Andriulli, Inc. 60 East 42nd Street New York, N.Y. 10165 (212) 682-1490

huerta

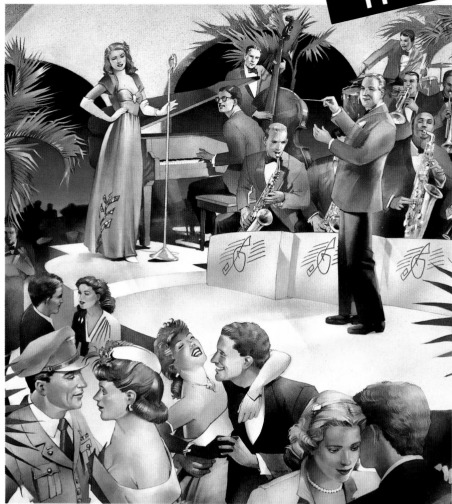

Catherine Huerta is represented by Bernstein & Andriulli, Inc. 60 East 42nd Street New York, N.Y. 10165 (212) 682-1490

kid kane

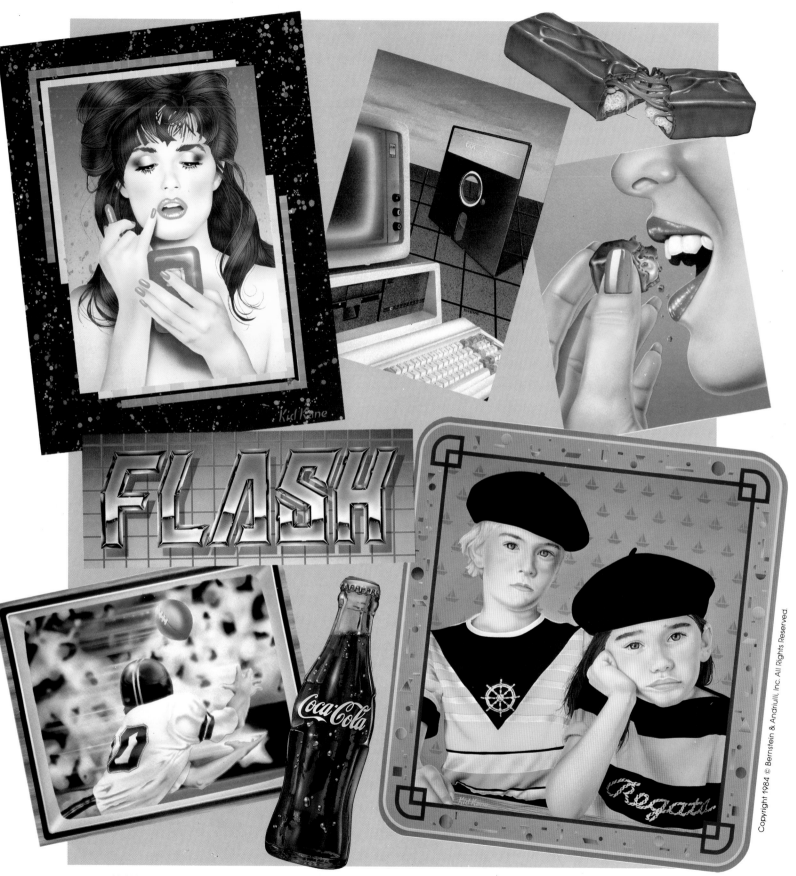

Kid Kane is represented by Bernstein & Andriulli, Inc. 60 East 42nd Street New York, N.Y. 10165 (212) 682-1490

Mary Ann Lasher

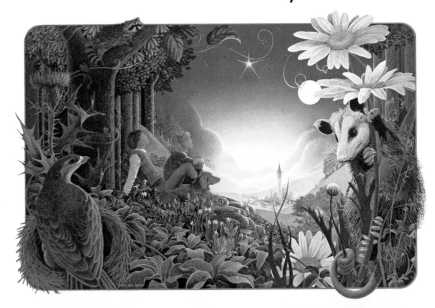

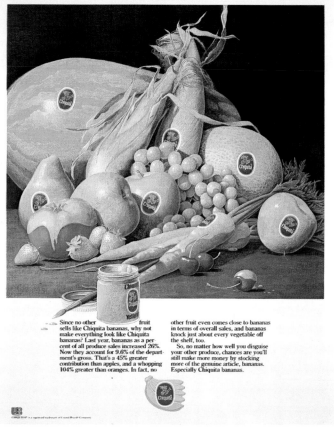

How to make the rest of your produce department almost as profitable as Chiquita bananas.

Since no other fruit sells like Chiquita bananas, why not make everything look like Chiquita bananas? Last year, bananas as a percent of all produce sales increased 26%. Now they account for 9.6% of the department's gross. That's a 45% greater contribution than apples, and a whopping 104% greater than oranges. In fact, no other fruit even comes close to bananas in terms of overall sales, and bananas knock just about every vegetable off the shelf, too.

So, no matter how well you disguise your other produce, chances are you'll still make more money by stocking more of the genuine article, bananas. Especially Chiquita bananas.

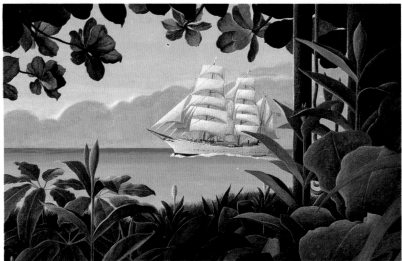

Mary Ann Lasher is represented by Bernstein & Andriulli, Inc. 60 East 42nd Street New York, N.Y. 10165 (212) 682-1490

BERNSTEIN & ANDRIULLI INC

Bette Levine

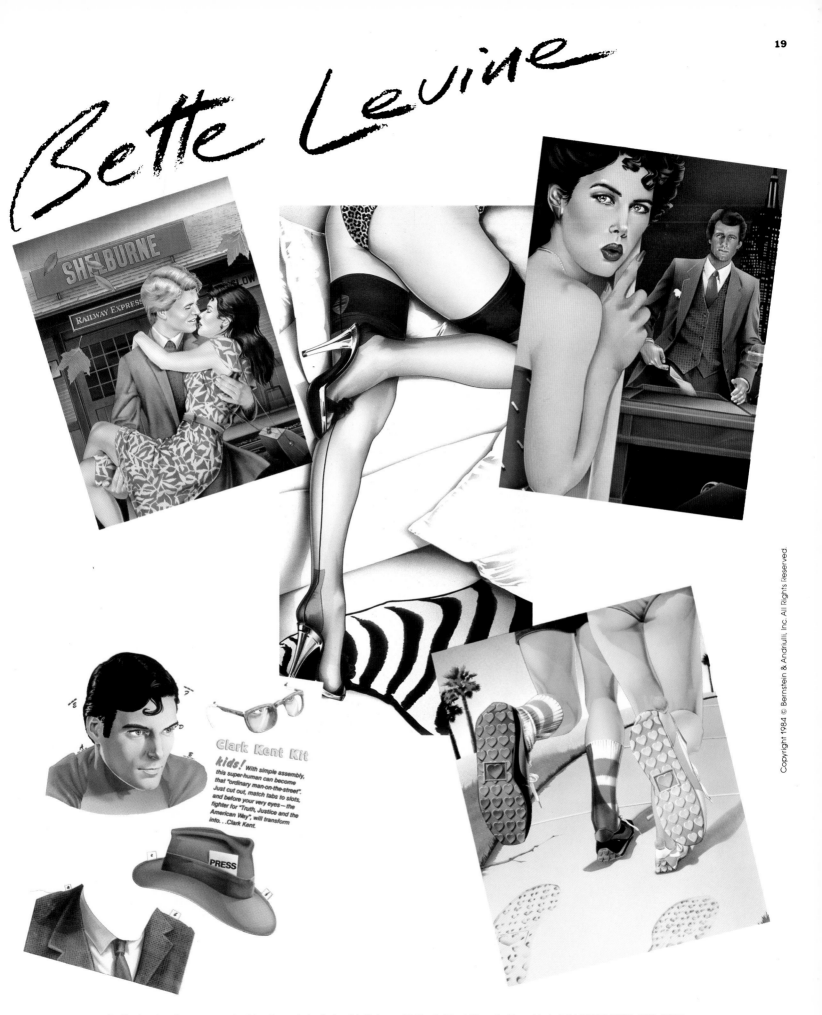

Clark Kent Kit

kids! With simple assembly, this super-human can become that "ordinary man-on-the-street". Just cut out, match tabs to slots, and before your very eyes — the fighter for "Truth, Justice and the American Way", will transform into. . .Clark Kent.

Bette Levine is represented by Bernstein & Andriulli, Inc. 60 East 42nd Street New York, N.Y. 10165 (212) 682-1490

Murray Tinkelman

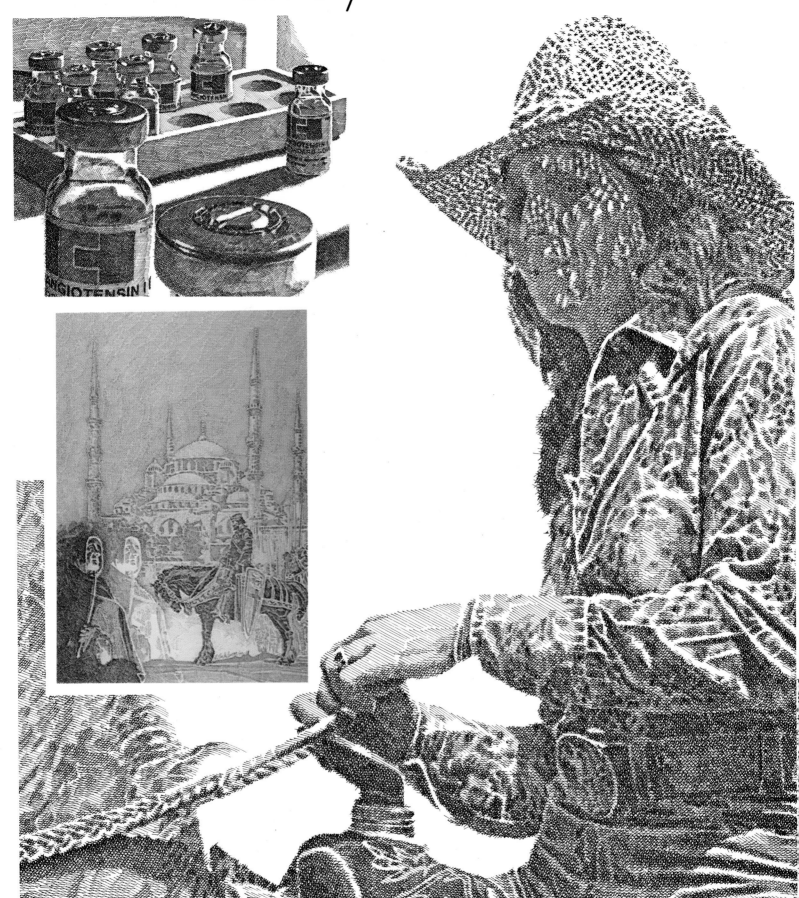

Murray Tinkelman is represented by Bernstein & Andriulli, Inc. 60 East 42nd Street New York, N.Y. 10165 (212) 682-1490

Chuck Wilkinson

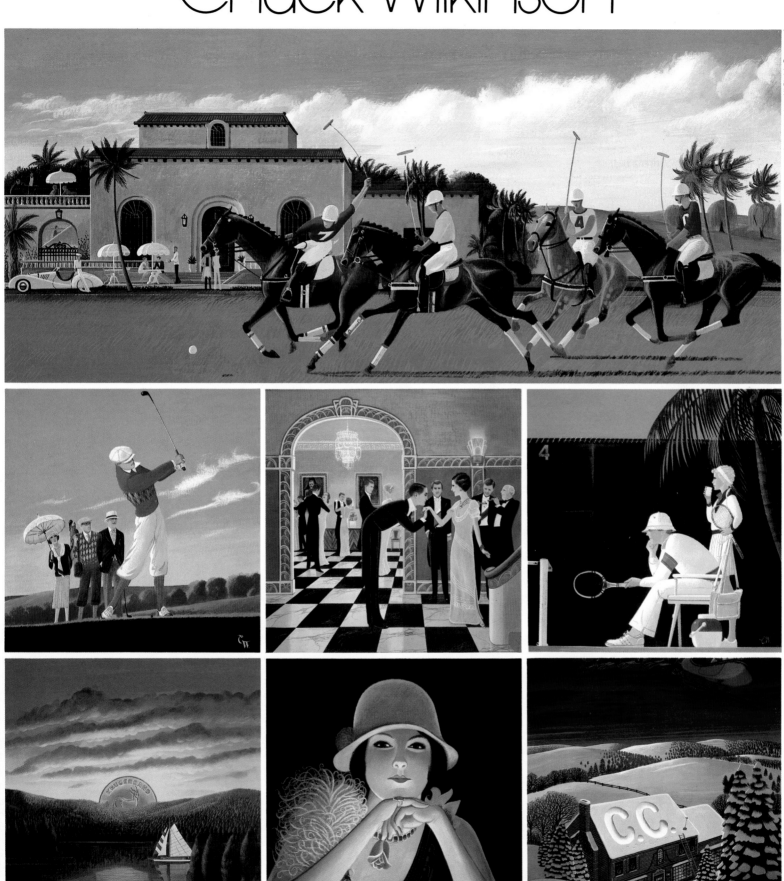

Chuck Wilkinson is represented by Bernstein & Andriulli, Inc., 60 East 42nd Street New York, N.Y. 10165 (212) 682-1490

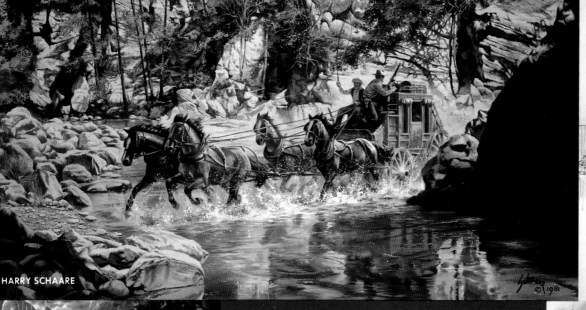
HARRY SCHAARE

PAUL GLEASON

KIRK REINERT

RALPH BRILLHART

JIM GRIFFIN

DAVID GAADT

FRANK STEINER

JOHN DISMUKES

DAVID GAADT

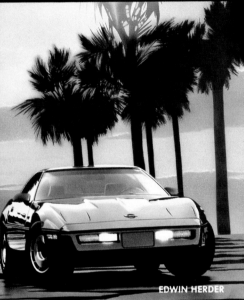

EDWIN HERDER

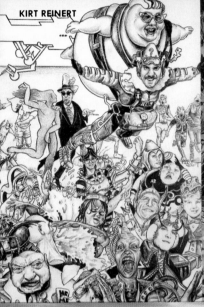

KIRT REINERT

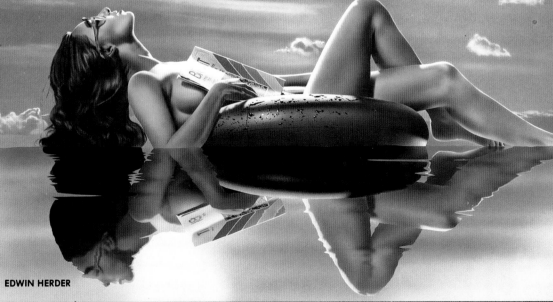

MICHAEL HERRING

NOTHING AND HAV[...]
A Practical Introduction to Small-Scale Suffi[...]
BY JANET CHADW[...]

WENDELL MINOR

EDWIN HERDER

VICTOR VALLA

JOHN DISMUKES

BOB TRAVERS

MICHAEL HERRING

HARRY SCHAARE

JOHN ENNIS

GREG MORAES

HFT

Hankins+Tegenborg

Artist's Representatives

David Hankins Lars Tegenborg
310 Madison Avenue
New York, N.Y. 10017
(212) 867-8092

BOB CROFUT

KIRK REINERT

BOB TRAVERS

RALPH BRILLHART

VICTOR VALLA

DAVID COOK

BOB CROFUT

WALTER RANE

BILL SCHMIDT

BILL SCHMIDT

ULDIS KLAVINS

JOHN DAWSON

BOB SABIN

EDWIN HERDER

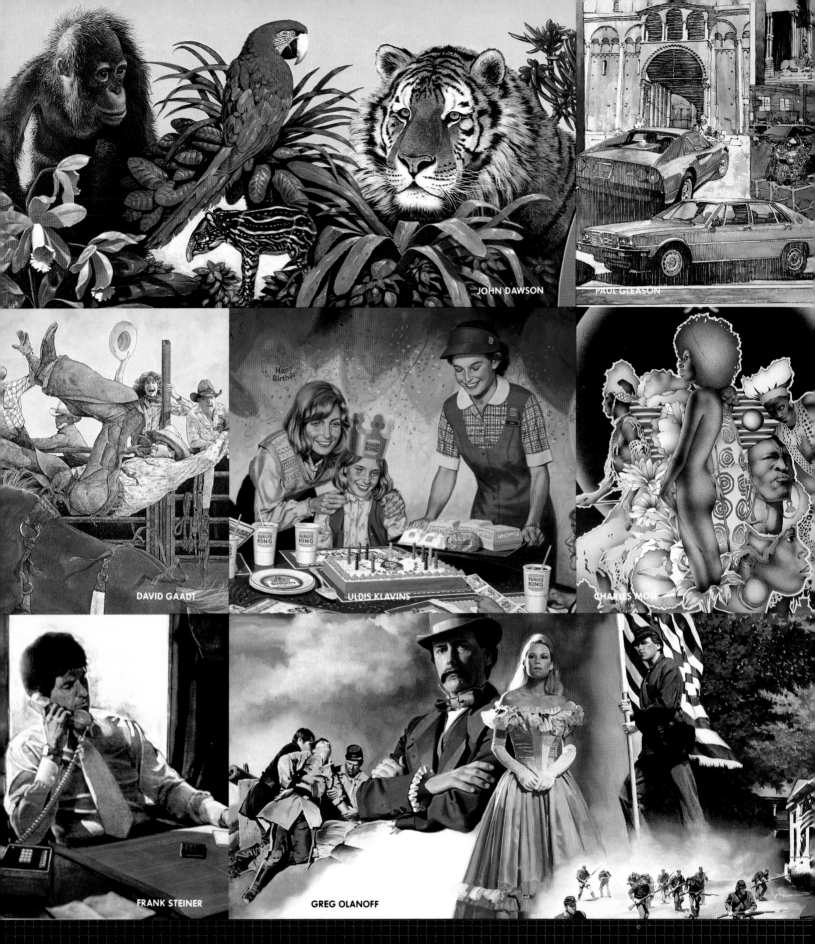

JOHN DAWSON

PAUL GLEASON

DAVID GAADT

ULDIS KLAVINS

CHARLES MOLL

FRANK STEINER

GREG OLANOFF

E·L·L·A

PHOTOGRAPHER'S & ARTIST'S REPRESENTATIVE

229 BERKELEY ST., BOSTON, MA 02116

(617) 266-3858/426-3565

ROGER LEYONMARK

FIRST CLASS FARE

EATON & IWEN

EATON & IWEN

BENTE ADLER

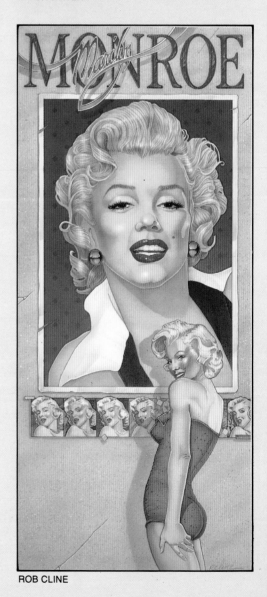

ROB CLINE

EATON & IWEN

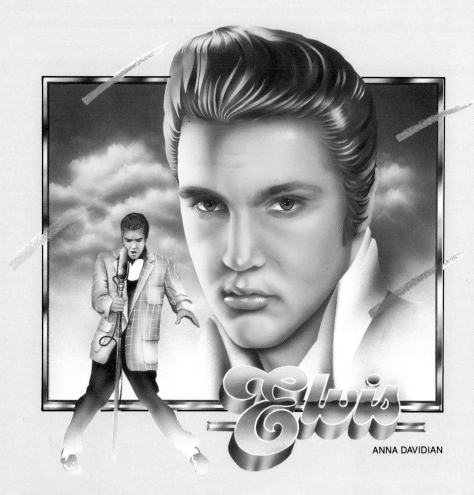

ANNA DAVIDIAN

EATON & IWEN

EATON & IWEN

EATON & IWEN

EATON & IWEN

ANN MEISEL

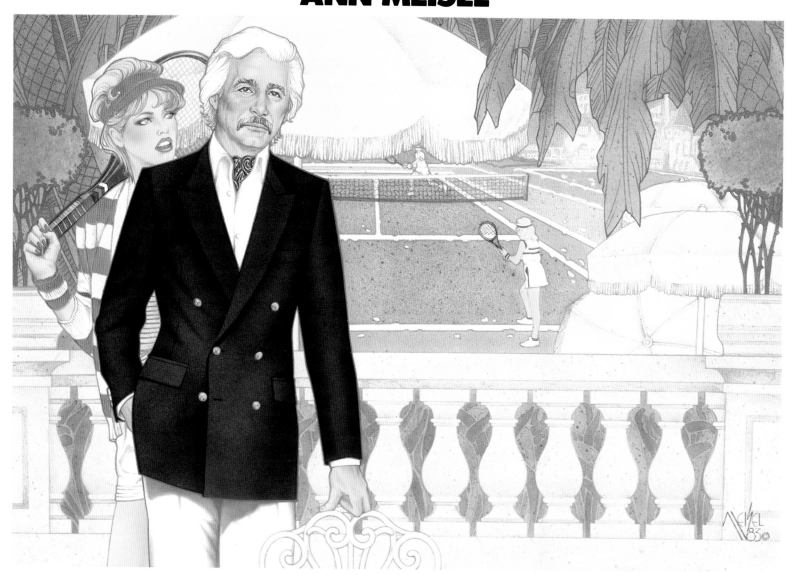

Mendola LTD.

GRAYBAR BLDG. • 420 LEXINGTON AVE. • SUITE 2911 • NEW YORK, N.Y. 10170 • (212) 986-5680

CARL CASSLER

WALLY NEIBART

PETER FIORE

DAVID SCHLEINKOFER

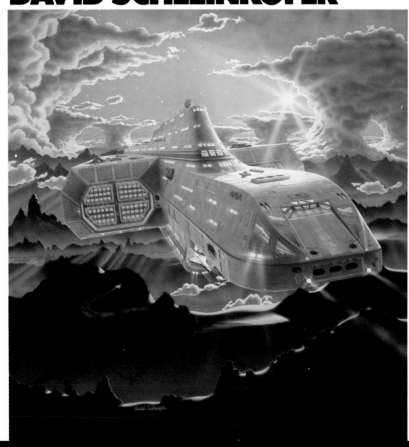

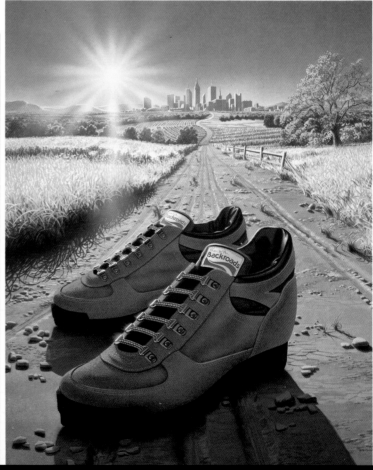

Mendola LTD.

GRAYBAR BLDG • 420 LEXINGTON AVE • SUITE 2911 • NEW YORK, N.Y. 10170 • (212) 986-5680

BOB JONES

BEN WOHLBERG

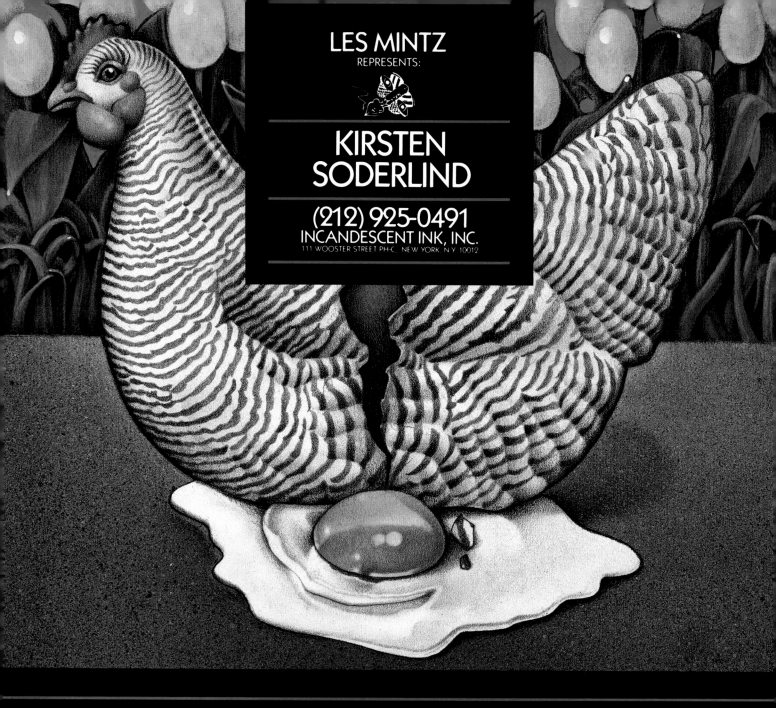

FINISH MAR

Shell Oil Company 1982 Annual Report

ANNE BRODY
Studio Six
55 Bethune Street
New York, New York 10014
(212) 242-1407

Represents:

DEBORA WHITEHOUSE

Clients include:
Ballentine Books; Grey Advertising; Guideposts;
Playboy Press; Playboy Promotion; *Ladies' Home Journal;*
Seventeen Magazine; Avon Cosmetics; Dell Books;
Time/Life; *Ms. Magazine.* Member Graphic Artists Guild

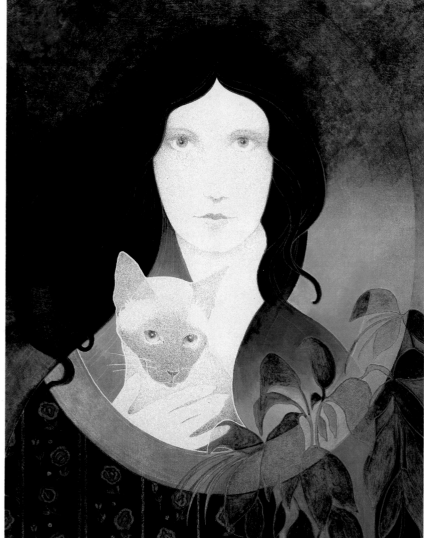

JIM HUNT

MICHAEL HAYNES

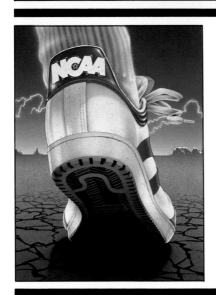

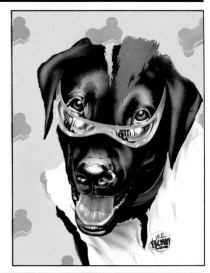

TIM HERMAN

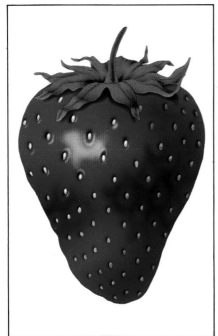

Split.

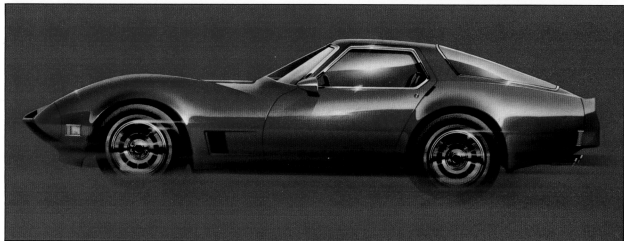

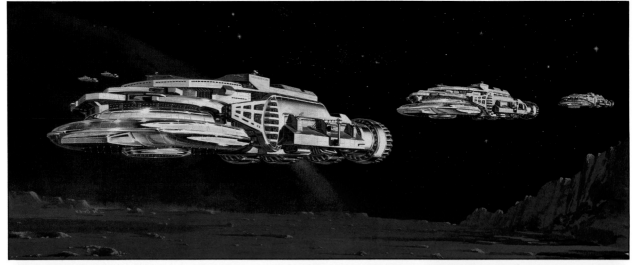

JOE OVIES

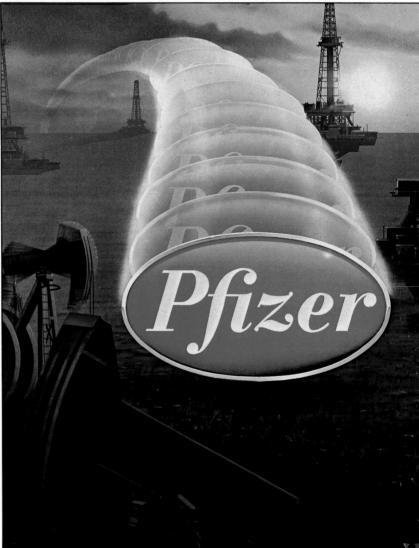

DANNY SMYTHE

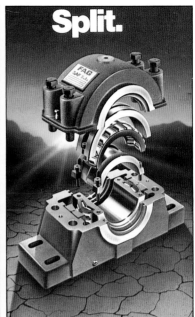

Split.

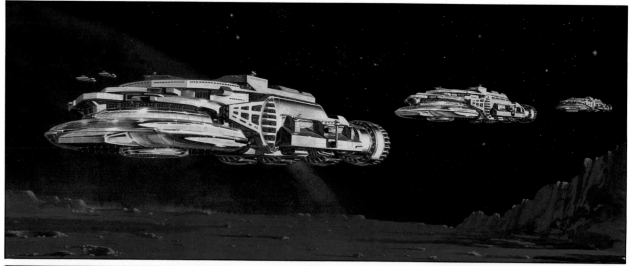

JOE OVIES

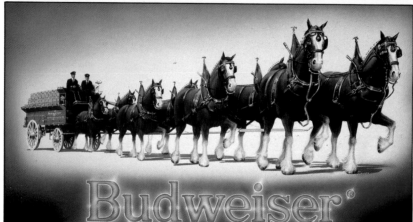

DANNY SMYTHE

CAROL CHISLOVSKY INC.
420 Madison Avenue
New York, New York 10017
(212) 980-3510

Call or write for Free File Box that
includes visual representation of all
our artists

Represents:

CHUCK SCHMIDT
JOE LAPINSKI

CHUCK SCHMIDT

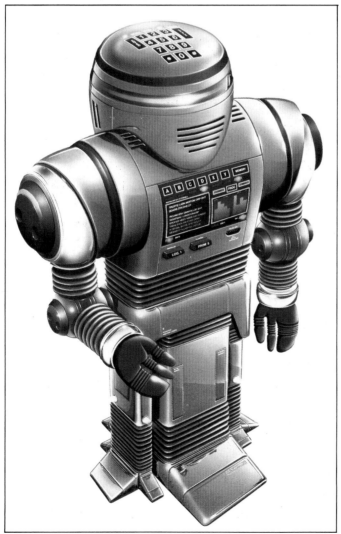

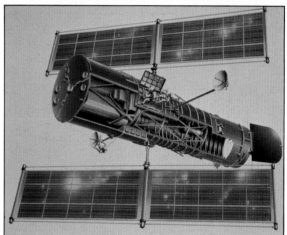

JOE LAPINSKI

continued from page 36

met in my life. Whatever the hell he is, he is sure to own this building, and maybe the whole street, before he's much older. He sure is <u>going</u> places, and it ain't just to Honolulu on the S.S. <u>Pansylvania</u>, either. He'll be in Washington in somebody's Cabinet, if we don't watch out. This character is dynamite...

I forgot to tell you that they were prepared to pay anywhere from thirty-five hundred to five thousand dollars for this drawing, but I don't suppose I have to tell you that I was certainly going to <u>try</u> for it, if it killed me.

First I held a council of war. I called Covarrubias, Johnnie Held and Al Hirschfeld and asked them to give me their well-considered advice about how to handle this booby trap.

"Forget it!" said Al. "And if you <u>insist</u> on monkeying with it, do it all above eye level. Like a semi-bird's-eye view, get it, so you get a titivating glimpse of the girls' cleavages. You might even have one of the couples necking in one of the lifeboats."

"The lifeboats are <u>covered</u>," I said. "And, besides, all these people are high in the chips, brother, and by the time you've accumulated a pile big enough for that kind of cruise, you're no longer young enough to leap in and out of lifeboats."

"Nonsense!" said Al. "If you make any of the jokers on that cruise older than twenty-four, they'll just laugh you right out of that office."

I realized, of course, that he was dead right.

Nobody in an American ad is ever out of his, or her, early twenties, unless it's an ad for some premature retirement fund. And even those inventions used to puzzle me like all hell. The couples in those ads would always be sitting in some landscape, or in some boat on a lake, with rambler roses in the foreground, orchids and palms in the near backdrop. <u>She</u> was generally a semi-motherly type. I say <u>semi</u>-motherly because you couldn't possibly imagine her in the sort of compromising condition that is bound to occur when a woman gives birth to something. Much less was it possible to visualize her involved in the disorderly machinations that must inevitably have taken place to result even in a minor pregnancy. Her hair was curled and coiffed like coiled aluminum, and she had been caught by the artist or photographer in the act of knitting some sort of incalculably pure piece of gossamer wearing apparel for a nixie. The husband had just at that moment nailed an enormous speckled trout (two and a half feet long at the most conservative estimate) and this trout was grinning toothily from gill to gill, obviously enchanted to have been captured by such a neat and eminently solvent couple.

Years ago the legend beneath this tableau used to read:

"Retire at <u>Fifty</u> on a <u>Hundred and Fifty a Month!</u>"

I notice that the ante has been raised a good deal since then. Things have gotten a lot more expensive in the interim, don't you see?

I wonder what ever became of that original couple when inflation started to set in. Where in hell can they possibly be now?

Washing dishes in some nearby diner, I suppose.

All these dismal musings, naturally, landed me nowhere. I just had to get down to limning my great cruising masterpiece if ever I expected to rake in all that rich, loose advertising kale.

I'll skip three bitter weeks and just tell you that it was pure, ever-suffering hell. You see, solvent people nowadays are so goddamned unpicturesque—<u>that</u> was my chief trouble. All those barbered, Brooks-tailored men, all those sanitary, carefully groomed women, just gave me the absolute willies. Let's face it, it was a lot easier for artists in the old days. The beards, the mustaches, the fuffs, the cuffs, the swords and the lutes were simply the greatest. Rembrandt and Van Dyke had a cinch; Holbein and even Ingres never knew what a portrait problem <u>really</u> was. They should have come to <u>me</u>. And I had to do eighty of these monsters. That's more people than El Greco painted at "The Funeral of Count Orgaz."

<u>Man!</u>

Well, it was finally done. I mean I <u>did</u> it. My household was completely demoralized when it was over, and I went to a Turkish bath just to make sure that all the remaining poison was properly sweated out of me. The following day I went up to the advertising agency to submit my creation. I was admitted at once.

Mr. Dekker, who had called me several times during the weeks of my labors, had a flower in his buttonhole. There was a festive, almost bridal air in the making. There was only one other person present, an elderly factotum who pretended to be busy in the far corner of the room. I wondered how many years this poor creature could possibly have worked in this soap-bubble factory, since he still wore black bombazine sleeve protectors on his withered arms.

At any rate, the mantel was cleared and I unveiled my opus.

Mr. Dekker stepped back, put a hand on his chin, cocked his head sideways and squinted critically at my picture.

"Ma-a-a-arvelous!!!" he said. "Absolutely ma-a-a-arvelous!!!"

continued on page 66

DANIELE COLLIGNON
200 West 15th Street
New York, New York 10011
(212) 243-4209

We work in all areas of the business: publishing, records and music promotion, editorial, posters, advertising, catalogues, fashion.

Our clients include: Time/Life Inc., Ziff-Davis, Bantam Books, *Penthouse,* ABC Inc., American Bell, Haggar Fashion, Avon Products, RCA Records, Arista Records, Warner Communications, *San Francisco Magazine, The New York Times, Texas Monthly, Redbook, Science Digest,* American Psychological Association, Harcourt-Brace-Jovanovich, Scholastic Inc., Harper & Row, Ogilvy & Mather, Tracy-Locke/BBDO, Henri Bendel, C.E.S. Publishing, *Essence,* Crown Publishers, William Morrow & Co.

Member Graphic Artists Guild

Member SPAR

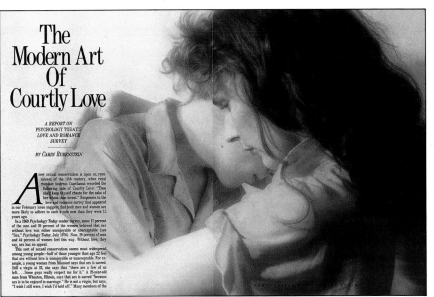
CHRISTINE RODIN

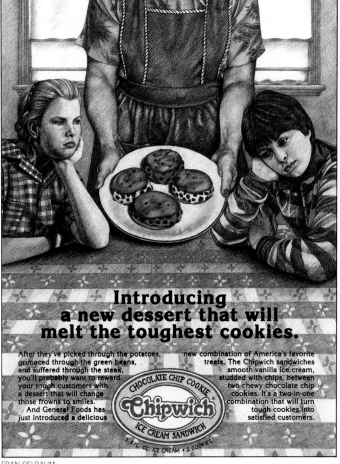
FRAN OELBAUM

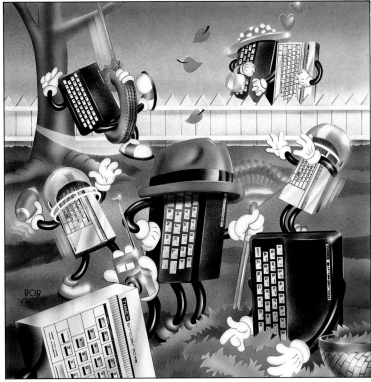
BOB AIESE

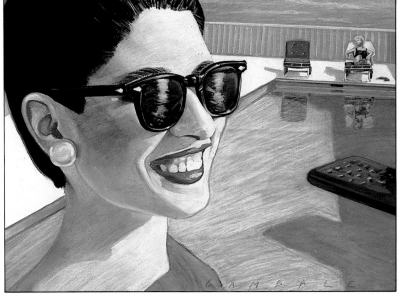
DAVID GAMBALE

BARBARA GORDON ASSOCIATES
165 East 32nd Street
New York, New York 10016
(212) 686-3514

Barbara and Elliott Gordon

Barbara Gordon Associates works in all areas of the business,
including advertising, paperbacks, movies, industrial,
pharmaceutical, fashion, corporate, government, packaging,
publishing and television.

Complete portfolios on all the artists and photographers
represented by the firm are available upon request.

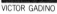

Barbara Gordon
Associates Ltd
165 East 32 Street
New York, N.Y. 10016
212 686 3514

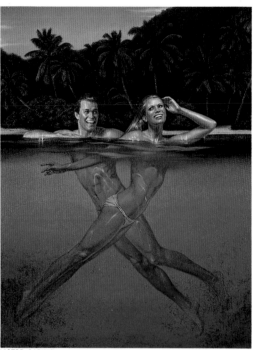

VICTOR GADINO

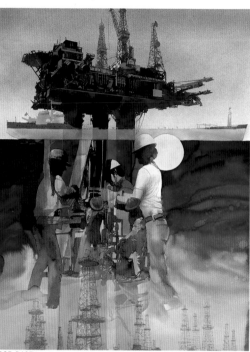

BOB DACEY

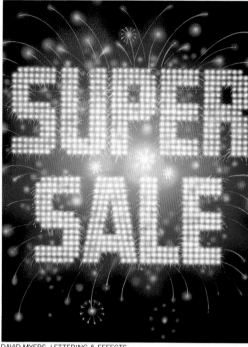

DAVID MYERS, LETTERING & EFFECTS

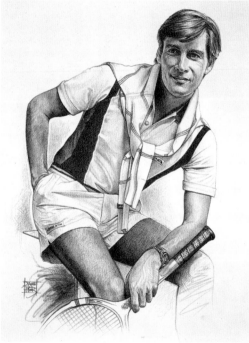

JACKIE JASPER

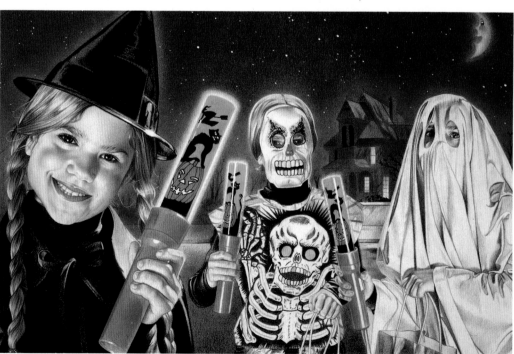

JACKIE JASPER

Barbara Gordon
Associates Ltd
165 East 32 Street
New York, N.Y. 10016
212 686 3514

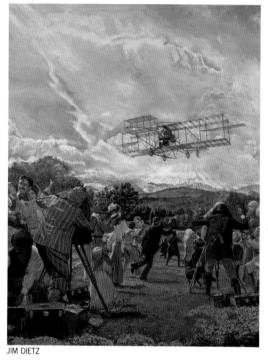

JIM DIETZ

GLENN HARRINGTON

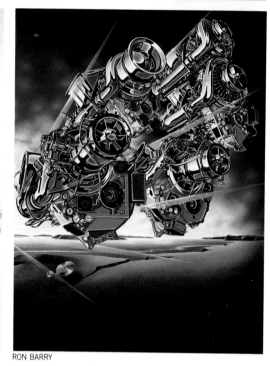

RON BARRY

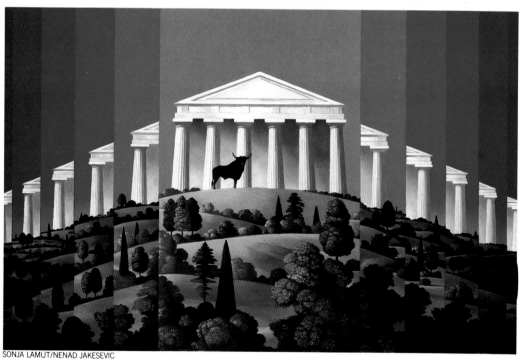

SONJA LAMUT/NENAD JAKESEVIC

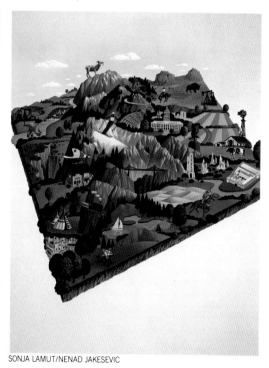

SONJA LAMUT/NENAD JAKESEVIC

TANIA KIMCHE
 ARTISTS REPRESENTATIVE
470 West 23rd Street
New York, New York 10011
(212) 242-6367

Representing:

MICHAEL HOSTOVICH
RAFAL OLBINSKI
MIRIAM SCHOTTLAND
E.T. STEADMAN

T A N I A

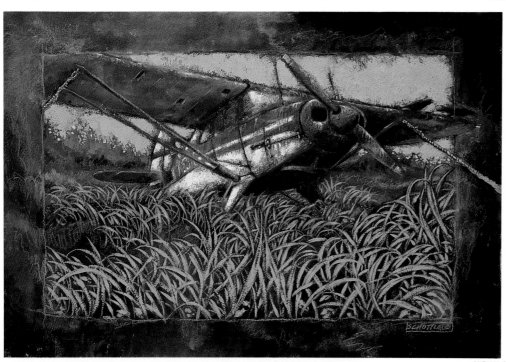

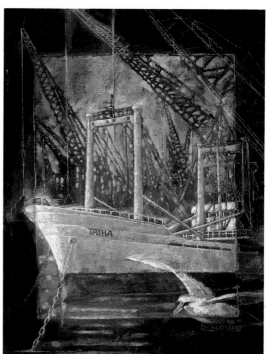

MIRIAM SCHOTTLAND

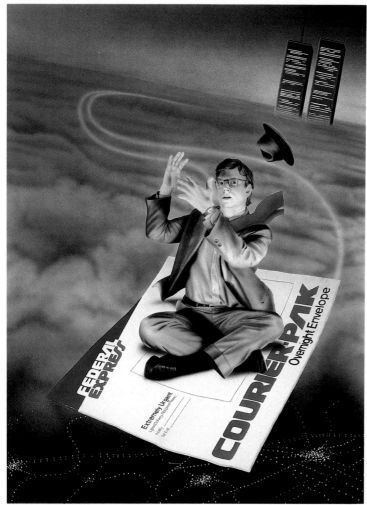

E.T. STEADMAN

E.T. STEADMAN

TANIA KIMCHE
ARTISTS REPRESENTATIVE
470 West 23rd Street
New York, New York 10011
(212) 242-6367

Representing:

MICHAEL HOSTOVICH
RAFAL OLBÍNSKI
MIRIAM SCHOTTLAND
E.T. STEADMAN

T A N I A

MICHAEL HOSTOVICH

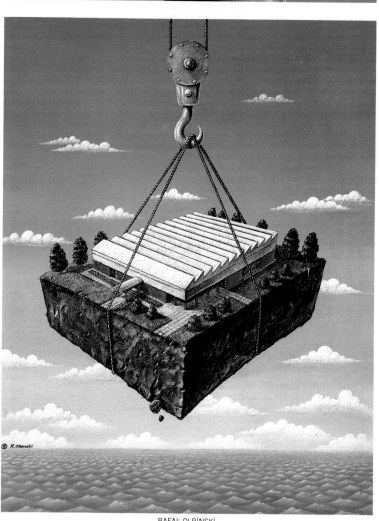

MICHAEL HOSTOVICH

RAFAL OLBÍNSKI

BILL and MAURINE KLIMT
15 West 72nd Street
New York, New York 10023
(212) 799-2231

Representing:

JEFFREY ADAMS
KEN JOUDREY
MICHAEL KANE
FRANK MORRIS
MICHAEL RODERICKS
and others.

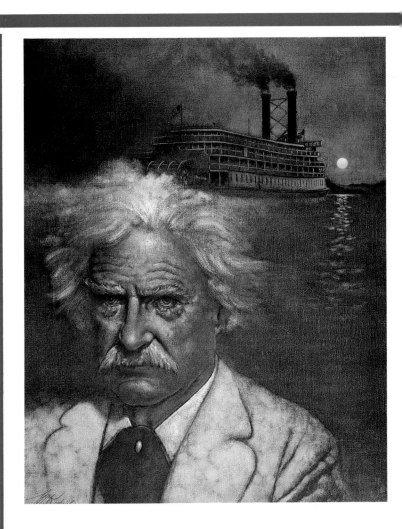

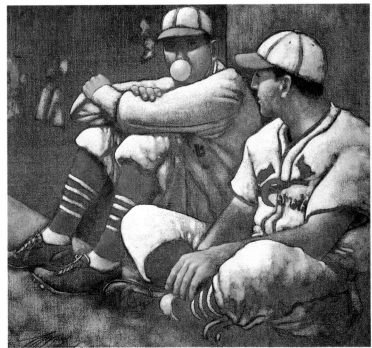

FRANK MORRIS

MICHAEL RODERICKS

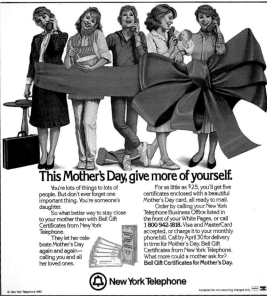

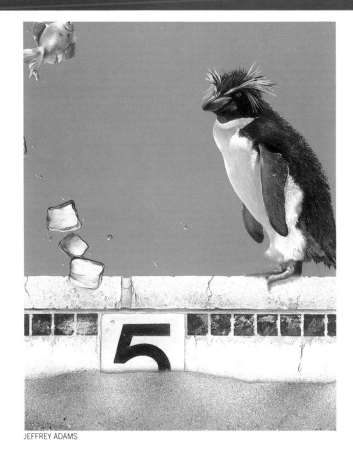

JEFFREY ADAMS

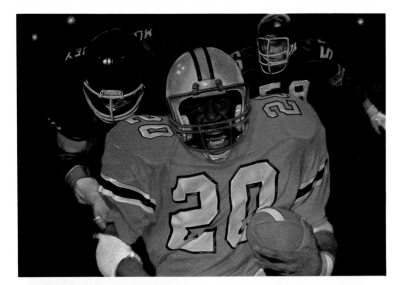

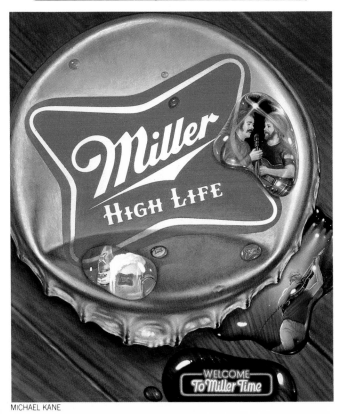

MICHAEL KANE

KEN JOUDREY

JANE LANDER ASSOCIATES
333 East 30th Street
New York, New York 10016
(212) 679-1358

Contact: Chris Osborne
Jane Lander

Representing:

FRANK RILEY
(201) 423-2659

Illustration and Design

Member Joint Ethics Committee,
Member Society of Illustrators

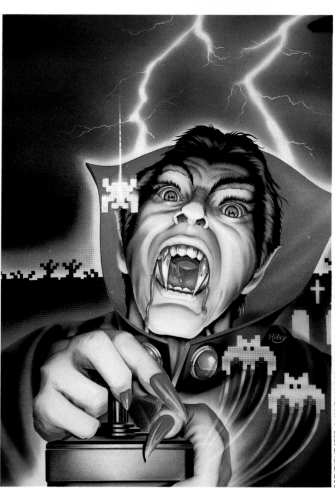

JANE LANDER ASSOCIATES
333 East 30th Street
New York, New York 10016
(212) 679-1358

Contact: Chris Osborne
 Jane Lander

Member Joint Ethics Committee
Member Society of Illustrators

Represents:

JACK PARDUE
(703) 765-2622
Visuals 1 thru 4

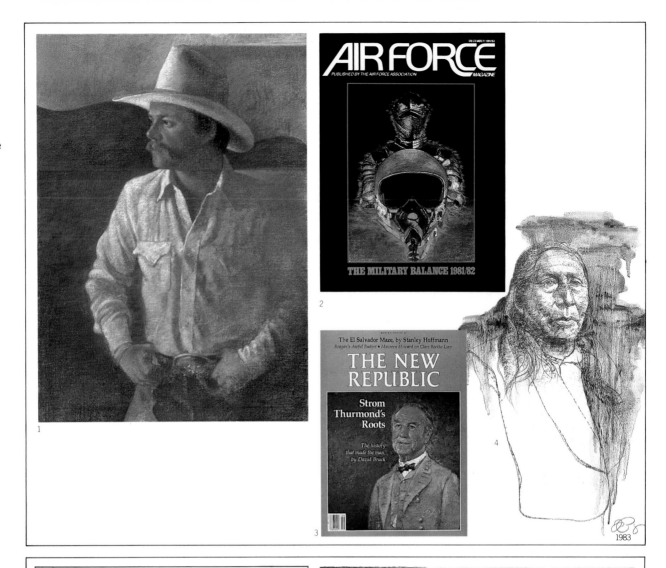

Represents:

MEL FURUKAWA
(212) 349-3225
Visuals 5 thru 9

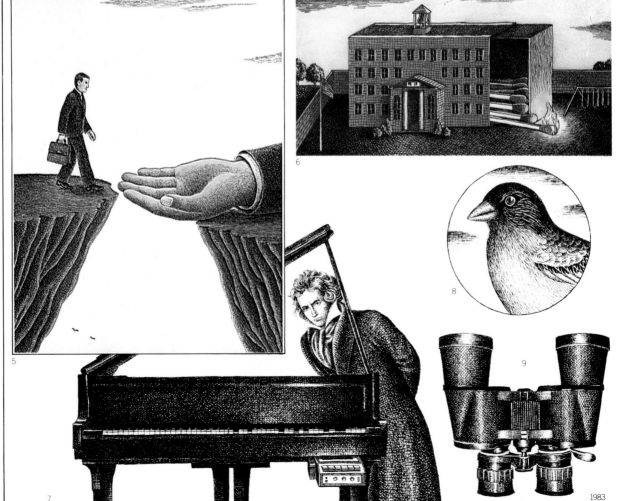

JERRY LEFF ASSOCIATES, INC.
342 Madison Avenue
New York, New York 10173
(212) 697-8525

Jerry and Wilma Leff

Complete portfolios on all of the artists represented
by the firm are available upon request.

Call us for your copy of our promotional brochure.

Whatever an assignment may call for, we'll be most
happy to match you up with the artist who best
suits your particular needs.

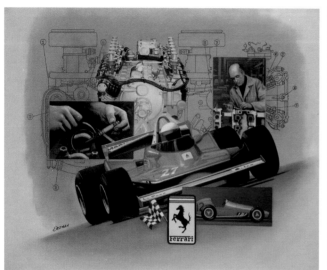

BRYANT EASTMAN

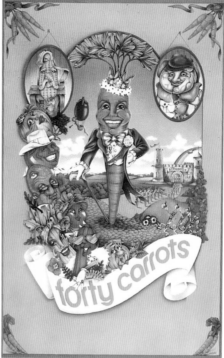

PENELOPE

FRANCO ACCORNERO

JON TOWNLEY

JOHN PARSONS

JIM BARKLEY

JERRY LEFF ASSOCIATES, INC.
342 Madison Avenue
New York, New York 10173
(212) 697-8525

Jerry and Wilma Leff

Complete portfolios on all of the artists represented
by the firm are available upon request.

Call us for your copy of our promotional brochure.

Whatever an assignment may call for, we'll be most
happy to match you up with the artist who best
suits your particular needs.

CHARLES GEHM

RON LESSER

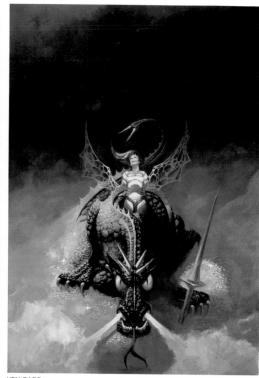

KEN BARR

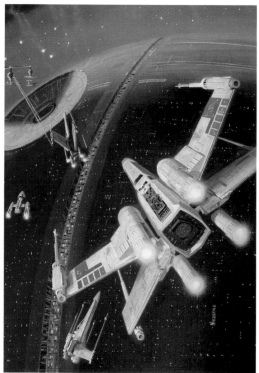

MICHAEL NICASTRE

DENNIS MAGDICH

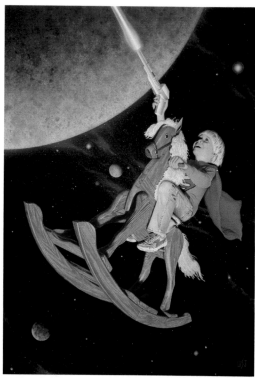

BILL SELBY

EILEEN MOSS
ARTIST'S REPRESENTATIVE
333 East 49th Street
New York, New York 10017
(212) 980-8061

Represents:

SCOTT POLLACK

Partial client list includes:
Barron's, Business Week, Doyle Dane Bernbach, Fairchild Publications,
Grey Advertising, *Inquiry Magazine, Outdoor Life, The Runner, Ski*
and *Working Mother Magazine.*

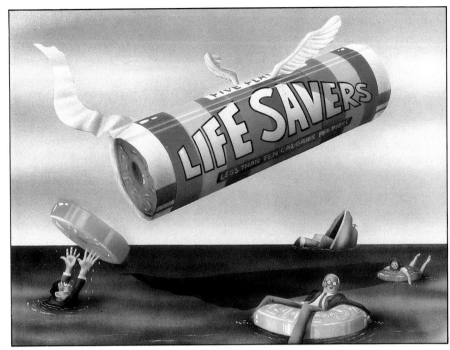

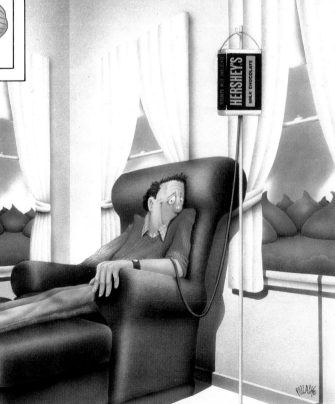

EILEEN MOSS
 ARTIST'S REPRESENTATIVE
333 East 49th Street
New York, New York 10017
(212) 980-8061

Represents:

KARI BRAYMAN
MICHAEL DAVIS

Partial client list includes:
Young & Rubicam; Hitachi; Ogilvy & Mather; Scali,
McCabe, Sloves; Backer & Spielvogel; Ally & Gargano;
N.W. Ayer.

Member of Graphic Artists Guild

KARI BRAYMAN

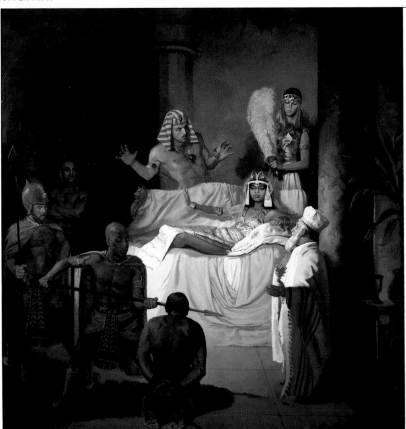

MICHAEL DAVIS

OPTICALUSIONS
9 East 32nd Street
New York, New York 10016
(212) 688-1080

Represented by: Rick Chalek

Super-realistic product, technical and semi-industrial illustration...
Fully drawn and rendered; not a photo-enhancement or retouching technique.

ROGER METCALF

GEORGE KANELOUS

TERRY RYAN

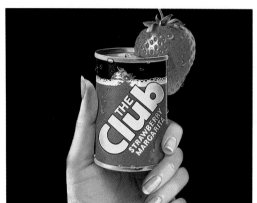
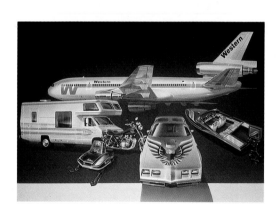

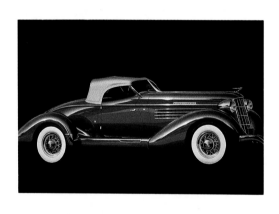
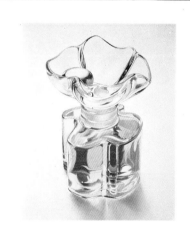

THE PENNY & STERMER GROUP
A division of:
Barbara Penny Associates, Inc.
114 East 32nd Street
New York, New York 10016
(212) 685-2770

Representing:

MICHAEL KANAREK

1. Glenmore Distilleries Co., AD: Charles Roth
2. Fortune Magazine, AD: Jean Held
3. Paramount Pictures, AD: Gene Kolomatsky
4. Anheuser Busch, AD: Charles Roth
5. Old Weller Bourbon, AD: Maryann Carls

Clients Include: Mazola, IBM, MCA, Atari,
American Airlines, RCA, Kodak, Remco,
R.T. French, Owens Corning, CBS Records.

THE
PENNY &
STERMER
GROUP

1.

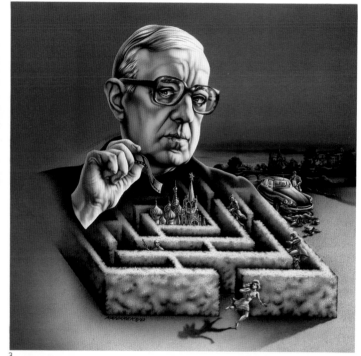

2.

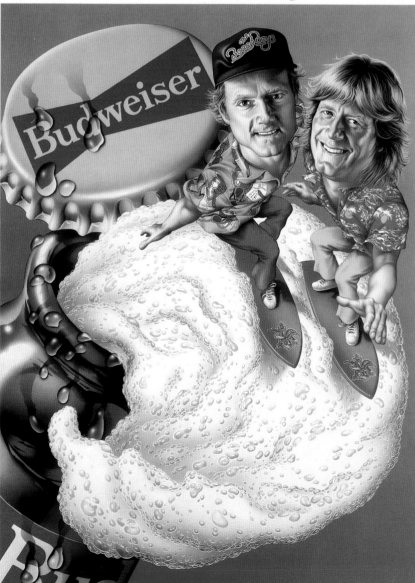

4.

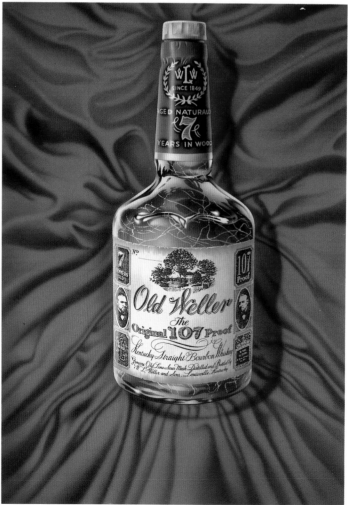

3.

5.

THE PENNY & STERMER GROUP
A division of:
Barbara Penny Associates, Inc.
114 East 32nd Street
New York, New York 10016
(212) 685-2770

Representing:

JULIAN GRADDON†
STEVE SHUB††

†Clients Include: Coca-Cola Co., R.T. French, Air Canada, British Tourist Board, Marine Midland Bank, R C A, London Transport, British Postal Authority, NBC, Smucker's, American Can, American Express, Celestial Seasonings, Lipton Tea, *People Magazine,* IBM, Shell Oil Co.

††Clients Include: Sunoco, Air Canada, American Airlines, Beefeater Gin, Wyeth Laboratories, Ciba-Geigy Corp., Roche, J.C. Penney, NBC, *Showtime,* Life Savers Inc., Con Edison, Digital Research, Fruit-of-the-Loom, Atari, General Foods.

THE
PENNY &
STERMER
GROUP

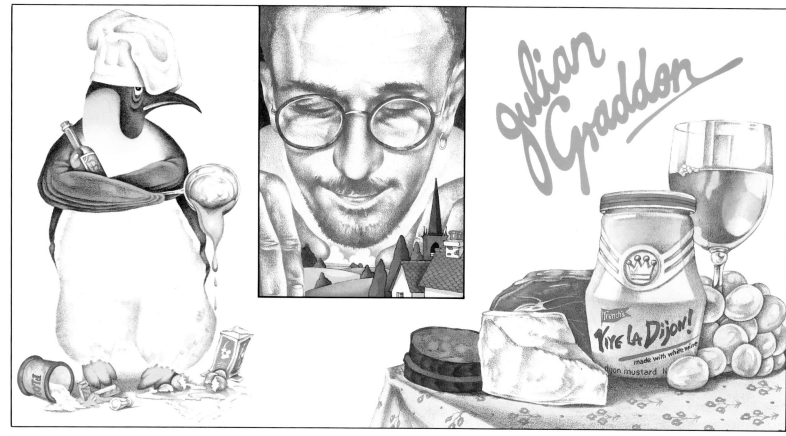

THE PENNY & STERMER GROUP
A division of:
Barbara Penny Associates, Inc.
114 East 32nd Street
New York, New York 10016
(212) 685-2770

Representing:

BOB ALCORN

© 1983 Barbara Penny Associates, Inc.
All rights reserved

1,2,3. Bloomingdale's, AD: Brian Burdine
4. ChemLawn, AD: M. Cancellieri/C. Saba
5. Redbook, AD: Maxine Davidowitz
6. Allied Corp. AD: Jerry Lenoff

Clients Include: Texaco, Visa, Wyeth Labs, *Rolling Stone, National Lampoon, Forbes Scientific American, Business Week, Newsweek,* General Foods, Ortho Pharmaceutical Corp., R.T. French, Remco Toys, TV Guide, Carrier Corp., Bacardi Rum, Schering Corp.

THE
**PENNY &
STERMER**
GROUP

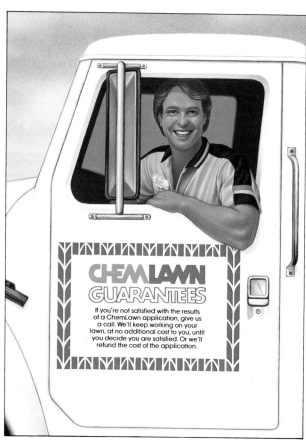

THE PENNY & STERMER GROUP
A division of:
Barbara Penny Associates, Inc.
114 East 32nd Street
New York, New York 10016
(212) 685-2770

Representing:

ANDY LACKOW

© 1983 Barbara Penny Associates, Inc.
All rights reserved

1. Atari, AD: Michelle Farnum
2. Atari, AD: Garrett Jewett
3. R.T. French, AD: Susan Rose
4. Heavy Metal Magazine, ED: Julie Simmons-Lynch
5. Self Promotion
6. Listerine, AD: Sal Lombardo

Clients Include: *Discover Magazine,* Oscar
De La Renta, Muzak, American Airlines,
Procter & Gamble Co., Consumer Reports,
Ore-Ida Foods, Lehn & Fink, Stroh Brewery,
X-Acto, *National Lampoon,* Friendship Dairy,
Western Union, ABC News, Anheuser Busch,
Time Inc., Hoffmann-La Roche Inc.

THE
PENNY &
STERMER
GROUP

1.

2.

3.

4.

5.

6.

THE PENNY & STERMER GROUP
A division of:
Barbara Penny Associates, Inc.
114 East 32nd Street
New York, New York 10016
(212) 685-2770

Representing:

DEBORAH BAZZEL

1. Self Promotion
2. Redbook Magazine, AD: Maxine Davidowitz
3. The Galleria, AD: William Snyder Design
4. Kayser-Roth Hosiery, AD: Bob Bryan

Clients Include: Coca-Cola U.S.A., Texaco, Exxon, American Airlines, Gaines, *Money Magazine*, Time Inc., *Business Week*, Citibank, R.T. French, Holland America Cruises, Marriott Hotel, Listerine, Western Union, J.C. Penney, Heinz, Life Savers, Inc.

THE
PENNY &
STERMER
GROUP

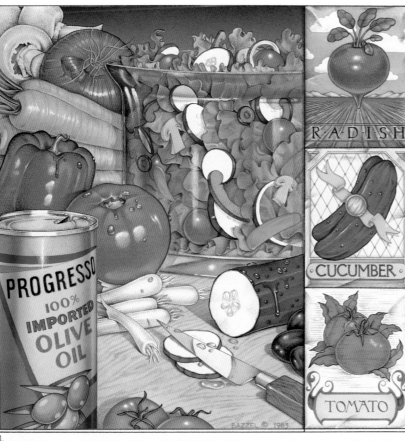

1.

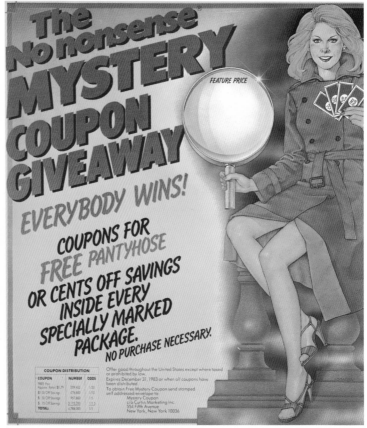

2.

3.

4.

THE PENNY & STERMER GROUP
A division of:
Barbara Penny Associates, Inc.
114 East 32nd Street
New York, New York 10016
(212) 685-2770

Representing:

PAGE WOOD

Clients Include: General Foods, *Newsweek,*
Good Housekeeping, Anheuser Busch,
R.T. French, Knickerbocker Toys, Fieldcrest,
Mobil, MCA, American Airlines, Carnival Films,
Bloomingdale's, GAF, *National Lampoon,* IHOP
Corp., *TV Guide, Rolling Stone,* Time Inc.

THE
**PENNY &
STERMER**
GROUP

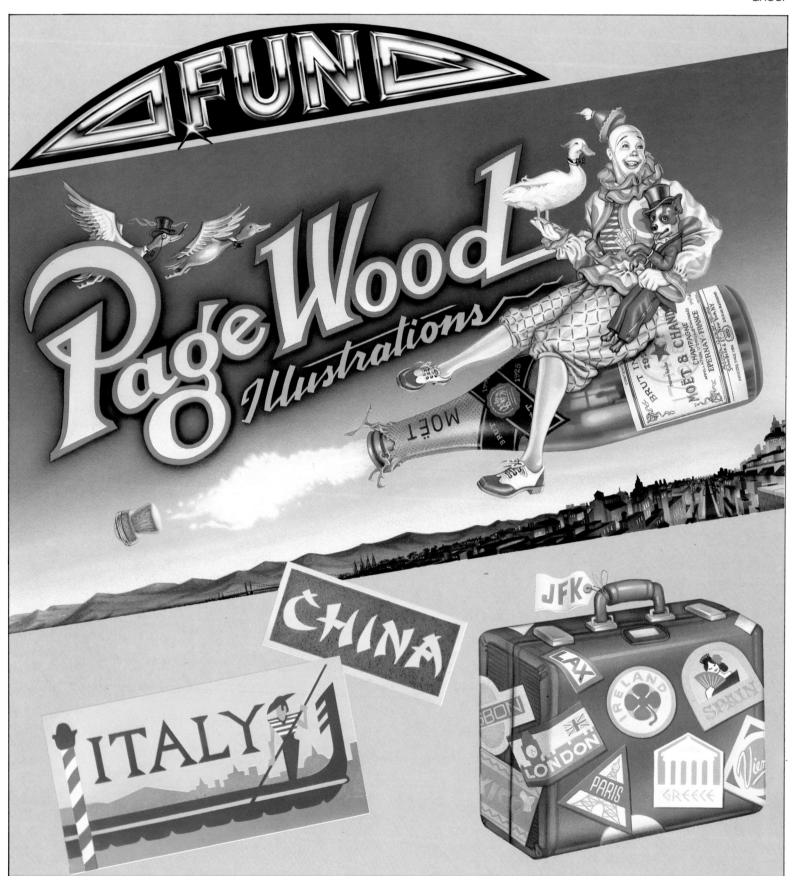

THE PENNY & STERMER GROUP
A division of:
Barbara Penny Associates, Inc.
114 East 32nd Street
New York, New York 10016
(212) 685-2770

Representing:

RICH GROTE

1. Schering Corp., AD: Joe Cacaro
2. Parke-Davis, AD: T. Wichowski/C. Gagliardi
3. Newsweek, AD: Ron Meyerson
4. Adidas, AD: Ann Occi
5. IBM, AD: Jean Fountain
6. Pocket Books, AD: Lynn Hollyn Design

Clients Include: MCA, HBO, Milliken & Co.,
American Express, Continental Insurance Co.,
General Electric, Warner-Lambert Co.,
Holland America Cruises, Texaco, American
Diabetes Association, Squibb, Dow Corning
Corp., *New York Times, National Lampoon,
Business Week, Forbes,* ABC.

THE
PENNY &
STERMER
GROUP

1.

2.

3.

4.

5.

6.

FRAN SEIGEL
515 Madison Avenue
New York, New York 10022
(212) 486-9644

Representing:

LESLIE CABARGA

Leslie Cabarga is a versatile illustrator who can be relied upon for original concepts. He does hand lettering, in conjunction with or separate from illustration, and trademarks, layout and design as well. In short, we offer one stop shopping! Please give us a chance to prove this to you soon.

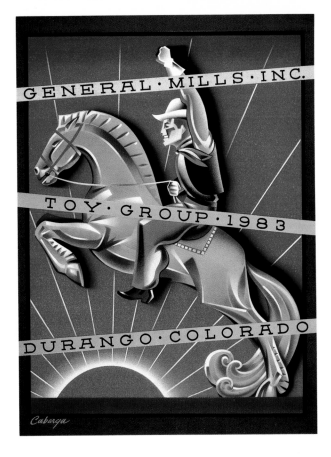

FRAN SEIGAL
515 Madison Avenue
New York, New York 10022
(212) 486-9644

Representing:
(on the East Coast)

KINUKO Y. CRAFT

Included here are just a few
of the many styles and mediums
Kinuko works in. To see a more
complete portfolio, please call.

For referral to representative
elsewhere, call (203) 542-5018.

TIME, INC.

CLAIROL/FOOTE, CONE & BELDING

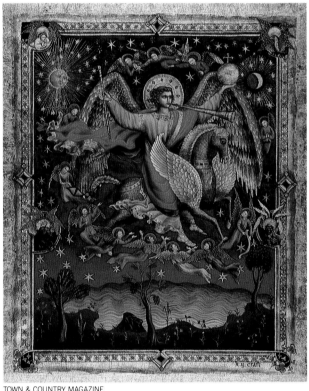

TOWN & COUNTRY MAGAZINE

UNION CARBIDE/NEEDHAM, HARPER & STEERS

AT&T/EICHINGER, INC.

PLAYBOY MAGAZINE

FRAN SEIGEL
515 Madison Avenue
New York, N.Y. 10022
(212) 486-9644

Representing:

PETER CROSS
Peter is an excellent conceptual
artist and designer who works in
many media including acrylic,
airbrush, watercolor, and various
black and white techniques.

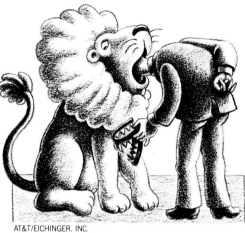

AT&T/EICHINGER, INC.

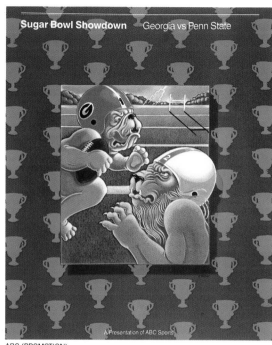

ABC (PROMOTION)

SELF-PROMOTION

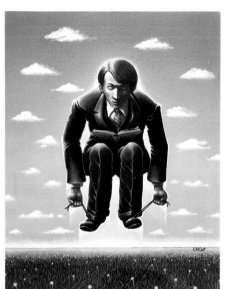

DELLA FEMINA, TRAVISANO

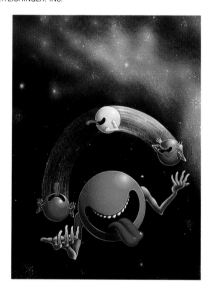

AT&T/EICHINGER, INC.

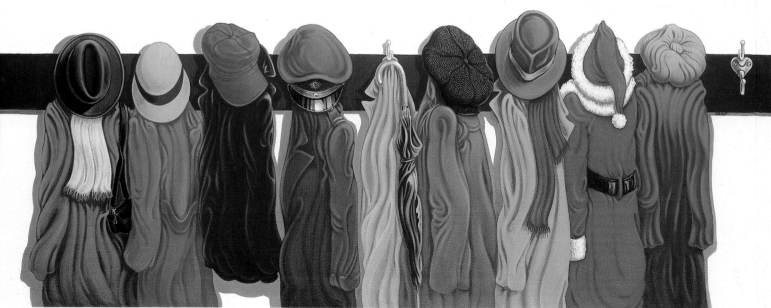

IBM/GGK INTERNATIONAL

PAUL WILLARD ASSOCIATES

313 East Thomas Road
Suite 205
Phoenix, Arizona 85012
(602) 279-0119

Representing illustrators who provide remarkable solutions to difficult problems, on time, and on budget; for clients in advertising, corporate, publishing, editorial, hi-tech, television, hotel, energy, transportation, automotive, industrial, government, packaging, retail...and more.

With the telecopier and air courier services we have available, you can receive roughs in minutes and have your finished art in the morning with your coffee and doughnuts.

Call us with any questions or ideas, or write us on your company letterhead with a project description, and we will rush you relevant samples and transparencies.

WAYNE WATFORD

RICK KIRKMAN

NANCY PENDLETON

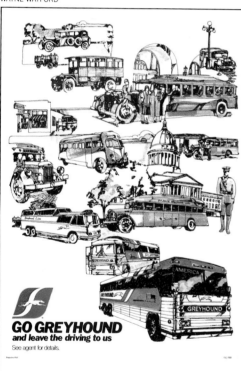

KEVIN MACPHERSON

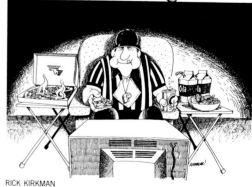

WAYNE WATFORD

KEVIN MACPHERSON

NANCY PENDLETON

RICK KIRKMAN

continued from page 44

He said it as if the word had six syllables at least. I can tell you, I nearly fainted with joy. So—I'd made it, after all. With all my misgivings and everything. Who knows, I thought, I might even have an unsuspected knack for the hideous crap. Talent is a mystery, isn't it? Well, I was glad. I was damned glad. Now we could build that additional porch on our country house. The kids' camp was coming up pretty soon, too. Well, there'd be plenty of moolah around for everything. But still my greatest satisfaction came from the surprise that I'd had it in me all the time. Forgotten were the dismal three weeks, the painfully deferred nervous breakdown, the Turkish bath and everything. I was on top of the world—and I just loved the view.

My rambling thoughts were interrupted by a cough. The old has-been, or never-was, with the sleeve protectors had broken the spell.

"Chrisholm," said Mr. Dekker, "get yourself some Ludens. You're bothering everybody." He looked stern during this piece of admonishment, but instantly turned a smiling face back to the picture.

"It's great, Mr. King," he said. "Great!" Then he stepped just a little closer.

"There's just one little thing I'd like you to do for me."

"Yes?" I said. And believe me, I loved that man so much at that moment that I would have leaped out of that window for him, although it was an unusually windy day.

"I'd like you," he said, "I'd like you to take those dancing people—those couples—"

"Those forty couples," I said.

"Those forty couples, and turn them all a little to the left."

I'm not good enough a reporter to tell you what happened immediately after that. The words "crazy son of a bitch" seem to recur constantly whenever I try to recall that dismal event, but then again I may be wrong; I may have used some other, more accurate terms.

When I finally landed out in the hall again, several decades later, I instantly tore my drawing into small fragments and flung them into a large metal trash can that was standing in one corner. As I turned away to go to the nearest elevator, old Mr. Chrisholm with the sleeve protectors suddenly appeared before me. He waggled his silly head from side to side and I could see that he eyed me with stern disapproval.

"You made a terrible mistake, Mr. King," he said.

"You're telling me! I made the mistake of coming into this goddamned building!"

He took hold of my sleeve, and because he was an old man I didn't bother to sock him one.

"You see, Mr. King," he went on, "your mistake was really a very simple one." He picked one of the pieces of my picture that was still sticking out of that garbage can and held it up before me. "You should have made a hairy, masculine hand, right here," he said, pointing straight at a girl's arm. I shook myself loose from him. "You're nuts!" I said. "That's a woman's arm you're pointing at. Why would I put a man's hand at the end of it?" "Ah!" said Mr. Chrisholm. "But if you had only done that it would have been an obvious mistake. Don't you see? Your drawing was really very good. Just about what he wanted, in fact. Indeed, it was so good you ruined your chances. If you'd only painted the wrong hand on that arm, he would have jumped at it at once. He would have been flushed with triumph that he spotted that terrible error just in time. And then you would have quietly taken the drawing back to your studio and you would have erased that flagrant error with a razor blade, and in less than twenty minutes you would have repainted it properly. Right? Everybody would have been happy. But you see, Mr. King, you unfortunately submitted a picture in which there was nothing for him to edit. You're a very young man, Mr. King. I advise you strongly to mend your rash ways while there is still time."

Steve Bernstein
Vice President
Senior Art Director
McCaffrey and McCall Advertising
New York City

Reprinted from:
May This House Be Safe From Tigers,
by Alexander King, Published by
Simon and Schuster.

ILLUSTRATION

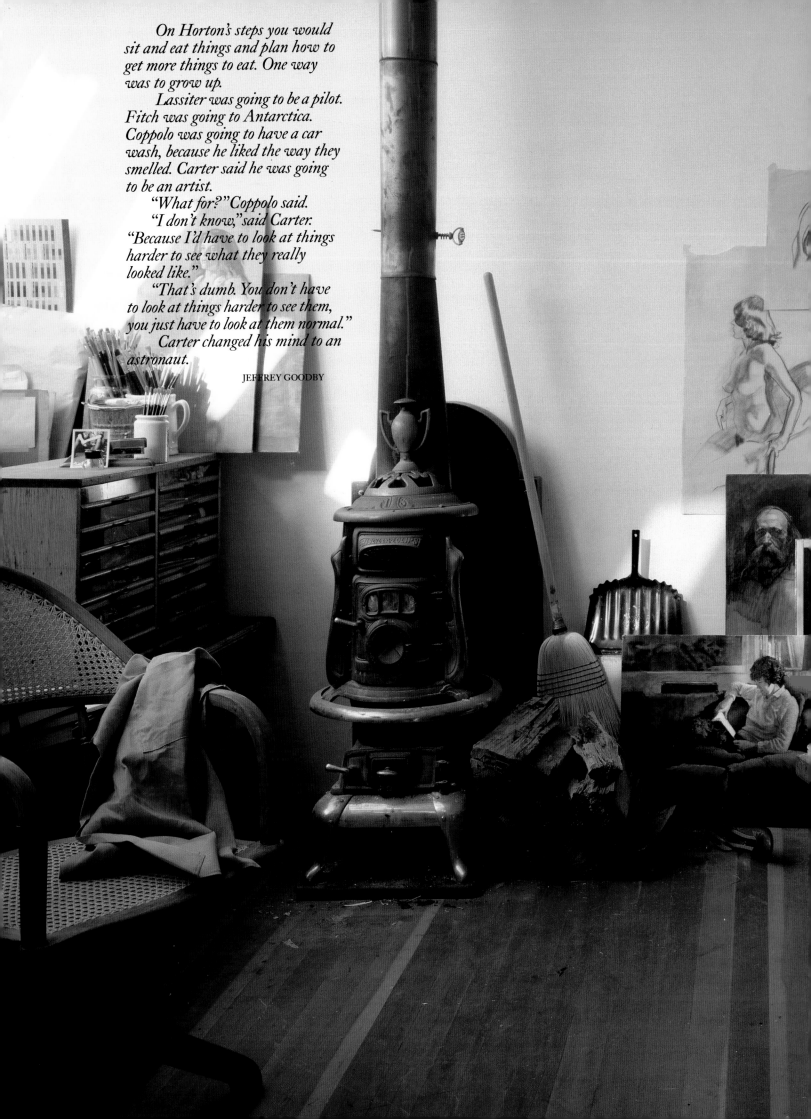

On Horton's steps you would sit and eat things and plan how to get more things to eat. One way was to grow up.

Lassiter was going to be a pilot. Fitch was going to Antarctica. Coppolo was going to have a car wash, because he liked the way they smelled. Carter said he was going to be an artist.

"What for?" Coppolo said.

"I don't know," said Carter. "Because I'd have to look at things harder to see what they really looked like."

"That's dumb. You don't have to look at things harder to see them, you just have to look at them normal."

Carter changed his mind to an astronaut.

JEFFREY GOODBY

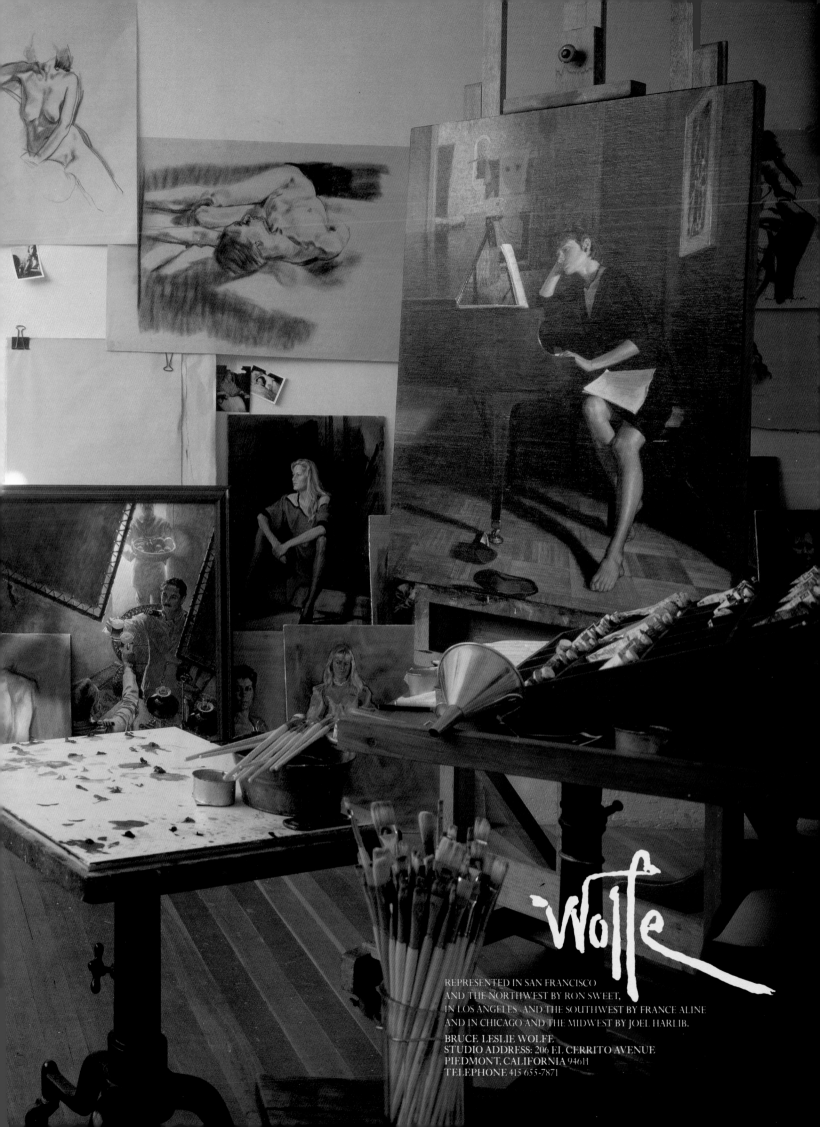

PUNZ WOLFF

151 EAST 20 ST. N.Y.C. 10003 (212) 254-5705

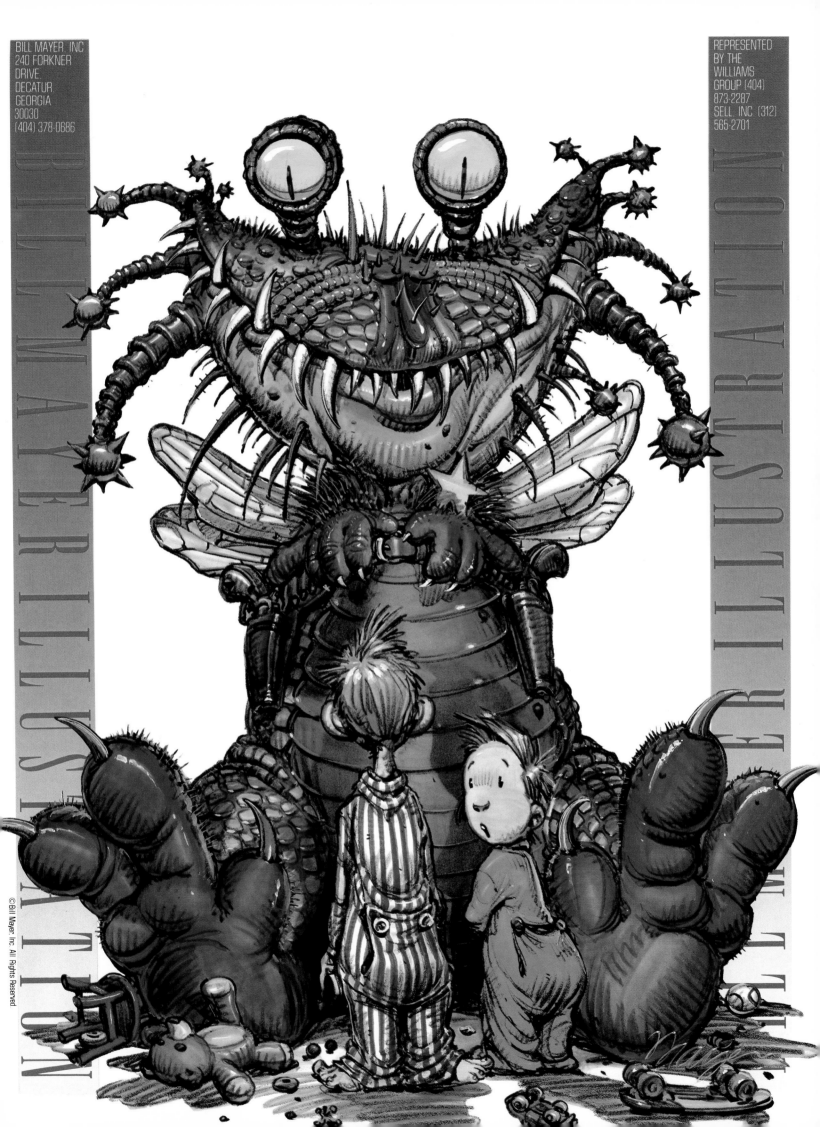

BILL MAYER, INC
240 FORKNER
DRIVE,
DECATUR,
GEORGIA
30030
(404) 378-0686

REPRESENTED
BY THE
WILLIAMS
GROUP (404)
873-2287
SELL. INC (312)
565-2701

JOHN D. AHEARN
151 South Elm Avenue
Webster Groves, Missouri 63119
(314) 961-8053
(314) 721-3997

From Historical to Hysterical, from slapstick to sublime, illustrations for all situations rendered precisely and delivered on time…every time.

Clients, direct or through affiliate agencies include: Anheuser-Busch, Webster University, Ralston Purina, The Seven-Up Company, The Juvenile Shoe Corporation of America, National Chiropractic Association, McGraw-Hill, Kerr-McGee, and Brown Shoe Company.

OLIVE ALPERT
9511 Shore Road
Brooklyn, New York 11209
(212) 833-3092

Specializing in, but not limited to, three dimensional illustration and design in a variety of mediums.

Clients have included: RCA Records, *Good Housekeeping,* Singer, RCA Selectavision, Coty, Avon Products, Elizabeth Arden, *Runner Magazine, Yachting,* O.A.F. (puppets for Canadian TV pilot), Stiefel/Raymond.

Awards/Shows:
AIGA Cover '71
AIGA The Mental Picture—two awards
Society of Illustrators The Videodisc Show

Work exhibited in Communication Arts, Idea special issue—Japan

Member Graphic Artists Guild

CHRISTOPHER D. ANDREWS
1515 North Beverly Avenue
Tucson, Arizona 85712
(602) 325-5126

Illustration, Design, Airbrush, Photo Enhancement, Airbrush
Effects for Animation.

Playboy Magazine, Pinnacle Books, Capitol Records,
Westways Magazine, Motown Records, *Chic Magazine,* CBO
Records, *Playgirl Magazine,* B. D. Fox & Friends, Texas
Instruments Inc., THE LORD OF THE RINGS—Ralph Bakshi
Productions, TRON—Walt Disney Productions.

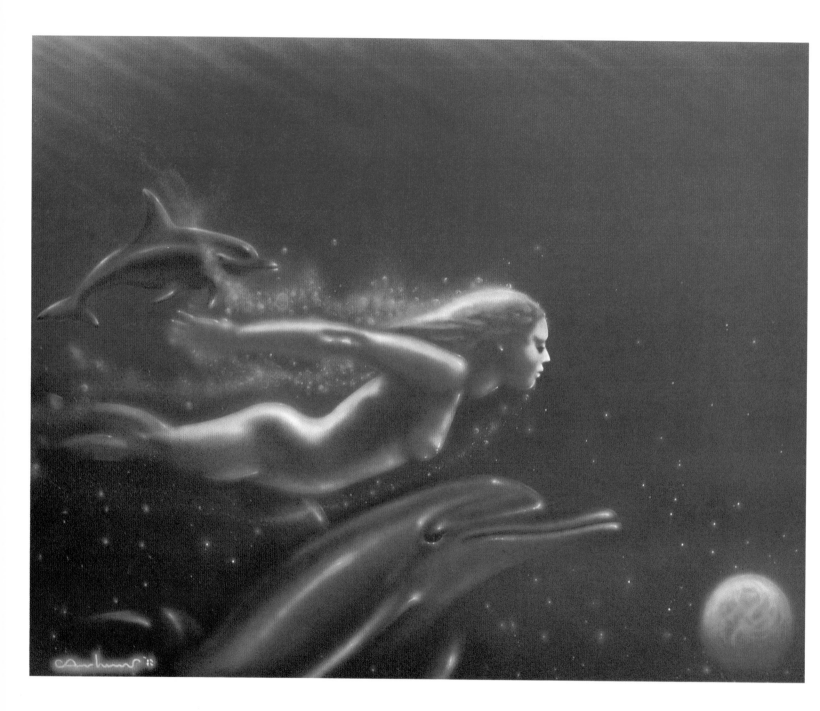

ANKA
50 Kings Road
Brisbane, California 94005
(415) 467-8108

Agent: Kathy Braun
(415) 543-7377
(415) 543-REPS

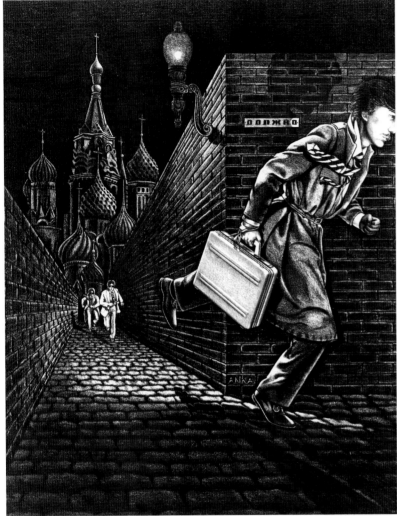

MALM LUGGAGE

CHEVRON

RACQUEL BALIN
334 West 87th Street, PH-B
New York, New York 10024
(212) 496-8358

Clients and awards upon request.

Member Graphic Artists Guild

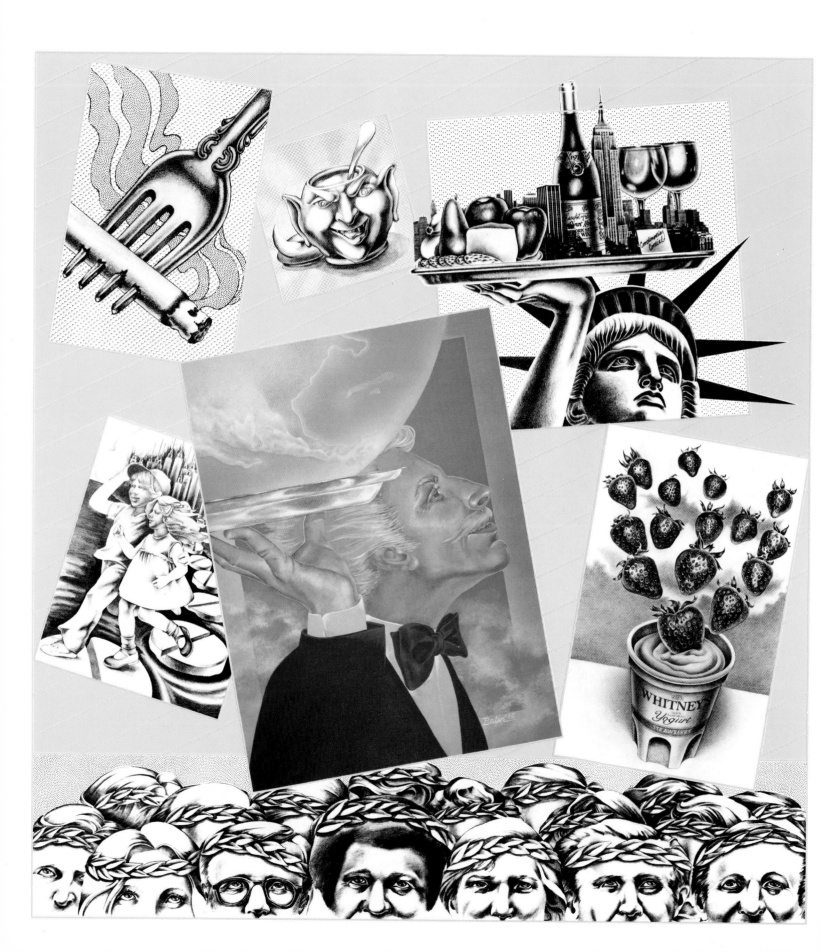

BARBARA BANTHIEN
Represented by Jan Collier
1535 Mission Street
San Francisco, California 94103
(415) 552-4252

Clients have included:

Apple, Bertolli, Chevron, Christian
Brothers, Consolidated Foods,
Crown Zellerbach, Del Monte,
Dole, Foremost, The Gap, S&W,
Shaklee, Spice Islands, Sun Maid,
Henry Weinhard, Westin Hotels.

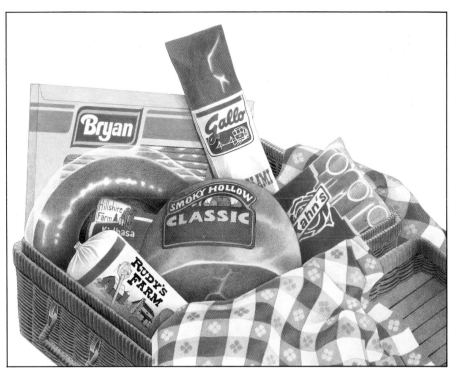

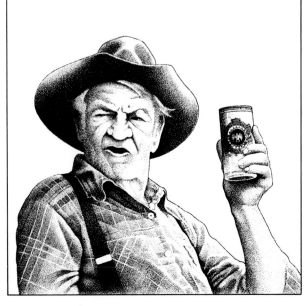

RON BARRETT
2112 Broadway
Room 402A
New York, New York 10023
(212) 874-1370

Clients include: Colgate-Palmolive, Einstein Moomjy
Carpet Department Store, Holiday Inns, *National Lampoon,
New York Post,* Proctor & Gamble, Ski Barn, Sony Corporation,
Talon, USA Cable Network

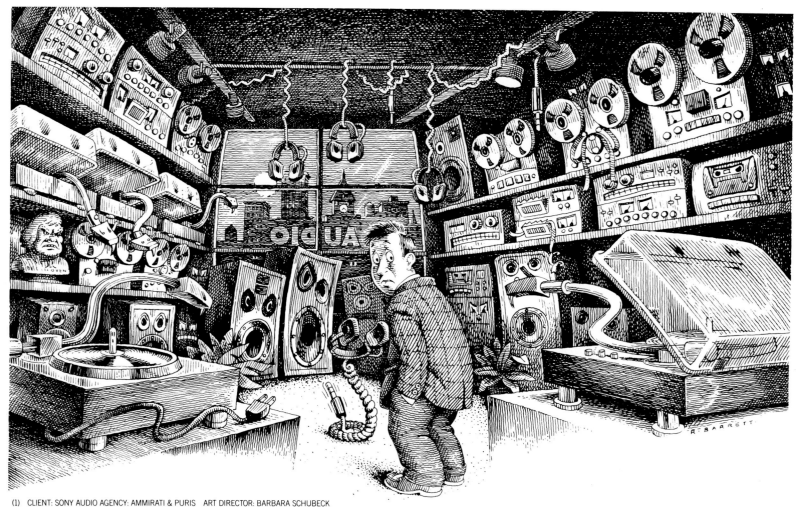

(1) CLIENT: SONY AUDIO AGENCY: AMMIRATI & PURIS ART DIRECTOR: BARBARA SCHUBECK

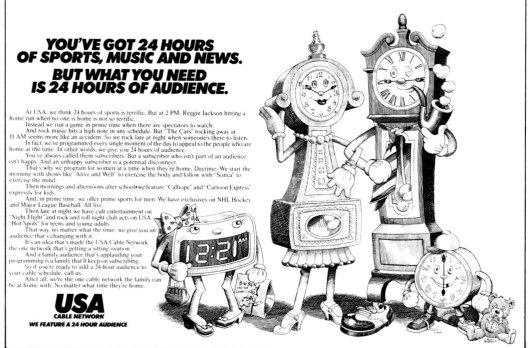

YOU'VE GOT 24 HOURS OF SPORTS, MUSIC AND NEWS. BUT WHAT YOU NEED IS 24 HOURS OF AUDIENCE.

At USA, we think 24 hours of sports is terrific. But at 2 PM, Reggie Jackson hitting a home run when no one is home is not so terrific.

Instead we run a game in prime time when there are spectators to watch.

And rock music hits a high note in any schedule. But "The Cars" rocking away at 11 AM seems more like an accident. So we rock late at night when someone's there to listen.

In fact, we've programmed every single moment of the day to appeal to the people who are home at the time. In other words, we give you 24 hours of audience.

You've always called them subscribers. But a subscriber who isn't part of an audience isn't happy. And an unhappy subscriber is a potential disconnect.

That's why we program for women at a time when they're home. Daytime. We start the morning with shows like "Alive and Well" to exercise the body and follow with "Sonya" to exercise the mind.

Then mornings and afternoons after school we feature "Calliope" and "Cartoon Express" expressly for kids.

And, in prime time, we offer prime sports for men. We have exclusives on NHL Hockey and Major League Baseball. All live.

Then late at night we have cult entertainment on "Night Flight" and rock and roll night club acts on USA "Hot Spots" for teens and young adults.

That way, no matter what the time, we give you an audience that's changing with it.

It's an idea that's made the USA Cable Network the one network that'll keep on subscribing.

And a family audience that's applauding your programming is a family that'll keep on subscribing.

So if you're ready to add a 24 hour audience to your cable schedule, call us.

After all, we're the one cable network the family can be at home with. No matter what time they're home.

USA
CABLE NETWORK
WE FEATURE A 24 HOUR AUDIENCE

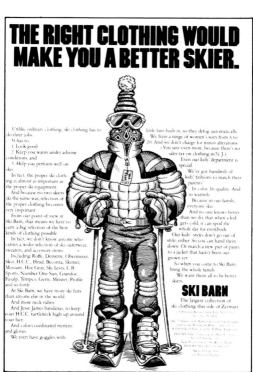

THE RIGHT CLOTHING WOULD MAKE YOU A BETTER SKIER.

Unlike ordinary clothing, ski clothing has to do three jobs.

It has to:
1. Look good
2. Keep you warm under adverse conditions, and
3. Help you perform well on skis.

In fact, the proper ski clothing is almost as important as the proper ski equipment.

And because no two skiers ski the same way, selection of the best kinds of clothing becomes very important.

From our point of view, at Ski Barn, that means we have to carry a big selection of the best kinds of clothing possible.

In fact, we don't know anyone who carries a wider selection of ski outerwear, sweaters, and accessory items.

Including Roffe, Demetre, Obermeyer, Skier, H.C.C., Head, Beconta, Skimer, Mossant, Hot Gear, Ski Levis, C.B. Sports, Number One Sun, Grandoe, Fusalp, Tempco, Gerry, Meister, Profile and so forth.

At Ski Barn, we have more ski hats than anyone else in the world.

And Jesse James bandanas, to keep your H.C.C. turtleneck high up around your face.

And color-coordinated mittens and gloves.

We even have goggles with little fans built in, so they defog automatically.

We have a range of women's sizes from 4 to 20. And we don't charge for minor alterations. (You save even more, because there's no sales tax on clothing in N.J.)

Even our kids' department is special.

We've got hundreds of kids' fashions to match their parents'.

In color. In quality. And in warmth.

Because in our family, everyone skis.

And no one knows better than we do, that when a kid gets cold, it can spoil the whole day for everybody.

Our kids' styles don't go out of style, either. So you can hand them down. Or match a new pair of pants to a jacket that hasn't been outgrown yet.

So when you come to Ski Barn, bring the whole family.

We want them all to be better skiers.

SKI BARN

The largest collection of ski clothing this side of Zermatt.

(2) AGENCY: DELLA FEMINA, TRAVISANO & PARTNERS ART DIRECTOR: MARK YUSTEIN (3) AGENCY: ALTSCHILLER, REITZFELD, SOLIN/NCK ART DIRECTOR: BOB REITZFEL

82

GUY BILLOUT

Represented by

JUDY MATTELSON
88 Lexington Avenue, 12G
New York, New York 10016
(212) 684-2974

From left to right and top to bottom:

1. *Squid & Spider,* written and illustrated by Guy Billout

2. Atlantic Magazine: "Snow"

3. Atlantic Magazine: "Entitlements"

4. Atlantic Magazine: "Time Line"

5. Atlantic Magazine: "Jungle"

Member Graphic Artists Guild

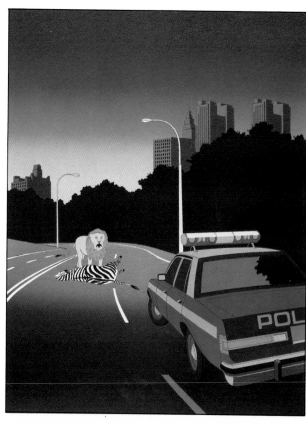

LOU BROOKS
415 West 55th Street
New York, New York 10019
(212) 245-3632

Illustration and Design

Clockwise, from upper left:

Cover for book featuring cat art by various artists.
Illustration about franchise investment for women.
Illustration about the danger of being a hockey fan.
Illustration about air taxi service for business people.
Magazine spread showing rewards and pitfalls of the cable television industry.

Member Graphic Artists Guild

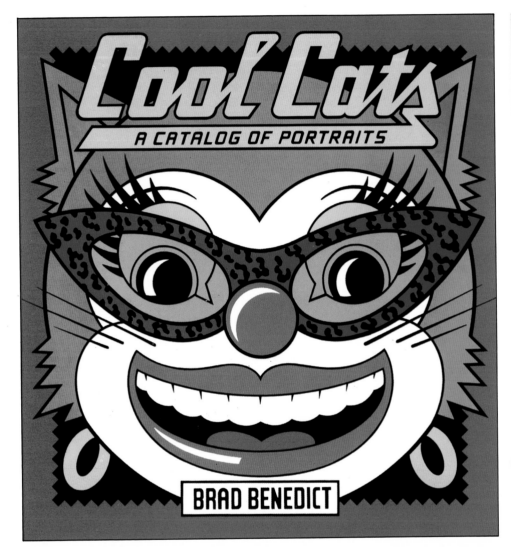

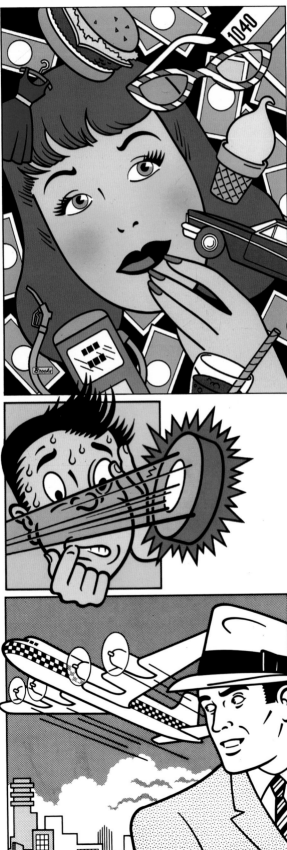

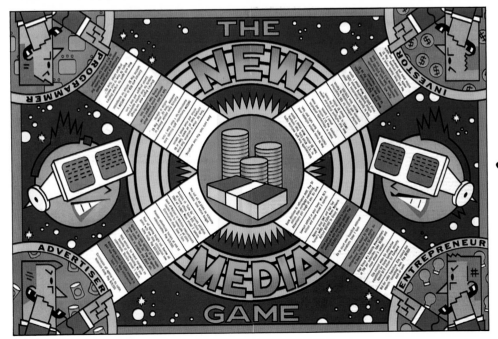

LOU BROOKS
415 West 55th Street
New York, New York 10019
(212) 245-3632

Illustration and Design

Clockwise, from upper left:

Illustration about Japan's involvement in the citrus market.
Cover for *Time* Magazine.
Illustration about love and romance.
Amusement park graphic for line of pop clothing.
Illustration announcing fireworks celebration for Fourth of July.

Member Graphic Artists Guild

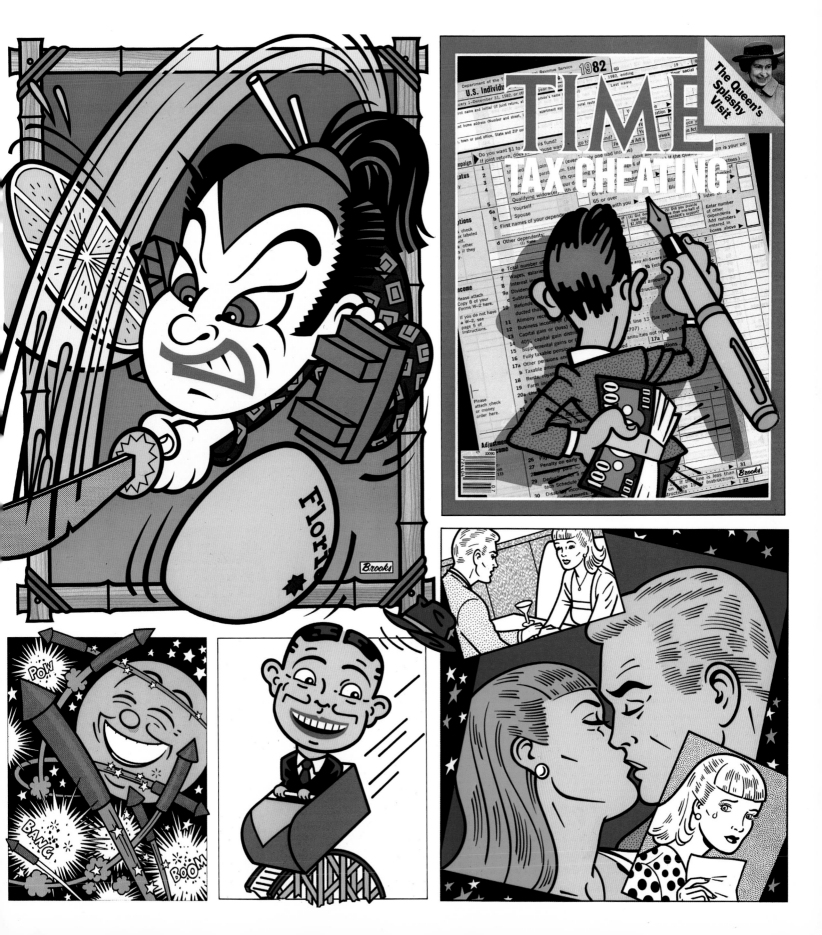

DIANA BRYAN
200 East 16th Street, #1D
New York, New York 10003
(212) 475-7927

Clients Include: Datsun, American Express, *Connoisseur Magazine, Business Week, Time Magazine, National Lampoon, The New York Times, Travel and Leisure, The Washington Post,* Time/Life Publications, *Mademoiselle, Saavy, Sports Illustrated, Working Woman, Rolling Stone,* Workman Publications, The New York Shakespeare Festival, the A.I.G.A.

Works Exhibited In: The Graphis Annual, Print Magazine, the Society of Illustrators Annual, Art Direction, Creativity '77, the New York Art Directors Club, the Society of Publication Designers, the A.I.G.A., the A.C.U.C.A.A. Graphics Competition, the Library of Congress.

Member Graphic Artists Guild

A mini-portfolio of samples sent upon request.

BLACK AND WHITE PAGE:

Row One and Two
Client: American Express

Row Three
Client: Travel and Leisure

Row Four
Left
Client: Travel and Leisure
Right
Client: the A.I.G.A.

DIANA BRYAN
200 East 16th Street, #1D
New York, New York, 10003
(212) 475-7927

Clients Include: Datsun, American Express, *Connoisseur Magazine, Business Week, Time Magazine, National Lampoon, The New York Times, Travel and Leisure, The Washington Post,* Time/Life Publications, *Mademoiselle, Saavy, Sports Illustrated, Working Woman, Rolling Stone,* Workman Publications, The New York Shakespeare Festival, the A.I.G.A.

Works Exhibited In: The Graphis Annual, Print Magazine, the Society of Illustrators Annual, Art Direction, Creativity '77, the New York Art Directors Club, the Society of Publication Designers, the A.I.G.A., the A.C.U.C.A.A. Graphics Competition, the Library of Congress.

Member Graphic Artists Guild

A mini-portfolio of samples sent upon request.

CLIENT: POSTER FOR THE G.P.P.A.W. INTERNATIONAL UNION

CLIENT: AMERICAN EXPRESS

CLIENT: TRAVEL AND LEISURE ART DIRECTOR: FRANK TAGARIELLO

CLIENT: PROMOTION FOR FOOD AND WINE MAGAZINE

CLIENT: PROMOTION FOR THE N.Y. TIMES ART DIRECTOR: ANDY KNER

YVONNE BUCHANAN
411 14th Street
Brooklyn, New York 11215
(212) 965-3021

Articles about Yvonne Buchanan's Illustrations have appeared in *Art Direction, Illustration* magazine, *In The Arts,* and *Print* magazine. Work has been exhibited in *Illustrators '23, Creativity 12* and *Art Directors, Inc.*

Partial list of clients: AT&T, Ford Foundation, *New York Times,* Cato-Johnson, J.P. Martin Associates, Attardi and Davis Advertising, John Waters Associates, Anthony Russell Design, *New York Daily News, T.V. Guide,* Fairchild Publications, Ashe-LeDonne, *Village Voice,* Scholastic Publications, McGraw-Hill

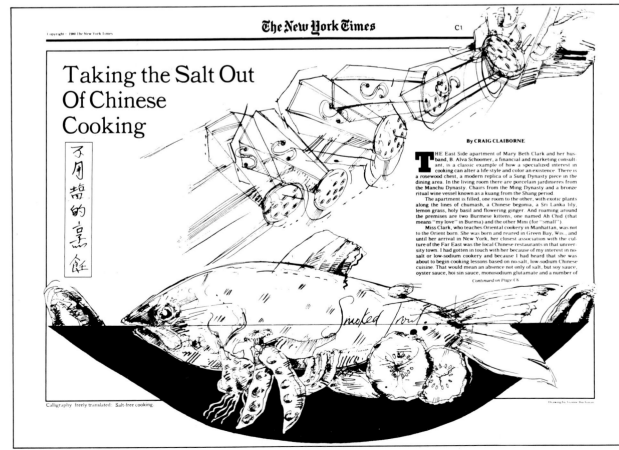

The New York Times

Taking the Salt Out Of Chinese Cooking

By CRAIG CLAIBORNE

THE East Side apartment of Mary Beth Clark and her husband, B. Alva Schoomer, a financial and marketing consultant, is a classic example of how a specialized interest in cooking can alter a life style and color an existence. There is a rosewood chest, a modern replica of a Sung Dynasty piece in the dining area. In the living room there are porcelain jardinieres from the Manchu Dynasty. Chairs from the Ming Dynasty and a bronze ritual wine vessel known as a kuang from the Shang period.

The apartment is filled, one room to the other, with exotic plants along the lines of chumash, a Chinese begonia, a Sri Lanka lily, lemon grass, holy basil and flowering ginger. And roaming around the premises are two Burmese kittens, one named Ah Chid (that means "my love" in Burma) and the other Mini (for "small")

Miss Clark, who teaches Oriental cookery in Manhattan, was not to the Orient born. She was born and reared in Green Bay, Wis., and until her arrival in New York, her closest association with the culture of the Far East was the local Chinese restaurants in that university town. I had gotten in touch with her because of my interest in no-salt or low-sodium cookery and because I had heard that she was about to begin cooking lessons based on no-salt, low-sodium Chinese cuisine. That would mean an absence not only of salt, but soy sauce, oyster sauce, hoi sin sauce, monosodium glutamate and a number of

Continued on Page C6

Calligraphy freely translated: Salt-free cooking.

MICHAEL BULL
75 Water Street
San Francisco, California 94133
(415) 776-7471

Represented by:
Kathy Braun
(415) 543-7377

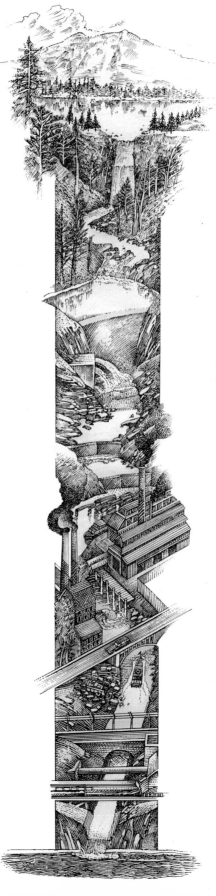

JUSTIN CARROLL
Born To Draw, Inc.
2228 21st Street
Santa Monica, California 90405
Studio: (213) 450-4197

Representatives:

Chicago—Dan Sell (312) 565-2701

San Francisco—Diane Sullivan (415) 543-8777

Los Angeles—Nancy George (213) 935-4696

Member Graphic Artists Guild

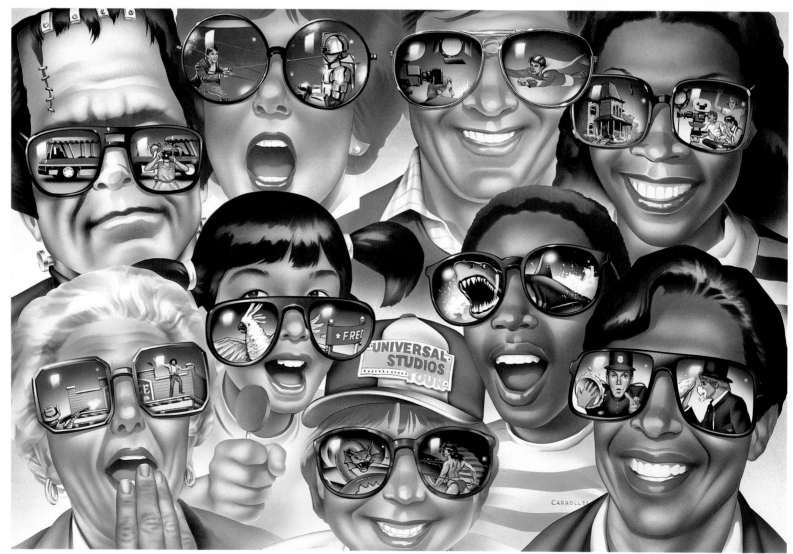

LINDA CLENNEY
San Francisco, California
(415) 641-4794

Represented in New York by Sam Brody
(212) 758-0640

Clients include:
Sony Corporation, New York Magazine, Money Magazine, Ogilvy and Mather,
Smith/Greenland Advertising, McCann Erickson, Working Woman, and Grey Advertising.

Member Graphic Artists Guild

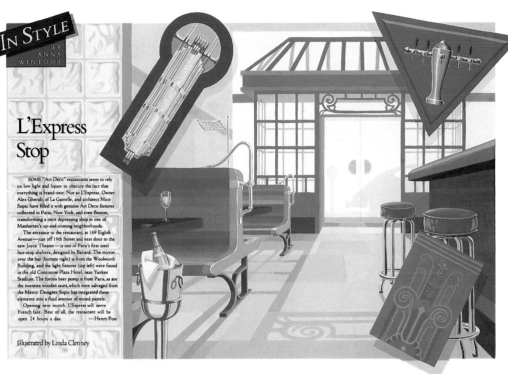

In Style

BY
ANNA
WINTOUR

L'Express Stop

SOME "Art Déco" restaurants seem to rely on low light and liquor to obscure the fact that everything is brand-new. Not so L'Express. Owner Alex Gherab, of La Gamelle, and architect Mico Sopic have filled it with genuine Art Deco fixtures collected in Paris, New York, and even Boston, transforming a once depressing shop in one of Manhattan's up-and-coming neighborhoods.

The entrance to the restaurant, at 169 Eighth Avenue—just off 19th Street and next door to the new Joyce Theater—is one of Paris's first steel bus-stop shelters, designed by Baïard. The mirror over the bar (bottom right) is from the Woolworth Building, and the light fixtures (top left) were found in the old Concourse Plaza Hotel, near Yankee Stadium. The forties beer pump is from Paris, as are the twenties wooden seats, which were salvaged from the Métro. Designer Sopic has integrated these elements into a fluid interior of muted pastels.

Opening next month, L'Express will serve French fare. Best of all, the restaurant will be open 24 hours a day.
—Henry Post

Illustrated by Linda Clenney

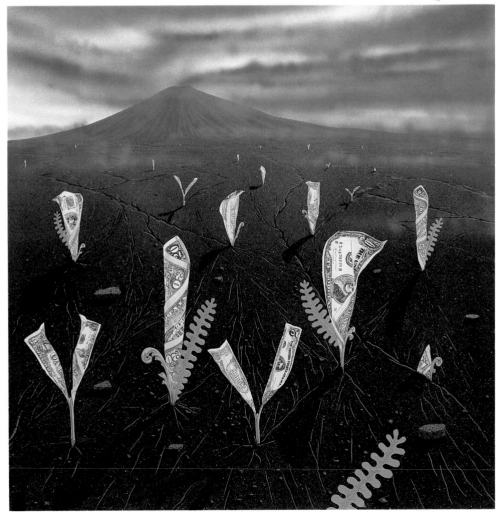

GRAPHIC ARTS ORGANIZATIONS

Arizona:

Phoenix Society of Visual Arts
P.O. Box 469
Phoenix, AZ 85001

California:

Advertising Club of Los Angeles
514 Shatto Pl., Rm. 328
Los Angeles, CA 90020
(213) 382-1228

Art Directors and Artists Club
2791 24th St.
Sacramento, CA 95818
(916) 731-8802

Book Club of California
312 Sutter St., Ste. 510
San Francisco, CA 94108
(415) 781-7532

Graphic Artists Guild of Los Angeles
1258 N. Highland, Ste. 102
Los Angeles, CA 90038
(213) 469-9409

Institute of Business Designers
c/o Gensler & Associates
550 Kearney St.
San Francisco, CA 94108
(415) 433-3700

Los Angeles Advertising Women
2410 Beverly Blvd.
Los Angeles, CA 90057
(213) 387-7432

San Francisco Society of Communicating Arts
445 Bryant St.
San Francisco, CA 94107
(415) 777-5287

Society of Illustrators of Los Angeles
1258 N. Highland Ave.
Los Angeles, CA 90038
(213) 469-8465

Society of Motion Picture & TV Art Directors
7715 Sunset Blvd., Ste. 224
Hollywood, CA 90046
(213) 876-4330

Western Art Directors Club
P.O. Box 996
Palo Alto, CA 94302
(415) 321-4196

Women in Design
P.O. Box 2607
San Francisco, CA 94126
(415) 397-1748

Women's Graphic Center
The Woman's Building
1727 N. Spring St.
Los Angeles, CA 90012
(213) 222-2477

Colorado:

International Aspen Design Conference
P.O. Box 664
Aspen, CO 81612
(303) 925-2257

Connecticut:

Connecticut Art Directors Club
P.O. Box 1974
New Haven, CT 06521

District of Columbia:

American Advertising Federation
1225 Connecticut Avenue, N.W., Ste. 401
Washington, DC 20036
(202) 659-1800

American Institute of Architects
1735 New York Avenue, N.W.
Washington, DC 20006
(202) 626-7300

Art Directors Club of Washington, DC
1523 22nd St., N.W.
Washington, DC 20037
(202) 293-3134

Federal Design Council
P.O. Box 7537
Washington, DC 20044

International Copyright Information Center, A.A.D.
1707 L Street, N.W.
Washington, DC 20036

NEA: Design Arts Program
1100 Pennsylvania Ave., N.W.
Washington, DC 20506
(202) 682-5400

Georgia:

Atlanta Art Papers, Inc.
P.O. Box 77348
Atlanta, GA 30357
(404) 885-1273

Graphics Artists Guild
3158 Maple Drive, N.E., Ste. 46
Atlanta, GA 30305
(404) 237-6390

Illinois:

Institute of Business Designers
National
1155 Merchandise Mart
Chicago, IL 60654
(312) 467-1950

Society of Environmental Graphics Designers
228 N. LaSalle St., Ste. 1205
Chicago, IL 60601

STA
233 East Ontario St.
Chicago, IL 60611
(312) 787-2018

Women in Design
400 West Madison, Ste. 2400
Chicago, IL 60606
(312) 648-1874

Kansas:

Wichita Art Directors Club
P.O. Box 562
Wichita, KS 67202

Maryland:

Council of Communications Societies
P.O. Box 1074
Silver Springs, MD 20910

Massachusetts:

Art Directors Club of Boston
214 Beacon St.
Boston, MA 02116
(617) 536-8999

Center for Design of Industrial Schedules
50 Staniford St., Ste. 800
Boston, MA 02114
(617) 523-6048

Graphic Artists Guild
P.O. Box 1454–GMF
Boston, MA 02205
(617) 451-5362

Michigan:

Creative Advertising Club of Detroit
c/o Rhoda Parkin,
30400 Van Dyke
Warren, MI 48093

Minnesota:

Minnesota Graphic Designers Association
P.O. Box 24272
Minneapolis, MN 55424

Missouri:

Advertising Club of Greater St. Louis
410 Mansion House Center
St. Louis, MO 63102
(314) 231-4185

Advertising Club of Kansas City
1 Ward Parkway, Ste. 102
Kansas City, MO 64112
(816) 753-4088

New Jersey:

Point-of-Purchase Advertising Institute
2 Executive Dr.
Fort Lee, NJ 07024
(201) 585-8400

New York:

The Advertising Club of New York
Roosevelt Hotel, Rm. 310
New York, NY
(212) 697-0877

The Advertising Council, Inc.
825 Third Ave.
New York, NY 10022
(212) 758-0400

Advertising Typographers Association of America, Inc.
5 Penn Plaza, 12th Fl.
New York, NY 10001
(212) 594-0685

Advertising Women of New York Foundation, Inc.
153 E. 57th St.
New York, NY 10022
(212) 593-1950

American Association of Advertising Agencies
666 Third Ave.
New York, NY 10017
(212) 682-2500

American Booksellers Association, Inc.
122 E. 42nd St.
New York, NY 10168
(212) 867-9060

American Council for the Arts
570 Seventh Ave.
New York, NY 10018
(212) 354-6655

The American Institute of Graphic Arts
1059 Third Ave.
New York, NY 10021
(212) 752-0813

continued on page 96

THE COMMITTEE
15468 Ventura Boulevard
Sherman Oaks, California 91403
(213) 986-4420

COMPUTER GENERATED ART

A new media developed from computer techniques. Our client's concepts are computer-generated and initial computer roughs can go from Los Angeles to anywhere, telecopy or facsimile transmission. The art is color separated by our computer making the final art, negatives and color keys ready for printing.

In business 12 years, The Committee's various clients include: IBM, Yamaha, Gallo Wines, Kahlua, Carnation, Disneyland, Buena Vista Productions, also film and recording companies.

JOHN CRAIG
Route 2 Box 81
Soldiers Grove, Wisconsin 54655
(608) 872-2371

Telecopier Available

Represented by:
Carolyn Potts & Assoc.
(312) 935-1707

Drafted Illustration

Clients include:
AAA, Advantage, Advertising Age,
Album Graphics Inc., Anheuser-
Busch, Channel 7 Chicago,
Chicago Ad Club, *Chicago, The
Chicago Tribune,* Cracker Jack,
Encyclopedia Britannica, *Entrée,*
Films Inc., First National Bank
of Chicago, Flavor House,
Follett Books, *Games,* Head &
Shoulders, *Horizon,* Kellogg's,
Mercury-Phillips Records,
Moviegoer, Minnesota Public
Radio, Nexus, *Northwest Orient,
Oui,* Papermasters, Parliament,
Philadelphia, Playboy, Ruby Street
Cards, Scott, Foresman & Co.,
Sesame Street, Sieber McIntyre,
7-UP, 13-30 Corporation, *TWA
Ambassador,* United Airlines,
Warner Bros. Records, Webb
Company, William's Pinball,
World Book.

Member Graphic Artists Guild

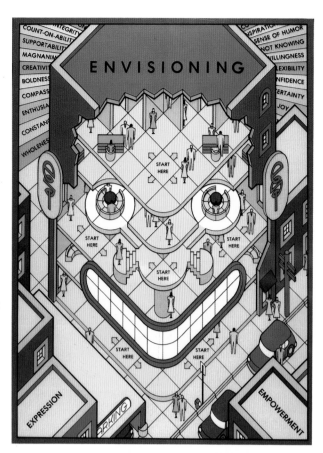

JOHN CRAIG
Route 2 Box 81
Soldiers Grove, Wisconsin 54655
(608) 872-2371

Telecopier Available

Represented by:
Carolyn Potts & Assoc.
(312) 935-1707

Collage

Clients include:
AAA, Advantage, Advertising Age,
Album Graphics Inc., Anheuser-
Busch, Channel 7 Chicago,
Chicago Ad Club, *Chicago, The
Chicago Tribune,* Cracker Jack,
Encyclopedia Britannica, *Entrée,*
Films Inc., First National Bank
of Chicago, Flavor House,
Follett Books, *Games,* Head &
Shoulders, *Horizon,* Kellogg's,
Mercury-Phillips Records,
Moviegoer, Minnesota Public
Radio, Nexus, *Northwest Orient,
Oui,* Papermasters, Parliament,
Philadelphia, Playboy, Ruby Street
Cards, Scott, Foresman & Co.,
Sesame Street, Sieber McIntyre,
7-UP, 13-30 Corporation, *TWA
Ambassador,* United Airlines,
Warner Bros. Records, Webb
Company, William's Pinball,
World Book.

Member Graphic Artists Guild

continued from page 92

American Society of Interior Designers
National Headquarters
1430 Broadway
New York, NY 10018
(212) 944-9220

New York Chapter
950 Third Ave.
New York, NY 10022
(212) 421-8765

American Society of Magazine Photographers
205 Lexington Ave.
New York, NY 10016
(212) 889-9144

Art Directors Club of New York
488 Madison Ave.
New York, NY 10022
(212) 838-8140

Association of American Publishers, Inc.
1 Park Ave.
New York, NY 10016
(212) 689-8920

Cartoonists Guild
156 W. 72nd St.
New York, NY 10023
(212) 861-6377

Center for Arts Information
625 Broadway
New York, NY 10012
(212) 677-7548

The Children's Book Council, Inc.
67 Irving Place
New York, NY 10003
(212) 254-2666

CLIO
336 E. 59th St.
New York, NY 10022
(212) 593-1900

Foundation for the Community of Artists
280 Broadway, Ste. 412
New York, NY 10007
(212) 227-3770

Graphic Artists Guild
30 E. 20th St., Rm. 405
New York, NY 10003
(212) 777-7353

Guild of Bookworkers
663 Fifth Ave.
New York, NY 10022
(212) 757-6454

Institute of Outdoor Advertising
342 Madison Ave.
New York, NY 10017
(212) 986-5920

International Advertising Association, Inc.
475 Fifth Ave.
New York, NY 10017
(212) 684-1583

The One Club
251 E. 50th St.
New York, NY 10022
(212) 935-0121

Printing Industries of Metropolitan New York, Inc.
5 Penn Plaza
New York, NY 10001
(212) 279-2100

The Public Relations Society of America, Inc.
845 Third Ave.
New York, NY 10022
(212) 826-1750
N.Y. Chapter: (212) 826-1756

Society of Illustrators
128 E. 63rd St.
New York, NY 10021
(212) 838-2560

Society of Photographers and Artists Representatives
1123 Broadway
New York, NY 10010
(212) 924-6023

Society of Publication Designers
25 W. 43rd St., Ste. 711
New York, NY
(212) 354-8585

Television Bureau of Advertising
485 Lexington Ave.
New York, NY 10017
(212) 661-8440

Type Directors Club of New York
545 W. 45th St.
New York, NY 10036
(212) 245-6300

U.S. Trademark Association
6 E. 45th St.
New York, NY 10017
(212) 986-5880

Volunteer Lawyers for the Arts
1560 Broadway, Ste. 711
New York, NY 10036
(212) 575-1150

Women in the Arts
325 Spring St.
New York, NY 10013
(212) 691-0988

Women in Design
P.O. Box 5315
FDR Station
New York, NY 10022

Ohio:

Advertising Club of Cincinnati
385 West Main St.
Batavia, OH 45103
(513) 732-9422

AIGA Cleveland Chapter
1021 Euclid Ave.
Cleveland, OH 44115
(216) 781-2400

Cleveland Society of Communicating Arts
812 Huron Rd.
Cleveland, OH 44115
(216) 621-5139

Columbus Society of Communicating Arts
c/o Salvato & Coe
2015 West Fifth Ave.
Columbus, OH 43221
(614) 488-3131

Design Collective
D.F. Cooke
55 Long St.
Columbus, OH 43215
(614) 464-4567

Society of Communicating Arts
c/o Tailford Assoc.
1300 Indian Wood Circle
Maumee, OH 43537
(419) 891-0888

Pennsylvania:

Art Directors Club of Philadelphia
2017 Walnut St.
Philadelphia, PA 19103
(215) 569-3650

Tennessee:

Engraved Stationery Manufacturers Association
c/o Printing Industries Association of the South
1000 17th Ave. South
Nashville, TN 37212
(615) 327-4444

Texas:

Advertising Artists of Fort Worth
3424 Falcon Dr.
Fort Worth, TX 76119

Art Directors Club of Houston
2135 Bissonet
Houston, TX 77005
(713) 523-1019

Dallas Society of Visual Communication
3530 High Mesa Dr.
Dallas, TX 75234
(214) 241-2017

Virginia:

Industrial Designers Society of America
6802 Poplar Pl., Ste. 303
McLean, VA 22101
(703) 556-0919

Tidewater Society of Communicating Arts
P.O. Box 153
Norfolk, VA 23501

Washington:

Puget Sound Ad Federation
c/o Sylvia Fruichantie
Kraft Smith Advertising
200 1st West St.
Seattle, WA 98119
(206) 285-2222

Seattle Design Association
P.O. Box 1097
Main Office Station
Seattle, WA 98111
(206) 322-2777
(Formerly Seattle Women in Design)

Seattle Women in Advertising
801 E. Harrison, Ste. 105
Seattle, WA 98102
(206) 322-2777

Society of Professional Graphic Artists
c/o Nancy Gellos, Pres.
1331 Third Ave., Ste. 504
Seattle, WA 98115
(206) 623-4163

Wisconsin:

The Advertising Club
407 E. Michigan St.
Milwaukee, WI 53202
(414) 271-7351

Illustrators & Designers of Milwaukee
c/o Don Berg
207 E. Michigan
Milwaukee, WI 53202
(414) 276-7828

RAY CRUZ

Represented by:
Vicki Morgan
194 Third Avenue
New York, New York 10003
(212) 475-0440

Telecopier in office

Member Graphic Artists Guild

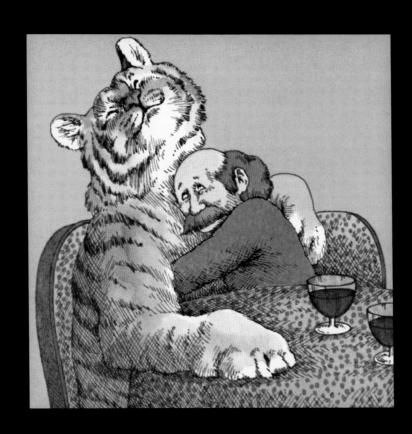

"Life is nothing without friendship."

CICERO

We've got the touch, and a pedigree that goes back to the beginning
of this genre. That's history … but our future belongs to you.

Studio Hotline: (801) 355-8555

Los Angeles: Joanne Hedge (213) 874-1661

San Francisco: Mary VanDamme (415) 433-1292

Chicago: Joel Harlib (312) 329-1370

New York: Rick Chalek (212) 688-1080

Dallas: Barbara Boster (214) 373-4284

Detroit: Brooks Saylor (313) 542-3404

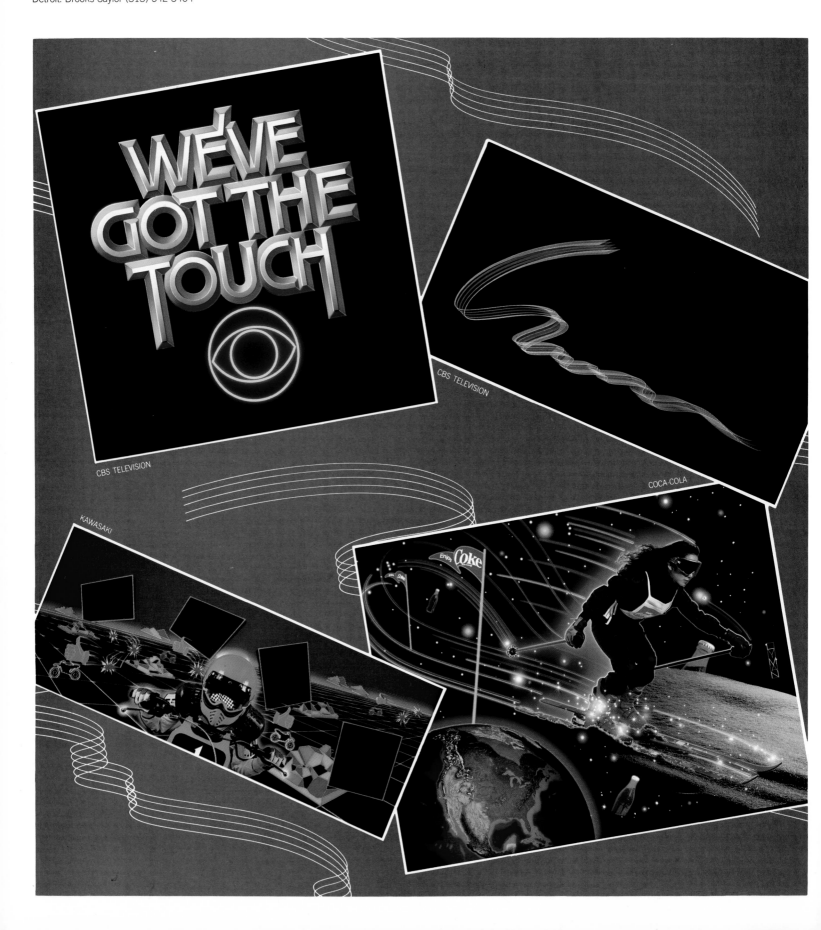

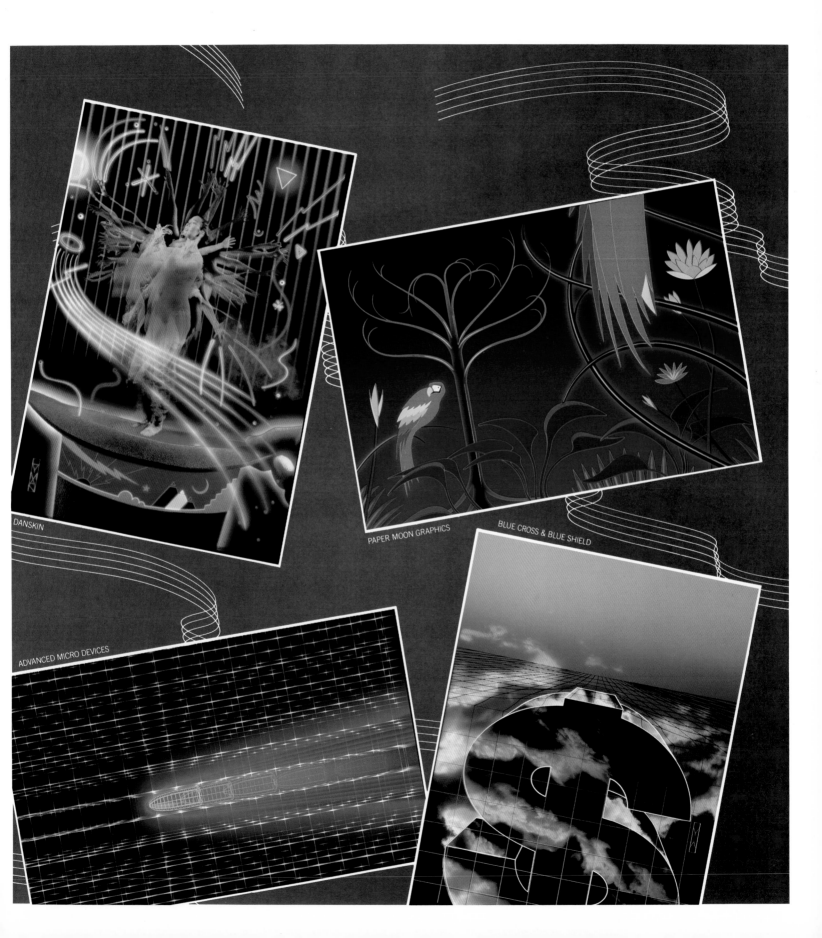

DANSKIN

PAPER MOON GRAPHICS

BLUE CROSS & BLUE SHIELD

ADVANCED MICRO DEVICES

JULIA DELLACROCE ASSOCIATES
 ARTISTS' REPRESENTATIVES
(212) 580-1321

WINSLOW PINNEY PELS

Clients include: EXXON/McCaffrey & McCall; EVITA/Ash LeDonne and Scali, McCabe, Sloves; American Ballet Theatre/P.B.S.; Metropolitan Opera; Empire State Institute for the Performing Arts; Saratoga Performing Arts Center; New York State Department of Health; New York State Fair; Department of Commerce; Bronx Zoological Society; *The New York Times; Business Week;* Random House; Putnam Publishing Group; Simon & Schuster; MacMillan Publishing; Farrar Strauss & Giroux.

Credits:
1. Clients: Random House/Pantheon Books
 Art Director: Louise Fili

2. Client: Gannett
 Art Director: Winslow Pinney Pels

3. Client: 1330 Company
 Art Director: Ken Smith

4. Client: Putnam Publishing
 Art Director: Lynn Hollyn

PRINTS AVAILABLE UPON REQUEST

J·U·L·I·A D·E·L·L·A·C·R·O·C·E A·S·S·O·C·I·A·T·E·S

ARTIST REPRESENTATIVES 226 EAST 53RD ST. NEW YORK, NEW YORK 10022 212.355.7670

1.

2.

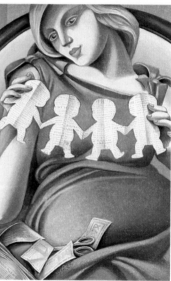

3.

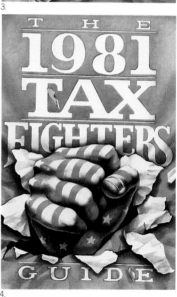

4.

JULIA DELLACROCE ASSOCIATES
 ARTISTS REPRESENTATIVE
(212) 580-1321

MICHAEL SELL

Clients Include: Estée Lauder; Aramis; Hertz/Scali, McCabe Sloves; American Express/Ogilvy & Mather; Marriott Hotels/Ogilvy & Mather; CBS Books; AVON Books; P.S.E. & G. Energy Exhibit; Paper Moon Graphics; *Redbook Magazine; Cosmopolitan Magazine; Science Digest.*

Credits:
1. Clients: Galliard Press
 Art Director: Michael Sell

2. Client: Paper Moon Graphics
 Art Director: Michael Sell

3. Client: Estée Lauder
 Art Director: Michael Sell

4. Self Promotion
PRINTS AVAILABLE UPON REQUEST

JULIA DELLACROCE ASSOCIATES
ARTIST REPRESENTATIVES 226 EAST 53RD ST. NEW YORK, NEW YORK 10022 212.355.7670

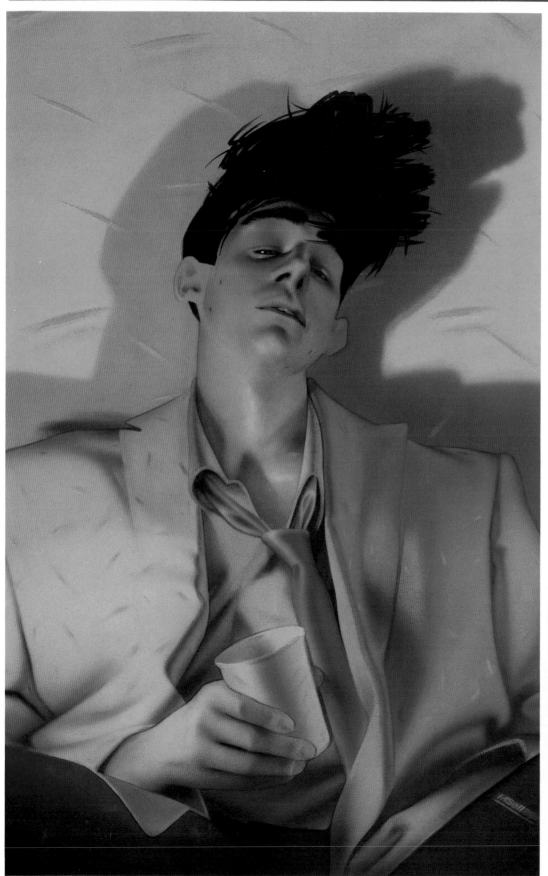

1.

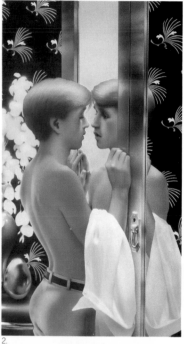

2.

3.

4.

Represented by:

New York/East Coast:
Jerry Leff Associates, Inc.
342 Madison Avenue
New York, New York 10017
(212) 697-8525

Chicago/Midwest:
Moshier & Maloney
535 North Michigan Avenue
Chicago, Illinois 60611
(312) 943-1668

Partial Client List:
ABC, NBC, McDonald's, Kendall (Curity), Servicemaster, Besnier
of France, US Gypsum, Clark Equipment Co., White Farm Equipment,

Cincinnati Symphony, Abbott Labs, G.D. Searle, Dorsey, Penwalt,
Keebler, Dacor Diving, United Airlines, NCAA, United States
Olympic Committee, Basketball Hall of Fame, Hammermill Paper Co.,
Mobil Oil, *US News and World Report,* Dartmouth, CNA Insurance,
Dean-Witter, Wells-Lamont, Dr. Scholls, State Farm Insurance,
Dial Soap, Signature Publishing, Montgomery Wards, Success Unlimited,
TRW, Rubbermaid, Weber Grills, Wolverine Boots, Starkist.

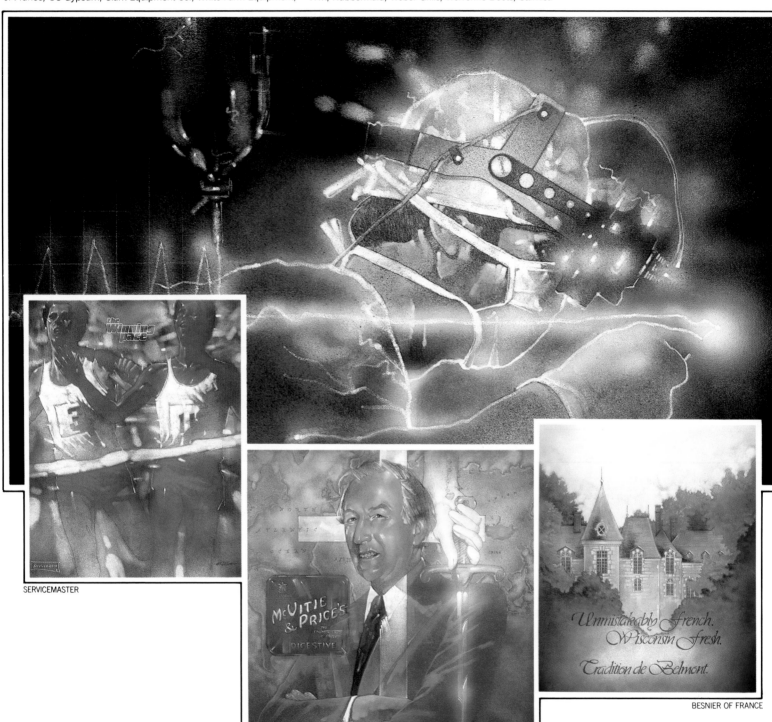

SERVICEMASTER

CHAIRMAN KEEBLER COMPANY

BESNIER OF FRANCE

DENNIS DITTRICH
42 West 72nd Street
New York, New York 10023
(212) 595-9773

Clients include: Time & Life, Revlon,
Calgon Corp, Equitable Life, USA
Network, *Psychology Today, Golf,
Outdoor Life* and *Scholastic*
Magazines.

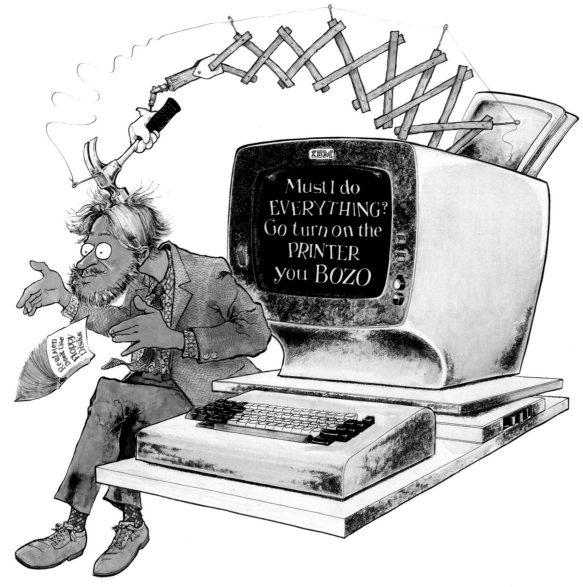

GLENN DODDS
392 Central Park West
New York, New York 10025
(212) 679-3630

Clients: Calvert Distillers Company, Texaco, NEC, Velcro,
St. Regis Paper, Fruit Of The Loom, Alitalia, Ricoh Cameras,
American Express, New York Telephone, Chick-Fil-A,
Pilot Pens, Seald Sweet Growers, Taylor California Cellars,
Staging Techniques, TDK, Coleco

Magazines: Newsweek, Forbes, Institutional Investor, Games
Magazine, Travel and Leisure, U.S. News

Agencies: McCann-Erickson, Grey, Calet-Hirsch Kurnit Spector,
Inc., N W Ayer, Della Femina, Travisano & Partners Inc.,
Jarman, Spitzer & Felix, Inc., William Esty, BBD&O

Films/Animation-General Foods (For Decomas)

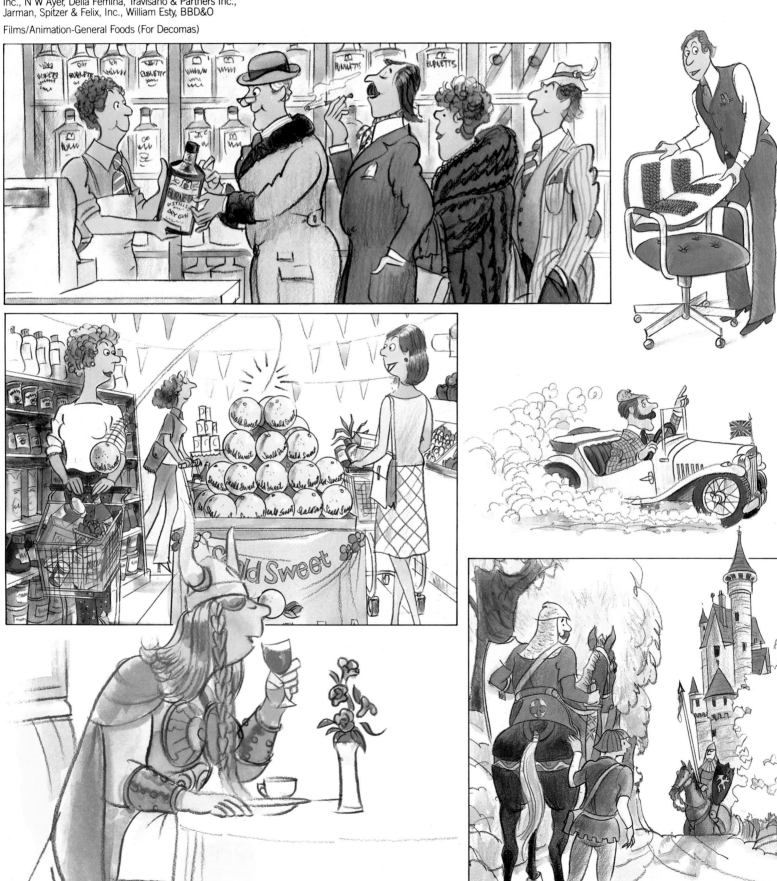

GLENN DODDS
392 Central Park West
New York, New York 10025
(212) 679-3630

Clients: Calvert Distillers Company, Texaco, NEC, Velcro, St. Regis Paper, Fruit Of The Loom, Alitalia, Ricoh Cameras, American Express, New York Telephone, Chick-Fil-A, Pilot Pens, Seald Sweet Growers, Taylor California Cellars, Staging Techniques, TDK, Coleco

Magazines: Newsweek, Forbes, Institutional Investor, Games Magazine, Travel and Leisure, U.S. News

Agencies: McCann-Erickson, Grey, Calet-Hirsch Kurnit Spector, Inc., N W Ayer, Della Femina, Travisano & Partners Inc., Jarman, Spitzer & Felix, Inc., William Esty, BBD&O

Films/Animation-General Foods (For Decomas)

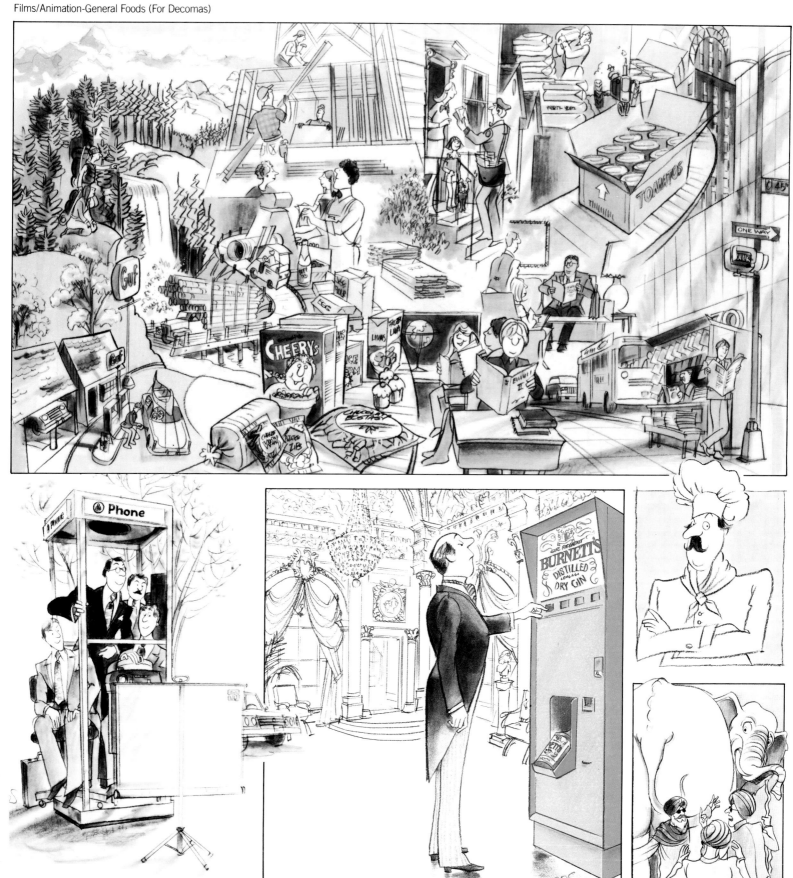

MICHAEL DORET, INC.
61 Lexington Avenue
New York, New York 10010
(212) 889-0490

Precision Illustration, Lettering and Design

Represented in the Southwest by:
Liz McCann
(214) 742-3138

Represented in Germany by:
Margarethe Hubauer
40/486 003

Clockwise from top:
Lettering/Illustration for recruitment
 ad for the U.S. Army.
Logo for an HBO in-house
 promotion.
Cover for a United States Golf
 Association brochure.
Logo for a new game from
 Parker Brothers.
Poster promoting the New York
 Times' Sunday travel
 supplement.
Logo for the Home Software Guild.

Member Graphic Artists Guild

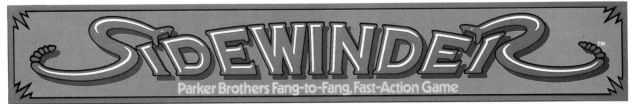

WENDY EDELSON
85 South Washington, Suite #311
Seattle, Washington 98104
(206) 625-0109

Represented by: Susan Trimpe
2717 Western Avenue
Seattle, Washington 98121
(206) 382-1100

As George Woods, children's book editor of the *New York Times* said about the illustrations in *Hambone,* "Wendy Edelson's work is like a breath of fresh Vermont air." Clients say, everything from "Wow, what incredible detail!" to "What an imagination!" Whatever it is, it's definitely her special vision that makes her illustrations brim with life.

She approaches every job with an excitement that enables her to take an idea further than expected. But then, that's Wendy.

Clients include: *Parents Magazine,* American Library Association, Sunrise Publications, Smith Publishers, Tundra Books, Jansport, K2 Skis, Vermont Castings, Ghiradelli Chocolates, Krusteaz, Roman Meal, Pacific Northwest Ballet, Washington State Lottery, Tree Top, Safeco, Eddie Bauer.

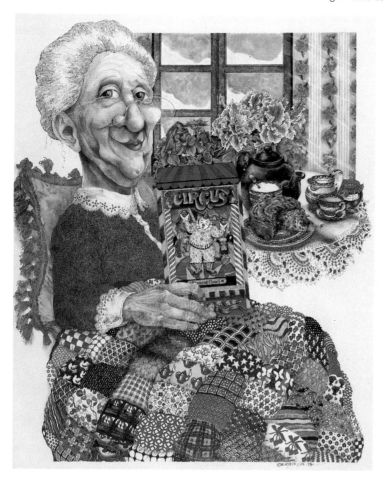

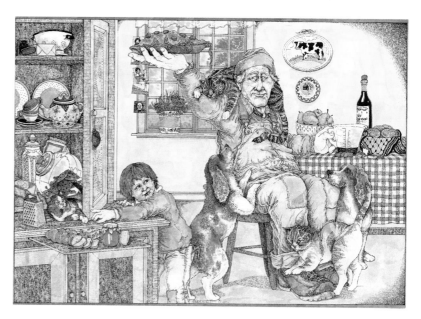

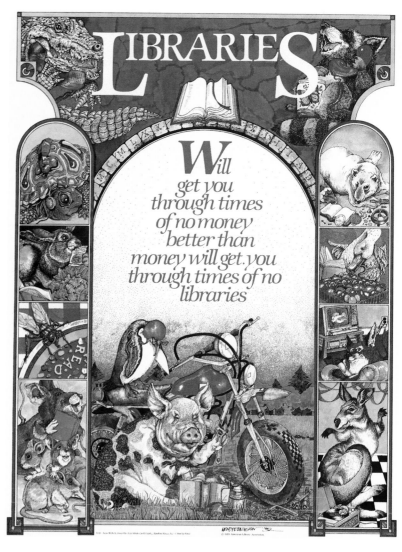

BRUCE EMMETT
285 Park Place
Brooklyn, New York 11238
(212) 636-5263

A partial list of clients includes:
Estée Lauder, Seagrams, Avon, Berkley, Dell and Warner
Books, NBC, United Artists, Busch Beer, CBS, *Cosmopolitan*,
and *Woman's Day*

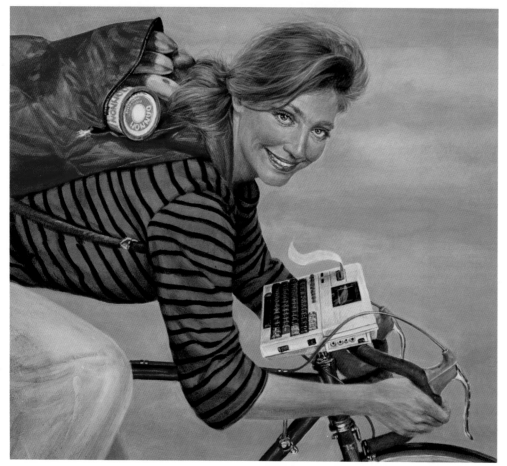

RCA

CHAPS/RALPH LAUREN

AL EVCIMEN
305 Lexington Avenue
New York, New York 10016
(212) 889-2995

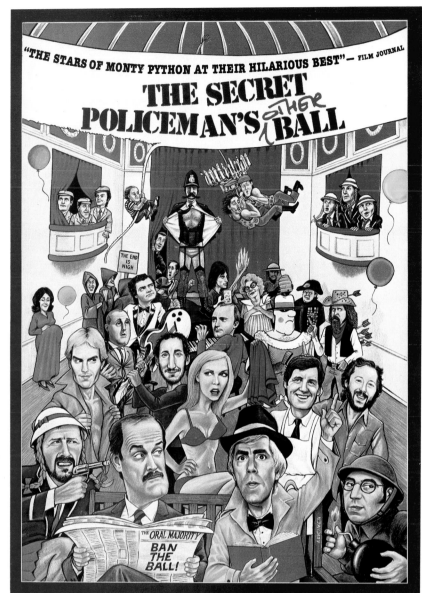

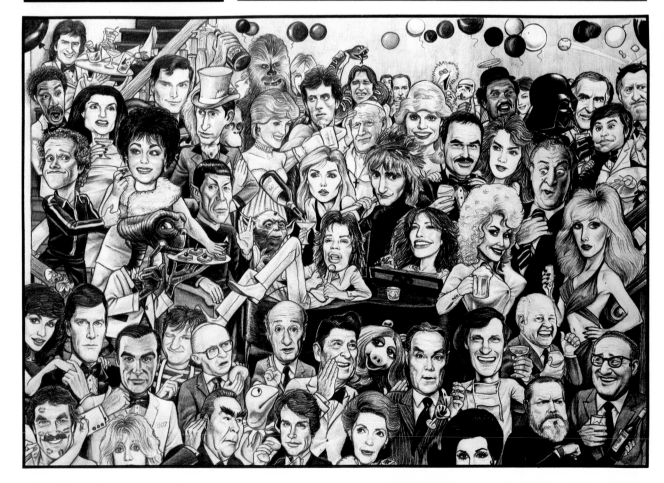

DAVID FE BLAND
670 West End Avenue
New York, New York 10025
(212) 580-9299

Clients include: J. Walter Thompson; Young & Rubicam; Ogilvy & Mather; McCaffrey & McCall; Dancer, Fitzgerald & Sample; N.W. Ayer; Cato-Johnson; Muir, Cornelius & Moore; Benton & Bowles; Nadler & Larimer; Leber-Katz; NBC; ABC, IBM; Exxon; Texaco; RCA; American Express; Burger King; Celanese; Avon Products; *New York Times;* McGraw Hill; Viking Press; Ziff-Davis; Macmillan Press; Harcourt, Brace, Jovanovich; Whitney Communications; McLean-Hunter; *Business Week; McCalls; Harper's; Ladies' Home Journal; Europeo; Saturday*

Review; Institutional Investor; Essence; Scholastic Publications; and Children's Television Workshop.

Awards: Art Directors Annual Exhibition, 1983
 Feature Profile in Advertising Techniques (Publication
 of Art Direction Magazine), Summer, 1981

Member Graphic Artists Guild

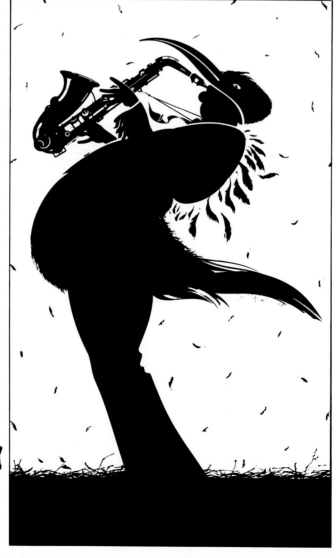

STANISLAW FERNANDES
Illustrator and designer

35 East 12th Street
New York, New York 10003
(212) 533-2648

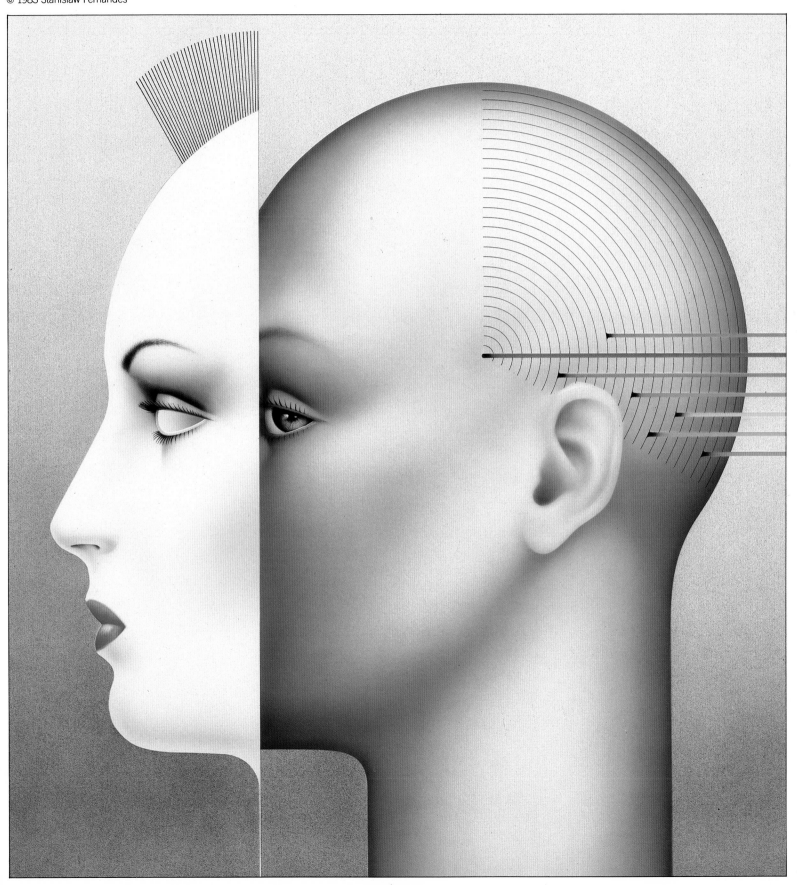

JUDY FRANCIS
110 West 96th Street
New York, New York 10025
(212) 866-7204

Illustration for fashion, beauty, merchandise and "how-to"; printed matter and animatics.

Clients include: *Good Housekeeping,* College-Town, Reborn Maternity, Grey Advertising, Jameson Advertising, Ogilvy & Mather, Sherwood & Schneider, Ballantine Books, Macmillan Publishing, SSC&B, Don Wise & Co., Long Haymes & Carr, *Weight Watchers Magazine.*

Member Graphic Artists Guild, Society of Illustrators.

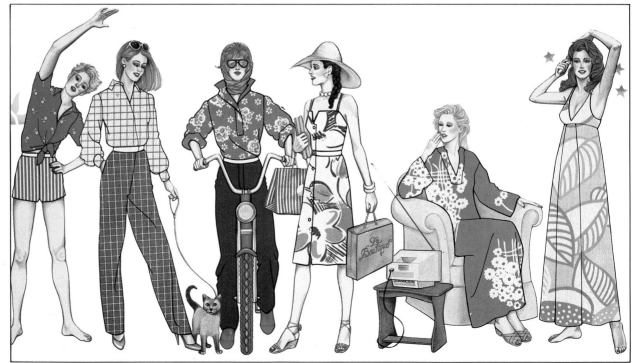

CYNTHIA GALE
229 East 88th Street
New York, New York 10028
(212) 860-5429

Cut paper & collage illustration

Clients include: Leber Katz Partners
Advertising, Chemical Business, Chemical
Engineering, Travel Agent magazines,
WLIB, Mummenschanz.

TIM GIRVIN DESIGN, INC.
911 Western Avenue
Suite 408
Seattle, Washington 98104
(206) 623-7808/7918
Telecopier (206) 623-7816

We design differently for Rand McNally, Sheraton Hotels, Nordstrom, Time/Life, Bloomingdale's, Herman Miller, Pennzoil, Walt Disney Studios and many others throughout the United States, Canada and Europe. Additional relevant samples and transparencies sent immediately by request with a project description on your company letterhead.

IAN GREATHEAD
2975 Christopher's Court
Marietta, Georgia 30062
(404) 952-5067

Represented by:
Barbara Wooden
(404) 892-6303

Clients include: BDA-BBDO,
Burton Campbell, Busch Gardens,
Cargill Wilson & Acree, Coca-Cola,
D'Arcy-MacManus & Masius,
Firestone, IBM, International
Harvester, John Harland &
Company, McDonald & Little,
NAPA, Nimslo, Ogilvy & Mather,
Siemans-Allis, Snapper Power
Equipment, Tappan Appliances,
Tucker Wayne, Wrangler.

DON GRIMES DESIGN
3514 Oak Grove
Dallas, Texas 75204
(214) 526-0040

When carefully conceived,
properly designed and skillfully
executed, a word can be worth a
thousand pictures.

Here are a few choice words from
the vocabulary of Don Grimes.

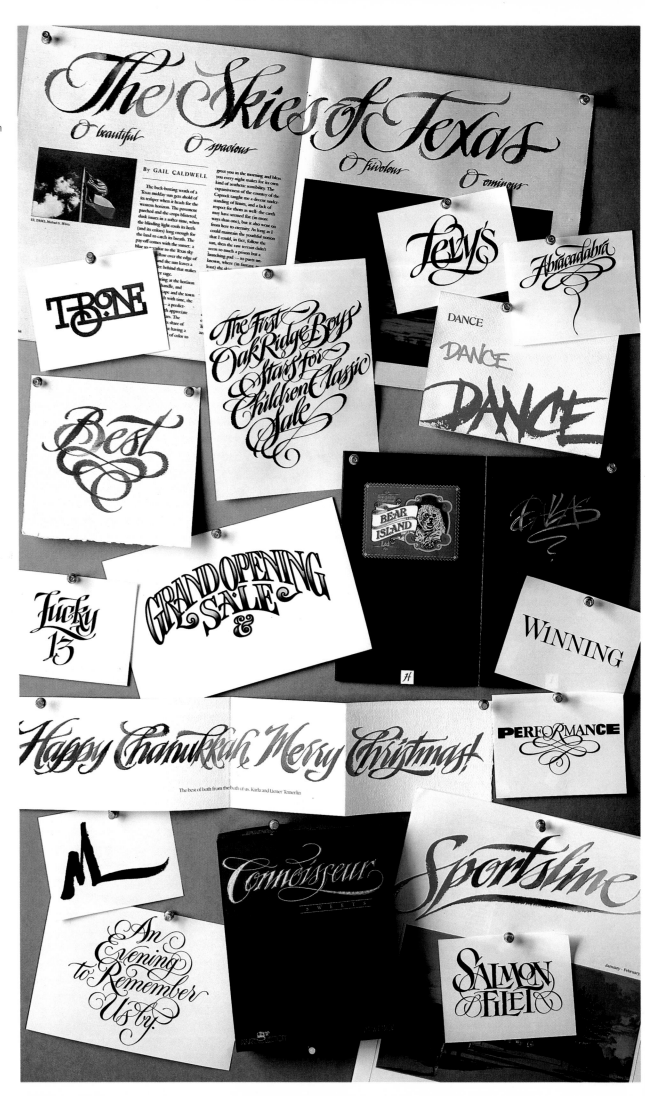

JOHN HAMAGAMI
7822 Croydon Avenue
Los Angeles, California 90045
(213) 641-1522

Representatives:

Los Angeles: Martha Productions (213) 204-1771

New York: American Artists (212) 682-2462

Chicago: Moshier & Maloney (312) 943-1668

San Francisco: Ron Sweet (415) 433-1222

Member Graphic Artists Guild

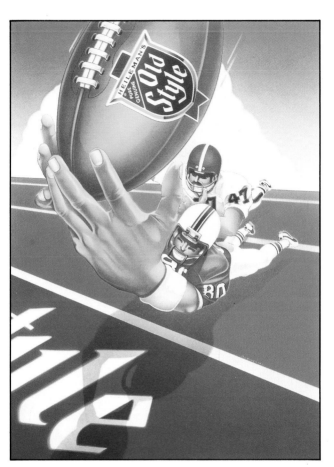

GEORGE HASENBECK
3600 Fifteenth Avenue West
Suite 201-A
Seattle, Washington 98119
(206) 283-0980

Effective graphic communications demand imaginative solutions.

Imaginative solutions require a knowledge of different markets, diversity of style and a dedication to craftsmanship.

The Hasenbeck Studio has been providing such solutions to a variety of clients for ten years—from expressing a subtle mood to translating technical jargon into a dynamic image.

We capture the essence of your message in an illustrative direction fitting the concept, medium, and market.

Whatever the solution and style, the result is the same—a strong statement that gets your point across.

Some of our clients (direct or with affiliate agencies) include Alaska Airlines, Allied Chemical, Boy Scouts of America, Bridgestone Tires, Computerland, Eddie Bauer, Herman Miller Research Corp., Husky Oil/Canada, Kenworth Truck Co., Memorex, NC Machinery/Caterpillar, Northwest Chevrolet Dealers, PenPly/ITT Rayonier, Pacific Northwest Bell, Televideo Systems, and Volvo Penta of America.

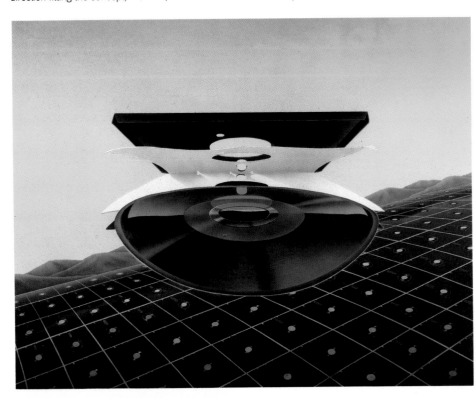

PAULA HAVEY
301 West 53rd Street
Suite #11 l
New York, New York 10019
(212) 245-6118

Illustration & Design

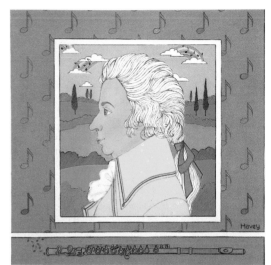

JOE & KATHY HEINER
Studio (801) 581-1612

New York: Vicki Morgan (212) 475-0440

Los Angeles: Ellen Knable (213) 855-8855

San Francisco: Mary Vandamme (415) 433-1292

Chicago: Bill Rabin (312) 944-6655

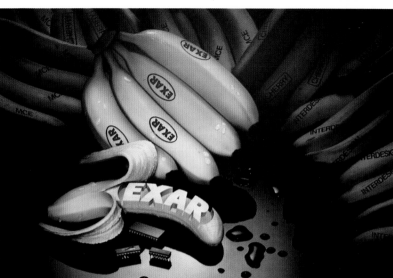

RICHARD HIGH DESIGN
4500 Montrose Suite D
Houston, Texas 77006
(713) 521-2772

Member Graphic Artists Guild

We design unique approaches for all creative and marketing strategies. Custom letter forms give our clients an identity, our logotypes a personality, and our headlines an emotion.

We work directly with clients and through their agencies. Our clients have included: American Civil Liberties Union, Amigos de las Americas, Blalock Nursing Homes, Brennan's Restaurant, Christian Dior, Copper Mountain Resort, Entex Gas Co., Exxon USA, Monarch Homes, Marathon Manufacturing (Bali Blinds) Pennzoil, Western Bank and Westin Hotels.

If you're interested in a different solution for your advertising, design, corporate identity, packaging, and signage call us for samples or slides from our local representative.

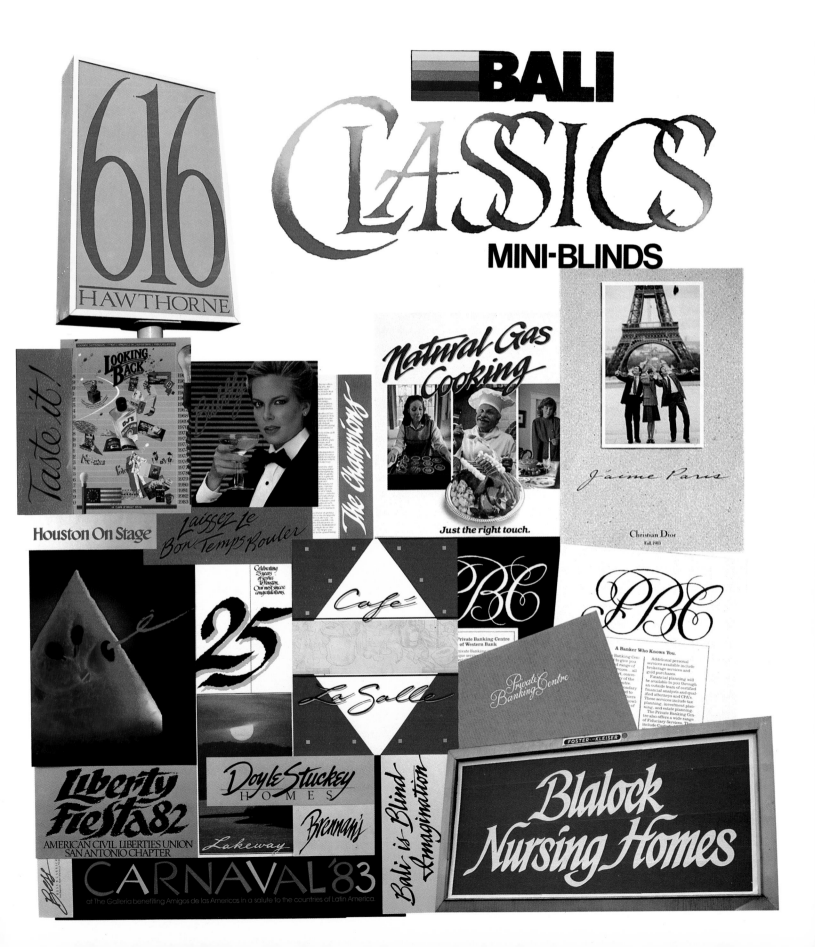

HOPKINS/SISSON, INC.
3113 Pico Boulevard
Santa Monica, California 90405
(213) 829-7216

Illustration and Design.

Illustrations by
Chris Hopkins.

1) Anheuser Busch, Inc.
2) Warner Bros.
3) Starpath, Corp.
4-5) Nike

1.

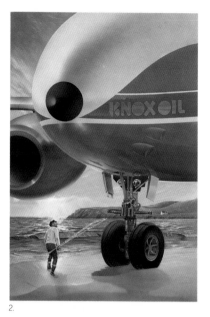

2.

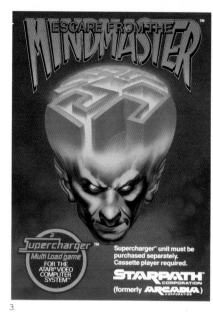

3.

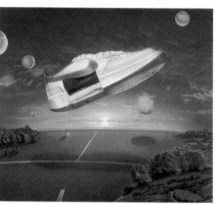

4.

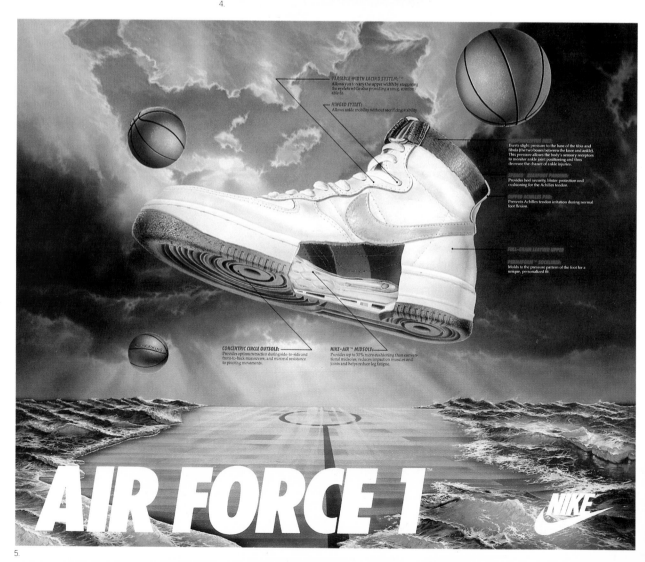

5.

ROBERT HUNT
4376 21st Street
San Francisco, California 94114
(415) 824-1824

Represented in Los Angeles by:
Elise Rosenthal (213) 204-3230

Represented in San Francisco by:
Jan Collier (415) 552-4252

Clients include: Bantam Books, Bank of America, Atari,
Lucasfilm, Levi Strauss, Hunt Wesson Foods, Del Monte
Foods, AT&T, Northrop Aircraft, Security Pacific Bank, Texas
Instruments, Imagic, Gemco, ChemLawn, Visa USA.

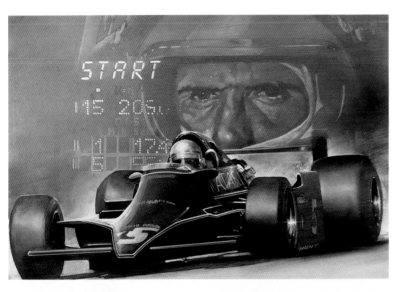

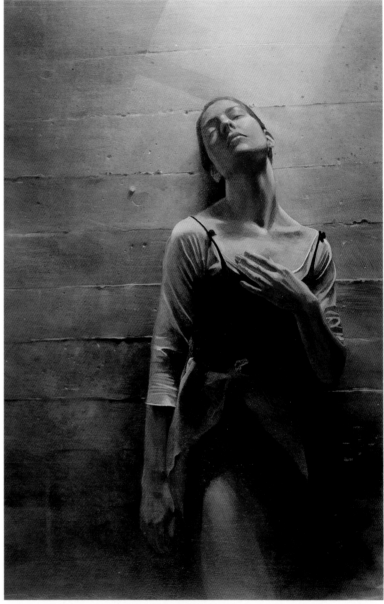

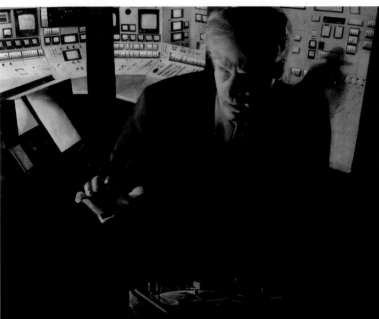

© 1983 TEXAS INSTRUMENTS

SETH JABEN
New York City
(212) 260-7859

Clients include:

	IBM,
Time-Life Inc.	1330 Corporation
McGraw-Hill	*New York Magazine*
New York Times	*Psychology Today*
Webb Company	*Science Digest*
Penthouse	*Family Health*
The Movies	*Esquire*
Playboy	Dish is It Tile
Book-of-the-Month	Rodale Press

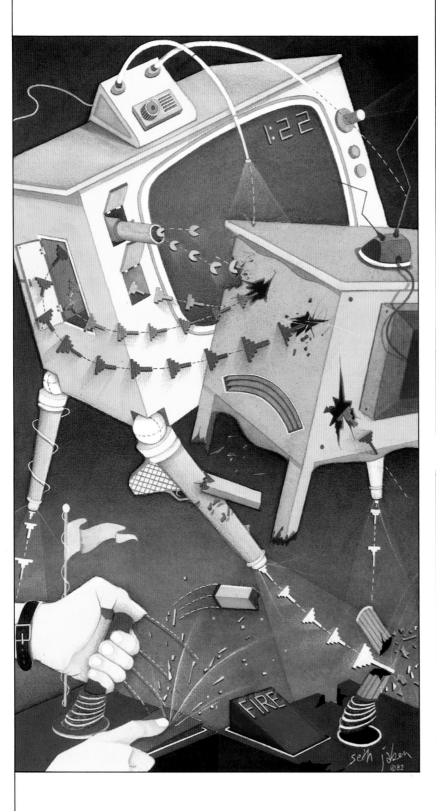

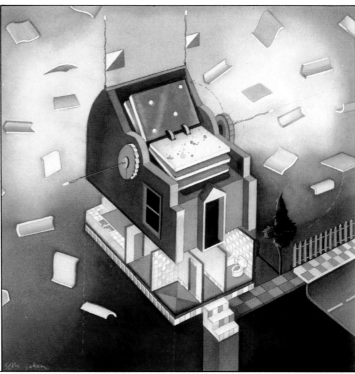

DOUG JAMIESON
42-20 69th Street
Woodside, New York 11377
(212) 565-6034

Clients include: *The New York Times, Psychology Today, Fortune, Business Week, Seventeen, Science Digest, Family Circle, Travel & Leisure, Co-Ed, Family Health, Institutional Investors, Financial World, The Daily News, Village Voice.*
Accounts include: Warner Communications, Atheneum, Scholastic, MacMillan, Doubleday, Harper & Row, McGraw-Hill, Western Publishing, C.T.W., Young & Rubicam, Benton & Bowles, Chalik & Dryer, Daniel & Charles.

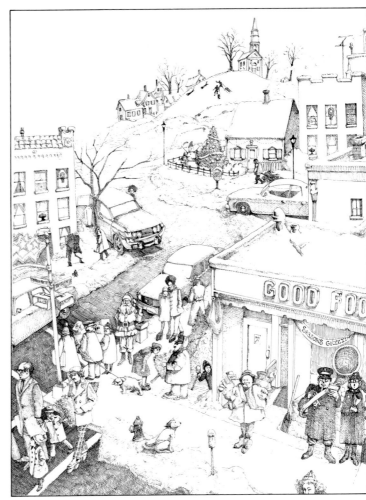

B.E. JOHNSON
366 Oxford Street
Rochester, New York 14607
(716) 461-4240

Los Angeles:
Robert Jones
10889 Wilshire Boulevard
Los Angeles, California 90024
(213) 208-5093

Specializing in, but not limited to,
Technical and Astronomical Art,
Motion Picture Special Effects,
Detailed Working Models.

©1983 B.E. Johnson

Member: Graphic Artists Guild,
Society of Illustrators

BJ's obvious love for human achievement and the unsurpassed beauty of the Cosmos, coupled with his training in Graphic and Industrial Design, Astronomy, and Astrophysics brings forth a somewhat unique level of sensitivity and accuracy in technical and advertising illustration. His enthusiasm for advanced technology and ability to translate difficult concepts into exiting imagery is fueled by one underlying desire:

"Currently, this is the only way I can spend this much time in orbit."

Once an illustration is completed, he invests a few minutes in flipping it this way and that to reveal hidden sensations that may be in store.

"There exists a phenomenon we call 'Earth Chauvinism.' On Earth, it is widely known that 'land' equals 'down'—*and well it should be*. In space, 'up' and 'down' are less easily defined and must be thought of as local points of reference only (or queasiness results). The illustrator, now freed of this convention, is open to new and innumerable directions of thought—and 'upside down' becomes . . . 'right side up.'"

Images left to right:

Golden Eagle—private collection

Sybron/Nalge Industrial Products
Hutchins/Y&R AD Bob Wisner

Ztel Communications Network
Blouin & Co. AD Dave Bastille

Strasenburgh Planetarium
Kinetic Projection

Self Promotion

Technology
and the Art to understand it,

Nature
and the Art to appreciate it,

The Unknown
and the Art to experience it.

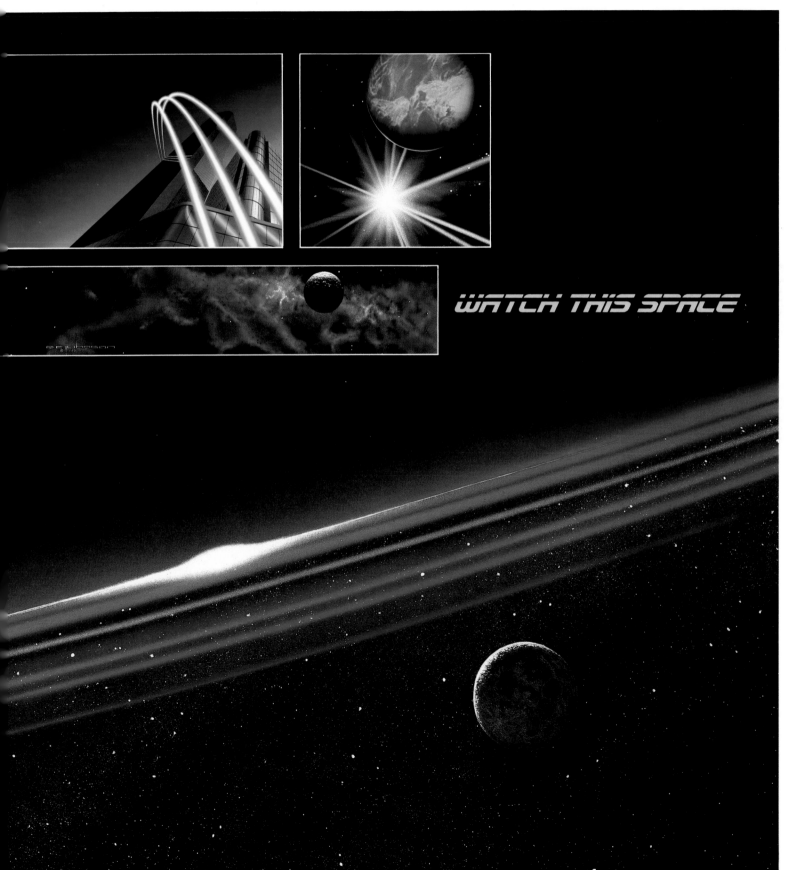

WATCH THIS SPACE

LES KATZ
New York, New York
(212) 284-4779

Represented by: Sharon Drexler

Like a well-designed product, where the form becomes beautiful because the function is so well served, an illustration can completely satisfy the client's selling requirements and still be exciting and creative.

1. Ciba-Geigy
2. Scholastic Books
3. M&M/Mars Company
4. The Doon Agency, NY/Sydney
5. Foote Cone & Belding Advertising

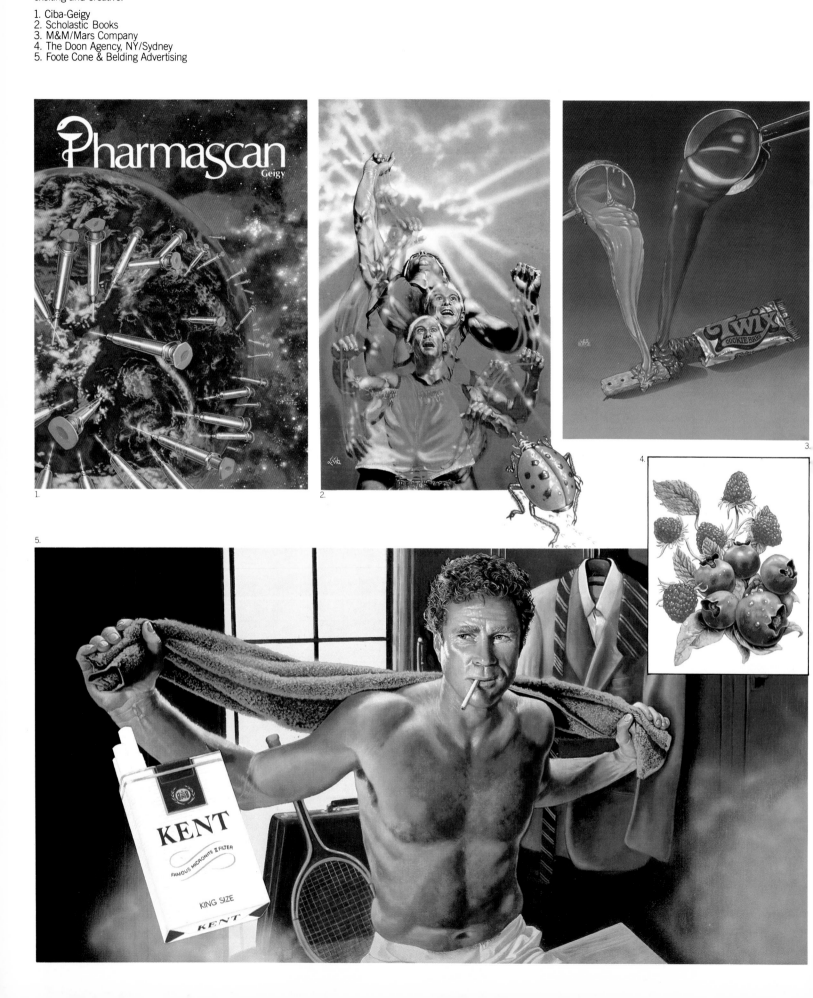

DANIEL KIRK
85 South Street
New York, New York 10038
(212) 825-0190

Member Graphic Artists Guild

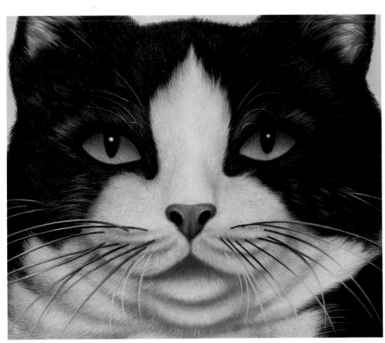

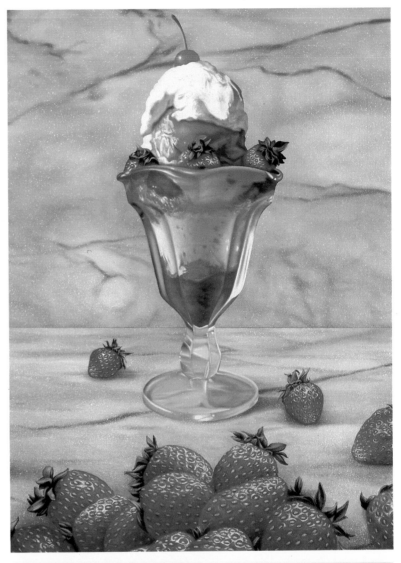

KAREN KLUGLEIN

Watercolor paintings

Represented by

JUDY MATTELSON
88 Lexington Avenue 12G
New York, New York 10016
(212) 684-2974

Member Graphic Artists Guild

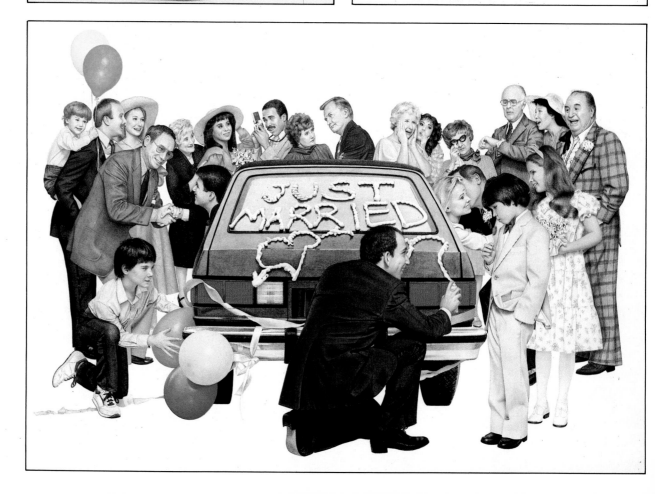

TERRY KOVALCIK
88 Union Avenue, Apt. C5
Clifton, New Jersey 07011
(212) 620-7772
(201) 478-1191

Clients include:
Scholastic Magazines; McGraw-Hill; Harcourt Brace Jovanovich; *Reader's Digest; Parents Magazine; Graduating Engineer; Consumer Electronics; Video Business; Audio Times; Institutional Investors; Medical Economics; Electronic Learning; The New York Times;* New Jersey First National Bank; Howard Savings; WNEW-FM; Vernon Valley Great Gorge Ski Corp.; Aspen Ski Corp.; Chas. P. Young; Fine Art Studio; Iberian Airlines; Well-Bred Loaf, Inc.

Member Graphic Artist Guild

KARIN KRETSCHMANN
323 West 75th Street
New York, New York 10023
(212) 724-5001

JOAN LANDIS
(PRIMITIVE)
Represented By:

Darwin Bahm
6 Jane Street
New York, New York 10014
(212) 989-7074

Bob Bahm
(216) 398-1338

Clients: Exxon Corporation, I.B.M., Smith Kline & Beckman, Swift, Olin Corporation, MGM/UA, Henri Monseiur Wines, *Redbook, Seventeen,* and *Cosmopolitan.*

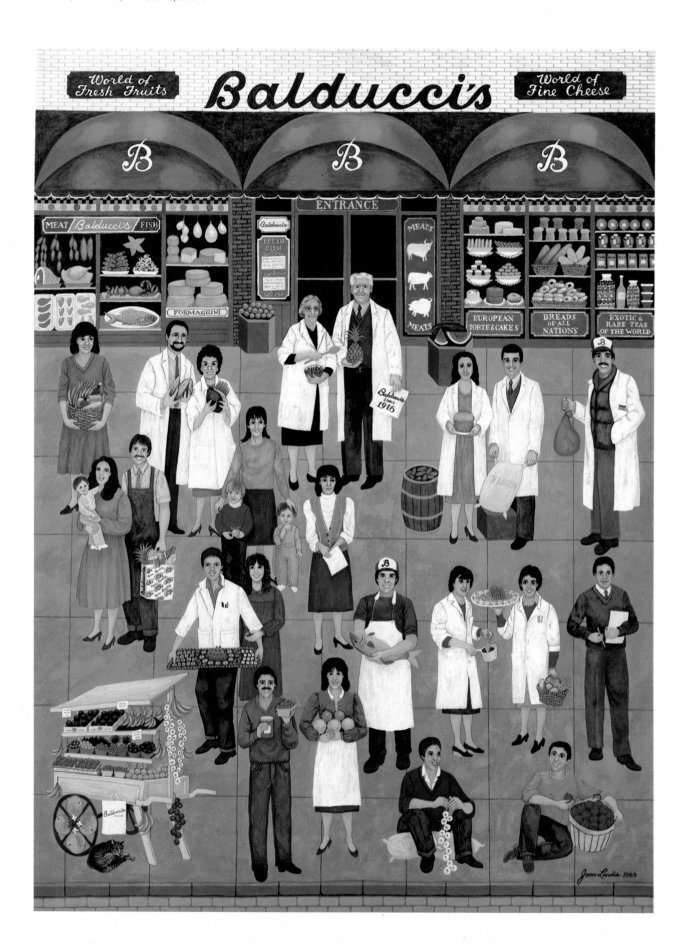

JOHN LANGDON
106 South Marion Avenue
Wenonah, New Jersey 08090
(609) 468-7868

John Langdon designs words.

Not just the letters that comprise them, but their
denotations and connotations as well.

His background in literature and linguistics, his
philosophies and humor, can often be found peeking out
from behind the letters and between the lines.

John has designed logos, logotypes, headlines,
titles, covers, and campaign theme lines, either directly
or through affiliated agencies, for:

The Pennsylvania Lottery
The Claridge Hotel and Casino
Bali Park Place Casino
Jefferson Starship
Gino's Restaurants
Tastykake
duPont
Réalités Magazine
Nursing Magazine
Philadelphia Magazine
Cycle Guide Publications
Playboy Enterprises

NANCY LAWTON

Represented by

JUDY MATTELSON
88 Lexington Avenue 12G
New York, New York 10016
(212) 684-2974

Member Graphic Artists Guild

BRYCE LEE
427 North Adams, Apt. #2
Glendale, California 91206
(818) 244-2310

Watercolorist

In San Francisco
Call: Betsy Hillman
(415) 563-2243

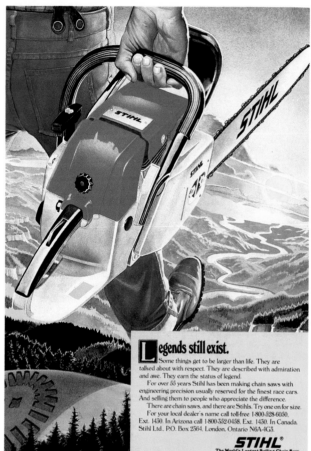

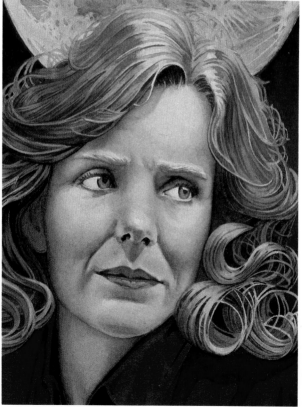

JARED D. LEE
2942 Hamilton Road
Lebanon, Ohio 45036
(513) 932-2154

Telecopier Service

Partial client list: Young &
Rubicam, BBD&O, J. Walter
Thompson, Foote Cone & Belding,
Doyle Dane Bernbach, Bozell &
Jacobs, Cunningham & Walsh,
*Sports Illustrated, Time, Fortune,
Changing Times, Psychology
Today,* Medical Economics,
American Way, Scholastic
Publications, Avon Publications.

Member Graphic Artists Guild

BOZELL & JACOBS

YOUNG & RUBICAM

WCKY

DOYLE DANE BERNBACH

AMERICAN WAY

MIKE LESTER
5218 Chamblee Dunwoody Road
Atlanta, Georgia 30338
(404) 399-5288

Illustration and Design

FIVE EXPERTS AGREE

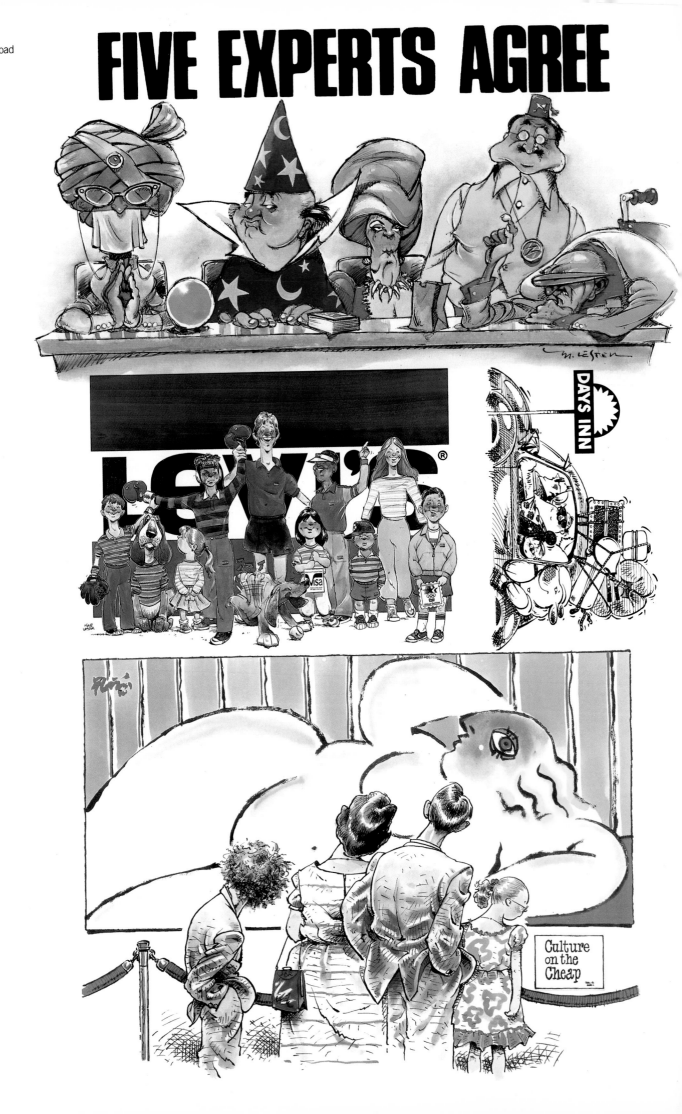

TIM LEWIS

Represented by:
Vicki Morgan
194 Third Avenue
New York, New York 10003
(212) 475-0440

Telecopier in office

Member Graphic Artists Guild

RON LIEBERMAN
109 West 28th Street
New York, New York 10001
(212) 947-0653

Illustration & Design

Member Graphic Artists Guild

Clients include: Eastern Airlines; Children's Television Workshop;
Volkswagen; Air France; Legg's Panty Hose; *New York Times;
New West; New York; Esquire;* Ballantine Books; Random
House; Harmony Books; Lily Tomlin; Peter Allen/Dee Anthony
Organization; Arista & Warner Bros. Records.

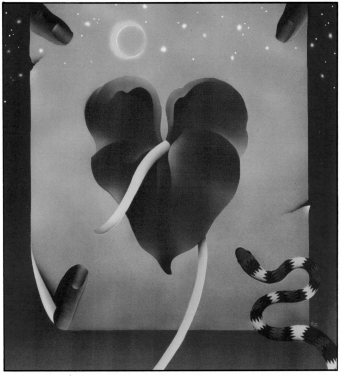

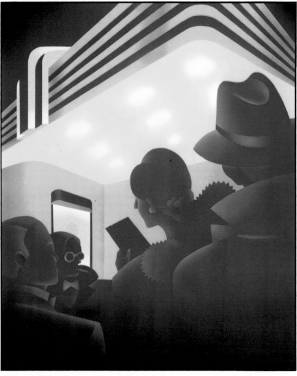

ED LINDLOF

Represented by:
American Artists
353 West 53rd Street, Suite 1W
New York, New York 10019
(212) 682-2462

Member: Graphic Artists Guild
 AIGA, Society of Illustrators

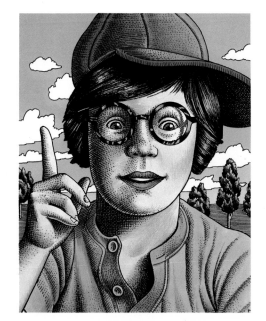

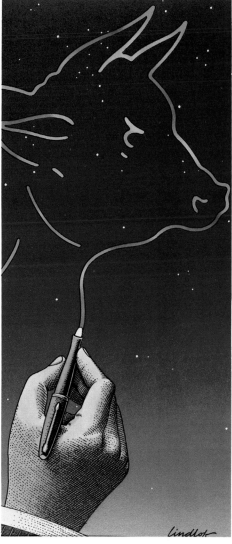

LITTLE APPLE ART
Marshall & Richie Moseley
409 Sixth Avenue
Brooklyn, New York 11215
(212) 499-7045

Illustration, graphic design and lettering.

Located in Park Slope, the studio of Marshall and Richie Moseley services advertising agencies, companies and publishers. Clients have included: DDB; BBDO; N.W. Ayer; Ted Bates; William Esty; Ogilvy & Mather; McCann-Erickson; Scali, McCabe, Sloves; Cunningham & Walsh; Doremus; Dancer Fitzgerald Sample; Hutchins/Y&R; Kasica & Brown; Edwin Bird Wilson; Polaroid; National Airlines; American Airlines; Coca-Cola; Parker Brothers; International Paper; Airwick; Sheraton International; Continental Insurance; Holiday Inn; Thomas Cook; General Foods; NBC; CBS Records; Proctor & Gamble; Dun & Bradstreet; Maxwell House; Southern Bell; Colgate-Palmolive; GAB; Avon Books; Dell; Ballantine; Random House; *Changing Times*; *Parents Magazine*; *N.Y. Times*; CTW; *Scholastic Magazine*. Additional samples available on request.

Member of the Graphic Artists Guild.

RICK LOVELL, INC.
745 Kirk Road
Decatur, Georgia 30030
(404) 371-0681

Represented by: The Williams Group
Contact Phillip Williams or Rich Coveny
(404) 873-2287

Clients Include: Time-Life Books, Exxon, Cameron Iron Works, Marathon-LeTourneau, Gerald Hines Interests, Drillco, Union Carbide, Abercrombie & Fitch, W.R. Grace, Freidrich, Sprite, Coca-Cola, Mello-Yello, Wise, Krystal, Equifax, Hilton Hotels, Southern Bell, South Central Bell, Avco Industries, Bryan Meats, Stihl, Rhone-Poulenc, John Harland Company, IBM, Busch Gardens, Anheuser-Busch, Cox Cable, Kraft, Cutty Sark, Bank of the South, Avon Books, Dell Publishers, Simon & Schuster, Baltimore Gas & Electric, *Houston City Magazine.*

Telecopier available

DEPARTMENT OF NATURAL RESOURCES

THE BIG BLUE BEAST
OLD DOMINION BASKETBALL AT SCOPE

DENNIS LUZAK
Box 342
Redding Ridge,
Connecticut 06876
(203) 938-3158

Clients:
Time Inc.
Ford Motor Company
Chrysler Corporation
NBC
National Geographic Society
Franklin Mint
Xerox Corporation
Eli Lilly Corporation
Outboard Marine Corporation
International Paper Company
Grey Advertising
Young & Rubicam Advertising
Universal City Studios
Paramount Pictures Corporation
Time-Life Records
Arista Records
Warner Communications
CBS
Institutional Investors
Randolph Computer Corporation
McCall's Magazine
Ladies Home Journal
Redbook
Playboy
Sports Illustrated
Fortune Magazine
Forbes
General Electric
Air Canada
Borden Company
Lederle Pharmaceutical
Manufacturers Hanover Trust
First National Bank of Chicago
First National Bank of Boston
McGraw-Hill Publishers
Renault Corporation
RCA
United States Postal Service
MBI
Beechnut
Random House
Reader's Digest Corporation
Simon & Schuster
New American Library
Franklin Library
Ayerst Pharmaceutical
Westwood Pharmaceutical
AmTrak
Schweppes
Colgate-Palmolive
Coca-Cola

Member:
Society of Illustrators
Graphic Artists Guild
Salmagundi Club

JOHN LYTLE
P.O. Box 5155
Sonora, California 95370
(209) 532-1115

Clients include: Atari, Ampex,
Bank of America, Hewlett-Packard,
Visa, Kaiser Steel, R.J. Reynolds,
Nike, Levi Strauss, PG&E,
Goodyear, Castle & Cook,
Del Monte, Walter Landor,
Jaguar, Ryder Trucks, Yamaha
Motorcycles, Treesweet,
San Francisco Magazine,
Mother Jones, J. Walter Thompson,
Lartec Scientific, RayChem,
Long Island Lighting Company,
Young and Rubicam.

Member Graphic Artists Guild

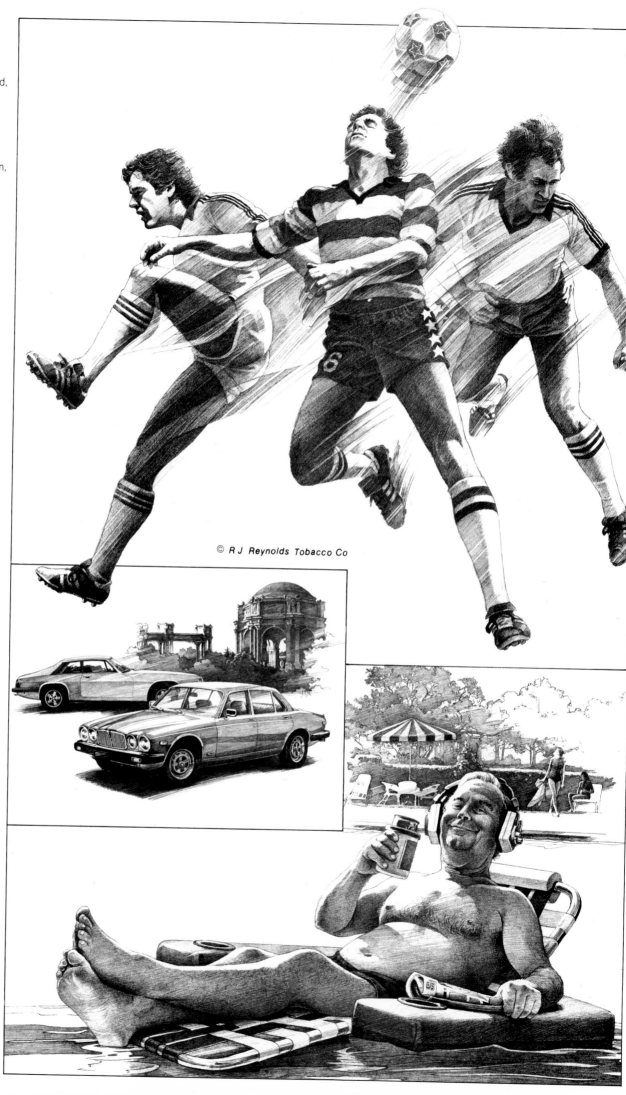

© R J Reynolds Tobacco Co

RICHARD MANTEL

Represented by:
Vicki Morgan
194 Third Avenue
New York, New York 10003
(212) 475-0440

Telecopier in office

Member Graphic Artists Guild

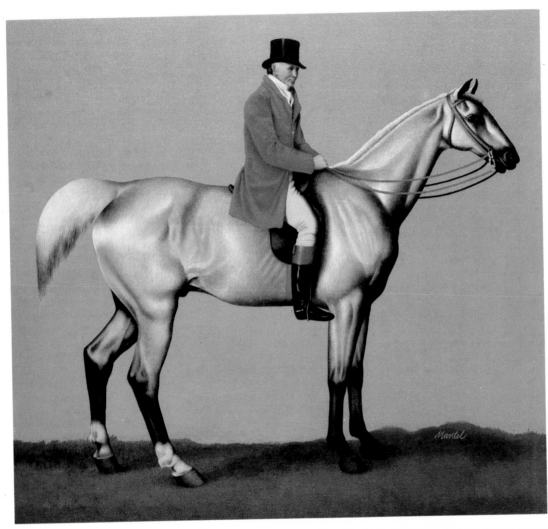

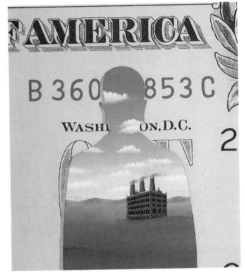

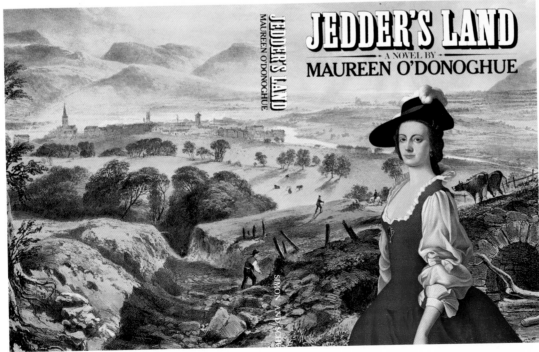

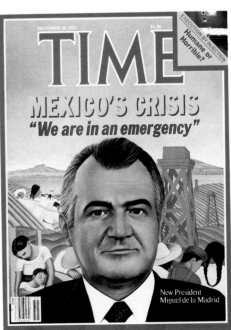

TONY MASCIO
4 Teton Court
Voorhees, New Jersey 08043
Service (215) 567-1585
(609) 424-5278

Represented by Pamela R. Neal Associates
128 East 91st Street
New York, New York 10028
(212) 348-3781 or 3782

Illustration and Design

Member Graphic Artists Guild

FRIENDS AND LOVERS INC.

SUGAR BOWL

WEST COAST SHIPPERS

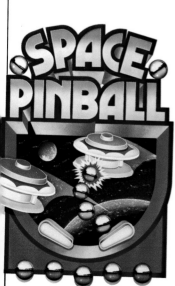

VIDEO GAMES

MARVIN MATTELSON

Represented by

JUDY MATTELSON
88 Lexington Avenue, 12G
New York, New York 10016
(212) 684-2974

Acrylic paintings

Member Graphic Artists Guild

SCOTT McDOUGALL
(206) 324-8640

Represented by:
Spencer Church
515 Lake Washington Boulevard
Seattle, Washington 98122
(206) 324-1199

DAVID MCKELVEY
2702 Frontier Court
Atlanta, Georgia 30341
(404) 457-3615

Represented by the Williams Group
Contact Phillip Williams or Richard Coveny
(404) 873-2287

Illustration and Design

Clients include: J. Walter Thompson Inc., The Coca-Cola Company, Mobil
Oil Corporation, Emory University, Dunlop Sports Company, Bell Telephone,
McCann-Erickson Inc., St. Pauli Brewery, Ford Motor Company,
John Harland Company, Cargill Wilson & Acree Inc., Wrangler, Henderson
Advertising, Bryan Foods, Burton Campbell Inc., Walt Disney World
Company, R.J. Reynolds, Westclox, The Taylor Wine Company, Ogilvy &
Mather, Bozell & Jacobs Inc., Gardner Advertising Inc.

Telecopier Available

WAYNE MCLOUGHLIN

Represented by:
Vicki Morgan
194 Third Avenue
New York, New York 10003
(212) 475-0440

Telecopier in office

Member Graphic Artists Guild

I enjoy bringing a unique conceptual approach to technological and nature subjects.

Awards include: *Playboy Magazine* Editorial Award, Society of Illustrators Silver Medal.

Clients include: National Geographic Society Books, Woodshole Oceanographic Institute, Texaco, Citicorp, CBS, AT&T, Time-Life, Pan Am, Adidas, *Science Digest, National Lampoon*.

I created and designed the dimensional construction "Space Ships" series for Little Brown Inc.

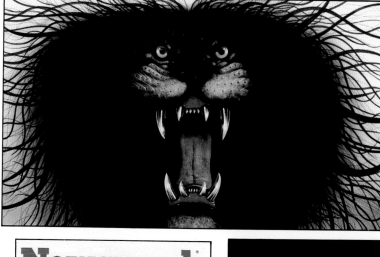

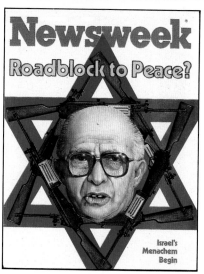

GARY MEYER
227 West Channel Road
Santa Monica, California 90402
(213) 454-2174

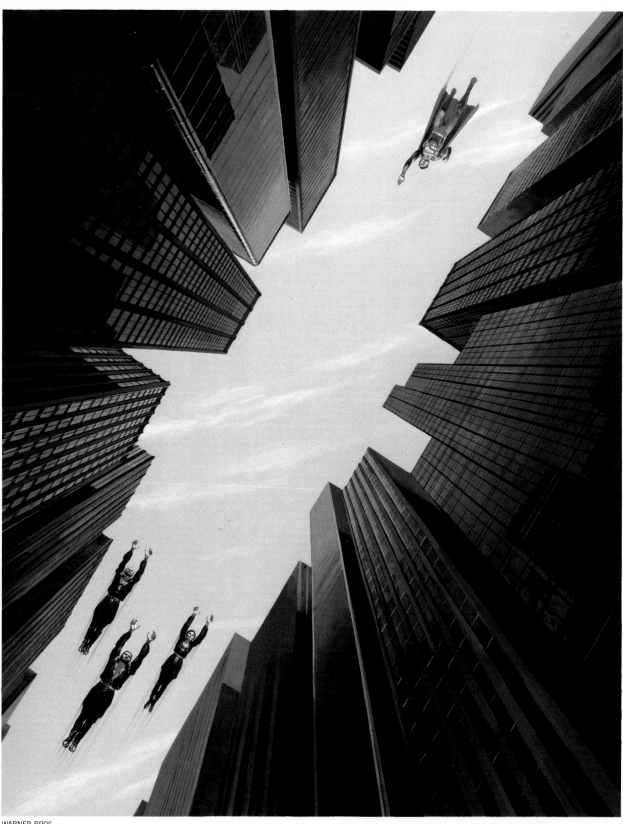

WARNER BROS.

WARNER BROS.

BLITZ WEINHARD

CBS RECORDS

UNIVERSAL PICTURES

MGM

UNIVERSAL PICTURES

WALT DISNEY

DAVID MONTIEL
115 West 16th Street
New York, New York 10011
(212) 989-7426

Illustrations:

From left to right, top to bottom

1. Self-Promotion: "Mangos de Mexico"
2. Ciba-Geigy Pharmaceuticals: "Poison from the Sea"
3. NEXT/Litton Industries: "The Gasohol Gamble"
4. Random House: "The Seabirds are Still Alive"
5. 13-30 Corporation: "The Sinking Economy in Latin America"
6. Random House: "The Fever Tree"

Other clients include: *Time, Discover, Business Week,* Kurtz and Tarlow, Wunderman Ricotta and Kline, Pan-Am Clipper, Harper and Row, *Redbook.*

BARRY MORGEN
425 West End Avenue
New York, New York 10024
(212) 595-6835

Represented by Curt Kaufman
320 East 58th Street
New York, New York 10022
(212) 759-2763

Clients Include:
N.W. Ayer, Anagraphics, Creative
Freelancers, American Express,
Warner Communcations, Inc.,
Reader's Digest, Exxon, Xerox,
Hummelwerk, Time-Life, Inc.,
Mobile Masterpiece Theatre, CBS
Records, RCA Selectavision,
Popular Library, New American
Library, Berkeley, Ballantine Books,
Filmways, HBO, *Showtime
Entertainment,* Columbia Pictures,
Inc., PBS-TV, CBS-TV, ABC-TV,
NBC-TV, Viacom.

Member Graphic Artists Guild

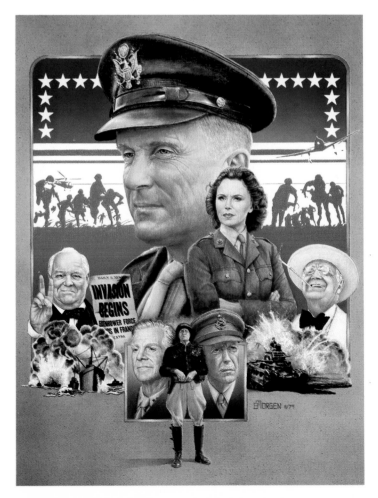

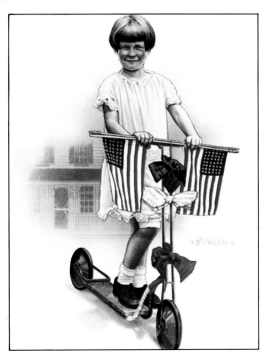

PAMELA NOFTSINGER
Represented by:
Bernstein & Andriulli, Inc.
60 East 42nd Street
New York, New York 10017
(212) 682-1490

Clients have included: ABC, NBC, Avis, Benton & Bowles, Doyle Dane Bernbach, McCaffrey & McCall, J. Walter Thompson, Avon, Dell, Putnam, *Business Week Magazine, New York Magazine,* Dannon Yogurt, 20th-Century Fox.

Member Graphic Artists Guild.

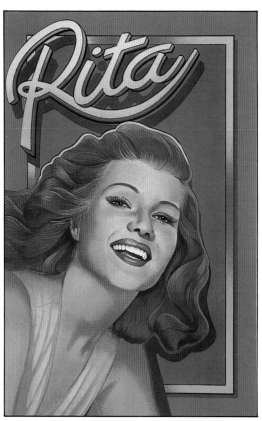

DANIEL PELAVIN
45 Carmine Street
New York, New York 10014
(212) 929-2706

MAKE THE LOGO LARGER

I relate to art directors. I used to be one of them. Sometimes I wish I still were. But most of the time I'm just glad to relate.

I remember when I got to do my first ad. It took three and a half weeks. A writer and I needed everyone in the agency to approve the ad before it went to the client. The mailroom boy rejected it twice.

My writer and I felt it was an award winner. Great concept. Terrific layout. Super copy. Even our group head liked it. He usually didn't like anything unless he did it. We got to present the ad to the client.

He told us to make the logo larger.

That's it. Three and a half weeks. One hundred and seventy-five hours.

Next time I made the logo smaller in anticipation. I once made the logo so small, the account man thought it was a spot and erased it. I did this for 12 years. I always had to make the logo larger. That's one of the reasons I became a "Rep."

"Rep is easier to say than "Artists and Photographers Representative." Sometimes I say "Agent." That's also easy to say.

I like being a "Rep." I get to work with art directors. Once in a while I even work with writers and account people. And on a rare occasion I might get to work with a client. Art directors and writers are the most fun. They always want to do award winners for their portfolios. So do the artists and photographers I represent.

When I first became a "Rep" I had to establish myself in the advertising and editorial community with my new identity. I sat in a phone booth in Grand Central Station with a roll of dimes calling art directors. "Hi. I represent two of the world's greatest undiscovered photographers. I'd like to show you their portfolios."

Art directors are usually pretty busy. They can't see all the "Reps" that call for appointments. Some art directors make appointments when they have nothing to do. They look busy that way. Most of the time when "Reps" call for an appointment, they can't get past the art secretary. It seems that her sole responsibility at the agency is to fend off "Rep" calls. I finally developed two lines to which no red-blooded A.D. could refuse to pick up a phone.

Tell him it's his wife's lawyer." That usually got him. If I knew he wasn't married, I hit him with my backup line—"Tell him Mr. Bernstein from the IRS is calling." He was so relieved I was only a "Rep" that I'd get an appointment.

Some people think being a "Rep" is an easy life. It's going from agency to agency transmitting Polish jokes. Did you hear the one about the Polish "Rep"...

A "Rep's" life can also be very trying. You get calls from your talent in the middle of the night. Calls like, "I can't finish the job, I'm throwing up in the bathroom." "My hand is paralyzed." "My boyfriend left me." "My wife left me." "They *both* left me." "Nobody loves me." A "Rep" once answered in response, "If you want affection, buy a dog." I wish I could remember his name.

A lot of people ask me how to become a "Rep." I tell them it's easy. All you do is put your left hand on a portfolio, raise your right hand and say, "I AM A REP."

I'm now president of Bernstein & Andriulli, Inc. We represent artists and photographers. We do a lot of promotional advertising. I don't have the time to do the layouts anymore. We hire a free-lance art director. I asked him to make the logo larger. But, I still relate. I even asked American Showcase to put our logo at the bottom of this essay.

Sam Bernstein
President
New York City

STEPHEN PERINGER, Illustrator
6046 Lakeshore Drive South
Seattle, Washington 98118
(206) 725-7779

Represented by: Susan Trimpe
2717 Western Avenue
Seattle, Washington 98121
(206) 382-1100

Serving up hot orders of
imagination to go!

Clockwise from upper left:

1. Seattle International Film
 Festival Poster
2. Nike Ad Kit 1983
3. "Circle of Love" Album Cover,
 Steve Miller Band, Capital
 Records
4. "Hot on Your Tail," Television Tag
 Illustration, Lawman Jeans
5. "Penguins in B Flat," 1983
 Penguin Calendar,
 Pomegranate Publications
6. "Doublemint Twins" Birth
 Announcement

Clients include: Capital Records,
First American Records, Nike,
McDonald's, Sea Galley,
Washington State Lottery, Alaska
Seafood Commission, California
Table Grape Commission, Roffe,
Lawman Jeans, Brittania
Sportswear, Ice Capades,
Kenworth Truck Company,
Microsoft, Boeing Aeronautics.

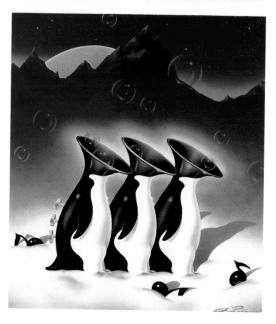

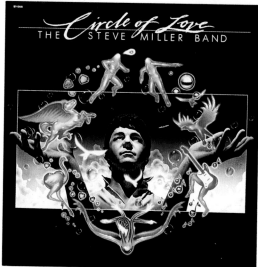

MIKE QUON
DESIGN OFFICE, INC.
53 Spring Street
New York, New York 10012
(212) 226-6024

Los Angeles Representative:
Milton Quon
(213) 293-0706

Full service design office
specializing in a stylized/design
approach to illustration.

Corporate design, sales promotion
collateral & direct mail packages,
lettering, illustration and graphics.

MIKE QUON
DESIGN OFFICE, INC.
53 Spring Street
New York, New York 10012
(212) 226-6024

Los Angeles Representative:
Milton Quon
(213) 293-0706

Design/Illustration

Clients have included: Merrill Lynch, *Business Week,* Time Inc., IT&T, CBS Records, Bell Telephone, American Express, Twentieth-Century Fox, E.F. Hutton, *McCall's,* Ziff-Davis Publishing, Holt Rinehart and Winston, Doyle Dane Bernbach, Young & Rubicam.

© Mike Quon 1983

ALAN REINGOLD
Represented by Anita Grien
155 East 38th Street
New York, New York 10016
(212) 697-6170

Clients include: ABC, CBS, NBC, Universal, Paramount, Diener
Hauser Bates, Bill Gold, *Discover, Forbes, Fortune, Time,*
McCaffrey & McCall, Scali McCabe Sloves, N.W. Ayer, Ogilvy &
Mather, Ted Bates, Atlantic Records, RCA, Bantam Books,
Ballantine Books, *Reader's Digest,* Franklin Mint, Exxon,
McGraw-Hill, Warner Communications, P.B.S., Sudler & Hennessey.

PAUL REOTT
51-10 Van Horn Street
Elmhurst, Queens, New York 11373
(212) 426-1928

Member Graphic Artists Guild

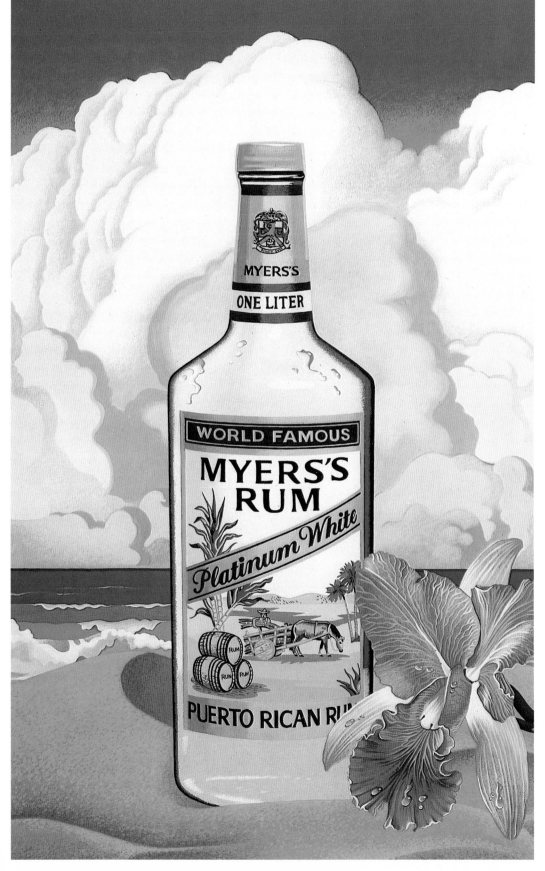

DAVID RICKERD
18 University Avenue
Chatham, New Jersey 07928
(201) 635-9513

Clients: *Science Digest,*
Columbia University, Polydor
Records, East/West Publishing,
Official Airline Guide, View
Communications, Restaurant
Business, *Playboy,* American
Bookseller, *Attenzione, Oui,
Games,* Home Video, *Sounds
Arts,* Home Electronics and
Entertainment, Cycle Publishing,
Video, Gallery, Scholastic
Magazines, Xerox Corporation.

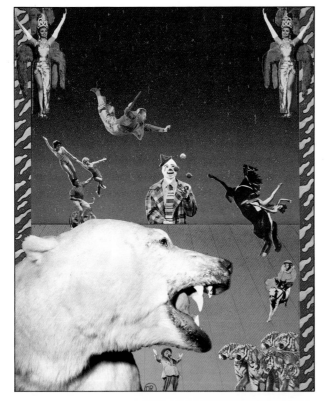

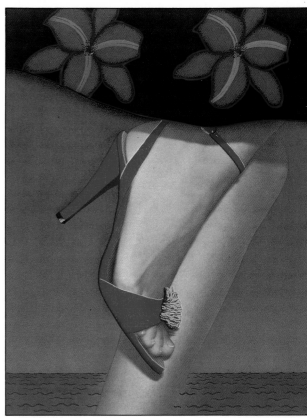

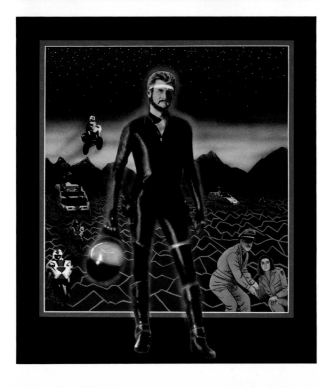

ELLEN RIXFORD
Represented by Anita Grien
155 East 38th Street
New York, New York 10016
(212) 697-6170

Dimensional Illustration, Sculpture, Puppets and Props in every media.

Clients include: N.W. Ayer, Ogilvy & Mather, Marsteller, Trahey Advertising, Avon, Exxon, Alexander Grant, Book of the Month Club, Harper & Row, McGraw-Hill, Corporate Annual Reports, *Fortune Magazine, Ms., Family Weekly, Good Housekeeping, Business Week, Reader's Digest,* Jonson Pedersen Hinrichs, United Technologies.

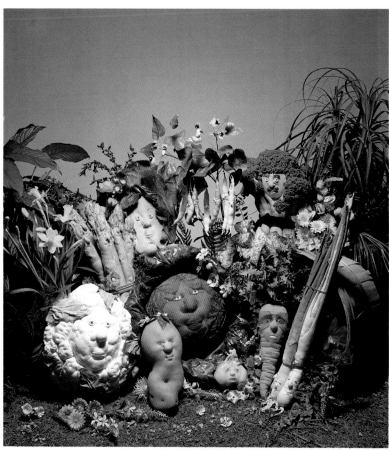

JOHN ROBINETTE
1147 South Prescott
Memphis, Tennessee 38111
(901) 452-9853

Southeast representative:
The Williams Group
Contact Phillip Williams
or Richard Coveny
(404) 873-2287

Clients: Dover Corporation,
Dr. Scholl, Eaton Industries,
Federal Express, *Fortune,* General
Electric, Heller, Holiday Inn Inc.,
Kraft, Krystal, National Wildlife,
Psychology Today, R.C.A.,
Rockwell, Time-Life Books.

See more examples of my work in
a feature article in the May-June,
1981 issue of *Communication
Arts* magazine.

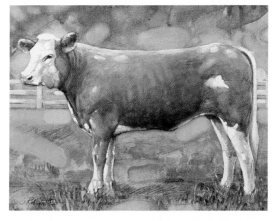

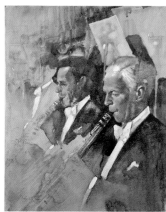

EMANUEL SCHONGUT

Represented by:
Vicki Morgan
194 Third Avenue
New York, New York 10003
(212) 475-0440

Telecopier in office

Member Graphic Artists Guild

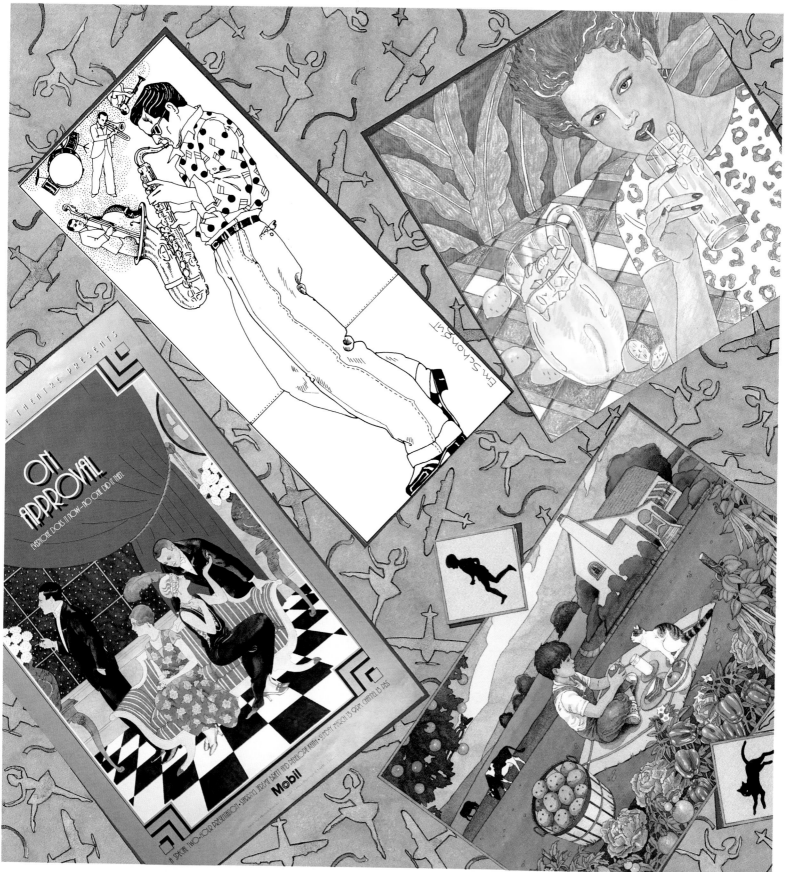

JEFF SEAVER
130 West 24th Street, #4B
New York, New York 10011
(212) 255-8299

Clients: ABC; Air Canada; Ally & Gargano; American Express;
Backer & Spielvogel; BBD&O; Ted Bates; Book-of-the-Month;
Business Week; Doubleday; Dow Jones; Doyle Dane Bernbach;
Dunkin' Donuts; *Fortune;* General Electric; Grey; GTE; Hertz;
IBM; Lever Bros.; Marshalk; McCaffrey & McCall; McCann-
Erickson; Merrill Lynch; Miller; *Mother Jones; National Lampoon;
New York; The New York Times;* Ogilvy & Mather; *Oui;* Pan Am;
Pfizer; Random House; RCA; Rumrill Hoyt; Sandoz; Scali,
McCabe & Sloves; *Science Digest; Science 83;* Sony; *Sports
Afield;* Texaco; J. Walter Thompson; Touche-Ross; Video Review;
Workman.

Works exhibited in Illustrators 19, 20, 23, 24; Communication
Arts Annual; New York Art Directors Club; Western Art Directors
Show; National Lampoon Art Poster Book and Exhibition;
American Humorous Illustration Exhibit, Tokyo, Japan; Museum
of Art and Science, Chicago.

Member Graphic Artists Guild

© 1983 Jeff Seaver

MARY ANNE SHEA
224 West 29th Street
New York, New York 10001
(212) 239-1076

Clients list includes:

AT&T Long Lines
The Continental Group
Deiner Hauser Bates
Bill Gold Advertising
Doyle Dane Bernbach
Marschalk Advertising
Mobil Oil
Museum of Modern Art
New Yorker Films

Young and Rubicam
Polydor Records
Doubleday Publishing
Cosmopolitan Magazine
National Lampoon
New York Times
Psychology Today
Home Electronics &
 Entertainment

Member Graphic Artists Guild

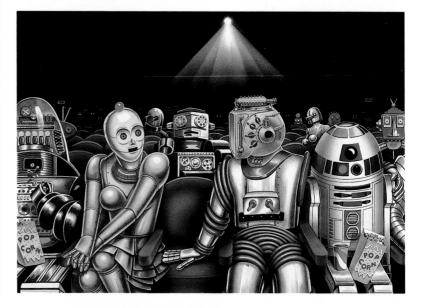

LAURA SMITH
61 Lexington Avenue
New York, New York 10010
(212) 889-0490

Graphic Illustration

Clients have included:
ABC, RCA Records, *Playgirl,*
Grey Direct, Time-Life Video,
Penthouse, Nabisco Brands,
Playboy.

Member Graphic Artists Guild

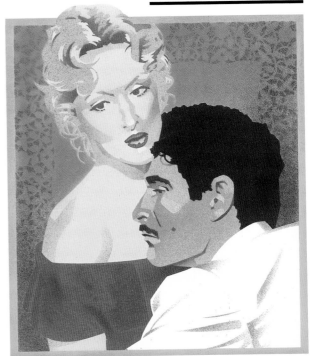

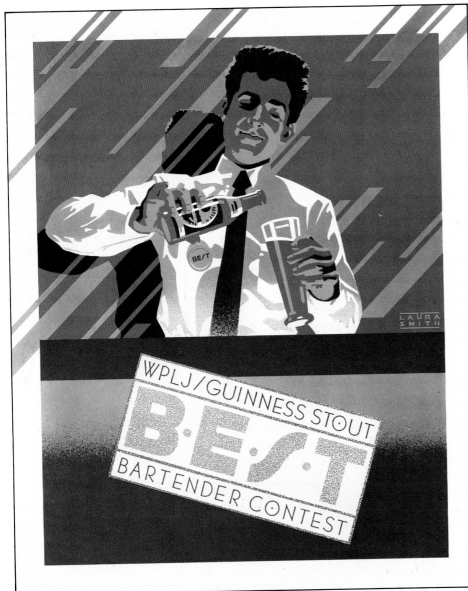

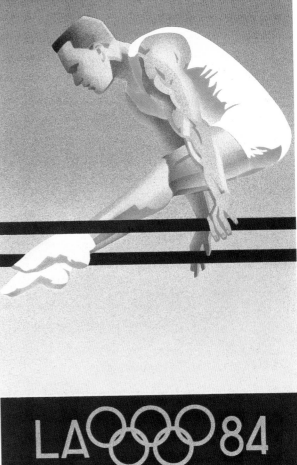

RAY SMITH
1546 West Sherwin
Chicago, Illinois 60626
(312) 973-2625

Advertising and editorial illustration

Top, left: A jacket cover for computer software which teaches mathematics. Microlab client. R.S. Feldman agency.

Top, center: Cover for the Uptowner Magazine on the subject of summer gifts: Uptown Federal Savings and Loan client. R.S. Feldman agency.

Top, right: Point of purchase poster. Devoe Paint Company client. Grey-North agency.

Center, right: Magazine ad promoting the benefits of surfactants. Stepan Chemical Company client. Frank C. Nahser agency.

Bottom, right: Unpublished

Bottom, left: One of a series of four souvenir magazine covers for the 1983 baseball season. Chicago Cubs National League Ball Club client.

Additional clients include: *Advertising Age, Chicago Magazine,* Clinton E. Frank (Reynolds Aluminum), Gardner Advertising (Ralston Purina), Hanley Partnership (Anheuser-Busch), Lee Hill (McDonald's), Leo Burnett (Kellogg's, United Airlines), *Playboy,* Ross & Harvey Design, R. Valencenti Design, and Xeno.

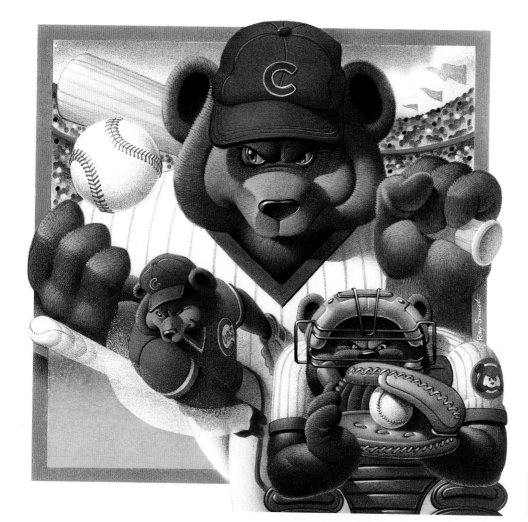

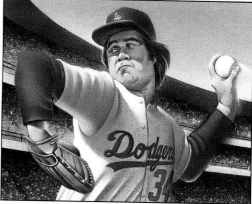

JUNE SOBEL
1128 23rd Street #2
Santa Monica, California 90403
(213) 829-4882

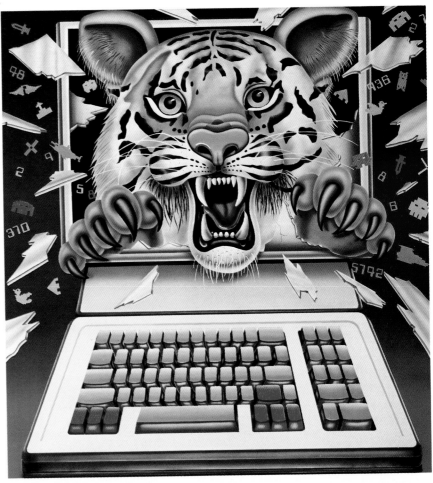

NANCY STAHL

Represented by:
Vicki Morgan
194 Third Avenue
New York, New York 10003
(212) 475-0440

Telecopier in office

Member Graphic Artists Guild

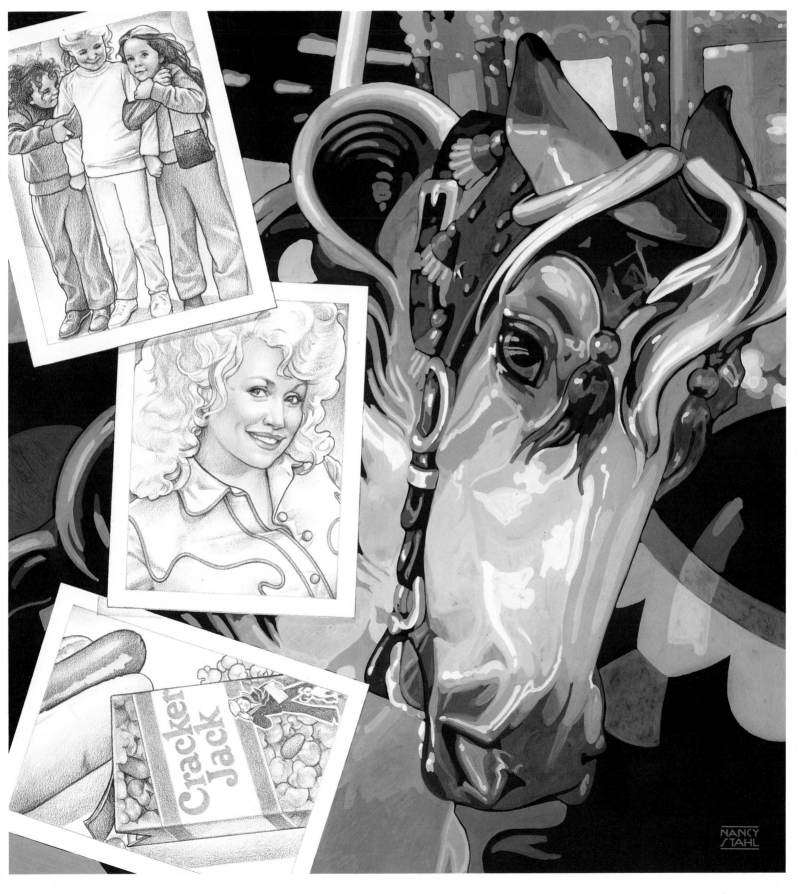

DAVID TAYLOR
1449 North Pennsylvania Street
Indianapolis, Indiana 46202
(317) 634-2728

Clients include: R.C.A., Sears, *Saturday Evening Post,* Lilly, World Book, N.B.C., *American Legion Magazine,* Gatorade, International Harvester, Burger Chef, McDonald's, Southwest Forest, Coke, American Cablevision, Firestone and Amax Coal Company.

Member Graphic Artists Guild

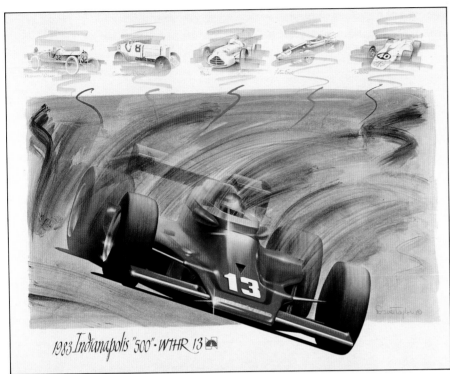

1983 Indianapolis "500" · WTHR 13

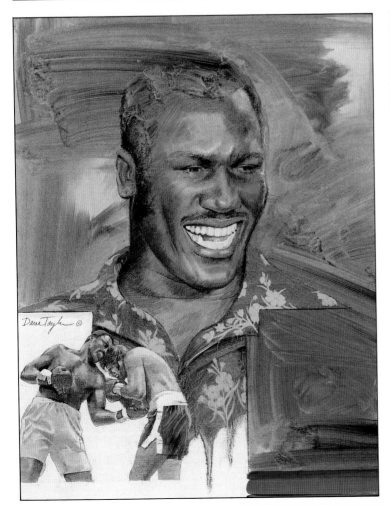

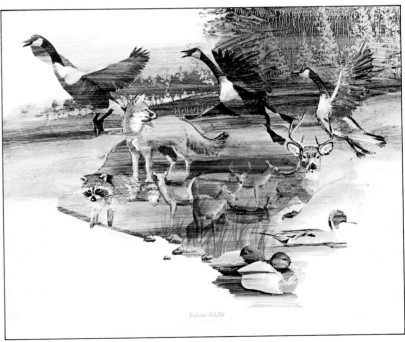

Indiana Wildlife

GEORGE TSUI
2250 Elliot Street
Merrick, New York 11566
(516) 223-8474

Advertising and editorial
illustration.

Clients have included: Benton &
Bowles; J. Walter Thompson; NBC;
ABC; Creative Alliance; Serino,
Coyne and Nappi; Showtime Cable
TV; Dell Books; Reader's Digest;
Warner Publications; Fawcett
Publications.

Member Graphic Artists Guild.

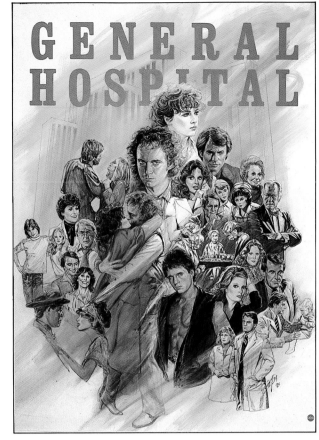

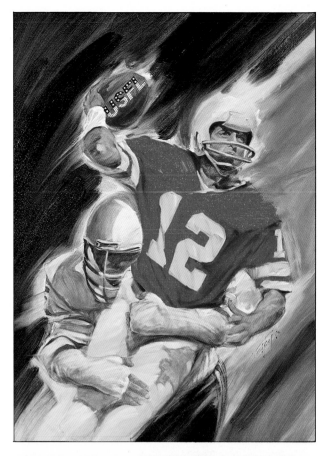

LAUREN URAM
251 Washington Avenue
Brooklyn, New York 11205
(212) 789-7717

Clients include:

British American Tobacco, NBC, NW Ayer, Cole and Weber,
Cunningham and Walsh, *Life Magazine, Music and Sound
Output, Health Magazine, Financial World Magazine, Redbook
Magazine,* The Kiplinger Washington Editors, The United States
International Communications Agency, American International
Pictures

Represented by

JUDY MATTELSON
88 Lexington Avenue 12G
New York, New York 10016
(212) 684-2974

Member Graphic Artists Guild

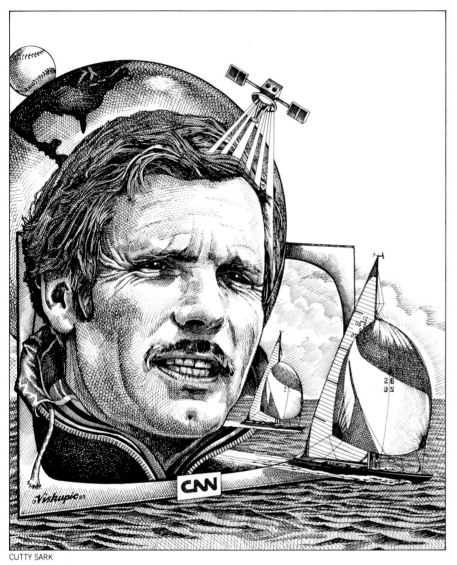

CUTTY SARK

TIME INC.

MERRILL LYNCH

XEROX

SAM VIVIANO
25 West 13th Street
New York, New York 10011
(212) 242-1471

Cartoon, caricature and humorous illustration

Clients include: ABC, BBD&O, CBS, Children's Television Workshop, Citibank, Cunningham & Walsh, Doyle Dane Bernbach, *Family Weekly,* IBM, *Mad Magazine,* McCaffrey & McCall, McCann-Erickson, McNeil-Lehrer Report, Metromedia, NBC, NW Ayer, New American Library, New Line Productions, Ogilvy & Mather, PBS, RCA, *Rolling Stone,* Scholastic, Showtime, United Artists.

Member Graphic Artists Guild

© Sam Viviano 1983

THE RACE NOBODY WINS:
The Search for National Security

Jill Clayburgh and **Tony Randall** narrate a Multi-Media Slide Show presented by **SANE** *(The Committee for a SANE Nuclear Policy).*

From New Line Presentations, Inc.

HAPPY DAYS
◻ ⓒⓑⓢ **8:00PM** ❼⑧

LAVERNE & SHIRLEY
◻ ⓒⓑⓢ **8:30PM** ❼⑧

CAMERON WASSON
4 South Portland Avenue #3
Brooklyn, New York 11217
(212) 875-8277

Illustration

Member Graphic Artists Guild

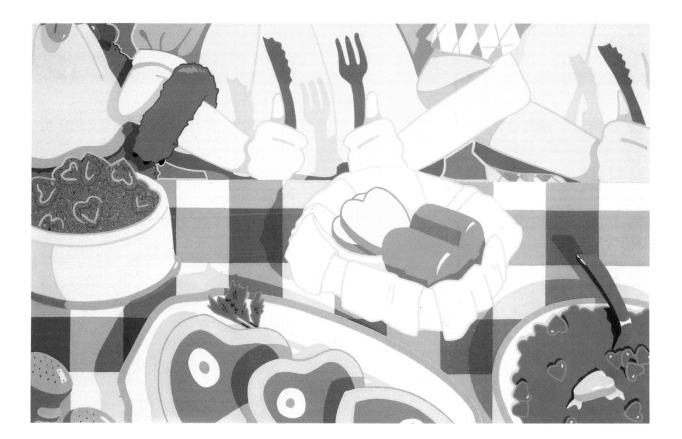

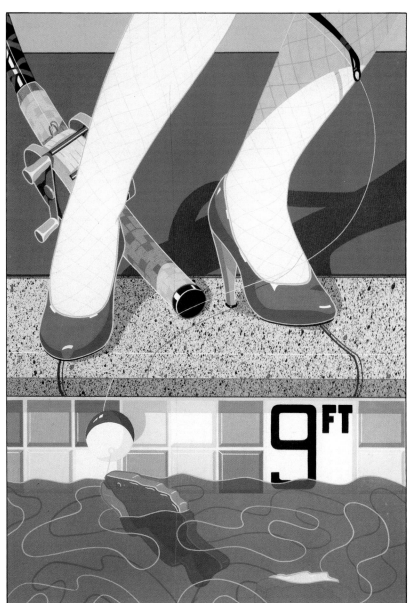

MARK WATTS
616 Iva Lane
Fairless Hills, Pennsylvania 19030
(215) 945-9422

Represented by MENDOLA
420 Lexington Avenue, Suite 2911
New York, New York 10170
(212) 986-5680

This is a list of some clients I've had the pleasure of working with:

Epcot Walt Disney World; AT&T; NBC; CBS; RCA; ABC; Pan Am; General Foods; Gravy Train; Union Carbide; E.F. Hutton; Coor's Beer; American Express; Sony; Burger King; Sun Oil; Avon; Certs; Milton Bradley; Bell Phone Center; Ringling Brothers Circus; Worlds Fair; *Penthouse*; *OMNI*; *National Lampoon*; *Golf Magazine*; M-TV; Nickelodeon; N.W. Ayer; R.T. Blass; Wells Rich & Green; Ogilvy & Mather; Muller Jorden & Weiss; Smith Kline & French; Lewis & Gilman; Gray & Rogers; Tower Books; Pinnacle; Crown, Doubleday; McGraw Hill; MacMillan; Boyds Clothing: Creative; Directors, Creative Alliance; AGI Records.

Awards: 2 DESI AWARDS FOR ILLUSTRATION

Member Graphic Artists Guild

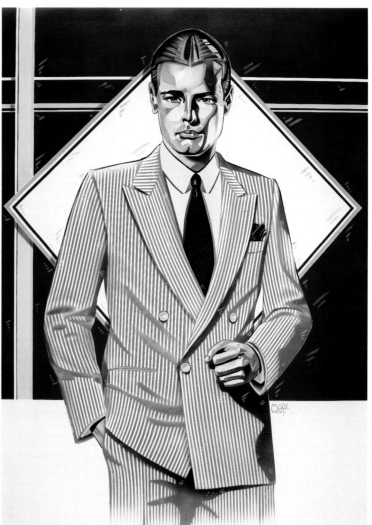

ED WEXLER
11668 Kiowa Avenue
Los Angeles, California 90049
(213) 826-1968

© Ed Wexler 1983

Member Graphic Artists' Guild

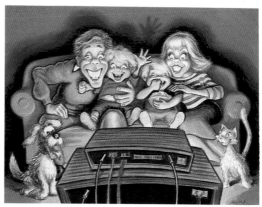

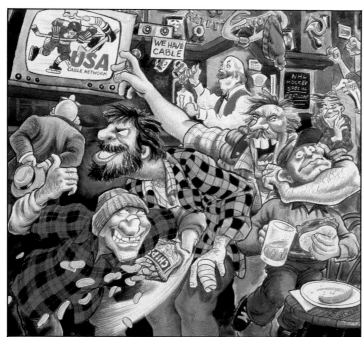

Experience the Stanley Cup Playoffs in living black and blue.

If you want to put yourself in the middle of all the hard-hitting hockey action, there's just one place to turn to: USA Cable Network. Because USA is the only network that gives you live NHL Hockey. With exclusive coverage straight through the Stanley Cup Playoffs and the Finals.

And that's just the beginning. Because every weeknight, USA gives you the kind of sports most networks save for the weekend. Major League sports. And lots of them.

USA covers over 500 exciting events a year. All year long. In fact, we give you more live Major League sports during prime time than any other network.

Monday nights: NHL Hockey (through the Finals)
Tuesday nights: College Basketball or Football
Wednesday nights: Professional Soccer (including the MISL Indoor Playoffs and Championship)
Thursday nights: NBA Basketball (through the Playoffs)
Friday nights: Top-ranked Professional Boxing

USA also has exclusive, live Major League Baseball every Thursday night—all season long. Plus Professional Tennis, Golf, Auto Racing, and much, much more.

So be sure to watch USA for the dates and times of all the NHL Playoff games. And experience one of the world's most colorful sports.

USA CABLE NETWORK

Weekend sports every weeknight.

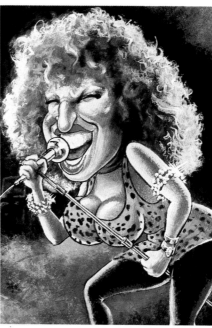

RESPONSIBILITY OF
THE ART DIRECTOR

I would like to speak for a moment about illustration. This piece is not addressed to illustrators but, rather, to those who commission them. Illustration is an ancient art…how old we really do not know. What we do know is that until relatively recently, illustration has been relegated to a *minor* art. That happened when a group of tradesmen became specialists in relieving the tedious look of the printed page. What was gained was a good living for a lot of people—but what was lost was the concept of the illustrator as a *true* artist. A separation came about between *fine* art and *commercial* arts. I believe that this distinction is false and should be changed.

Those who commission work for publication are to a great extent responsible for making it happen. Illustrators themselves tend to please the client. They truly want to be loved. If they are challenged to be wonderful—they are. If they are treated as a necessary evil—that, too, is reflected in what they do. Let us now look at those who commission work and what their responsibility is.

A great majority, if not most, art directors are asked to do a variety of jobs: design, direct photography and commission artists. I really want to deal with only one aspect here, commissioning artists. The thing becomes muddled when those who commission a work restrict or narrow the parameters of that work to only what is expected of them, not what they should be doing. Most art directors today do not draw or produce art themselves, and I have no quarrel with that. What does seem particularly insensitive is when art directors have not provided themselves with a history of the field in which they participate. It is a rich field, indeed, that includes the work of artists we all see in museums and admire on our walls at home. Art directors dilute the power of their projects by restricting the range of their artists to a banal representation of the perfect hamburger. Although the artist has the ability to profoundly move people (just think about advertising you have seen that goes beyond what we have come to expect), they seldom are sufficiently challenged or have the freedom to participate in the look of the piece.

If ever there were a time for art directors to see what is being done outside their immediate area, it is now. The separation of fine art and commercial art is *less* distinct now than ever before. Go to some of Chicago's galleries and to the Museum of Contemporary Art. Draw inspiration from the past. In other words, treat your profession as an *art form.* It is, you know, and a unique art form. Consider for a moment the number of people your work touches. Whether you like it or not, you are to a great extent responsible for the level of their taste. This responsibility becomes awesome when you think of yourselves as teachers of the visual arts to those who will never attend classes to learn about it. Too often, art directors simply look to each other's taste as the final word and simply ride with what's "hot." It is, to a great extent, an inbred society that pats each other on the back for doing what they themselves would have done.

Any real business is obligated to encourage research and development, and ours particularly should, considering the fact that it changes dramatically every few years. I am *not* suggesting that everyone should go his own way and produce unworkable pieces, but only that we must all work to constantly upgrade our profession.

We are in a particularly conservative mood in this country now. Business is rampant with skepticism about its immediate future. The conservative mood in our profession is clear. Why, then, do I suggest that we engage in chance-taking now? Because I believe this is the optimum time to create an experimental climate to be used in the next business surge that is sure to come. When that happens, be prepared to convince those you deal with that their goals should be set higher, removing the necessity for clients to do below-normal-taste advertising and then later contribute grants to the arts.

Kerig Pope
Managing Art Director
Playboy Magazine
Chicago

Reprinted from Chicago Flash

BILL WILKINSON
Represented by Anita Grien
155 East 38th Street
New York, New York 10016
(212) 697-6170

Technical and Architectural Renderings.

Clients include:
N.W. Ayer, Benton & Bowles, Doyle Dane Bernbach,
Gross Townsend Frank, McCaffrey and McCall, Needham
Harper Steers, Ogilvy & Mather, Young & Rubicam, BMW,
Mercedes Benz, *Reader's Digest,* U.S. Army, Chemico Co.,
International Paper, Great Western Wine Co., Skidmore,
Owings & Merrill.

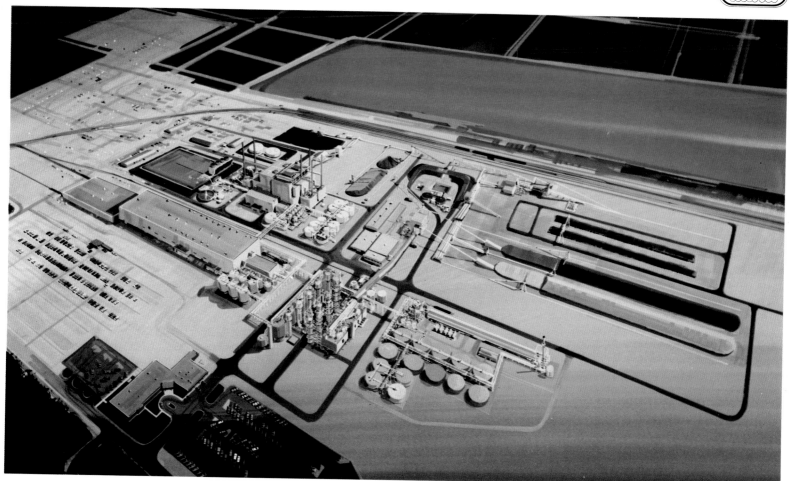

WILLARDSON + WHITE INC.

8383 Grandview Drive
Los Angeles, California 90046
(213) 656-9461

Illustration/Design: Dave Willardson, Charles White, III
Illustration: Rick Brown, Bob Hickson, Ken Rosenberg
Design: Paul Mussa

A full service studio encompassing conceptual illustration, design, and lettering.

Telecopier in studio.

Member Graphic Artists Guild

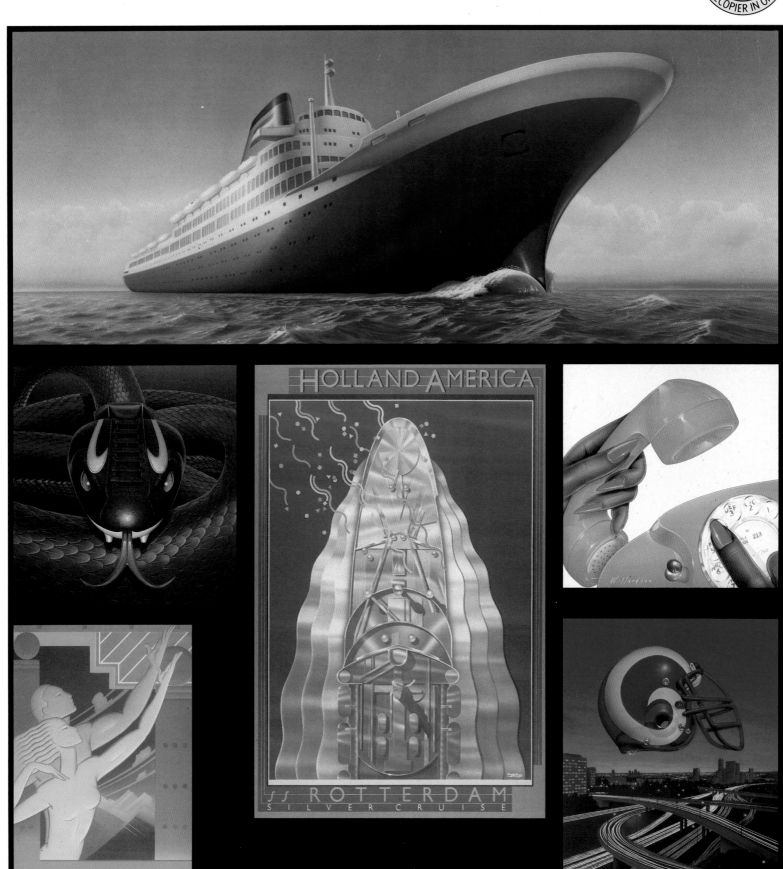

1 9 8 3 A P A A S H O W

KangaROOS
PRESENTS
ROCK 'N' RUN
FIRST ANNUAL 10K
ROCK 'N' RUN
3K CELEBRITY RUN AND CONCERT
UCLA DRAKE STADIUM
MAY 8, 1983

AIR FORCE 1
NIKE

Earning them has made us what we are.

EASTERN
America's favorite way to fly.

CHUCK WIMMER
5000 Ira Avenue
Cleveland, Ohio 44144
(216) 651-1724

Clients include: ABC, NBC, CBS, PBS, affiliates; American Red Cross; Fiat; GE; *Industry Week*; *National Geographic*; Ohio Bell; Ohio Lottery; Paramount Distillers; Pepsi-Cola; *Reader's Digest*; Rivet Jeans; Standard Oil; Young & Rubicam.

Qwip Telecopier Service.

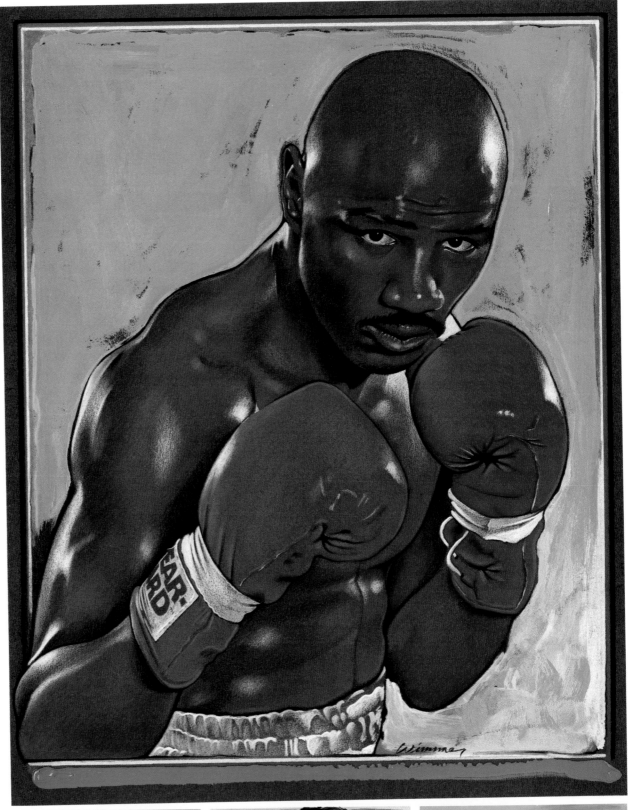

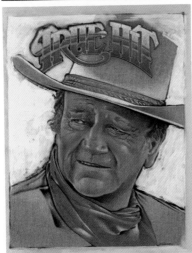

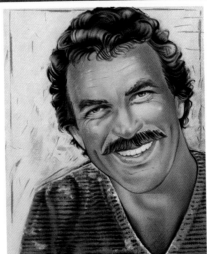

Represented by Carolyn Potts & Associates
2350 North Cleveland
Chicago, Illinois 60614
(312) 935-1707

Drawings Shown Include:
"It's Delicious," a self promotion
"Chicken Soup"—*Oui Magazine*
"Florida"—*Ad Age* (Art Director: Geoffrey Shives)
Kelloggs—Leo Burnett (Art Director: Dick Weiner)
Zebras—Sieber & McIntyre, Inc. (Art Director: Vicki Logan,
 Client: Dorsey Labs)

Other Clients Include:
Needham, Harper & Steers; Foote, Cone & Belding;
J. Walter Thompson; Tatham-Laird & Kudner;

Ogilvy & Mather; *Playboy; Chicago Magazine*;
BBD&O; N.W. Ayer; Scott, Foresman and Co.

Also consumer ads for: McDonald's, United Airlines,
Illinois Bell Telephone, Hyatt Hotels, Kraft Foods, and
Thompson Vacations.

© Leslie Wolf 1984

ROBT. YOUNG ASSOCIATES
78 North Union Street
Rochester, New York 14607
(716) 546-1973

Building on years of success as a respected airbrush illustration/
photo retouching house, Robt. Young Associates has expanded
to become a complete creative studio producing contemporary
print design and illustration.

From concepts to comps to mechanicals, an experienced staff
meets the varied needs of the advertising and promotional
community with a commitment to quality.

Partial list of clients includes: Eastman Kodak, Xerox, Corning
Glass Works, Mobil Chemical, Itek, Goulds Pumps.

Represented by:

Moshier & Maloney
535 North Michigan Avenue
Chicago, Illinois 60611
(312) 943-1668

Partial client list:
Kraft Foods, Inland Steel, Philco, Pennsylvania Lottery, Mattel,
Album Graphics, *Playboy, Science '83 Magazine,* Phonogram Records,
McDonald's, 7-Up, International Harvester, United Airlines,
Sunkist, Abbott Labs, G.D. Searle, Kellogg's, *Chicago Tribune,*
Anheuser-Busch.

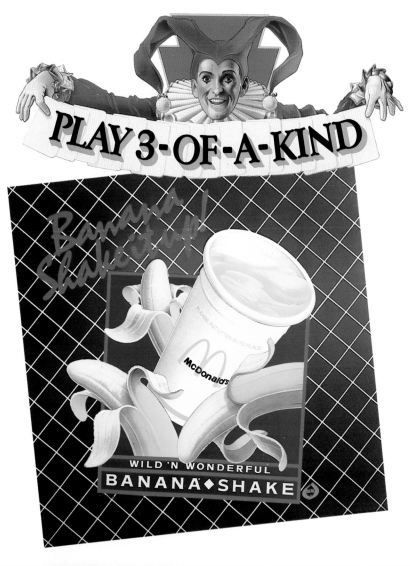

BRIAN ZICK

New York: Vicki Morgan (212) 475-0440
Los Angeles: Ellen Knable (213) 855-8855
Telecopier in studio
Member Graphic Artists Guild

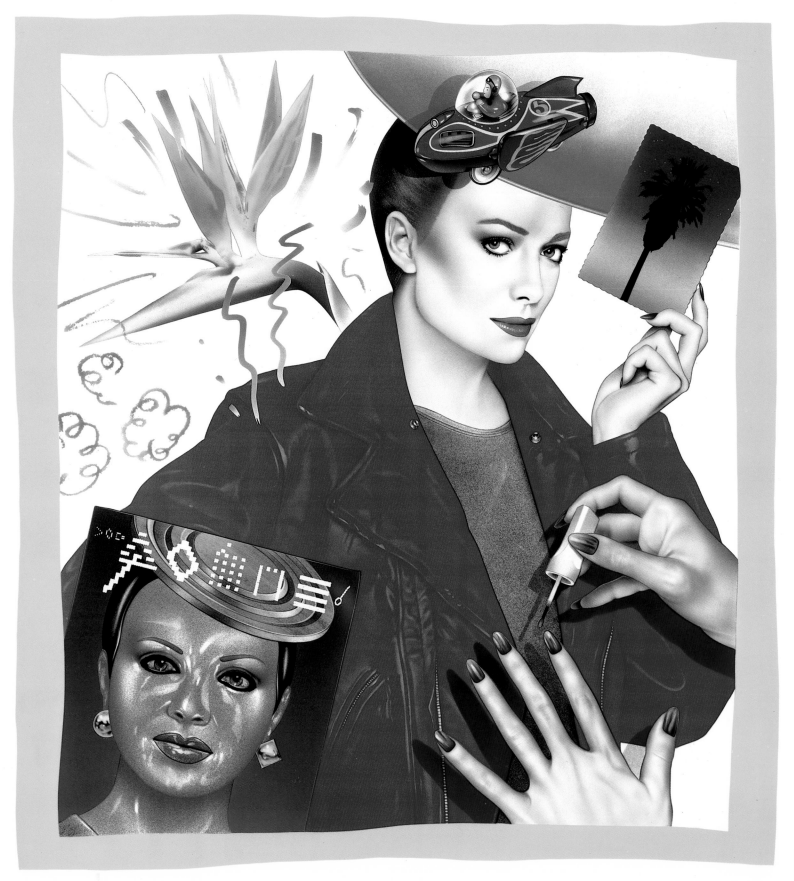

INDEX

continued on page 192

INDEX

continued from page 191

PHONE LISTINGS & ADDRESSES OF VISUAL ARTISTS & REPRESENTATIVES

REPRESENTATIVES

A = Animator, AV = Audio Visual, C = Cartoonist, D = Director, F = Film, G = Graphic Designer, H & MU = Hair & Make-up, I = Illustrator, L = Lettering, M = Music, P = Photographer, R = Retoucher, TV = Television

NEW YORK CITY

A

Abbey, Ken & Assoc/421 Seventh Ave, New York, NY	212-758-5259
David Greenberg, (P), Alan Kaplan, (P), Hal Oringer, (P)	
Adams, Kristine/62 W 45th St, New York, NY	212-869-4170
Adams, Ray/105 E 29th St, New York, NY	212-986-5453
American Artists/353 W 53rd St #1W, New York, NY	212-682-2462
Don Almquist, (I), Michael Davis, (I), Gabe Defiore, (I), Jan Esteves, (I), George Gaadt, (I), Jackie Geyer, (I), Rainbow Grinder, (I), Todd Kat, (I), Gregory King, (I), Richard Krieger, (I), Ed Lindlof, (I), Don Mahoney, (I), Ray Paleastra, (I), Bob Radigan, (I), Mike Ruland, (I), Jan Sawka, (I), Joe Scrofani, (I), Arthur Shilstone, (I), Jim Trusilo, (I), Ron Wolin, (I), Andy Zito, (I)	
Anderson, Michael/125 Fifth Ave, New York, NY	212-620-4075
Frank Siciliano, (P)	
Anton, Jerry/107 E 38th St #5A, New York, NY	212-679-4562
Bobby Cochran, (I), Abe Echevarria, (I), Norman Green, (I), Bob Ziering, (I)	
Arnold, Peter Inc/1466 Broadway, #1405, New York, NY	212-840-6928
Fred Bavendam, (P), Bob Evans, (P), Jacques Jangoux, (P), Manfred Kage, (P), Stephen Krasemann, (P), Hans Pfletschinger, (P), David Scharf, (P), Bruno Zehnder, (P)	
Artists Associates/211 E 51st St, New York, NY	212-755-1365
Don Braupigam, (I), Michael Deas, (I), Alex Gnidziejko, (I), Robert Heindel, (I), Steve Karchin, (I), Dick Krepel, (I), Rick McCollum, (I), Fred Otnes, (I), Hodges Soileau, (I)	
Arton Associates/342 Madison Ave, New York, NY	212-661-0850
Paul Giovanopoulos, (I), Laurent Hubert, (I), Dan Sneberger, (I), Katrina Taylor, (I)	
Ash, Michael/5 W 19th St, New York, NY	212-741-0015

B

Backer, Vic/30 W 26th St, New York, NY	212-620-0944
Norman Nishimura, (P)	
Badin, Andy/333 E 49th St, #7H, New York, NY	212-980-3578
Jeff Feinen, (I), Vera, (I), Brad Guice, (P), Alan Neider, (I)	
BAHM, DARWIN/6 JANE ST, NEW YORK, NY (P 133)	**212-989-7074**
Joan Landis, (I), Rick Meyerowitz, (I), Don Ivan Punchatz, (I), Arno Sternglass, (I), Robert Weaver, (I)	
Barclay, R Francis/5 W 19th St, New York, NY	212-255-3440
Michele Barclay, (P), Art Cashin, (P), Jim Martone, (P)	
Basile, Ron/381 Fifth Ave, New York, NY	212-986-6710
Becker, Noel/150 W 55th St, New York, NY	212-757-8987
Howard Tangye, (P), Sy Vinopoll, (P), Faustino, (P)	
Beilin, Frank/405 E 56th St, New York, NY	212-751-3074
Benedict, Brinker/6 W 20th St, New York, NY	212-675-8067

Nancy Brown, (P)	
BERNSTEIN & ANDRIULLI/60 E 42ND ST, NEW YORK, NY (P 11-21)	**212-682-1490**
Airstream, (I), Garie Blackwell, (I), Tony Antonios, (I), Everett Davidson, (I), Catherin Deeter, (I), Joe Genova, (I), Griesbach/Martucci, (I), Veronika Hart, (I), Catherine Huerta, (I), Kid Kane, (I), Mary Ann Lasher, (I), Bette Levine, (I), Frank Mascotti, (P), Simpson/Flint, (P), Pamela Noftsinger, (I), Chuck Slack, (I), Murray Tinkelman, (I), Chuck Wilkinson, (I)	
Berthezen, Cyndie/372 Fifth Ave., New York, NY	212-685-0488
Bishop, Lynn/134 E 24th St, New York, NY	212-254-5737
Irene Stern, (P)	
Black, Joel P/29 E 32nd St, New York, NY	212-685-1555
Norm Bendell, (I), B Lynne Foster, (I)	
Blair, Robin/400 E 78th St, New York, NY	212-249-3138
Lyons/Stevens, (R)	
Bloncourt, Nelson/308 W 30th St, New York, NY	212-594-3679
Blum, Felice S/79 W 12th St, New York, NY	212-929-2166
Boghosian, Marty/7 E 35th St #2B, New York, NY	212-685-8939
Stephen McCoy, (P), James Salzano, (P)	
Bohmark Ltd/404 Park Ave S, New York, NY	212-889-9670
Booth, Tom Inc/435 W 23rd St, New York, NY	212-243-2750
Mike Datoli, (P), Mats Gustavson, (I), Jon Mathews, (I), Co Rentmeester, (P), Mike VanHorn, (I)	
Brackman, Henrietta/415 E 52nd St, New York, NY	212-753-6483
Brackman, Selma/251 Park Ave S, New York, NY	212-777-4210
Brennan, Dan/27 E. 37th St., New York, NY	212-889-6555
Brindle, Carolyn/203 E 89th St #3D, New York, NY	212-249-8883
BRODY, ANNE/55 BETHUNE ST, NEW YORK, NY (P 37-39)	**212-242-1407**
Randy Jones, (I), Claude Martinot, (I), Ann Neumann, (I), Rich Timperio, (I) , Debora Whitehouse, (I)	
Brody, Sam/141 E 44th St #907, New York, NY	212-758-0640
Linda Clenney, (I), Peter B. Kaplan, (P), Ed Kasper, (I), Chuck Kuhn, (P), Alan Lieberman, (P), Rudi Tesa, (P)	
Brown, Doug/400 Madison Ave, New York, NY	212-980-4971
Andrew Unangst, (P)	
Browne, Pema Ltd/185 E 85th St, New York, NY	212-369-1925
Joe Burleson, (I), Peter Catalanotto, (I), Ted Enik, (I), Ron Jones, (I), Glee LoScalzo, (I), David Plourde, (I), Paul Reott, (I), John Rush, (I)	
Bruck, J.S/157 W 57th St, New York, NY	212-247-1130
Joseph Cellini, (I), Michael Dudash, (I), Tom Freeman, (I), Donald Hedin, (I), Jim Mathewuse, (I), John Mello, (I), Richard Newton, (I), Victoria Vebell, (I), Sally Jo Vitsky, (I), Gary Watson, (I)	
Bruml, Kathy/262 West End Ave, New York, NY	212-874-5659

Bush, Nan/56 E 58th St, New York, NY ... 212-751-0996
 Bruce Weber, (P)
Byrnes, Charles/5 E 19th St, New York, NY ... 212-982-9480
 Steve Steigman, (P)

C

Cafiano, Charles/140 Fifth Ave, New York, NY ... 212-777-2616
 Stan Fellerman, (P), Kenro Izu, (P)
Cahill, Joe/135 E 50th St, New York, NY ... 212-751-0529
 Brad Miller, (P), Howard Sochurek, (P)
Camera 5/6 W 20th St, New York, NY ... 212-989-2004
 Bob Bishop, (P), Peter Calvin, (P), Christopher Casler, (P),
 Karin Epstein, (P), John Giordano, (P), Curt Gunther, (P),
 Ralph Lewin, (P), Joe McNally, (P), Ralph Pabst, (P), Neal
 Preston, (P), Ken Regan, (P), Bob Sherman, (P), Ben
 Weaver, (P), Bob Wiley, (P)
Camp, Woodfin & Assoc/415 Madison Ave, New York, NY ... 212-750-1020
Carmel/69 Mercer St, New York, NY ... 212-925-6216
Carp, Stanley/11 E 48th St, New York, NY ... 212-759-8880
 Allen Vogel, (P)
Caruso, Frank/523 E 9th St, Brooklyn, NY ... 212-854-8346
Casey, Judy/201 W 16th St #12D, New York, NY ... 212-929-0537
 Michael Doster, (I), G Paul Haynes, (I), Giles Tapie, (P)
Casey, Marge/245 E. 63rd St., New York, NY ... 212-486-9575
CHALEK, RICK/9 E 32ND ST, NEW YORK, NY (P 58) ... **212-688-1080**
Chapnick, Ben/450 Park Ave S, New York, NY ... 212-679-3288
Chie/15 E 11th St #3M, New York, NY ... 212-685-6854
CHISLOVSKY, CAROL/420 MADISON AVE #401,
NEW YORK, NY (P 40-43) ... **212-980-3510**
 Russell Cobane, (I), Robert Cooper, (I), John Gray, (I), Alan
 Henderson, (I), Tim Herman, (I), William Hosner, (I), Jim
 Hunt, (I), Joe Lapinski, (I), Felix Marich, (I), Joe Ovies, (I),
 Vincent Petragnani, (I), Chuck Schmidt, (I), Danny Smythe,
 (I), Bob Thomas, (I)
Clarfeld, Suzy/PO Box 455 Murray Hill Station, New York, NY ... 212-889-3920
COLLIGNON, DANIELE/200 W 15TH ST,
NEW YORK, NY (P 45) ... **212-243-4209**
 Bob Aiese, (I), David Gambale, (I), Fran Oelbaum, (I),
 Christine Rodin, (P), Barbara Sandler, (I), Varlet-Martinelli, (I)
Collins, Chuck/545 W 45th St, New York, NY ... 212-765-8812
Conroy, Chris/124 E. 24th St., New York, NY ... 212-598-9766
The Corporate Picture/231 E. 76th St., New York, NY ... 212-861-0489
 Dan Lenore, (P), Steve Niedorf, (P), Christopher
 Springmann, (P)
Crabb, Wendy/320 E 50th St, #5A, New York, NY ... 212-355-0013
 Linda Crockett-Henzel, (A), Sandra Shap, (I), Norman
 Walker, (A)
Creative Freelancers/62 W 45th St, New York, NY ... 212-398-9540
 Harold Brooks, (I), Howard Darden, (I), Claudia Fouse, (I),
 Arie Hass, (I), Rosanne Percivalle, (I), Alex Tiari, (I)
Cullom, Ellen/55 E 9th St, New York, NY ... 212-777-1749
Czapnik, Tobie/12 W 27th St, New York, NY ... 212-354-4916

D

DPI-ALFRED FORSYTH/521 MADISON AVE,
NEW YORK, NY (P 42,43) ... **212-752-3930**
 Robert Panuska, (P), Shorty Wilcox, (P)
Davies, Nora/370 E 76th St, New York, NY ... 212-628-6657
DeBacker, Clo/29 E 19th St, New York, NY ... 212-420-1276
 Bob Kiss, (P)
Dedell, Jacqueline/58 W 15th St, New York, NY ... 212-741-2539
 Ivan Chermayeff, (I), Teresa Fasolino, (I), Kip Lott, (I), Ivan
 Powell, (I), Tommy Soloski, (I), Richard Williams, (I), Henry
 Wolf, (P)
DELLACROCE, JULIA/226 E 53RD ST #3C,
NEW YORK, NY (P 100,101) ... **212-580-1321**
 Shig Ikeda, (P), Winslow Pinney Pels, (I), Michael Sell, (I)
Delvecchio, Lorraine/3156 Baisley, Bronx, NY ... 212-829-5194
Des Verges, Diana/73 Fifth Ave, New York, NY ... 212-691-8674
Deverin, Daniele/226 E 53rd St, New York, NY ... 212-755-4945
 Kenneth Dewey, (I), Mort Drucker, (I), Lazlo Kubinyi, (I),
 Stan Mack, (I), Charles Shields, (I), Don Weller, (I)
DeVito, Kitty/43 E 30th St, New York, NY ... 212-889-9670
DeWan, Michael/154 W 77th St, New York, NY ... 212-362-0043

 Nancy Bundt, (P), Ted Kaufman, (P), Don Sparks, (P)
Dewey, Frank & Assoc/420 Lexington Ave, New York, NY ... 212-986-1249
Di Como, Charles & Assoc Inc/12 W 27th St, New York, NY ... 212-689-8670
DiBartolo, Joseph/270 Madison Ave, New York, NY ... 212-532-0018
 Larry Robins, (P)
DiCarlo, Barbara/500 E 85th St, New York, NY ... 212-734-2509
 John Gregory, (P)
Dickinson, Alexis/42 E 23rd St, New York, NY ... 212-473-8020
 Gianni Cargasacchi, (P), Richard Dunkley, (P), Doug
 Hopkins, (P)
DiMartino, Joseph/200 E 58th St, New York, NY ... 212-935-9522
 Graphicsgroup, (I), Whistl'n-Dixie, (I)
Dorman, Paul/419 E 57th St, New York, NY ... 212-826-6737
 Studio DGM, (I)
Drexler, Sharon/New York, NY ... 212-284-4779
Du Bane, Jean-Jacques/130 W 17th St, New York, NY ... 212-697-6860
 Bruce Plotkin, (P), Carmen Schiavone, (P)
Dubner, Logan/342 Madison Ave, New York, NY ... 212-883-0242
 Charles Kemper, (P), Siorenzo Niccoli, (P)
Dunkel, Elizabeth/231 E 76th St, New York, NY ... 212-861-0489
 Dan Lenore, (P), Steve Niedorf, (P), Christopher
 Springmann, (P)

E F

East Village Enterprises/231 29th St #807, New York, NY ... 212-563-5722
 Gordon Harris, (I), David Jehn, (G), Carlos Torres, (I)
Edlitz, Ann/230 E 79th St #14F, New York, NY ... 212-744-7945
Eng, Barbara/110 E 23rd St, New York, NY ... 212-254-8334
Erlacher, Bill/211 E 51st St, New York, NY ... 212-755-1365
Feldman, Robert/358 W 18th St, New York, NY ... 212-741-7254
 Alen MacWeeney, (P), Terry Niefield, (P)
Ficalora, Michael/28 E 29th St, New York, NY ... 212-679-7700
Fischer, Bob/135 E 54th St, New York, NY ... 212-755-2131
 Bill Siliano, (P)
Flood, Phyllis Rich/67 Irving Pl, New York, NY ... 212-674-8080
 Christopher Blumrich, (I), Seymour Chwast, (I), Vivienne
 Flesher, (I), Kallan Kallan, (I), Sarah Moon, (P), Elwood H
 Smith, (I), Stanislaw Zagorski, (I)
Foster, Peter/870 United Nations Plaza, New York, NY ... 212-593-0793
 Charles Tracey, (P)
Friscia, Salmon/20 W 10th St, New York, NY ... 212-228-4134
Furst, Franz/420 E 55th St, New York, NY ... 212-753-3148

G

Gamma-Liason/150 E 58th St, New York, NY ... 212-888-7272
Garten, Jan And Jack/50 Riverside Dr, New York, NY ... 212-787-8910
 Drovetto, (I)
Gebbia, Doreen/156 Fifth Ave., New York, NY ... 212-807-0588
Gelb, Elizabeth/330 W 28th St, New York, NY ... 212-222-1215
Ginsburg, Michael/Furer, Douglas/145 E 27th St, #7L,
New York, NY ... 212-628-2379
Giraldi, Tina/160 W 46th St, New York, NY ... 212-840-8225
Goldman, David/18 E 17th St, New York, NY ... 212-807-6627
Goldstein, Michael L/107 W 69th St, New York, NY ... 212-874-6933
 Sandra Cheiten, (P), Fred Schulze, (P)
Goodman, Barbara L/435 E 79th St, New York, NY ... 212-288-3076
 Pat Hill, (P), Bryan King, (P), Bill Margerine, (P)
Goodwin, Phyllis A/10 E 81st St, New York, NY ... 212-570-6021
 Art Kane, (P), Neil Rice, (P)
GORDON, BARBARA ASSOC/165 E 32ND ST,
NYC, NY (P 46,47) ... **212-686-3514**
 Ron Barry, (I), Higgins Bond, (I), Bob Clarke, (I), Keita
 Colton, (I), Bob Dacey, (I), James Dietz, (I), Emily
 Dubowski, (I), Victor Gadino, (I), Glenn Harrington, (I),
 Nenad Jaksevic, (I), Jackie Jasper, (I), Dick Kramer, (I),
 Sonja Lamut, (I), Dick Lubey, (I), Cliff Miller, (I), David
 Myers, (I), Sharleen Pederson, (I), Judith York, (I),
Grayson, Jay/230 Park Ave, New York, NY ... 212-490-6490
 Paul Barton, (I), Bob Gomel, (I), David Hendrich, (I), James
 B Wood, (P), Ed Zak, (P)
GREEN, ANITA/160 E 26TH ST, NEW YORK, NY (P 148) ... **212-532-5083**
 Nick Mellillo, (I), Stuart Peltz, (P)
Greenblatt, Eunice N/370 E 76th St, New York, NY ... 212-772-1776
Grey, Barbara L/1519 50th St, Brooklyn, NY ... 212-851-0332

Please send us your additions and updates.

GRIEN, ANITA/155 E 38TH ST, NEW YORK, NY (P 162,165) **212-697-6170**
 Dolores Bego, (I), Bruce Cayard, (I), Hal Just, (I), Jerry McDaniel, (I), Don Morrison, (I), Marina Neyman-Levikova, (I), Alan Reingold, (I), Ellen Rixford, (I), Bill Wilkinson, (I)
Griffith, Valerie/10 Sheridan Square, New York, NY 212-675-2089
Groves, Michael/113 E 37th St, New York, NY 212-532-2074

H Handwerker, Elise/2752 Whitman Dr, Brooklyn, NY 212-251-9404
HANKINS & TEGENBORG LTD/310 MADISON AVE #1225, NEW YORK, NY (P 22-27) **212-867-8092**
 Ralph Brillhart, (I), David Cook, (I), Robert Crofut, (I), John Dawson, (I), John Dismukes, (I), John Ennis, (I), David Gaadt, (I), Paul Gleason, (I), James Griffin, (I), Edward Herder, (I), Michael Herring, (I), Uldis Klavins, (I), Wendell Minor, (I), Charles Moll, (I), Greg Moraes, (I), Greg Olanoff, (I), Walter Rane, (I), Kirk Reinert, (I), Robert Savin, (I), Harry Schaar, (I), Bill Schmidt, (I), Mario Stasolla, (I), Frank Steiner, (I), Robert Travers, (I), Victor Valla, (I)
Hanson, Wendy/126 Madison Ave, New York, NY 212-684-7139
Hare, Fran/126 W 23rd St, New York, NY 212-794-0043
 Peter B Kaplan, (P)
Harmon, Rod/130 W 57th St, New York, NY 212-582-1501
Henry, John/237 E 31st St, New York, NY 212-686-6883
 David W Hamilton, (P), Iain Lowrie, (P), Walter Putrez, (P)
HEYL, FRAN/230 PARK AVE, STE 2525, NEW YORK, NY (P 100) **212-687-8930**
Hoeye, Michael/120 W 70th St, New York, NY 212-362-9546
 Richie Williamson, (P)
Hollyman, Audrey/300 E 40th St 19R, New York, NY 212-867-2383
 Ted Horowitz, (P)
Holt, Rita/280 Madison Ave, New York, NY 212-683-2002
Hovde, Nob/829 Park Ave, New York, NY 212-753-0462
 Malcolm Kirk, (P), J Frederick Smith, (P), Michel Tcherevkoff, (P)
Hurewitz, Gary/5 E 19th St, New York, NY 212-982-9480
 Steve Steigman, (P)
Husak, John/444 E 82nd St, #12-C, New York, NY 212-988-6267
 Frank Marchese, (G), William Sloan, (I)
Hyde, Pamela/532 E 83rd St, New York, NY 212-734-9456

J Jacobsen, Vi/333 Park Ave S, New York, NY 212-677-3770
Jedell, Joan/370 E 76th St, New York, NY 212-861-7861
Johnson, Evelyne Assoc/201 E 28th St, New York, NY 212-532-0928
Johnson, Janice/340 E 93rd St, NY, NY 212-722-4964
 Fred Winkowski, (I)
Judge, Marie/1 W 64th St, New York, NY 212-874-4200
Jupena, Nancy/310 Madison Ave., New York, NY 212-883-8977
 West Fraser, (I), David Gadt, (I), Paul Gleason, (I), Perico Pastor, (I), Joe Saffold, (I), Victor Valla, (I)

K Kahn, Harvey/50 E 50th St, New York, NY 212-752-8490
 Nicholas Gaetano, (I), Gerald Gersten, (I), Hal Herrman, (I), Wilson McLean, (I), Bob Peak, (I), Robert Peak, (P), Isadore Seltzer, (I), Kirsten Soderlind, (I)
Kammler, Fred/225 E 67th St, New York, NY 212-249-4446
 Joe Long, (P)
Kane, Barney Inc/120 E 32nd St, New York, NY 212-689-3233
 Alan Daniels, (I), Michael Farina, (I), William Harrison, (I), Steve Hochman, (I), Peter Lloyd, (I), Ted Lodigensky, (I), Rich Mahon, (I), Robert Melendez, (I), Larry Winborg, (I)
Keating, Peggy/30 Horatio St, New York, NY 212-691-4654
 Georgan Damore, (I), June Grammer, (I), Gerri Kerr, (I), Bob Parker, (I), Frank Paulin, (I), Fritz Varady, (I), Carol Vennell, (I)
Keaton, Liz/40 W 27th St, New York, NY 212-532-2580
Kenney, John/12 W 32nd St, New York, NY 212-594-1543
 James McLoughlin, (P)
Kestner, VG/427 E 77th St #4C, New York, NY 212-535-4144
Kim/209 E 25th St, New York, NY 212-679-5628
KIMCHE, TANIA/470 W 23RD ST, NEW YORK, NY (P 48,49) **212-242-6367**
 Michael Hostovich, (I), Rafal Olbinski, (I), Miriam Schottland, (I), E T Steadman, (I)

Kirchmeier, Susan/c/o N Lee Lacy, 160 E 61st St, New York, NY 212-758-4242
Kirchoff-Wohlberg Inc./866 UN Plaza #4014, New York, NY 212-644-2020
 Angela Adams, (I), Bob Barner, (I), Bradley Clark, (I), Brian Cody, (I), Gwen Connelly, (I), Betsy Day, (I), Alice D'Onofrio, (I), Arlene Dubanevich, (I), Lois Ehlert, (I), Al Fiorentino, (I), Frank Fretz, (I), Jon Friedman, (I), Jon Goodell, (I), Jeremy Guitar, (I), Konrad Hack, (I), Pamela Higgins, (I), Ron Himler, (I), Rosekrans Hoffman, (I), Gerry Hoover, (I), Mark Kelley, (I), Christa Kieffer, (I), Dora Leder, (I), Tom Leonard, (I), Susan Lexa, (I), Ron Logan, (I), Don Madden, (I), Lyle Miller, (I), Carol Nicklaus, (I), Ed Parker, (I), Charles Robinson, (I), Sue Rother, (I), Trudi Smith, (I), Robert Steele, (I), Arvis Stewart, (I), Jas Szygiel, (I), Phero Thomas, (I), Pat Traub, (I), Lou Vaccaro, (I), Joe Veno, (I), John Wallner, (I), Alexandra Wallner, (I), Arieh Zeldich, (I)
Klein, Leslie D/130 E 37th St, New York, NY 212-683-5454
 Eric Meola, (P)
KLIMT, BILL & MAURINE/15 W 72ND ST, NYC, NY (P 50,51) **212-799-2231**
 Jeffrey Adams, (I), Ted Detoy, (P), David FeBland, (I), Ken Joudrey, (I), Michael Kane, (I), Frank Morris, (I), Joseph Nettis, (P), Greg Pheakston, (I), Pino, (I), Michael Rodericks, (I), Sharon Spiak, (I), Steven Stroud, (I), Ben Swedowsky, (P),
Kooyker, Valerie/201 E 12th St, New York, NY 212-673-4333
Kopel, Shelly & Assoc/342 Madison Ave #261, New York, NY 212-986-3282
Kotin, Rory/1414 Ave. of the Americas, New York, NY 212-832-2343
Kramer, Joan & Assoc/720 Fifth Ave, New York, NY 212-224-1758
 Ron Botier, (P), John Brooks, (P), David Cornwell, (P), Tom DeSanto, (P), Clark Dunbar, (P), John Lawlor, (P), Tom Leighton, (P), Frank Moscati, (P), Jeff Perkell, (P), John Russell, (P), Ken Whitmore, (P), Bill Wilkinson, (P)
Kreis, Ursula G/63 Adrian Ave, Bronx, NY 212-562-8931
 Stephen Green-Armytage, (P), Bruce Pendleton, (P)
Krongard, Paula/1 Riverview Dr W, Upper Montclair, NJ 201-783-6155
 Skip Hine, (P)

L Lada, Joe/330 E 19th St, New York, NY 212-254-0253
 George Hausman, (P)
Lafayette-Nelson & Assoc/64 W 15th St, New York, NY 212-989-7059
Lakin, Gaye/345 E 81st St, New York, NY 212-861-1892
Lamont, Mary/200 W 20th St, New York, NY 212-242-1087
LANDER, JANE ASSOC/333 E 30TH ST, NEW YORK, NY (P 52,53) **212-679-1358**
 Francois Cloteaux, (I), Patrick Couratin, (I), Phil Franke, (I), Mel Furukawa, (I), Helen Guetary, (I), Cathy Culp Heck, (I), Saul Lambert, (I), Dan Long, (I), Jack Pardue, (I), Frank Riley, (I),
Lane Talent Inc/104 Fifth Ave, New York, NY 212-861-7225
Larkin, Mary/503 E 72nd St, New York, NY 212-861-1188
Lavaty, Frank & Jeff/50 E 50th St #5, New York, NY 212-355-0910
 John Berkey, (I), Tom Blackshear, (I), Jim Butcher, (I), R Crosthwaite, (I), Don Dally, (I), Bernie D'Andrea, (I), Domenick D'Andrea, (I), Roland Descombes, (I), Christine Duke, (I), Gervasio Gallardo, (I), Martin Hoffman, (I), Stan Hunter, (I), Chet Jezierski, (I), David McCall Johnston, (I), Mart Kunstler, (I), Lemuel Line, (I), Robert LoGrippo, (I), Don Maitz, (I), Mara McAfee, (I), Darrell Millsap, (I), Carlos Ochagavia, (I)
Lee, Alan/33 E 22nd St, NY, NY 212-673-2484
 David Haggerty, (P), Werner Kappes, (I)
Lee, Barbara/307 W 82nd St, New York, NY 212-724-6176
 Russell Kirk, (P)
LEFF, JERRY/342 MADISON AVE #949, NEW YORK, NY (P 54,55) **212-697-8525**
 Franco Accornero, (I), James Barkley, (I), Ken Barr, (I), Tom Beecham, (I), Mel Crair, (I), Ron DiCianne, (I), Bryant Eastman, (I), Charles Gehm, (I), Penelope Gottlieb, (I), Steve Gross, (I), Gary Lang, (I), Jeff Leedy, (I), Ron Lesser, (I), Dennis Magdich, (I), Saul Mandel, (I), Michael Nicastre, (I), John Parsons, (I), Bill Selby, (I), Marie Tobre, (I), Jon Townley, (I), James Woodend, (I)

Legrand, Jean Yves & Assoc/41 W. 84th St., New York, NY 212-724-5981
 Robert Farber, (P), Peter Sato, (I)
Leonian, Edith/220 E 23rd St, New York, NY 212-989-7670
Lerman, Gary/40 E 34th St #203, New York, NY 212-683-5777
 John Bechtold, (P)
Levy, Leila/4523 Broadway #7G, New York, NY 212-942-8185
Lichtman, Cathy/5 E 17th St 8th flr, New York, NY 212-736-2639
Lingren, Patricia/194 Third Ave, New York, NY 212-475-0440
Locke, John Studios Inc/15 E 76th St, New York, NY 212-288-8010
 Ernst Aebi, (I), Walter Allner, (I), John Cayea, (I), John Clift,
 (I), Laura Cornell, (I), Oscar DeMejo, (I), Jean-Pierre
 Desclozeaux, (I), Blair Drawson, (I), James Endicott, (I),
 Richard Erdoes, (I), Jean Michel Folon, (I), Michael
 Foreman, (I), Andre Francois, (I), George Giusti, (I), Edward
 Gorey, (I), Peter Lippman, (I), Sam Maitin, (I), Richard
 Oden, (I), William Bryan Park, (I), David Passalacqua, (I),
 Colette Portal, (I), Robert Pryor, (I), Fernando Puigrosado,
 (I), Hans-Georg Rauch, (I), Ronald Searle, (I), Tim, (I),
 Roland Topor, (I)
Loshe, Diane/10 W 18th St, New York, NY 212-691-9920
Lott, George/60 E 42nd St #411, New York, NY 212-687-4185
 Ted Chambers, (I), Tony Cove, (I), Jim Dickerson, (I), David
 Halpern, (I), Ed Kurtzman, (I), Marie Peppard, (I), Steen
 Svensson, (P)
Lundgren/45 W 60th St, New York, NY 212-399-0005
Lurman, Gary/117 E 31 St, New York, NY 212-533-1422

M

Mace, Zelda/1133 Broadway, New York, NY 212-929-7017
Madris, Stephen/445 E 77th St, New York, NY 212-744-6668
 Gary Perweiler, (P)
Mandel, Bette/265 E 66th St, New York, NY 212-737-5062
Mann, Ken/313 W 54th St, New York, NY 212-245-3192
Mann, William Thompson/219 W 71st St, New York, NY 212-228-0900
Marchesano, Frank/Cosimo Studio/35 W 36th St,
 New York, NY 212-563-2730
Marino, Frank/35 W 36th St, New York, NY 212-563-2730
Mariucci, Marie A/c/o R&V Studio 32 W 39th St, New York, NY 212-944-9590
Marks, Don/50 W 17th St, New York, NY 212-807-0457
Mars, Sallie/30 E. 38th St., New York, NY 212-684-2828
 Don Hamerman, (P), Layman/Newman, (P), Nobu, (P),
 Peter Ross, (G) Don Hamerman, (P), Layman/Newman,
 (P), Nobu, (P), Peter Ross, (G)
Marshall, Mel/40 W 77th St, New York, NY 212-877-3921
Marshall, Winifred/2350 Broadway #625, New York, NY 212-674-1270
 Richard Dunkley, (P), Doug Hopkins, (P), James A Spilman,
Mason, Kathy/101 W 18th St 4th Fl., New York, NY 212-675-3809
Masucci, Myrna/Image Bank/633 Third Ave., New York, NY 212-953-0303
Mathias, Cindy/7 E 14th St, New York, NY 212-741-3191
MATTELSON, JUDY/88 LEXINGTON AVE,
NEW YORK, NY (P 83,130,148) 212-684-2974
 Karen Klugein, (I), Marvin Mattelson, (I), Gary Viskupic, (I)
Mautner, Jane/85 Fourth Ave, New York, NY 212-777-9024
McVey, Meg/54 W 84th St #2F, New York, NY 212-362-3739
 Barbra Walz, (P)
Media Management Corp/12 W 27th St, New York, NY 212-696-0880
Melsky, Barney/157 E 35th St, New York, NY 212-532-3311
Mendelsohn, Richard/353 W 53rd St #1W, New York, NY 212-682-2462
MENDOLA, JOSEPH/420 LEXINGTON AVE,
NEW YORK, NY (P 30-33) 212-986-5680
 Paul Alexander, (I), Robert Berrar, (I), Dan Brown, (I), Jim
 Campbell, (I), Carl Cassler, (I), Joe Csatari, (I), Jim Dye, (I),
 John Eggert, (I), Peter Fiore, (I), Antonio Gabriele, (I), Tom
 Gala, (I), Hector Garrido, (I), Mark Gerber, (I), Ted Giavis,
 (I), Dale Gustavson, (I), Chuck Hamrick, (I), Richard Harvey,
 (I), Dave Henderson, (I), John Holmes, (I), Mitchell Hooks,
 (I), Joel Iskowitz, (I), Bob Jones, (I), Stuart Kaufman, (I),
 Michael Koester, (I), Richard Leech, (I), Dennis Lyall, (I),
 Jeffery Mangiat, (I), Goeffrey McCormack, (I), Ann Meisel,
 (I), Ted Michner, (I), Mike Mikos, (I), Jonathon Milne, (I),
 Wally Neibart, (I), Tom Newsome, (I), Mike Noome, (I),
 Chris Notarile, (I), Kukalis Romas, (I), Mort Rosenfeld, (I),

 Greg Rudd, (I), Rob Sauber, (I), David Schleinkofer, (I),
 Mike Smollin, (I), Kip Soldwedel, (I), John Solie, (I), George
 Sottung, (I), Joel Spector, (I), Cliff Spohn, (I), Jeffrey
 Terreson, (I), Mark Watts, (I), Allen Welkis, (I), Ben
 Wohlberg, (I), Ray Yeldman, (I)
Michalski, Ben/118 E 28th St, New York, NY 212-683-4025
Miller, Marcia/60 E 42nd St #648, New York, NY 212-682-2555
 Monica Incisa, (I), Donald Kahn, (I), Yourcorporatelook, (G),
 Johanna Sherman, (I)
MINTZ, LES/111 WOOSTER ST, #PHC,
NEW YORK, NY (P 34,35) 212-925-0491
 Robert Burger, (I), Hovik Dilakian, (I), Amy Hill, (I),
 Susannah Kelly, (I), George Masi, (I), Tina Mercie, (I),
 Kirsten Soderlind, (I), Dennis Ziemienski, (I),
Mohan, Jim/160 W 46th St, New York, NY 212-247-2777
 Ben Fernandez, (P), Frank Giraldi, (P), Hedi Tahar, (P)
Moretz, Eileen P/141 Wooster St, New York, NY 212-254-3766
MORGAN, VICKI/194 THIRD AVE, NEW YORK, NY (P 97,120, 212-475-0440
139,146,151,167,173,184,185,190)
 Joe Heiner, (I), Kathy Heiner, (I), Tim Lewis, (I), Wayne
 McLoughlin, (I), Emanuel Schongut, (I), Nancy Stahl, (I),
 Williardson/White, (I), Brian Zick, (I)
Morse, Lauren/78 Fifth Ave., New York, NY 212-807-1551
 Alan Zenreich, (P)
Mosel, Sue/310 E 46th St, New York, NY 212-599-1806
 Bill Connors, (P), Mark Platt, (P)
Moskowitz, Marion/315 E 68th St, New York, NY 212-472-9474
 Diane Teske Harris, (I), Arnie Levin, (I), Geoffrey Moss, (I),
 Marty Norman, (I), Gary Ruddell, (I)
MOSS, EILEEN/333 W 49TH ST #3J,
NEW YORK, NY (P 56,57) 212-980-8061
 Kari Brayman, (I), Mike Davies, (I), Scott Pollack, (I), Phillip
 Salaverry, (P), Norm Siegel, (I),
Moss, Susan/29 W 38th St, New York, NY 212-354-8024
Mulvey Associates/1457 Broadway #1001, New York, NY 212-840-8223
 Dick Amundsen, (I), Gil Cohen, (I), Olivia Cole, (I), Bill
 Colrus, (I), Art Cumings, (I), Lou Cunette, (I), Ric DelRossi,
 (I), John Dyess, (I), Len Epstein, (I), Ethel Gold, (I), Leigh
 Grant, (I), Les Gray, (I), Meryl Henderson, (I), Phil Jones,
 (I), John Killgrew, (I), Bob Kray, (I), Ken Longtemps, (I),
 Rebecca Merrilees, (I), John Murphy, (I), Tom Noonan, (I),
 Michael O'Reilly, (I), Taylor Oughton, (I), Tom Powers, (I),
 Don Pulver, (I), Herb Reed, (I), Jose Reyes, (I), Diane
 Shapiro, (I), Kyuzo Tsugami, (I), Ron Wing, (I), Jim
 Woodend, (I)

NO

Newborn, Milton/135 E 54th St, New York, NY 212-421-0050
 Stephen Alcorn, (I), Braldt Bralds, (I), Mark English, (I),
 Robert Giusti, (I), Dick Hess, (I), Mark Hess, (I), Edward
 Sorel, (I), Simms Taback, (I), David Wilcox, (I)
OPTICALUSIONS/9 E 32ND ST, NEW YORK, NY (P 58) 212-688-1080
 Stephen Durke, (I), George Kanelous, (I), Rudy Laslo, (I),
 Kenvin Lyman, (I), Roger Metcalf, (I), George I Parish, (I),
 Penelope, (I), Mike Robins, (I), Terry Ryan, (I), Ed
 Scarisbrick, (I), Bruce Young, (I)
O'Rourke, Gene/200 E 62nd St, New York, NY 212-935-5027
 Warren Flagler, (P), Sam Haskins, (P), Douglas Kirkland,
 (P), Robert Kligge, (P), James Long, (P), Smith-Garner, (P),
 William Sumner, (P), John Thornton, (P), Alexis Urba, (P),
 Rob VanPetten, (P), Balfour Walker, (P), John Zimmerman, (P)

PQ

Palevitz, Bob/333 E 30th St, New York, NY 212-684-6026
Palmer-Smith, Glenn Assoc/160 Fifth Ave, New York, NY 212-807-1855
 Claude Mougin, (P), John Stember, (P)
PENNY & STERMER GROUP/114 E 32ND ST,
NEW YORK, NY (P 59-65) 212-685-2770
 Bob Alcorn, (I), Manos Angelakis, (I), Deborah Bazzel, (I),
 Ron Becker, (I), Julian Graddon, (I), Rich Grote, (I), Michael
 Kanarek, (I), Andy Lackow, (I), Alan Lynch, (I), Steve Shub,
 (I), Page Wood, (I)
Peretti, Linda/420 Lexington Ave., New York, NY 212-687-7392
Peters, Barbara/280 Madison Ave, Rm 1103, New York, NY 212-683-2830

*Leslie Harris, (P), Thomas Hooper, (P), Studio McLaughlin,
(P), Ron Morecraft, (P), Leonard Nones, (P), Bradley
Olman, (P)*

Plessner International/95 Madison Ave, New York, NY	212-686-2444
Powers, Elizabeth/1414 Ave. of the Americas, New York, NY	212-832-2342
Quercia, Mat/78 Irving Pl, New York, NY	212-477-4491
The Quinlan Artwork Co/330 E 49th St, New York, NY	212-867-0930

R

RAPP, GERALD & CULLEN INC/108 E. 35TH ST #1, NEW YORK, NY (P 10)	**212-889-3337**
Ray, Marlys/350 Central Pk W, New York, NY	212-222-7680
Reese, Kay Assoc/156 Fifth Ave #1107, New York, NY	212-924-5151

*Jonathan Atkin, (P), Lee Balterman, (P), Lev Borodulin, (P),
Richard Checani, (P), Gerry Cranham, (P), Scott C Dine,
(P), Claudio Edinger, (P), Ashvin Gatha, (P), Peter Gullers,
(P), Arno Hammacher, (P), Jay Leviton, (P), George Long,
(P), George Love, (P), Lynn Pelham, (P), Richard Saunders,
(P), T Tanuma, (P), Mark Wexler, (P)*

Reid, Pamela/420 E 64th St, New York, NY	212-832-7589

*Sandy Hill, (S), Bert Stern, (P), Sandy Hill, (S), Bert Stern,
(P)*

Renard, Madeline/501 Fifth Ave #1407, New York, NY	212-490-2450

*Chas Wm Bush, (P), John Collier, (I), Etienne Delessert, (I),
Tim Girvin, (I), Kunio Hagio, (I), Lamb-Hall, (P), Rudy
Legname, (P), Al Pisano, (I), Robert Rodriguez, (I), Michael
Schwab, (I), Jozef Sumichrast, (I), Kim Whitesides, (I)*

Rhodes, Lela/327 West 89 St, New York, NY	212-787-3885
Riley, Catherine/12 E 37th St, New York, NY	212-532-8326
Riley, Ted/215 E 31st St, New York, NY	212-684-3448

*Zevi Blum, (I), William Bramhall, (I), David Gothard, (!),
James Grashow, (I), Paul Hogarth, (I), Edward Koren, (I),
Pierre Le-Tan, (I), Joseph Mathieu, (I), Roy McKie, (I),
Robert Parker, (I), Cheryl Peterson, (I), J J Sempe, (I),
Patricia Wynne, (I)*

Rivelli, Cynthia/303 Park Ave S, New York, NY	212-254-0990
Rosenberg, Arlene/200 E 16th St, New York, NY	212-289-7701
Rothenberg, Judith A/123 E 75th St, New York, NY	212-861-7745
Rubin, Elaine R/301 E 38th St #14E, New York, NY	212-725-8313
Rudoff, Stan/271 Madison Ave, New York, NY	212-679-8780

S

S. I. Artists/43 E. 19th St, New York, NY	212-254-4996
SPAR/PO Box 845, FDR Sta, New York, NY	212-490-5895
Sacramone & Valentine/302 W 12th St, New York, NY	212-929-0487

*Stephen Ladner, (P), Tohru Nakamura, (P), John Pilgreen,
(P), Robin Saidman, (P), Gianni Spinazzola, (P)*

Salomon, Allyn/271 Madison Ave #207, New York, NY	212-684-5586
Samuels, Rosemary/39 E 12th St, New York, NY	212-477-3567
Sander, Vicki/48 Gramercy Park North #3B, New York, NY	212-674-8161
Savello, Denise/381 Park Ave S, New York, NY	212-730-1188
Sawyer/Nagakura & Assoc Inc/36 W 35th St, New York, NY	212-563-1982
Schecter Group, Ron Long/430 Park Ave, New York, NY	212-752-4400
Schickler, Paul/135 E 50th St, New York, NY	212-355-1044
Schon, Herb/1240 Lexington Ave, New York, NY	212-249-3236
Schub, Peter & Robert Bear/37 Beekman Pl, New York, NY	212-246-0679

*Peter Hill Beard, (P), Robert Freson, (P), Alexander
Lieberman, (P), Gordon Parks, (P), Irving Penn, (P), Rico
Puhlmann, (P), Snowdon, (P), Albert Watson, (P)*

SEIGEL, FRAN/515 MADISON AVE, NEW YORK, NY (P 66-68)	**212-486-9644**

*Leslie Cabarga, (I), Cheryl Cooper, (I), Kinuko Craft, (I),
Peter Cross, (I), Earl Keleny, (I)*

Shamilzadeh, Sol/1155 Broadway 3rd Fl, New York, NY	212-532-1977

The Strobe Studio, (P)

Shapiro, Elaine c/o Doyle Reporting/369 Lexington Ave, New York, NY	212-867-8220
Sheer, Doug/29 John St, New York, NY	212-732-4216
Shepherd, Judith/186 E 64th St, New York, NY	212-838-3214

Barry Seidman, (P)

Shostal Assoc/60 E 42nd St, New York, NY	212-687-0696
Sigman, Joan/336 E 54th St, New York, NY	212-832-7980

Robert Goldstrom, (I), John H Howard, (I), Jeff Seaver, (I)

Simon, Debra/527 Madison Ave # 310, New York, NY	212-421-5703
Sims, Jennifer/1150 Fifth Ave, New York, NY	212-860-3005

Chris Collins, (P), Shorty Wilcox, (P)

Slocum, Linda/15 W. 24th St. 11th fl., New York, NY	212-243-0649
Slome, Nancy/125 Cedar St, New York, NY	212-227-4854

Joe Morello, (P)

Smith, Emily/30 E 21st St, New York, NY	212-674-8383
Smith, Karen/202 E 42nd St, New York, NY	212-490-0355

Didier Dorot, (P)

Smith, Rose/400 E 56th St, #19D, New York, NY	212-758-8711

Peter Sagara, (P)

Solomon, Richard/121 Madison Ave, New York, NY	212-683-1362

*Stanislaw Fernandes, (I), Vivienne Flesher, (I), Mark Edward
McCandlish, (I), Lev Nisnevich, (P), Shelly Thornton, (I)*

Spencer, Carlene/462 W 23rd St, New York, NY	212-924-2498
Steiner, Susan/130 E. 18th St., New York, NY	212-673-4704
Stermer, Carol Lee/114 E 32nd St, New York, NY	212-685-2770
Stevens, Norma/1075 Park Ave, New York, NY	212-427-7235

Hiro, (P)

Stockland, Bill/7 W 16th St, New York, NY	212-242-7693

Laurence Bartone, (P)

Susse, Ed/40 E 20th St, New York, NY	212-477-0674

T

Therese, Jane/6 W 20th St, New York, NY	212-675-8067

Nancy Brown, (P)

Thomas, Brenda & Assoc/127 W 79th St, New York, NY	212-873-7236
Tise, Katherine/200 E 78th St, New York, NY	212-570-9069

*Raphael Boguslav, (I), John Burgoyne, (I), Bunny Carter, (I),
Cheryl Roberts, (I)*

Tralono, Katrin/144 W 27th St, New York, NY	212-255-1976

UV

Umlas, Barbara/131 E 93rd St, New York, NY	212-534-4008

Hunter Freeman, (P)

Van Arnam, Lewis/154 W 57th St, New York, NY	212-541-4787

Paul Amato, (P), Mike Reinhardt, (P)

Van Orden, Yvonne/119 W 57th St, New York, NY	212-265-1223
Vollbracht, Michelle/225 E 11th St, New York, NY	212-475-8718

WYZ

Wainscott, Barbara/321 E 54th St, New York, NY	212-753-1249
Walker, Eleanora/120 E 30th St, New York, NY	212-689-4431
Walker, Nancy/160 E 65th St #18C, New York, NY	212-744-3608
Wasserman, Ted/331 Madison Ave #1007, New York, NY	212-867-5360
Watterson, Libby/350 E 30th St, New York, NY	212-696-1461

Lee Balterman, (P)

Wein, Gita/320 E 58th St, New York, NY	212-759-2763
Weissberg, Elyse/299 Pearl St, New York, NY	212-406-2566
West, Beatrix/485 Fifth Ave. #407, New York, NY	212-986-2110
Wheeler, Paul/50 W 29th St, #11W, New York, NY	212-696-9832

*Enrico Ferorelli, (P), John McGrail, (P), Michael Melford,
(P), Bill Pierce, (P), Steven Smith, (P), Peter Tenzer, (P)*

Williamson, Jack/1414 Ave. of the Americas, New York, NY	212-832-2343
Yellen, Bert & Assoc/838 Ave of Americas, New York, NY	212-889-4701

Gordon Munro, (P)

Zanetti, Lucy/139 Fifth Ave, New York, NY	212-473-4999

NORTHEAST

AB

Ackermann, Marjorie/2112 Goodwin Lane, North Wales, PA	215-646-1745
Bancroft, Carol & Friends/185 Goodhill Rd., Weston, CT	203-226-7674

*Judith Cheng, (I), Bernie Colonna, (I), Jim Cummins, (I),
Alan Daniel, (I), Kees DeKiefte, (I), Andrea Eberbach, (I),
Fuka, (I), Jackie Geyer, (I), Fred Harsh, (I), Dennis
Hockerman, (I), Ann Iosa, (I), Doug Jamieson, (I), Laurie
Jordan, (I), Mila Lazarevich, (I), Karin Lidbeck, (I), Suen
Lindman, (I), Karen Loccisano, (I), Al Lorenz, (I), Bob
Masheris, (I), Yoshi Miyake, (I), Daryl Moore, (I), Nancy
Munger, (I), Rodney Pate, (I), Larry Raymond, (I), Jenny
Rutherford, (I), Judy Sakaguchi, (I), Monica Santa, (I),
Miriam Schottland, (I), Blanche Sims, (I), Sally Springer, (I),
Clifford Timm, (I), Linda Boehm Weller, (I), Debby Young, (I)*

Birenbaum, Molly/7 Williamsburg Dr, Cheshire, CT	203-272-9253
Bloch, Peggy J/464 George Rd #5A, Cliffside Park, NJ	201-943-9435
Brown, Jill/911 State St, Lancaster, PA	717-393-0918

REPRESENTATIVES CONT'D.

Please send us your additions and updates.

CD
Callahan, Jim/A & M Resources/US Rte 202, Peterborough, NH — 603-924-6168
CAMP, WOODFIN INC/925 1/2 F ST NW, WASHINGTON, DC (P 240) — **202-638-5705**
Chandoha, Sam/RD 1 PO Box 287, Annandale, NJ — 201-782-3666
Crandall, Robert/Saunders, Marvin Assoc/516 West Boston Post Rd, Mamaroneck, NY — 914-381-4400
Curtin, Susan/323 Newbury St, Boston, MA — 617-536-6600
D'Aquino, Connie/Rt 22, PO Box 64, Bedford Village, NY — 914-234-3123
Donaldson, Selina/118 Lowell St, Arlington, MA — 617-646-1687
Dunn, Tris/20 Silvermine Rd, New Canaan, CT — 203-966-9791

GHI
Gidley, Fenton/43 Tokeneke Rd, Darien, CT — 212-772-0846
 Mark Segal, (P)
Glover, Cynthia/103 E Read St, Baltimore, MD — 301-385-1716
Gruder, Jean/90 Park Ave, Verona, NJ — 201-239-7088
Haas, Ken/717 N Fifth St, Reading, PA — 215-374-4431
Hopkins, Nanette/18 North New St, Westchester, PA — 215-431-3240
Hubbell, Marian/99 East Elm St, Greenwich, CT — 203-629-9629
Imlay, Kathy/41 Upton St, Boston, MA — 617-262-5388

KL
Kell & Associates/1110 Fidler Ln, #710, Silver Spring, MD — 202-585-0700
KENNEY, ELLA/229 BERKELEY #52, BOSTON, MA (P 28,29) — **617-266-3858**
 Bente Adler, (I), Wilbur Bullock, (I), Anna Davidian, (I), Eaton & Iwen, (R), Ralph King, (P)
Kessler, Linda/PO Box 1352, Princeton, NJ — 609-466-3718
Lubbe, Francis/PO Box 215, Stevenson, MD — 301-583-9147

MN
McNamara, Paula B/182 Broad St, Wethersfield, CT — 203-563-6159
 Jack McConnell, (P)
Metzger, Rick/186 South St, Boston, MA — 617-426-2290
Morgan, Wendy/5 Logan Hill Rd, Northport, NY — 516-757-5609
 Fred Schrier, (I), Mary Selfridge, (I), Art Szabo, (P), Wozniaks, (I)
Nealy, Jesse/Conant Valley Rd, Pound Ridge, NY — 914-764-5981
 Bob Baxter, (I), Jon & Tony Gentile, (I), Barney Plotkin, (I), Benjamin Stahl, (I), Herb Tauss, (I)
Nichols, Eva/1241 University Ave, Rochester, NY — 716-275-9666

OPR
Olsen, James A/c/o Smith, Tower Dr, Darien, CT — 203-655-2899
Photo-Graphic Agency/58 Pine St, Malden, MA — 617-944-3166
Photogroup/5161 River Rd, Washington, DC — 301-652-1303
 Steve Little, (P), Lenny Rizzi, (P), Paul Eric Smith, (P), Barry Soorenko, (P)
Picture That, Inc/880 Briarwood, Newtown Square, PA — 215-353-8833
Radxevich Standke/15 Intervale Terr, Reading, MA — 617-944-3166
Ricci, Ron/201 King St, Chappaqua, NY — 914-238-4221

ST
Schooley & Associates/10 Highland Ave, Rumson, NJ — 201-530-1480
 Lorraine Dey, (I), Kevin Dougherty, (I), Geoffrey Gove, (I), William Laird, (I), Gary Smith, (I)
Schoon, Deborah/838 Columbia Ave, Lancaster, PA — 717-626-0296
Smith, Wayne R./The Penthouse, 145 South St, Boston, MA — 617-426-7262
Stevens, Rick/925 Penn Ave, #404, Pittsburgh, PA — 412-765-3565
Ternay, Louise/119 Birch Ave, Bala Cynwyd, PA — 215-664-3761
 Bruce Blank, (P), Len Epstein, (I), Don Everhart, (I), Geri Grienke, (I), Peter Sasten, (G), Bill Ternay, (I), Kate Ziegler, (I)
Troussoff, Gail/925 1/2 F St NW, Washington, DC — 202-393-2658

UV
Unicorn Enterprises, Jean Gruder/90 Park Ave, Verona, NJ — 201-239-7088
Valen Assocs/PO Box 8, Westport, CT — 203-227-7806
 George Booth, (C), Whitney Darrow, (C), Elvin Dedini, (C), Joe Farris, (C), William Hamilton, (C), Bud Handelsman, (I), Stan Hunt, (C), Anatol Kovarsky, (C), Lee Lorenz, (C), Henry Martin, (C), Warren Miller, (C), Frank Modell, (C), George Price, (C), Mischa Richter, (C), Charles Saxon, (C), Jim Stevenson, (C), Henry Syverson, (C), Bob Weber, (C), Gahan Wilson, (C), Rowland Wilson, (I), Bill Woodman, (C), Bill Ziegler, (I)

W
Waldron, Diana/1411 Hollins St, Baltimore, MD — 301-566-1222
Wolf, Deborah/731 N 24th St, Philadelphia, PA — 215-928-0918
 John Collier, (I), Paul Dodge, (I), Dan Forer, (P), Robert Halalski, (P), Ron Lehew, (I), Bill Margerin, (I), Bruce McAllister, (P), Fran Orlando, (P), Bob Schenker, (I), Jim Sharpe, (I), Charles Weckler, (P), Frank Williams, (I), Liz Wuillerman, (P)
Worral, Dave/125 S 18th St, Philadelphia, PA — 215-567-2881

SOUTHEAST

ABCF
Aldridge, Donna/1154 #2 Briarcliff NE, Atlanta, GA — 404-872-7980
 Trevor Irwin, (I)
Ayres, Beverly/PO Box 11531, Atlanta, GA — 404-262-2740
Beck, Susanne/2721 Cherokee Rd, Birmingham, AL — 205-871-6632
Burnett, Yolanda/559 Dutch Vall Rd, Atlanta, GA — 404-873-5858
 Charlie Latham, (P)
Couch, Tom/1164 Briarcliff Rd, NE #2, Atlanta, GA — 404-872-5774
 Richard Hoflich, (P), Warren Weber, (I)
Fink, Duncan/437 S Tryon St, Charlotte, NC — 704-377-4217

JLM
Jourdan, Carolyn/4222 Inverrary Blvd, Lauderhill, Fl — 305-350-5596
Linden, Tamara/One Park Place #120 1900 E, Atlanta, GA — 404-355-0729
 Joseph M Ovies, (I), Charles Passarelli, (I), Larry Tople, (I)
McGee, Linda/1816 Briarwood Industrial Ct, Atlanta, GA — 404-633-1286
McLean Represents/401 W Peachtree St NW #3050, Atlanta, GA — 404-221-0700
 Jack Jones, (I), Martin Pate, (I), Steve Spetzeris, (I), Warren Weber, (I)

PQ
The Phelps Agency/32 Peachtree St NW #201, Atlanta, GA — 404-524-1234
 Tom McCarthy, (P), Tommy Thompson, (P), Bill Weems, (P)
Poland, Kiki/848 Greenwood Ave NE, Atlanta, GA — 404-875-1363
Quinlan, Kelly/6053 Tammy Dr, Alexandria, VA — 703-971-2584
 Jamie Phillips, (P)

ST
Silva, Naomi/100 Colony Square (n) 200, Atlanta, GA — 404-892-8314
 Joe DiNicola, (I), Rob Horn, (G), Christy Sheets Mull, (I), Gary Penca, (I), Don Sparks, (P)
Tamara Inc/One Park Place #120, Atlanta, GA — 404-355-0729
 Tom Fleck, (I), Joseph M Ovies, (I)
Torres, Martha/1715 Burgundy, New Orleans, LA — 504-895-6570

W
Watson, Beth/1925 College Ave, Atlanta, GA — 404-371-8086
Wells, Susan/51434 Timber Trails, Atlanta, GA — 404-255-1430
Wexler, Marsha Brown/6108 Franklin Park Rd, McLean, VA — 703-241-1776
Williams, Phillip/1106 W Peachtree St, #201, Atlanta, GA — 404-873-2287
 Jamie Cook, (P), Stan Hobbs, (I), Rick Lovell, (I), Bill Mayer, (I), David McKelvey, (I), John Robinette, (I)
Wooden Reps/503 Ansley Villa Dr, Atlanta, GA — 404-892-6303
 Ian Greathead, (I), Mike Lester, (I), Chris Lewis, (I), Ted Rodgers, (P), Joe Saffold, (P), Bruce Young, (I), Cooper-Copeland, (I)

MIDWEST

AB
Appleman, Norm/679 E Mandoline, Madison Hts, MI — 313-589-0066
 Art Hansen, (P), Jerry Kolesar, (P), Larry Melkus, (P), Glenn Schoenbach, (P)
Asad, Susan/420 W Huron, Chicago, IL — 312-266-7540
Ball, John/203 N Wabash, Chicago, IL — 312-332-6041
 Christy Sheets Mull, (I), Joe Saffold, (I), Janie Wright, (I)
Berk, Ida/1350 N La Salle, Chicago, IL — 312-944-1339
Berntsen, Jim/520 N Michigan Ave, Chicago, IL — 312-822-0560
 Jim Conahan, (I), Denis Johnson, (I), Diana Magnuson, (I), Simeon Marshall, (P), Leonard Morgan, (P), Sam Thiewes, (I), Jim Turgon, (P)
Blanchette, Dan/645 N Michigan Ave, Chicago, IL — 312-280-1077

Brenner, Harriet/660 W Grand Ave, Chicago, IL 312-243-2730
Buermann, Jeri/321 N 22nd St, St Louis, MO 314-231-8690

C

Chauncey, Michelle/1029 N Wichita #13 & 15, Wichita, KS 316-262-6733
Christell, Jim & Assoc/307 N Michigan Ave, Chicago, IL 312-236-2396
 Michel Ditlove, (P), Ron Harris, (P), Sinnott/Assoc, (F),
 Michel Ditlove, (P), Ron Harris, (P), Sinnott/Assoc, (F)
Clausen, Bo/643 W Arlington Pl, Chicago, IL 312-871-1242
Cohen, Janice/117 North Jefferson, Chicago, IL 312-454-0680
Coleman, Woody/1034 Main Ave, Cleveland, OH 216-621-1771
Conahan-Berntsen/520 N Michigan Ave, Chicago, IL 312-822-0560
 Jim Conahan, (I), Denis Joanson, (I), Diana L Magnuson, (I),
 Josef Sumichrast, (I), Sam Thiewes, (I), Jim Turgeon, (I)

EF

Emerich Studios/300 W I9th Terr, Kansas City, MO 816-474-8888
Erdos, Kitty/210 W Chicago, Chicago, IL 312-787-4976
Fiat, Randy/208 W Kinzie, Chicago, IL 312-467-1430
Fleming, Laird Tyler/1 Memorial Dr., St. Louis, MO 314-982-1700
 John Bilecky, (P), Willardson & White, (P)
Frost, Brent/4037 Queen Ave S, Minneapolis, MN 612-920-3864

H

Hanson, Jim/6959 N Hamilton, Chicago, IL 312-338-4344
Harlib, Joel/405 N Wabash #3203, Chicago, IL 312-329-1370
 Bob August, (I), John Casado, (I), Peter Elliott, (P), Ignacio
 Gomez, (I), Barbara Higgins-Bond, (I), Richard Leech, (I),
 Tim Lewis, (I), Peter Lloyd, (I), David McMacken, (I),
 Midocean, (F), Claude Mougin, (P), Dennis Mukai, (I), Joe
 Ovies, (I), Tony Petrocelli, (P), Todd Shorr, (I), Kim
 Whitesides, (I), Bruce Wolfe, (I), Bob Ziering, (I)
Hartig, Michael/3620 Pacific, Omaha, NB 402-345-2164
Harwood, Tim/646 N Michigan, Chicago, IL 312-828-9117
Hedrich-Blessing/11 W Illinois, Chicago, IL 312-321-1151
Higgens Hegner Genovese Inc/510 N Dearborn St, Chicago, IL 312-644-1882
Horton, Nancy/939 Sanborn, Palatine, IL 312-934-8966
Hull, Scott/2154 Willowgrove Ave, Dayton, OH 513-298-0566
 Tracy Britt, (I), Andy Buttram, (I), Richard Cohen, (I), David
 Groff, (I), John Maggard, (I), Ernest Norcia, (I), Mark Riedy,
 (I), Don Vanderbeck, (I)

KL

Kamin, Vince/42 E Superior, Chicago, IL 312-787-8834
 Jan Cobb, (P), Nicholas DeSciose, (P), Lee Duggin, (I), Dick
 Durrance, (P), Dennis Gray, (P), Hans Hoffman, (P), Dave
 Jordano, (P), Dan Morrill, (P), Michael Pruzan, (P), Steve
 Steigman, (P), Roy Volkman, (P)
Kapes, Jack/218 E Ontario, Chicago, IL 312-664-8282
 Jerry Friedman, (P), Carl Furuta, (P), Klaus Lucka, (P), Dan
 Romano, (I), Nicolas Sidjakov, (G)
Kezelis, Elena/215 W Illinois, Chicago, IL 312-644-7108
Klemp, O.J./311 Good Ave., Des Plaines, IL 312-297-5447
Koralik, Connie/26 E Huron, Chicago, IL 312-944-5680
 Robert Keeling, (P)
Lakehomer & Assoc/307 N Michigan, Chicago, IL 312-236-7885
 Tom Petroff, (P), Fredric Stein, (P)
Lasko, Pat/452 N Halsted, Chicago, IL 312-243-6696
Linzer, Jeff/4001 Forest Rd, Minneapolis, MN 612-926-4390

M

McManus, Mike/3423 Devon Rd, Royal Oak, MI 313-549-8196
McMasters, Deborah/157 W Ontario, Chicago, IL 312-943-9007
McNamara Associates/1250 Stephenson Hwy, Troy, MI 313-583-9200
 Max Alterruse, (I), Gary Ciccarelli, (I), Garry Colby, (I),
 Hank Kolodziej, (I), Chuck Passarelli, (I), Tony Randazzo,
 (I), Gary Richardson, (I), Dick Scullin, (I), Don Wieland, (I)
McNaughton, Toni/230 N Michigan, Chicago, IL 312-782-8586
 Pam Haller, (P), Rodica Prato, (I), James B. Wood, (P)
Melkus, Larry/679 Mandoline, Madison Hts, MI 313-589-0066
 Bob Hughes, (P), Jerry Kolesar, (P), Glenn Schoenbach, (P)
Miller, Richard/743 N Dearborn, Chicago, IL 312-280-2288
Moore, Connie/1540 North Park, Chicago, IL 312-787-4422
 Richard Shirley, (F), Richard Shirley, (F)
MOSHIER & MALONEY/535 N MICHIGAN,
CHICAGO, IL (P 102,189) **312-943-1668**
 Nicolette Anastas, (I), Kenneth Call, (I), Steve Carr, (P),

 Dan Clyne, (I), Dan Coha, (P), Joyce Culkin, (I), Ron
 DiCianni, (I), Pat Dypold, (I), David Gaadt, (I), John
 Hamagami, (I), Rick Johnson, (I), Bill Kastan, (I), Roy
 Moody, (I), Colleen Quinn, (I), Paul Ristau, (I), Stephen
 Rybka, (I), Skidmore-Sahratian, (I), Ray Smith, (I), Kathy
 Spalding, (I), Al Stine, (I), Jim Trusilo, (I), George Welch, (I),
 John Youssi, (I)
Murphy, Sally/70 W Hubbard, Chicago, IL 312-751-2977
Myrna Hogan & Assoc/333 N Michigan, Chicago, IL 312-372-1616

NO

Nagan, Rita/1514 NE Jefferson St, Minneapolis, MN 612-788-7923
Newman, Richard/1866 N Burling, Chicago, IL 312-266-2513
Nicholson, Richard B/2310 Denison Ave, Cleveland, OH 216-398-1494
 J David Wilder, (P)
O'Farrel, Eileen/311 Good Ave, Des Plaines, IL 312-297-5447
Osler, Spike/2616 Industrial Row, Troy, MI 313-280-0640
 Madison Ford, (P), Rob Gage, (P), Rick Kasmier, (P), Jim
 Secreto, (P)

P

Parker, Tom/1750 N Clark, Chicago, IL 312-266-2891
Perne, Tom/9124 W Terrace Pl, Des Plaines, IL 312-635-0864
Photographic Services Owens-Corning/Fiberglass Towers,
 Toledo, OH 419-248-8041
 Jay Langlois, (P), Joe Sharp, (P)
Pike, Cindy/510 N Dearborn, Chicago, IL 312-644-1882
Platzer, Karen & Assoc/535 N Michigan Ave, Chicago, IL 312-467-1981
 Michael Caporale, (P), Steve Clay, (I), Don Getsug, (P), Jan
 Halt, (P), Dion Hitchings, (I), Robert Sacco, (P), Peter
 James Samerjan, (P)
POTTS, CAROLYN/2350 N CLEVELAND,
CHICAGO, IL (P 94,95,171,187,286) **312-935-1707**
 John Craig, (I), Gregory King, (I), Gregory Murphey, (P),
 Raymond Smith, (I), Bill Tucker, (P), Leslie Wolf, (I)
Potts, Vicki/139 N. Wabash, Chicago, IL 312-726-5678
 Tom Perne, (P), Bob Randall, (P), Kenneth Short, (P)

R

Rabin, Bill & Assoc/666 N Lake Shore Dr, Chicago, IL 312-944-6655
 Joel Baldwin, (P), Guy Billout, (I), Fred Brodersen, (P),
 Robert Giusti, (I), Lamb&Hall, (I), Joe Heiner, (I), Kathy
 Heiner, (I), Mark Hess, (I), Richard Hess, (I), Lynn St John,
 (P), Art Kane, (P), Rudy Legname, (P), Jay Maisel, (P), Eric
 Meola, (P), Richard Noble, (P), Robert Rodriguez, (I), John
 Thompson, (I), Pete Turner, (P), David Wilcox, (I), John
 Zimmerman, (P)
Ray, Rodney/405 N Wabash #3106, Chicago, IL 312-472-6550

S

Scarff, Signe/22 W Erie, Chicago, IL 312-266-8352
Schuck, John/614 Fifth Ave S, Minneapolis, MN 612-338-7829
Sell, Dan/233 E Wacker, Chicago, IL 312-332-5168
 Alvin Blick, (I), Wayne Carey, (I), Dick Flood, (I), Bill
 Harrison, (I), Gregory Manchess, (I), Bill Mayer, (I), Tim
 Raglin, (I), Theo Rudnak, (I), Mark Schuler, (I), R J Shay,
 (I), Phil Wendy, (I), Gene Wilkes, (I), John Zielinski, (I)
Sharrard, Chuck/1546 N Orleans, Chicago, IL 312-751-1470
Shulman, Salo/215 W Ohio, Chicago, IL 312-337-3245
Siegel, Gerald & Assoc/118 W Ohio, Chicago, IL 312-266-2323
 Bruce Rosmis, (P)
Skillicorn, Roy/233 E Wacker #29031, Chicago, IL 312-856-1626
 Tom Curry, (I), David Scanlon, (I)
Stephenson & Taylor/19 N Erie St, Toledo, OH 419-242-9170
 Tony Duda, (I), Richard Reed, (I)
Strickland, Joann/405 N Wabash #1003, Chicago, IL 312-467-1890
Strohmeyer, Pamela/929 Argyle St, Chicago, IL 312-271-6110

T

Timon, Clay & Assoc Inc/405 N Wabash, Chicago, IL 312-527-1114
 Bob Bender, (P), Michael Fletcher, (P), Larry Dale Gordon,
 (P), Don Klumpp, (P), Chuck Kuhn, (P), Barry O'Rourke,
 (P), Ron Pomerantz, (P), Al Satterwhite, (P), Michael
 Slaughter, (P)
Trinko, Genny/126 W Kinzie St, Chicago, IL 312-222-9242
Tuke, Joni/368 W Huron, Chicago, IL 312-787-6826
 Bill DeBold, (P), Ken Goldammer, (I), Dennis Magdich, (I),

John Welzenbach, (P)

WYZ

Walsh, Richard/1118 W Armytage, Chicago, IL — 312-944-4477
Wilde, Nancy/2033 N Orleans, Chicago, IL — 312-642-4426
Witmer, Bob c/o Norris McNamara/411 North LaSalle,
Chicago, IL — 312-944-4477
Yunker, Kit/3224 N Racine, Chicago, IL — 312-975-8116
Zann, Shelia/502 N Grove, Oak Park, IL — 312-386-2864

SOUTHWEST

ABC

Art Rep Inc/3511 Cedar Springs #4a, Dallas, TX — 214-521-5156
Assid, Carol/122 Parkhouse, Dallas, TX — 214-748-3765
Booster, Barbara/4001 Byrn Maur, Dallas, Tx — 214-373-4284
Callahan, Joe/224 N Fifth Ave, Phoenix, AZ — 602-248-0777
Kateri Dufault, (I), Tom Gerczynski, (P), Mike Gushock, (I), Mike Karbelnikoff, (P), Jon Kleber, (I), Marlowe Minnich, (I), Howard Post, (I), Dick Varney, (I), Balfour Walker, (P)
Campbell, Patty/1222 Manufacturing St, Dallas, TX — 214-330-0304
Corcoran, Arlene/224 N 5th Ave, Phoenix, AZ — 602-257-9509
Crowder, Bob/3603 Parry Ave, Dallas, TX — 214-823-9000
Mark Johnson, (P), Barry Kaplan, (P), Moses Olmoz, (P), Al Rubin, (P)

DFH

DiOrio, Diana/4146 Amherst St, Houston, TX — 713-669-0362
JoAnn Collier, (I), Ray Mel Cornelius, (I), Regan Dunnick, (I), Richard High, (I), Larry Keith, (I), Dennis Mukai, (I), Patrick Nagel, (I), Thom Ricks, (I), Randy Rogers, (I), Peter Stallard, (I), James Stevens, (I)
Fuller, Alyson/5610 Maple Ave, Dallas, TX — 214-688-1855
Hamilton, Chris/3900 Lemmon, Dallas, TX — 214-526-2050
Harris Management Technology/2900 N Loop West #700,
Houston, TX — 713-680-1888

LMP

Laurance Lynch/Repertoire/3317 Montrose #1130,
Houston, TX — 713-520-9938
Robert Lattorre, (P)
McCann/3000 Carlisle #202, Dallas, TX — 214-742-3138
Michael Doret, (I)
Production Services/1711 Hazard, Houston, TX — 713-529-7916
George Craig, (P), C Bryan Jones, (P), Thaine Manske, (P)

SVW

Smith, Linda/3511 Cedar Springs #4a, Dallas, TX — 214-521-5156
Vidal, Jessica/155 Pittsburg, Dallas, TX — 214-747-7766
Jerry Segrest, (P)
WILLARD, PAUL ASSOC/313 E THOMAS RD #205,
PHOENIX, AZ (P 69) — **602-279-0119**
Rick Kirkman, (I), Kevin MacPherson, (I), Nancy Pendleton, (I), Bob Peters, (I), Rick Rusing, (P), Wayne Watford, (I)

WEST

A

After Image Inc/6855 Santa Monica Blvd, Los Angeles, CA — 213-467-6033
Albertine, Dotti/202 A Westminster Ave, Venice, CA — 213-392-4877
Aline, France & Marsha Fox/4121 Wilshire Blvd,
Los Angeles, CA — 213-933-2500
Lou Beach, (I), Guy Billout, (I), Thomas Blackshear, (I), Ed Curvin, (I), Guy Fery, (I), Randy Glass, (I), Bret Lopez, (P), Steve Miller, (I), Bill Rieser, (I), Carl Savlicek, (I), Dave Scanlon, (I), Joe Spencer, (I), Joe Spencer, (A), Steve Sulen, (P), Ezra Tucker, (I), Kim Whitesides, (I), Bruce Wolfe, (I), James Wood, (P), Bob Zoell, (A)
Annika/8301 W Third St, Los Angeles, CA — 213-655-3527

B

Bob Morris/JCA/14019-A Paramount Ave., Los Angeles, CA — 213-633-4429
Bonar, Ellen/1925 S Beverly Glenn, Los Angeles, CA — 213-474-7911
Chuck Schmidt, (I)
Bowler, Ashley & Assoc/2194 Ponet Dr, Los Angeles, CA — 213-467-8200
Brady, Dana/125 N Doheny Dr, Los Angeles, CA — 213-275-4455
Bright & Agate Inc/8322 Beverly Rd, Los Angeles, CA — 213-658-8844
Brooks/6628 Santa Monica Blvd, Los Angeles, CA — 213-463-5678

Paul Gersten, (P), Bill Robbins, (P)
Brown, Dianne/732 N Highland, Los Angeles, CA — 213-464-2775
Burlingham, Tricia/8275 Beverly Blvd, Los Angeles, CA — 213-651-3212

C

Carroll, J J/Los Angeles, CA — 213-545-3583
Christine Nasser, (I), Studio Swarthout, (P)
Church, Spencer/515 Lake Washington Blvd., Seattle, WA — 206-324-1199
John Fretz, (I), Mits Katayama, (I), Light Language, (P), Ann Marra, (G), Scott McDougall, (I), Dale Nordell, (I), Marilyn Noudell, (I), Rusty Platz, (I), Ted Rand, (I), Diane Solvang-Angell, (I), Dugald Stermer, (I), West Stock, (S), Craig Walden, (I), Dale Windham, (P)
Collier, Jan/1535 Mission St, San Francisco, CA — 415-552-4252
Conroy, Marie-Anais/603 Kings Rd, Newport Beach, CA — 714-646-8604
Greg Fulton, (P), Dean Gerrie, (I), Walter Urie, (I), Roger Vega, (I)
Consolidated Artists/22561 Claude Cir, El Toro, CA — 714-770-9738
Art Banuelos, (I), Mark K Brown, (I), Randy Chewning, (I), Kevin Davidson, (I), Kernie Erickson, (I), Bob Hord, (I), Joe Kennedy, (I), Larry McAdams, (I), Kenton Nelson, (I), Mike Rill, (I), Robert Woodcox, (I)
Cook, Warren/PO Box 2159, Laguna Hills, CA — 714-770-4619
Copeland, Stephanie M/11836 San Vicente Blvd #20,
Los Angeles, CA — 213-826-3591
Ralph B Pleasant, (P)
Cormany, Paul/11607 Clover Ave, Los Angeles, CA — 213-828-9653
Jim Endicott, (I), Bob Gleason, (I), Jim Heimann, (I), Bob Krogle, (I), Lamb/Hall, (P), Gary Norman, (I), Ed Scarisbrick, (I), Stan Watts, (I), Dick Wilson, (I), Andy Zito, (I)
Cornell, Kathleen/90 Corona #508, Denver, CO — 303-778-6016
Nancy Duell, (I), Miles Hardiman, (I), Masami, (I), Daniel McGowan, (I), Jan Oswald, (P), David Spira, (I), Bonnie Timmons, (I)
Costello/Daley/1317 Maltman St, Los Angeles, CA — 213-667-2959
Courie, Jill/8322 Beverly Blvd., Los Angeles, CA — 213-658-8844
Courtney, Mary Ellen/1808 Diamond, So Pasadena, CA — 213-256-4655
Creative Assoc/5233 Bakman Ave, North Hollywood, CA — 213-985-1224
Creative Associates/5233 Bakman Ave, N. Hollywood, CA — 213-985-1224
Chris Dellorco, (I), Don Dixon, (I), Derrick Gross, (I), Phillip Howe, (I), Davin Mann, (I), Pat Ortega, (I), Scott Ross, (I), Paul Stinson, (I)
Cross, Anne/10642 Vanora Dr, Sunland, CA — 213-792-9163

DEF

Denkensohn, Dale/520 N Western Ave, Los Angeles, CA — 213-467-2135
Design Pool/11936 Darlington Ave, #303, Los Angeles, CA — 213-826-1551
Diskin, Donnell/143 Edgemont, Los Angeles, CA — 213-383-9157
Drayton, Sheryl/5018 Dumont Pl, Woodland Hills, CA — 213-347-2227
Drexler, Steve/2256 Pinecrest, Altadena, CA — 213-684-7902
Teri Sandison, (P)
Du Bow & Hutkin/7461 Beverly Blvd, Los Angeles, CA — 213-938-5177
DuBow & Hutkin/7461 Beverly Blvd, Los Angeles, CA — 213-938-5177
Eisenrauch, Carol & Assoc/1105 Alta Loma #3,
Los Angeles, CA — 213-652-4183
Ericson, William/1714 N Wilton Pl, Hollywood, CA — 213-461-4969
Fleming, Laird Tyler/407 1/2 Shirley Pl, Beverly Hills, CA — 213-552-4626
John Bilecky, (P), Willardson & White, (P)

G

George, Nancy/360 1/2 N Mansfield Ave, Los Angeles, CA — 213-935-4696
Brent Bear, (P), Justin Carroll, (I), Randy Chewning, (I), Bruce Dean, (I), Hank Hinton, (I), Gary Hoover, (I), Andy Hoyos, (I), Richard Kriegler, (I), Larry Lake, (I), Gary Lund, (I), Rob Sprattler, (I)
Geovani, Harry/947 La Cienaga, Los Angeles, CA — 213-652-7011
Gilbert, Sam/410 Sheridan, Palo Alto, CA — 415-325-2102
Gilson, Janet/820 N LaBrea Ave, Los Angeles, CA — 213-466-5404
Globe Photos/8400 W Sunset Blvd, Los Angeles, CA — 213-654-3350
Gonter, Richard/1765 N. Highland Ave., #40, Los Angeles, CA — 213-874-1122
Roger Marshutz, (P)
Gray, Connie/248 Alhambra, San Francisco, CA — 415-922-4304
Debbie Cotter, (I), Alan Daniels, (I), Don Evenson, (I), Ernie Friedlander, (P), Max Gisko, (I), Bob Gleason, (I), Fred

Nelson, (I), David Oshiro, (GD), Suzanne Phister, (I), Randy South, (I), Michael Utterbock, (P), Raul Vega, (P), Will Westin, (I), Barry Wetmore, (I)

Greenwald, Kim/1115 5th St #202, Santa Monica, CA — 213-394-6502
Grossman, Neal/Los Angeles, CA — 213-462-7935
Tom Zimberoff, (P)
Group West/5455 Wilshire Blvd #1212, Los Angeles, CA — 213-937-4472

H

Hackett, Pat/2030 1st Ave, #201, Seattle, WA — 206-623-9459
Larry Duke, (I), Bill Evans, (I), Randy Grochoske, (D), Rudi Legname, (P), Louise Lewis, (I), Bill Mayer, (I), Booker McDraw, (I), Mike Schumacher, (I), Gretchen Siege, (G), John C Smith, (I), John Terence Turner, (P)
Haigh, Nancy/90 Natoma St, San Francisco, CA — 415-391-1646
Hallowell, Wayne/11046 Mccormick, North Hollywood, CA — 213-769-5694
Alden Butcher, (AV), Emerson/Johnson/MacKay, (I), Ed Masterson, (P), Bill McCormick, (G), Louis McMurray, (I), Pro/Stock, (P), Diana Robbins, (I)
Hamik/Marechal/PO Box 1677, Sausalito, CA — 415-332-8100
Hamilton Productions, Dan Wilcox/1484 Hamilton Ave, Palo Alto, CA — 415-321-6837
Happe, Michele L/1183 N Michigan, Pasadena, CA — 213-684-3037
Tom Engler, (P), Rich Mahon, (I), Linda Medina, (I)
Harris, Amy/536 Westbourne, Los Angeles, CA — 213-659-7466
Harte, Vikki/409 Bryant St, San Francisco, CA — 415-495-4278
Hauser, Barbara/7041 Hemlock St., Oakland, CA — 415-339-1885
Hawke, Sindy/22612 Leaflock Rd - Lake Fores, El Toro, CA — 714-837-7138
Hedge, Joanne/1838 El Cerrito Pl #3, Hollywood, CA — 213-874-1661
Delana Bettoli, (I), John Harmon, (I), Bo Hylen, (P), Jeff Leedy, (I), Kenvin Lyman, (I), Scott Miller, (I), Dennis Mukai, (I)
Hillman, Betsy/65 Cervantes Blvd #2, San Francisco, CA — 415-563-2243
Tim Boxell, (I), Graham Henman, (P), Hiro Kimura, (I), Michael Koester, (I), John Marriott, (P), J T Morrow, (I), Joe Spencer, (I), Jeremy Thornton, (I), Jackson Vereen, (P)
Homan, Beth, Group West, Inc./5455 Wilshire Blvd., #1212, Los Angeles, CA — 213-937-4472
Hunt, Lou/Los Angeles, CA — 213-462-6565
Hyatt, Nadine/P O Box 2455, San Francisco, CA — 415-543-8944
Jeanette Adams, (I), Ted Betz, (P), Ellen Blonder, (I), Charles Bush, (P), Frank Cowan, (P), Duck-Soup, (A), Marty Evans, (P), Gerry Gersten, (I), John Hyatt, (I), Bret Lopez, (I), Tom McClure, (I), Jan Schockner, (L), Liz Wheaton, (I)

JK

Jones, B.C./229 S Kenmore Ave, Los Angeles, CA — 213-389-5196
Kerz, Valerie/P.O. Box 480678, Los Angeles, CA — 213-876-6232
Brian Leatart, (P), Ken Nahoun, (P), Jane O'Neill, (P), Matthew Rosen, (P)
Kirsch, Melanie/2643 S Fairfax Ave, Culver City, CA — 213-559-0059
Knable, Ellen/717 N La Cienega, Los Angeles, CA — 213-855-8855
Bryant Eastman, (I), Marc Feldman, (P), Joe Heiner, (I), Kathy Heiner, (I), Rudy Legname, (P), Dave McMacken, (I), Richard Noble, (P), Vigon/Nahas/Vigon, (I), Brian Zick, (I)

L

Laycock, Louise/8800 Venice Blvd, Los Angeles, CA — 213-870-6565
Mike Barry, (I), Ben Bensen, (I), Ray Cadd, (I), Bob Drake, (I), Rod Dryden, (I), Ken Hoff, (I), Dick Laycock, (I), Nancy Moyna, (I), Ben Nay, (I), Ken Siefried, (I), Shari Wickstrom, (I)
Lee & Lou/618 S Western Ave #202, Los Angeles, CA — 213-388-9465
Rob Gage, (P), Bob Grige, (P), Richard Leech, (I)
Lerwill, Phyllis/6635 Leland Way, Los Angeles, CA — 213-461-5540
Lilie, Jim/1801 Franklin St #404, San Francisco, CA — 415-441-4384
Lou Beach, (I), Sid Evans, (I), Nancy Freeman, (I), Steve Fukuda, (P), Sharon Harker, (I), Jen-Ann Kirchmeier, (I), Jeff Leedy, (I), Jeff McCaslin, (I), Masami Miyamoto, (I), Mike Murphy, (I), Dennis Ziemienski, (I)
Lippert, Tom/1100 Glendon Ave, Los Angeles, CA — 213-279-1539
London, Valerie Eve/820 N Fairfax Ave, Los Angeles, CA — 213-655-4214
Robert Stein, (P)
Luna, Tony/45 E Walnut, Pasadena, CA — 213-681-3130

M N

Marie, Rita/6443 Lindenhurst Ave., Los Angeles, CA — 213-247-0135
Marlene/7801 Beverly Blvd, Los Angeles, CA — 213-934-5817
Martha Productions/1830 S. Robertson Blvd, Los Angeles, CA — 213-204-1771
Ken Lee Chung, (P), Jacques Devand, (I), Stan Evenson, (I), John Hamagami, (I), Catherine Leary, (I), Manuel Nunez, (I), Rudy Obrero, (I)
Maslansky, Marsha/7927 Hillside Ave., Los Angeles, CA — 213-851-0210
McBride, Elizabeth/70 Broadway, San Francisco, CA — 415-986-2733
Keith Criss, (I), Robert Holmes, (P), Patricia Pearson, (I), Bill Sanchez, (I), Earl Thollander, (I), Tom Vano, (P)
McCullough, Gavin/638 S Van Ness, Los Angeles, CA — 213-382-6281
McKenzie, Dianne/839 Emerson St, Palo Alto, CA — 415-322-8036
Victor Budnik, (P)
Media Services/Gloria Peterson/10 Aladdin Terr, San Francisco, CA — 415-928-3033
Merschel, Sylvia/1341 Ocean Ave, Santa Monica, CA — 213-826-9155
Elizabeth Brady, (I), Kevin Burke, (P), Bob Drake, (I), David Gaines, (I), John Megowan, (I), Curtis Mishiyama, (I), Janice O'Meara, (I), Robert Ruff, (P)
Michaels, Martha/3279 Kifer Rd, Santa Clara, CA — 408-735-8443
Millsap, Darrel/1744 6th Ave, San Diego, CA — 619-232-4519
Minter, John/911 Western #510, Seattle, WA — 206-292-9931
Morgan, Michele/22561 Claude, El Toro, CA — 714-770-9738
Morico, Mike/638 S Van Ness, Los Angeles, CA — 213-382-6281
Chuck Coppock, (I), Carl Crietz, (I), George Francuch, (I), Bill Franks, (G), Jill Garnett, (I), Duane Gordon, (G), Elgas Grim, (I), Chuck Coppock, (I), Carl Crietz, (I), George Francuch, (I), Bill Franks, (G), Jill Garnett, (I), Duane Gordon, (G), Elgas Grim, (I)
Morris, Bob Jr/JCA/14019-A Paramount Ave, Paramount, CA — 213-633-4429
Morris, Leslie/1062 Rengstorff Ave, Mountain View, CA — 415-966-8301
Paul Olsen, (I)
Murray, Natalia/Impact Photo/San Vincente, Los Angeles, CA — 213-852-0481
Brent Bear, (P), Roy Bishop, (P), Jim Cornfield, (P), Arthur Montes DeOca, (P), Tom Engler, (P), Doug Kennedy, (P), Steve Smith, (P), Steve Strickland, (P), Ken Whitmore, (P)
Noyd, Jim/6412 Hollywood Blvd, Los Angeles, CA — 213-469-9924

OPQ

Ogden, Robin/412 N Doheny Dr, Los Angeles, CA — 213-858-0946
Bob Commander, (I), Paul Kiesow, (I), Marilyn Shinokochi, (I), Bob Simmons, (I), Bob Towner, (I), Jeannie Winston-Davis, (I), The Wizard Works, (AV)
Parsons, Ralph/1232 Folsom St, San Francisco, CA — 415-339-1885
Pate, Randy/The Source/5029 Westpark Dr, North Hollywood, CA — 213-985-8181
Patterson, Lore L/3281 Oakshire Dr., Los Angeles, CA — 213-851-3284
Pepper, Don/638 S Van Ness, Los Angeles, CA — 213-382-6281
Chuck Coppock, (I), Carl Crietz, (I), George Francuch, (I), Bill Franks, (G), Jill Garnett, (I), Duane Gordon, (G), Elgas Grim, (I), Chuck Coppock, (I), Carl Crietz, (I), George Francuch, (I), Bill Franks, (G), Jill Garnett, (I), Duane Gordon, (G), Elgas Grim, (I)
Pierceall, Kelly/25260 Piuma Rd, Malibu, CA — 213-559-4327
Piscopo, Maria Representatives/2038 Calvert Ave, Costa Mesa, CA — 714-556-8133
Prapas, Christine/3757 Wilshire Blvd #205, Los Angeles, CA — 213-385-1743
Pre-Production West/6429 W 6th St, Los Angeles, CA — 213-655-1263
Quon, Milton/3900 Somerset Dr, Los Angeles, CA — 213-293-0706

R

Robbins, Leslie/68 Cumberland St, San Francisco, CA — 415-826-8741
Jim Korte, (I), James LaMarche, (I), Scott Miller, (I), Vida Pavesich, (I), Julie Peterson, (I), David Tise, (P), Tom Wyatt, (P)
Rosenthal, Elise/3336 Tilden Ave, Los Angeles, CA — 213-204-3230
Alan Daniels, (I), Myron Grossman, (I), Alan Hashimoto, (I), James Henry, (I), Tim Huhn, (I), Robert Hunt, (P), Mark Edward McCandlish, (I), Tom Pansini, (I), Kim Passey, (I), Ward Shumacker, (I), Will Weston, (I), Larry Winborg, (I)

S

Salisbury, Sharon/185 Berry St, San Francisco, CA — 415-495-4665
Stewart Danials, (I), Jim Endicott, (I), Jim Evans, (I), Bob

Graham, (I), Dennis Gray, (P), Dave McMacken, (I), Norman
 Seef, (P), John VanHammersveld, (G)

Salzman, Richard W/1352 Honrblend St, San Diego, CA 619-272-8147

Scroggy, David/2124 Froude St, San Diego, CA 619-222-2476
 Chris Miller, (I), John Pound, (I)

Slobodian, Barbara/745 N Atta Vista Blvd, Hollywood, CA 213-935-6668
 David Graves, (I), Bob Greisen, (I), Tom O'Brien, (P), Scott
 Slobodian, (P), Gary Watson, (I)

Sobol, Lynne/4302 Melrose Ave, Los Angeles, CA 213-665-5141
 Frank Marquez, (I)

The Source/5029 Westpark Dr, North Hollywood, CA 213-985-8181
 Mario Cassilli, (P), Steve Chorny, (I), Studio Pacifica, (L),
 Pencil Pushers,Inc, (D), Drew Struzan, (I)

Spraulding, David/2019 Pontiuf Ave, Los Angeles, CA 213-475-7794

Steinberg, John/10434 Corfu Lane, Los Angeles, CA 213-279-1775
 John Alvin, (I), Roger Bergendorf, (I), Phil Davis, (I),
 Penelope Gottlieb, (I), Hank Hinton, (I), David Kimble, (I),
 Reid Miles, (P), Larry Noble, (I), Chuck O'Rear, (P), Frank
 Page, (I), Carol Shields, (I), Bob Tanenbaum, (I)

Stern, Gregg/23870 Madison St, Torrence, CA 213-373-6789

Sullivan, Diane/10 Hawthorne St, San Francisco, CA 415-543-8777

Sweeney, Barbara/1720 Whiteley Ave, Hollywood, CA 213-462-2143

Sweet, Ron/716 Montgomery St, San Francisco, CA 415-433-1222
 Charles East, (D), John Hamagami, (I), Bob Haydock, (I),
 Richard Leech, (I), Walter Swarthout, (P), Don Weller, (I),
 Bruce Wolfe, (I), James B Wood, (P)

T

Taggard, Jim/PO 4064 Pioneer Square Station, Seattle, WA 206-935-5524
 Sjef's-Photographie, (P)

Terry, Gloria/511 Wyoming St, Pasadena, CA 213-681-4115

Todd, Deborah/259 Clara St, San Francisco, CA 415-495-3556

Torrey/11201 Valley Spring Lane, Studio City, CA 213-277-8086
 Stewart Daniels, (I), Jim Evans, (I), Bob Hickson, (I), Peter
 Lloyd, (I), Jim Miller, (P), Michael Schwab, (I), Jackson
 Vereen, (P), Barry Wetmore, (C), Dick Zimmerman, (P),
 Lumeni-Productions, (A)

Tos, Debbie/119 N La Brea, Los Angeles, CA 213-932-1291
 Art Pasquali, (P)

**TRIMPE, SUSAN/2717 WESTERN AVE,
SEATTLE, WA (P 107,159)** 206-382-1100

V

Vandamme, Mary/1165 Francisco #5, San Francisco, CA 415-433-1292
 John Collier, (I), Robert Giusti, (I), Joe and Kathy Heiner,
 (I), Alan Krosnick, (P), Kenvin Lyman, (I), Dennis Mukai, (I),
 Pat Nagel, (I), Bill Rieser, (I), Ed Scarisbrick, (I), Michael
 Schwab, (I), Joseph Sellers, (I), Charles Shields, (I), Rick
 Strauss, (P), Carol Wald, (I), Kim Whitesides, (I)

Varie, Chris/2210 Wilshire Blvd, Santa Monica, CA 213-395-9337

W

Wagoner, Jae/200-A Westminster Ave, Venice, CA 213-392-4877
 Michael Backus, (I), Roger Beerworth, (I), Stephen Durke,
 (I), Bruce Miller, (I), Tom Nickosev, (I), Gregg Rowe, (I),
 Randy Scott, (I), Alice Simpson, (I), Robert Tanenbaum, (I),
 Don Weller, (I)

Wallach, Terri/1039 S Fairfax, Los Angeles, CA 213-931-1169

Walsh, Sam/PO Box 5298, University Statio, Seattle, WA 206-522-0154

West End Studios/1100 Glendon #732, Los Angeles, CA 213-279-1539

West Light/1526 Pontius Ave, Los Angeles, CA 213-473-3736
 Chuck O'Rear, (P)

Wiegand, Chris/7106 Waring Ave, Los Angeles, CA 213-931-5942

Wilcox, Dan/1484 Hamilton Ave, Palo Alto, CA 413-321-6837
 Sally Landis, (G)

Williams, Gavin/638 S Van Ness, Los Angeles, CA 213-382-6281

Williams, George A/638 S Van Ness, Los Angeles, CA 213-382-6281

Wood, Joan/141 N St Andrews Pl, Los Angeles, CA 213-463-7717

YZ

Youmans, Jill/830, Los Angeles, CA 213-469-8624
 Carole Etow, (I), Jeff George, (I), Roger Gordon, (I), Brian
 Leng, (P), Russ Simmons, (I)

Young, Jill/Compendium Inc/945 Front St #201,
San Francisco, CA 415-392-0542
 Richard Clark, (P), Judy Clifford, (I), Celeste Ericsson, (I),
 Marilee Heyer, (I), Bonnie Matza, (G), Barbara Mulhauser,
 (G), Donna Mae Shaver, (P), Sarn Suvityasin, (I), Ed Taber,
 (I)

Young, RW/9445 Amboy Ave, Pacoima, CA 213-767-1945

Youno, Max/7207 Melrose Ave, Los Angeles, CA 213-937-2255

Zimmerman, Delores H/9135 Hazen Dr., Beverly Hills, CA 213-273-2642

ILLUSTRATORS

ILLUSTRATORS

NEW YORK CITY

A
Abraham, D E/425 Fifth Ave	212-673-4976
Abrams, Kathie/41 Union Square W, #1001	212-741-1333
ACCORNERO, FRANK/61 E 11TH ST (P 54)	**212-674-0068**
Accurso, Tony/5309 7th Ave	212-435-1323
Acuna, Ed/353 W 53rd St #1W	212-682-2462
Adams, Angela/866 U N Plaza #4014	212-644-2020
Adams, Jeanette/261 Broadway	212-732-3878
ADAMS, JEFFREY/15 W 72ND ST (P 51)	**212-799-2231**
Advertsing Partners/383 Fifth Ave	212-683-5065
AIRSTREAM/60 E 42ND ST #505 (P 11)	**212-682-1490**
ALCORN, BOB/114 E 32ND ST (P 61)	**212-685-2770**
Alcorn, John/135 E 54th St	212-421-0050
Alcorn, Stephen/135 E 54th St	212-421-0050
Allaux, Jean Francois/21 W 86th St	212-873-8404
Alleman, Annie/255 W 84th St	212-874-4109
Allen, Julian/31 Walker St	212-925-6550
Allen, Mary/145 E 27th St	212-689-3902
Aloise, Frank/NBC, 30 Rockefeller Plaza	212-664-4127
Alpert, Alan/405 E 54th St	212-421-8160
ALPERT, OLIVE/9511 SHORE RD (P 77)	**212-833-3092**
Altemus, Robert/401 E 64th St	212-861-5080
Amity, Elena/339 E 77th St	212-879-4690
Amsel, Richard/353 E 83rd St	212-744-5599
Angelakis, Manos/114 E 32nd St	212-685-2770
Angerame, Diane/1459 Third Ave	212-988-8970
Antoni, Volker E H/889 Pacific St	212-636-4670
ANTONIOS, TONY/60 E 42ND ST #505 (P 12)	**212-682-1490**
Applebaum & Curtis/333 E 49th St	212-752-0679
Arcelle, Joan/430 W 24th St	212-924-1865
Aristovulos, Nick/16 E 30th St	212-725-2454
The Art Farm/420 Lexington Ave	212-688-4555
Aruego, Jose/301 E 78th St	212-988-5463
Arwin, Melanie Gaines/236 W 26th St	212-924-2020
Asch, Howard/21-04 Utopia Pkwy	212-352-0256
Ashmead, Hal/353 W 53rd St #1W	212-682-2462
Ayers, Jessie/336 E 81st St	212-472-3871
Azzopardi, Frank/1039 Victory Blvd	212-273-4343

B
Backhaus, R B/280 West End Ave	212-877-4792
Baldus, Fred/29 Jones St	212-757-6300
BALIN, RACQUEL/334 W 87TH ST PHB (P 80)	**212-496-8358**
Ballanger, Tom/333 E 30th St	212-679-1358
Ballantyne, Joyce/353 W 53 #1W	212-682-2462
Barancik, Bob/146 E 89th St #1R	212-903-4425
BARKLEY, JIM/342 MADISON AVE (P 54)	**212-697-8525**
Barner, Bob/866 U N Plaza #4014	212-644-2020
BARR, KEN/342 MADISON AVE (P 55)	**212-697-8525**
BARRETT, RON/2112 BROADWAY (P 82)	**212-874-1370**
BARRY, RON/165 E 32ND ST (P 47)	**212-686-3514**
Bauer, Carla Studio/156 Fifth Ave #1100	212-807-8305
Bauman, Jill/PO Box 152	212-658-3888
BAZZEL, DEBORAH/114 E 32ND ST (P 63)	**212-685-2770**
Becker, Ron/265 E 78th St	212-535-8052
Beecham, Tom/342 Madison Ave	212-697-8525
Bego, Dolores/155 E 38th St	212-697-6170
Bek-gran, Phyllis/145 E 27th St	212-689-3902
Bergman, Barbra/107 E 38th St	212-689-5886
Berkey, John/50 E 50th St	212-355-0910
Berns, Ellen S./181 E 93rd St #3A	212-831-0747
Berran, Robert/420 Lexington Ave #2911	212-986-5680
BILLOUT, GUY/222 W 15TH ST (P 83)	**212-255-2023**
Blackshear, Tom/50 E 50th St	212-355-0910
BLACKWELL, GARIE/60 E 42ND ST #505 (P 13)	**212-682-1490**
Blakey, Paul/226 E 53rd St	212-755-4945
Blum, Zevi/215 E 31st St	212-684-3448
Blumrich, Christopher/67 Irving Pl	212-674-8080
Boguslav, Raphael/200 E 78th St	212-570-9069
BONHOMME, BERNARD/111 WOOSTER ST PHC (P 35)	**212-925-0491**
Boyd, Harvey/24 Fifth Ave	212-475-5235

(continued)
Bozzo, Frank/400 E 85th St	212-535-9182
Brainin, Max/135 Fifth Ave	212-254-9608
Bralds, Braldt/135 E 54th St	212-421-0050
Bramhall, William/215 E 31st St	212-684-3448
Brautigan, Doris/210 Fifth Ave, #501	212-685-8611
BRAYMAN, KARI/333 W 55TH ST (P 57)	**212-582-6137**
Brickner, Alice/4720 Grosvenor Ave	212-549-5909
Bridy, Dan/353 W 53 #1W	212-682-2462
Brier, David/130 E 18th St #5W	212-674-6062
BRILLHART, RALPH/310 MADISON AVE #1225 (P 22, 25)	**212-867-8092**
Broderson, Charles/873 Broadway	212-925-9392
Brofsky, Miriam/186 Riverside Dr	212-595-8094
Brooks, Andrea/99 Bank St	212-924-3085
Brooks, Harold/62 W 45th St	212-398-9540
BROOKS, LOU/415 W 55TH ST (P 84,85)	**212-245-3632**
Brown, Bob/267 Fifth Ave, #803	212-686-5576
Brown, Dan/420 Lexington Ave	212-986-5680
Brown, Judith Gwyn/522 E 85th St	212-288-1599
Brown, Kirk Q/1092 Blake Ave	212-342-4569
Brundage, Dick/145 E 27th St	212-689-3902
BRYAN, DIANA/200 E 16TH ST (P 86,87)	**212-475-7927**
Bryant, Rick J/18 W 37th St #301	212-594-6718
BUCHANAN, YVONNE/411 14TH ST BKLYN (P 88)	**212-965-3021**
BURGER, ROBERT/111 WOOSTER ST (P 35)	**212-925-0491**
Burgoyne, John/200 E 78th St	212-570-9069
Byrd, Bob/353 W 53rd #1W	212-682-2462

C
Campbell, Jim/420 Lexington Ave	212-986-5680
Cantarella, Virginia Hoyt/107 Sterling Pl	212-622-2061
Caras, Peter/157 W 57th St	212-247-1130
Carbone, Kye/101 Charles St	212-242-5630
Carter, Bunny/200 E 78th St	212-570-9069
Carter, Penny/342 Madison Ave	212-986-3282
CASSLER, CARL/420 LEXINGTON AVE, (P 33)	**212-986-5680**
Cavanagh, Dorothe/135 W 79th St	212-580-7132
Cayard, Bruce/155 E 38th St	212-697-6170
Cellini, Eva/157 W 57th St	212-247-1130
Cellini, Joseph/157 W 57th St	212-247-1130
Chan, Dale/51-23 Reeder	212-687-5295
Charmatz, Bill/25 W 68th St	212-595-3907
Chen, Tony/53-31 96th St	212-699-4813
Chermayeff, Ivan/58 W 15th St	212-741-2539
Cherry, James/336 E 30th St #1B	212-686-0861
Chester, Harry/501 Madison Ave	212-752-0570
Chorao, Kay/290 Riverside Dr	212-749-8256
Christopher, Tom/342 Madison Ave	212-986-3282
Chu, Patrick/51-23 Reeder ST	212-986-3282
Chwast, Seymour/67 Irving Place	212-677-3506
Ciccarielli, Gary/353 W 53rd St #1W	212-682-2462
Ciesiel, Christine G/101 MacDougal St	212-982-9461
Clark, Bradley/866 U N Plaza #4014	212-644-2020
Clarke, Bob/159 W 53rd St	212-581-4045
Clifton, John/114-24 200th St	212-464-6746
Cloteaux, Francois/333 E 30th St	212-679-1358
COBANE, RUSSELL/75 E 55TH ST (P 41)	**212-980-3510**
Cober, Alan E/70 E 56th St	212-752-8490
Cody, Brian/866 U N Plaza #4014	212-644-2020
Colton, Keita/165 E 32nd St	212-686-3514
Conley, Frank P/14 E 52nd St	212-759-6791
Connelly, Gwen/866 U N Plaza #4014	212-644-2020
Continuity Graphics Associated, Inc/62 W 45th St	212-869-4170
COOK, DAVID/310 MADISON AVE #1225 (P 25)	**212-867-8092**
Cooley, Gary/23 W 35th St	212-695-2426
Cooper, Cheryl/160 West End Ave	212-877-5253
Cooper, Robert/420 Madison Ave #401	212-980-3510
Cornell, Laura/118 E 93rd St #1A	212-534-0596
Corvi, Donna/1591 Second Ave	212-628-4868
Couch, Gregg/132 Terrace Place	212-436-0309
Couratin, Patrick/333 E 30th St	212-679-1358
Crair, Mel/342 Madison Ave	212-697-8525
Crane, Eileen (Good Works)/30 E 20th St	212-677-6607
Crawford, Margery/237 E 31st St	212-686-6883

ILLUSTRATORS CONT'D.

Please send us your additions and updates.

Crawford, Robert/340 E 93rd St #9I	212-722-4464
Crews, Donald/653 Carroll St	212-636-5773
CROSS, PETER/645 WEST END AVE, #9E (P 68)	**212-362-3338**
Crosthwaite, Royd C./50 E 50th St	212-355-0910
CRUZ, RAY/162 W 13TH ST (P 97)	**212-243-1199**
Csatari, Joe/420 Lexington Ave	212-986-5680
Cuevos, Stillerman, Plotkin/230 E 44th St	212-661-7149
Cunningham, Robert M/177 Waverly Pl #4F	212-675-1731

D
DACEY, BOB/157 W 57TH ST (P 46)	**212-247-1130**
Dale, Robert/1573 York Ave	212-737-1771
Dallison, Ken/108 E 35th St #1	212-889-3337
Daly, Sean/85 South St	212-668-0031
D'Andrea, Bernie/50 E 50th St	212-355-0910
D'Andrea, Domenick/50 E 50th St	212-355-0910
Daniels, Alan/120 E 32nd St	212-689-3233
Darden, Howard/62 W 45th St	212-398-9540
Davidson, Everett/60 E 42nd St #505	212-682-1490
Davis, Allen/50-36 Horatio Pkwy	212-428-1471
Davis, Jack/108 E 35th St #1	212-889-3337
DAVIS, MICHAEL/333 E 49TH ST (P 57)	**212-980-8061**
Davis, Nelle/20 E 17th St	212-807-7737
Dawson, Diane/160 West End Ave	212-362-7819
DAWSON, JOHN/310 MADISON AVE #1225 (P 26, 27)	**212-867-8092**
Day, Betsy/866 U N Plaza #4014	212-644-2020
Deas, Michael/39 Sidney Pl	212-852-5630
DeCamps, Craig/341 W 38th St	212-564-2691
DEETER, CATHERINE/60 E 42ND ST #505 (P 14)	**212-682-1490**
Degen, Paul/135 Eastern Parkway	212-636-8299
Deigan, Jim/353 W 53rd St #1W	212-682-2462
DeLattre, Georgette/100 Central Park South	212-247-6850
Deschamps, Bob/108 E 35th St #1	212-889-3337
Descombes, Roland/50 E 50th St 5th Fl	212-355-0910
Detrich, Susan/253 Baltic St	212-237-9174
Dewey, Kenneth F/226 E 53rd St	212-755-4945
DeWolf, Gordon A/300 E 39th St	212-889-1001
Diamond Art Studio/515 Madison Ave	212-355-5444
DiCione,Ron/342 Madison Ave	212-697-8525
DiComo Comp Art/12 W 27th St	212-689-8670
DIETZ, JIM/165 E 32ND ST (P 47)	**212-686-3514**
DiFranza-Williamson, Inc/1414 Ave of the Americas	212-832-2343
DILAKIAN, HOVIK/111 WOOSTER ST #PHC (P 35)	**212-925-0491**
Dillon, Diane/221 Kane St	212-624-0023
Dillon, Leo/221 Kane St	212-624-0023
Dinnerstein, Harvey/933 President St	212-783-6879
DITTRICH, DENNIS/42 W 72ND ST #12B (P 103)	**212-595-9773**
Dixon, Ron/218 Benziger Ave	212-727-1701
DODDS, GLENN/392 CENTRAL PARK WEST (P 104,105)	**212-679-3630**
Domingo, Ray/108 E 35th St #1	212-889-3337
Domino, Bob/60 Sutton Pl So	212-935-0139
D'Onofrio, Alice/866 U N Plaza #4014	212-644-2020
DORET, MICHAEL/61 LEXINGTON AVE (P 106)	**212-889-0490**
D'Ortenzio, Alfred/353 W 53 St	212-682-2462
Drovetto, Richard/355 E 72nd St	212-787-8910
Drucker, Mort/226 E 53rd St	212-755-4945
Duarte, Mary/350 First Ave	212-674-4513
Dubanevich, Arlene/866 U N Plaza	212-644-2020
Dudash, Michael/157 W 57th St	212-247-1130
Dunn, Robert S/168-14 127th Ave #9F	212-276-1529
Dupont, Lane/353 W 53rd St #1W	212-682-2462
Durke, Stephen/9 E 32nd St	212-688-1080
Dyess, John/157 W 57th St	212-247-1130

E
EAst Village Enterprises/231 W 29th St #807	212-563-5722
Eggert, John/420 Lexington Ave #2911	212-986-5680
Egielski, Richard/463 West St	212-255-9328
Ehlert, Lois/866 UN Plaza	212-644-2020
Ellis, Dean/30 E 20th St	212-254-7590
Ely, Richard/207 W 86th St	212-874-4816
Emerson, Matt (Emerson-Wajdowicz)/1123 Broadway	212-807-8144
EMMETT, BRUCE/285 PARK PL (P 108)	**212-636-5263**
Endewelt, Jack/50 Riverside Dr	212-877-0575

Enik, Ted/82 Jane St, #4A	212-620-5972
ENNIS, JOHN/310 MADISON AVE #1225 (P 24)	**212-867-8092**
Ettlinger, Doris/73 Leonard St	212-226-0331
Eutemy, Loring/51 Fifth Ave	212-741-0140
EVCIMEN, AL/305 LEXINGTON AVE (P 109)	**212-889-2995**

F
Familton, Herb/59 W 10 St #1D	212-254-2943
Farina, Michael/120 E 32nd St	212-689-3233
Farley, Eileen M/383 First Ave	212-674-3602
Farmakis, Andreas/75 E 55th St	212-758-5280
Farrell, Marybeth/644 E 24th St	212-859-1824
Fasolino, Teresa/58 W 15th St	212-741-2539
Fassell, Beatrice/785 West End Ave, #11D	212-865-2144
FEBLAND, DAVID/670 WEST END AVE (P 110)	**212-580-9299**
Fennimore, Linda/808 West End Ave	212-866-0279
FERNANDES, STANISLAW/35 E 12TH ST (P 111)	**212-533-2648**
Fichera, Maryanne/12 W 27th St	212-689-8670
FIORE, PETER/230 PARK AVE (P 30)	**212-986-5680**
Fiorentino, Al/866 UN Plaza	212-644-2020
Fitzgerald, Frank/212 E 89th St	212-722-6793
Flesher, Vivienne/95 Christopher St	212-620-3182
Flint, Mike/163 E 33rd St #G4	212-420-8984
Fouse, Claudia/62 W 45th St	212-398-9540
Fox, Barbara/301 W 53rd St	212-245-7564
Francis, Anna/305 West End Ave, #16A	212-580-0911
FRANCIS, JUDY/110 W 96TH ST (P 112)	**212-866-7204**
Franke, Phil/333 E 30th St	212-679-1358
Fraser, Betty/240 Central Park South	212-247-1937
Freeman, Irving/145 Fourth Ave	212-674-6705
Freeman, Tom/157 W 57th St	212-247-1130
Fretz, Frank/866 UN Plaza #4014	212-644-2020
Fricke, Warren/15 W 72nd St	212-799-2231
Friedland, Lew/26-25 141st St	212-359-3420
Friedman, Jon/866 UN Plaza #4014	212-644-2020
Froom, Georgia/62 W 39th St #803	212-944-0330
FURUKAWA, MEL/333 E 30TH ST (P 53)	**212-679-1358**

G
GAADT, DAVID/310 MADISON AVE #1225 (P 22, 23, 27)	**212-867-8092**
Gaadt, George/353 W 53rd St #1W	212-682-2462
Gabriele, Antonio J/230 Park Ave	212-986-5680
GADINO, VICTOR/1601 THIRD AVE (P 46)	**212-534-7206**
Gahan, Nancy Lou/3 Washington Square Village	212-674-2644
Gala, Tom/420 Lexington Ave #2911	212-986-5680
GALE, CYNTHIA/229 E 88TH ST (P 113)	**212-860-5429**
Gallardo, Gervasio/50 E 50th St	212-355-0910
GAMBALE, DAVID/268 E 7TH ST (P 45)	**212-982-8793**
Gampert, John/55 Bethune St.	212-242-1407
Garrido, Hector/420 Lexington Ave #2911	212-986-5680
Garrison, Barbara/12 E 87th St	212-348-6382
Gayler, Anne/320 E 86th St	212-734-7060
Geatano, Nicholas/821 Broadway	212-674-5749
GEHM, CHARLES/342 MADISON AVE (P 55)	**212-697-8525**
Geller, Martin/105 Montague St	212-237-1733
Gem Studio/420 Lexington Ave 2nd fl	212-687-3460
Genova, Joe/60 E 42nd St #505	212-682-1490
Gentile, John & Antony/850 7th Ave #1006	212-757-1966
Gerber, Mark & Stephanie/420 Lexington Ave #2911	212-986-5680
Gersten, Gerry/1380 Riverside Dr	212-928-7957
Geyer, Jackie/353 W 53rd St #1W	212-682-2462
Giavis, Ted/230 Park Ave	212-986-5680
Giglio, Richard/299 W 12th St	212-675-7642
Gignilliat, Elaine/150 E 56th St	212-935-1943
Gill, Richard/866 Second Ave	212-980-1835
Gillot, Carol/162 W 13th St	212-243-6448
Giovanopoulos, Paul/119 Prince St	212-661-0850
Giusti, Robert/135 E 54th St	212-421-0050
GLEASON, PAUL/310 MADISON AVE #1225 (P 22, 27)	**212-867-8092**
Goldstom, Robert/336 E 54th St	212-832-7980
Good Works/30 E 20th St	212-677-6607
Goodell, Jon/866 UN Plaza #4014	212-644-2020
Gothard, David/215 E 31st St	212-684-3448
Gottlieb, Penelope/342 Madison Ave	212-679-8525

Graboff, Abner/310 Madison Ave	212-687-2034
GRADDON, JULIAN/114 E 32ND ST (P 60)	**212-685-2770**
Graham, Mariah/670 West End Ave	212-580-8061
Grammer, June/126 E 24th St #3B	212-475-4745
Granshaw, David/215 E 31st St	212-684-3448
Grashow, David/215 E 31st St	212-684-3448
Gray, John/264 Van Duzer St	212-447-6466
Green, Norman/11 Seventy Acres Rd	203-438-9909
GRIESBACH/MARTUCCI/35 STERLING PL (P 15)	**212-622-1831**
Griffel, Barbara/8006 47th Ave	212-446-0285
GRIFFIN, JIM/310 MADISON AVE #1225 (P 22)	**212-867-8092**
Gross, Steve/342 Madison Ave	212-697-8525
Grossberg, Manuel/1200 Broadway	212-532-3335
Grossman, Robert/19 Crosby St	212-925-1965
GROTE, RICH/114 E 32ND ST, #902 (P 65)	**212-685-2770**
Grovanopaulos, Paul/342 Madison Ave	212-661-0850
Grunfeld Graphics Ltd/80 Varick St	212-431-8700
Guarnaccia, Steven/89 Bleecker St #6B	212-982-2032
Guetary, Helen/333 E 30th St	212-679-1358
Guitar, Jeremy/866 UN Plaza #4014	212-644-2020

H

Haas, Arie/35 W 38th St #3W	212-382-1677
Hack, Konrad/866 UN Plaza #4014	212-644-2020
Hall, Joan/463 West St	212-243-6059
Hallgren, Gary/6 W 37th St	212-947-1054
Hamrick, Chuck/420 Lexington Ave #2911	212-986-5680
The Handy Lettering Co./232 E 12th St	212-982-9303
HARRINGTON, GLENN/165 E 32ND ST (P 47)	**212-686-3514**
Harrison, Sean/1349 Lexington Ave	212-369-3831
Harrison, William/120 E 32nd St	212-689-3233
Hart, Veronika/60 E 42nd St	212-682-1490
Harvey, Richard/420 Lexington Ave #2911	212-986-5680
HAVEY, PAULA/301 W 53RD ST (P 119)	**212-245-6118**
HAYNES, MICHAEL/420 MADISON AVE, , (P 40)	**212-980-3510**
Heck, Cathy/200 E 57th St #12D	212-838-9128
Hedin, Donald/157 W 57th St	212-247-1130
Heindel, Robert/211 E 51st St	212-755-1365
HEINER, JOE & KATHY/194 THIRD AVE (P 120)	**212-475-0440**
Henderson, Dave/420 Lexington Ave #2911	212-986-5680
Henry, Paul/157 W 57th St	212-247-1130
HERDER, EDWIN/310 MADISON AVE #1225 (P 23, 26)	**212-867-8092**
Hering, Al/342 Madison Ave #261	212-986-3282
HERMAN, TIM/420 MADISON AVE #401 (P 40)	**212-980-3510**
Hernandez, Richard/144 Chambers St	212-732-3474
HERRING, MICHAEL/244 W 103RD ST (P 23, 24)	**212-663-2848**
Herrmann, Hal/50 E 50th St	212-752-8490
Hess, Mark/135 E 54th St	212-421-0050
Higgins, Pamela/866 UN Plaza #4014	212-644-2020
HILL, AMY/111 WOOSTER ST PH C (P 35)	**212-925-0491**
Himmler, Ron/866 UN Plaza #4014	212-644-2020
Hinck, Fred/116 Richmond St	212-235-0809
Hochman, Steve/120 E 32nd ST	212-689-3233
Hoffman, Ginnie/108 E 35th St #1	212-889-3337
Hoffman, Martin/300 Mercer St	212-777-4148
Hoffman, Rosekrans/866 UN Plaza #4014	212-644-2020
Hogarth, Paul/215 E 31st St	212-684-3448
Holland, Brad/96 Greene St	212-226-3675
Holmes, John/420 Lexington Ave #2911	212-986-5680
Holt, Katheryn/45 Riverside Dr	212-874-2345
Hooks, Mitchell/321 E 83rd St	212-737-1853
Hoover, Gerry/866 UN Plaza #4014	212-644-2020
Hortens, Walter/154 E 64th St	212-838-0014
Hosner, William/420 Madison Ave #401	212-980-3510
HOSTOVICH, MICHAEL/470 W 23RD ST (P 49)	**212-242-6367**
Howard, John/336 E 54th St	212-832-7980
The Hub/16 E 52nd St #504	212-421-5807
Hubert, Laurent/342 Madison Ave	212-661-0850
HUERTA, CATHERINE/60 E 42ND ST #505 (P 16)	**212-682-1490**
Hughes, Mary Ellen/403 E 70th St	212-288-8375
Hull, Cathy/236 E 36th St	212-683-8559
HUNT, JIM/420 MADISON AVE (P 40)	**212-980-3510**
Hunter, Stan/50 E 50th St	212-355-0910

Huyssen, Roger/1059 Third Ave	212-888-9193

IJ

Idelson, Joyce/11 Riverside Dr	212-877-6161
Iskowitz, Joel/420 Lexington Ave #2911	212-986-5680
Ivenbaum, Elliott/267 W 90th St	212-664-5656
JABEN, SETH/47 E 3RD ST #3 (P 124)	**212-260-7859**
JAKSEVIC, NENAD/165 E 32ND ST (P 47)	**212-686-3514**
JAMIESON, DOUG/42-20 69TH ST, WOODSIDE, NY (P 125)	**212-565-6034**
JASPER, JACKIE/165 E 32ND ST (P 46)	**212-686-3514**
Jeffers, Kathy/106 E 19th St	212-475-1756
Jezierski, Chet/50 E 50th St	212-355-0910
Jobe, Jody/875 W 181st St	212-795-4941
Johnson, Doug/45 E 19th St	212-260-1880
Johnson, Kristin/902 Broadway, #1609	212-477-4033
JONES, BOB/420 LEXINGTON AVE #2911 (P 31)	**212-986-5680**
Joseph, Paula/147 W 13th St, #2F	212-242-6137
JOUDREY, KEN/15 W 72ND ST (P 51)	**212-799-2231**
Just, Hal/155 E 38th St	212-697-6170

K

Kallan, Elizabeth Kada/67 Irving Pl	212-674-8080
Kampmier, Jill/320 E 22nd St	212-674-8379
KANAREK, MICHAEL/114 E 32ND ST (P 59)	**212-685-2770**
Kane, Harry/310 E 49th St	212-486-0180
KANE, KID/60 E 42ND ST #505 (P 17)	**212-682-1490**
KANE, MICHAEL/15 W 72ND ST (P 51)	**212-799-2231**
KANELOUS, GEORGE/9 E 32ND ST (P 58)	**212-688-1080**
Kappes, Werner/345 E 73rd St	212-673-2484
Karlin, Bernie/41 E 42nd St	212-687-7636
Karlin, Eugene/39-73 48th St	212-457-5086
KATZ, LES/451 WESTMINSTER BKLYN (P 128)	**212-284-4779**
Kaufman, Stuart/420 Lexington Ave #2911	212-986-5680
Kelley, Mark/866 UN Plaza #4014	212-644-2020
KELLY, SUSANNAH/111 WOOSTER ST (P 35)	**212-925-0491**
Kendrick, Dennis/99 Bank St	212-924-3085
Kibbee, Gordon/6 Jane St	212-989-7074
Kieffer, Christa/866 UN Plaza #4014	212-644-2020
King, Jean/315 Riverside Dr	212-866-8488
Kingsley, Melinda/120 E 79th St	212-879-2042
Kingston, James/31 E 31st St	212-685-2520
Kirk, Charles/333 Park Ave S	212-677-3770
KIRK, DANIEL/85 SOUTH ST #6N (P 129)	**212-825-0190**
KLAVINS, ULDIS/310 MADISON AVE #1225 (P 26, 27)	**212-867-8092**
KLUGLEIN, KAREN/88 LEXINGTON AVE (P 130)	**212-684-2974**
Knettell, Sharon/108 E 35th St #1	212-889-3337
Knight, Jacob/342 Madison Ave	212-661-0850
Koester, Michael/420 Lexinton Ave #2911	212-986-5680
Korda, Leslie/150 W 80th St	212-595-3711
Koren, Edward/215 E 31st St	212-684-3448
Krakovitz, Harlan/145 E 27th St	212-689-3902
Kramer, Carveth/342 Madison Ave	212-661-0850
KRETSCHMANN, KARIN/323 W 75TH ST #1A (P 132)	**212-724-5001**
Kriegler, Richard/353 W 53rd St	212-682-2462
Kubinyi, Laszlo/41 Union Sq W #1228	212-691-5296
Kuester, Bob/353 W 53rd ST #1W	212-682-2462
Kukalis, Romas/420 Lexington Ave #2911	212-986-5680
Kunstler, Mort/50 E 50th St	212-355-0910
Kursar, Ray/1 Lincoln Plaza #43R	212-873-5605

L

LACKOW, ANDY/114 E 32ND ST #902 (P 62)	**212-685-2770**
LaGrone, Roy/151 Schenectady Ave	212-773-3091
Lakeman, Steven/115 W 85th St	212-877-8888
LAMUT, SONYA/165 E 32ND ST (P 47)	**212-686-3514**
LANDIS, JOAN/6 JANE ST (P 133)	**212-989-7074**
Lang, Gary/342 Madison Ave	212-697-8525
LAPINSKI, JOE/420 MADISON AVE #401 (P 43)	**212-980-3510**
Lapsley, Robert/145 E 27th St	212-689-3902
LASHER, MARY ANN/60 E 42ND ST (P 18)	**212-682-1490**
Laslo, Larry/179 E 71st St	212-737-2340
Laslo, Rudy/9 E 32nd St	212-688-1080
Laurence, Karen/342 Madison Ave	212-661-0850
Lauter, Richard/157 W 57th St	212-247-1130
LAWTON, NANCY/8 SHELTERVIEW DR (P 135)	**212-720-0157**

Lazarevich, Mila/225 E 63rd St	212-371-9173
Leake, Don/124 W 80th St	212-877-8405
Lebbad, Jim Design/220 Fifth Ave #1707	212-679-2234
Leder, Dora/866 UN Plaza #4014	212-644-2020
Leonard, Tom/866 UN Plaza #4014	212-644-2020
LESSER, RON/342 MADISON AVE (P 55)	**212-697-8525**
LeTan, Pierre/215 E 31st St	212-684-3448
Levin, Arnie/315 E 68th St	212-472-9474
Levine, Rena/200 Bethel Loop, #12-G	212-642-7339
Levine, Ron/1 W 85th St, #4D	212-787-7415
Levirne, Joel/151 W 46th St	212-869-8370
LEWIS, TIM/194 THIRD AVE (P 139)	**212-475-0440**
Lexa, Susan/866 UN Plaza #4014	212-644-2020
LIEBERMAN, RON/109 W 28TH ST (P 140)	**212-947-0653**
Lieppman, Jeff/349 Clinton St	212-237-1862
Lieppman, Lynn Stephens/349 Clinton St	212-237-1862
Lilly, Charles/56 W 82nd St, #15	212-873-3608
LINDLOF, ED/353 W 53RD ST (P 141)	**212-682-2462**
Line, Lemuel/50 E 50th St	212-355-0910
LITTLE APPLE ART/409 6TH AVE BKLYN (P 142)	**212-499-7045**
Little, Bob/ 111 W. 42	212-944-1548
Lloyd, Peter/120 E 32nd St	212-689-3233
LoGrippo, Robert/50 E 50th St	212-355-0910
Lodigensky, Ted/120 E 32nd St	212-689-3233
Logan, Ron/866 UN Plaza #4014	212-644-2020
Long, Dan/333 E 30th St	212-679-1358
Lopez, Antonio/31 Union Square W #10A	212-924-2060
Lurio, Eric/250 W 15th St	212-564-4838
Lyall, Dennis/420 Lexington Ave #2911	212-986-5680
Lynch, Alan/114 E 32nd St	212-685-2770
M Mack, Stan/226 E 53rd St	212-755-4945
Maddalone, John/310 Madison Ave	212-807-6087
Madden, Don/866 U N Plaza #4014	212-644-2020
Magagna, Anna Marie/2 Tudor City Pl	212-840-1234
Mahon, Rich/120 E 32nd St	212-689-3233
Mahoney, Ron/353 W 53rd Ave #1W	212-682-2462
Maitz, Don/50 E 50th St	212-355-0910
Mambach, Alex/102-35 64th Rd	212-275-4269
Mandel, Saul/342 Madison Ave	212-697-8525
Manders, John/42 W 72nd St #12B	212-595-9773
Mangiaf, Jeffery/420 Lexington Ave #2911	212-986-5680
Manos, Jim/342 Madison Ave	212-986-3282
MANTEL, RICHARD/194 THIRD AVE (P 146)	**212-475-0440**
Marcellino, Fred Studio/432 Park Ave S, Rm 601	212-532-0150
Mardon, Allan/108 E 35th St	212-889-3337
Margaret & Frank & Friends Inc/124 Hoyt St	212-237-0145
Marich, Felix/420 Madison Ave #401	212-980-3510
Marinelli, Robert/165 Bryant Ave	212-979-4018
Marshall, Frank B, III/PO Box 1078	212-621-5352
Martin's, Bruce Rough Riders/389 Ave of the Americas	212-620-0539
MARTINOT, CLAUDE/55 BETHUNE ST (P 38)	**212-242-1407**
MASI, GEORGE/111 WOOSTER ST #PHC (P 35)	**212-925-0491**
Mathewuse, James/157 W 57th St	212-247-1130
Mathieu, Joseph/215 E 31st St	212-684-3448
MATTELSON, MARVIN/88 LEXINGTON AVE (P 148)	**212-684-2974**
Maxwell, Brookie/53 Irving Pl	212-475-6909
Maye, Warren/3621 DeReimer Ave	212-655-7116
McAfee, Mara/345 E 86th St	212-348-9284
McCormack, Geoffrey/420 Lexington Ave #2911	212-986-5680
McCoy, Steve/514 E 83rd St	212-866-9536
McCrady, Lady/17 Park Ave	212-532-6317
McDaniel, Jerry/155 E 38th St	212-697-6170
McKie, Roy/75 Perry	212-989-5186
McLean, Wilson/50 E 50th St	212-752-8490
MCLOUGHLIN, WAYNE/194 THIRD AVE (P 151)	**212-475-0440**
Medoff, Jack Wells Rich Green/767 Fifth Ave	212-758-4300
Mehlman, Elwyn/108 E 35th St #1	212-889-3337
MEISEL, ANN/420 LEXINGTON AVE #2911 (P 32)	**212-986-5680**
Melendez, Robert/120 E 32nd St	212-689-3233
MERCIE, TINA/111 WOOSTER ST #PHC (P 35)	**212-925-0491**
METCALF, ROGER/9 E 32ND ST (P 58)	**212-688-1080**

Meyerowitz, Rick/68 Jane St	212-989-2446
Michaels, Bob/304 E 49 St	212-752-1185
Michal, Marie/108 E 35th St #1	212-889-3337
Michner, Ted/420 Lexington Ave #2911	212-986-5680
Mikos, Mike/420 Lexington Ave #2911	212-986-5680
Milicic, Michael/234 W 48th St #1115	212-878-3700
Miller, Lyle/866 U N Plaza #4014	212-644-2020
Miller, Steve/11-18 47th Ave	212-784-3351
Milne, Jonathon/420 Lexington Ave	212-986-5680
MINOR, WENDELL/277 W 4TH ST (P 23)	**212-691-6925**
Mitchell, Maceo/446 Central Park West #4E	212-865-1059
Mitsuhashi, Yoko/43 E 29th St	212-683-7312
Miyamoto, Linda/488 Warren St	212-596-4787
MOLL, CHARLES/310 MADISON AVE #1225 (P 27)	**212-867-8092**
MONTIEL, DAVID/115 W 16TH ST #211 (P 154)	**212-989-7426**
MORAES, GREG/310 MADISON AVE #1225 (P 24)	**212-867-8092**
Morgan, Jacqui/315 E 58th St	212-421-0766
MORGEN, BARRY/425 WEST END AVE (P 155)	**212-595-6835**
MORRIS, FRANK/15 W 72ND ST (P 50)	**212-799-2231**
Morrison, Don/155 E 38th St	212-697-6170
MOSELEY, MARSHALL/409 SIXTH AVE BKLYN (P 142)	**212-499-7045**
Moss, Geoffrey/315 E 68th St	212-472-9474
Murawski, Alex/108 E 35th St #1	212-889-3337
MYERS, DAVID/165 E 32ND ST (P 46)	**212-686-3514**
Myers, Lou/108 E 35th St #1	212-889-3337
N Neff, Leland/506 Amsterdam Ave, #61	212-724-1884
Nelson, Bill/311 E 71st St	212-734-3773
Nessim, Barbara/80 Varrick St	212-677-8888
Neubecker, Robert/137 Fifth Ave	212-674-6806
NEUMANN, ANN/444 BROOME ST (P 37)	**212-431-7141**
Newsome, Tom/420 Lexington Ave #2911	212-986-5680
Newton, Richard/157 W 57th St	212-247-1130
Neyman-Levikova, Marina/155 E 38th St	212-697-6170
NICASTRE, MICHAEL/342 MADISON AVE (P 55)	**212-697-8525**
Nicklaus, Carol/866 U N Plaza #4014	212-644-2020
NOFTSINGER, PAMELA/7 CORNELIA ST (P 156)	**212-807-8861**
Noome, Mike/420 Lexington Ave #2911	212-986-5680
Noonan, Julia/873 President St	212-622-9268
Notarile, Chris/420 Lexington Ave #2911	212-986-5680
O Ochagavia, Carlos/50 E 50th St	212-355-0910
Odom, Mel/252 W 76th St	212-724-9320
OELBAUM, FRAN/196 W 10TH ST (P 45)	**212-691-3422**
O'Keefe, June/256 DeKalb Ave	212-636-9816
OLANOFF, GREG/310 MADISON AVE #1225 (P 27)	**212-867-8092**
OLBINSKI, RAFAL/470 W 23RD ST (P 48, 49)	**212-242-6367**
Olson, Maribeth/145 E 27th St	212-689-3902
OPTICALUSIONS/9 E 32ND ST (P 58)	**212-688-1080**
Orlin, Richard/2550 Olinville Ave	212-882-6177
Orloff, Denis/310 E 9th St	212-982-8341
Overacre, Gary/108 E 35th St #1	212-889-3337
PQ Pahmer, Hal/8 W 30th St 7th Fl	212-889-6202
Pantomine Pictures Inc/12144 Riverside Dr	213-980-5555
Parker, Robert Andrew/215 E 31st St	212-684-3448
Parrish, George I Jr/9 E 32nd St	212-688-1080
PARSONS, JOHN/342 MADISON AVE (P 54)	**212-697-8525**
Paslavsky, Ivan/510-7 Main St N	212-759-3985
Passons, John/342 Madison Ave	212-697-8525
Paul, Tony/235 E 49th St	212-986-8161
Peak, Bob/50 E 50th St	212-752-8490
Peele, Lynwood/344 W 88th St	212-799-3305
PELAVIN, DANIEL/45 CARMINE ST (P 157)	**212-929-2706**
PELS, WINSLOW PINNEY/226 E 53 #3C (P 100)	**212-355-7670**
PENELOPE/342 MADISON AVE (P 54)	**212-697-8525**
Percivalle, Rosanne/62 W 45th St	212-398-9540
Perdue, Jack/311 E 71st St	212-734-3773
Persivalle, Rosanne/62 W 45th St	212-398-9540
Peterson, Cheryl/215 E 31st St	212-684-3448
Petragnani, Vincent/420 Madison Ave #401	212-980-3510
Pettingill, Ondre/295 Bennett Ave #4E	212-942-1993

ILLUSTRATORS CONT'D.

Please send us your additions and updates.

Pimsler, Alvin J/101 Central Park West	212-787-4967
Podwill, Jerry/108 W 14th St	212-255-9464
Powell, Ivan/58 W 15th St	212-741-2539
Pribula, Jo/59 First Ave	212-260-4548
Primavera, Elise/145 E 27th St	212-689-3902
Punchatz, Don Ivan/6 Jane St	212-989-7074
Purdon, Bill/780 Madison Ave #7A	212-988-4566
Quartuccio, Dom/5 Tudor City Pl	212-661-1173
Quay, Mary Jo/521 E 85th St	212-308-6970
QUON, MIKE/53 SPRING ST (P 160,161)	**212-226-6024**

R

Radigan, Bob/353 W 53rd St #1W	212-682-2462
Raglin, Tim/138 W 74th St	212-873-0538
Rainbow Grinder/353 W 53rd St #1W	212-682-2462
RANE, WALTER/310 MADISON AVE #1225 (P 26)	**212-867-8092**
Reddin, Paul/120 Terrace Pl	212-633-0541
REINERT, KIRK/310 MADISON AVE #1225 (P22, 23, 25)	**212-867-8092**
REINGOLD, ALAN/155 E 38TH ST (P 162)	**212-697-6170**
Renfro, Ed/250 E 83rd St	212-879-3823
REOTT, PAUL/51-10 VAN HORN ST QUEENS (P 163)	**212-426-1928**
RIXFORD, ELLEN/308 W 97TH ST (P 165)	**212-865-5686**
Roberts, Cheryl/200 E 78th St	212-570-9069
Robins, Mike/9 E 32nd St	212-688-1080
Robinson, Charles/866 UN Plaza #4014	212-644-2020
RODERICKS, MICHAEL/15 W 72ND ST (P 50)	**212-799-2231**
RODIN, CHRISTINE/38 MORTON ST (P 45)	**212-242-3260**
Rogers, Paul/353 W 53rd St	212-682-2462
Rosenblum, Richard/392 Fifth Ave	212-279-2068
Rosenfeld, Mort/420 Lexington Ave #2911	212-986-5680
Rosenthal, Doug/24 Fifth Ave	212-475-9422
Rosenwald, Laurie/45 Lispenard St	212-966-6896
Rosner, Meryl/342 Madison Ave	212-986-3282
Ross, Barry/838 West End Ave, #9A	212-663-7386
Ross, Peter/38 E 21st St	212-674-6771
Roy, Frederick/56 W 45th St	212-730-0479
Rudd, Greg/420 Lexington Ave #2911	212-986-5680
Ruffins, Reynold/38 E 21st St	212-674-8150
Ruland, Mike/353 W 53rd St #1W	212-682-2462
Rumbola, John/3804 Varragut Rd	212-736-8499
Russell, Billy D/152 W 58th St #6D	212-246-0965
RYAN, TERRY/9 E 32ND (P 58)	**212-688-1080**

S

SABIN, BOB/310 MADISON AVE #1225 (P 26)	**212-867-8092**
Salaverry, Phillip/333 E 49th St	212-980-8061
Saldutti, Denise/463 West St #354H	212-255-9328
Salerno, Steve/226 E 53rd St #3C	212-673-2298
Samuels, Mark/163 Corson Ave	212-447-8536
Sandler, Barbara/221 W 20th St	212-691-2342
Sardello, Joseph/203 Center St	212-351-2289
Saris, Anthony/103 E 86th St	212-831-6353
Sauber, Rob/230 Park Ave	212-986-5680
Savin, Robert/310 Madison Ave	212-867-8092
Sawka, Jan/353 W 53rd St #1W	212-682-2462
Scarisbrick, Ed/9 E 32nd St	212-688-1080
SCHAARE, HARRY/310 MADISON AVE #1225 (P 22, 24)	**212-867-8092**
SCHLEINKOFER, DAVID/230 PARK AVE (P 30)	**212-986-5680**
SCHMIDT, BILL/310 MADISON AVE #1225 (P 26)	**212-867-8092**
SCHMIDT, CHUCK/75 E 55TH ST (P 43)	**212-980-3510**
Schneegass, Martin/35 Carmine #9	212-909-9331
SCHONGUT, EMANUEL/194 THIRD AVE (P 167)	**212-475-0440**
Schorr, Todd/353 W 53rd #1W	212-682-2462
SCHOTTLAND, MIRIAM/470 W 23RD ST (P 48)	**212-242-6367**
Schumach, Michael P./42-34 Saull St	212-445-1587
Schwartz, Frank/145 E 27th St	212-689-3902
Scrofani, Joe/353 W 53rd St #1W	212-682-2462
SEAVER, JEFFREY/130 W 24TH ST (P 168)	**212-255-8299**
SELBY, BILL/342 MADISON AVE (P 55)	**212-697-8525**
SELL, MICHAEL/253 W 72ND ST (P 101)	**212-724-3406**
Seltzer, Isadore/336 Central Park West	212-666-1561
Sempe, J J/215 E 31st St	212-684-3440
Shap, Sandra/342 Madison Ave	212-986-3282
SHEA, MARY ANNE/224 W 29TH ST (P 169)	**212-239-1076**

Sherman, Mary/165 E 32nd ST	212-686-3514
Shields. Charles/226 E 53rd ST	212-755-4945
SHUB, STEVE/114 E 32ND ST (P 60)	**212-685-2770**
Siegel, Norm/333 E 49th St	212-980-8061
Silverman, Burt/324 W 71st St	212-799-3399
Singer, Alan D/70 Prospect Park West	212-788-7760
Slack, Chuck/60 E 42nd St #505	212-682-1490
Slackman, Charles B/320 E 57th St	212-758-8233
Sloan, William/444 E 82nd St, #12C	212-988-6267
Smith, Brett/353 W 53rd St	212-682-2462
Smith, Cornelia/145 E 27th St	212-689-3902
Smith, Edward/114 E 32nd St	212-686-5818
Smith, Jeffrey/226 E 53rd St	212-755-4945
Smith, Joseph/159 John St	212-825-1475
SMITH, LAURA/61 LEXINGTON AVE (P 170)	**212-889-0490**
Smith, Trudi/866 UN Plaza #4014	212-644-2020
Smollin, Mike/420 Lexington Ave #2911	212-986-5680
SMYTHE, DANNY/420 MADISON AVE #401 (P 42)	**212-980-3501**
Sneberger, Dan/342 Madison Ave	212-661-0850
Sobel, Phillip/80-15 41st Ave #128	212-476-3841
SODERLIND, KIRSTEN/111 WOOSTER ST PHC (P 34)	**212-925-0491**
Soileau, Hodges/211 E 51st St	212-755-1365
Soldwedel, Kip/420 Lexington Ave #2911	212-986-5680
Solie, John/420 Lexington Ave	212-986-5680
Sorel, Ed/135 E 54th St	212-421-0050
Sottung, George/420 Lexington Ave	212-986-5680
Spector, Joel/420 Lexington Ave #2911	212-986-5680
Spollen, Chris/203 Center St	212-979-9695
Sposato, John/43 E 22nd St	212-477-3909
Stabin, Victor/100 W 15th St, #4l	212-243-7688
STAHL, NANCY/194 THIRD AVE (P 173)	**212-475-0440**
Stamaty, Mark Alan/118 MacDougal St	212-475-1626
Stasolla, Mario/310 Madison Ave	212-867-8092
Steadman, Barbara/330 E 33rd St, #10-A	212-684-6326
STEADMAN, E.T./470 W 23RD ST (P 48)	**212-242-6367**
STEINER, FRANK/310 MADISON AVE #1225 (P 22, 27)	**212-867-8092**
Sternglass, Arno/6 Jane St	212-989-7074
Sterrett, Jane/160 Fifth Ave	212-929-2566
Stewart, Arvis/866 U N Plaza #4014	212-644-2020
Stillerman, Robbie/230 E 44th St #2F	212-661-7149
Stipleman, Steven/145 E 27th St	212-689-3902
Stone, Bernard Associates/310 Madison Ave	212-675-0226
Stone, Gilbert/58 W 15th St	212-741-2539
Strimban, Robert/349 W 20th St	212-243-6965
Swanson, Robert/17 W 45th St 6th Fl	212-840-8516
Szygiel, Jas/866 U N Plaza #4014	212-644-2020

TU

Taback, Simms/38 E 21st St	212-674-8150
Tankersley, Paul/29 Bethune St	212-924-0015
Taylor, Doug/106 Lexington Ave	212-674-6346
Taylor, Katrina/342 Madison Ave	212-661-0850
Terreson, Jeffrey/420 Lexington Ave #2911	212-986-5680
Theakston, Greg/15 W 72nd St	212-799-2231
Thomas, Bob/420 Madison Ave #401	212-980-3510
Thomas, Phero/866 U N Plaza #4014	212-644-2020
Thornton, Richard/145 E 27th St	212-689-3902
Thornton, Shelley/121 Madison Avenue	212-683-1362
Tiani, Alex/62 W 45th St	212-398-9540
Tobre, Marie/342 Madison Ave	212-697-8525
Tod-Kat Studios/353 W 53rd St #1W	212-682-2462
TRAVERS, BOB/310 MADISON AVE #1225 (P 24, 25)	**212-867-8092**
Trossman, Michael/337 W 20th St	212-243-8839
Trull, John/1573 York Ave	212-535-5383
Tunstull, Glenn/47 State St	212-834-8529
Underwood, Beth/449 W 43rd St #3C	212-246-9788
URAM, LAUREN /251 WASHINGTON AVE (P 176)	**212-789-7717**

V

Vaccaro, Lou/866 U N Plaza #4014	212-644-2020
VALLA, VICTOR/310 MADISON AVE #1225 (P 24, 25)	**212-867-8092**
Van Horn, Michael/49 Crosby St	212-226-8341
Vargo, Kurt/111 E 12th St, Loft #4	212-982-6098
Varlet-Martinelli/200 W 15th St	212-243-4209

ILLUSTRATORS CONT'D.

Please send us your additions and updates.

ILLUSTRATORS

Vebell, Victoria/157 W 57th ST	212-247-1130
Veno, Joe/866 U N Plaza #4014	212-644-2020
Vermont, Hillary/218 East 17th St	212-674-3845
Victor, Joan B #11E/863 Park Ave	212-988-2773
Vitsky, Sally/821 A Union St	212-857-3814
VIVIANO, SAM/25 W 13TH ST (P 178)	**212-242-1471**
Vizbar, Milda/529 E 84th St	212-944-9707

W
Wajdowicz, Jurek/1123 Broadway	212-807-8144
Wald, Carol/57 E 78th St	212-737-4559
Waldman, Michael/506 W 42nd St	212-239-8245
Walker, Norman/535 E 86th St	212-355-0013
Wallner, Alexandra/866 UN Plaza #4014	212-644-2020
Wallner, John/866 U N PLaza #4014	212-644-2020
Ward, Wendy/200 Madison Ave #2402	212-684-0590
WASSON, CAMERON/4 S PORTLAND AVE #3 (P 179)	**212-875-8277**
Weaver, Robert/42 E 12th St	212-254-4289
Weiman, Jon/147 W 85th St #3F	212-787-3184
Wells, Skip/244 W 10th St	212-242-5563
Whistl'N Dixie/200 E 58th St	212-935-9522
WHITEHOUSE, DEBORA/55 BETHUNE ST (P 39)	**212-242-1407**
Wilcox, David/135 E 54th St	212-421-0050
WILKINSON, BILL/155 E 38TH ST (P 183)	**212-697-6170**
WILKINSON, CHUCK/60 E 42ND ST #505 (P 21)	**212-682-1490**
WILLARDSON & WHITE/194 THIRD AVE (P 184,185)	**212-475-0440**
Williams, Richard/58 W 15th St	212-741-2539
Wilson, Jim/311 E 71st St	212-734-3773
WOHLBERG, BEN/43 GREAT JONES ST (P 31)	**212-254-9663**
WOLFF, PUNZ/151 E 20TH ST #5G (P 74)	**212-254-5705**
Wolin, Ron/353 W 53rd St #1W	212-682-2462
WOOD, PAGE/114 E 32ND ST (P 64)	**212-685-2770**
Woodend, James/342 Madison Ave	212-697-8525
Word-Wise,/325 W 45th St	212-246-0430
Wynne, Patricia/446 Central Pk West	212-865-1059

YZ
Yeldham, Ray/230 Park Ave	212-986-5680
York, Judy/165 E 32nd St	212-686-3514
Young, Bruce/9 E 32nd St	212-688-1080
Yule, Susan Hunt/176 Elizabeth St	212-226-0439
Zagorski, Stanislaw/142 E 35th St	212-532-2348
Zaid, Barry/108 E 35th St #1	212-889-3337
Zann, Nicky/521 E 85th St	212-249-5288
Zeldrich, Arieh/866 UN Plaza #4014	212-644-2020
ZIEMIENSKI, DENNIS/121 W 3RD ST (P 35)	**212-254-0233**
Ziering, Bob/151 W 74th St	212-873-0034
Zito, Andy/353 W 53rd St #1W	212-682-2462
Zitting, Joel/333 E 49th St #3J	212-980-8061
Zwarenstein, Alex/15 W 72nd St	212-799-2231

NORTHEAST

A
Abel, Ray/18 Vassar Pl, Scarsdale, NY	914-725-1899
Adam Filippo & Moran/1206 Fifth Avenue, Pittsburgh, PA	412-261-3720
Adams, Norman/229 Berkeley #52, Boston, MA	617-266-3858
Addams, Charles/P O Box 8, Westport, CT	203-227-7806
ADLER, BENTE/103 BROAD ST, BOSTON, MA (P 28)	**617-266-3858**
AIESE, BOB/12 CHARLES, LYNBROOK, NY (P 45)	**516-887-1367**
Alexander, Paul R/37 Pine Mountain Rd, West Redding, CT	203-544-9293
Allen, Christina/289 Main St, Hingham, MA	617-749-0264
Almquist, Don/166 Grovers Ave, Bridgeport, CT	203-336-5649
Ancas, Karen/7 Perkins Manor ll, Jamaica Plain, MA	617-522-2958
Archambault, David/56 Arbor St, Hartford, CT	203-523-9876
The Art Source/201 King St, Chappaqua, NY	914-238-4221
Avati, Jim/10 Highland Ave, Rumson, NJ	201-530-1480

B
Bakley, Craig/68 Madison Ave, Cherry Hill, NJ	609-667-0022
Ball, Harvey/340 Main St, Wooster, MA	617-752-9154
Bang, Molly Garrett/Box 299, Water St, Woods Hole, MA	617-548-7135
Bangham, Richard/7115 Sycamore Ave, Takoma Park, MD	301-460-3698
Banta, Susan/72 Newbern Ave, Medford, MA	617-396-1792
Barkely, James/25 Brook Manor, Pleasantville, NY	914-769-5207

Barrett, Tom/20 Castleton St, Jamaica Plain, MA	617-524-1623
Bass & Goldman/RD 3, Gipsy Trail Rd, Carmel, NY	914-225-8611
Beckelman, Barbara/49 Richmondville Ave, Westport, CT	203-226-3233
Bedard, Rob Ms/10215 Fernwood Rd, Bethesda, MD	301-530-9624
Bellows, Amelia/6438 Brookes Ln, Washington, DC	202-337-0412
Belser, Burkey/1337 Corcoran St NW, Washington, DC	202-462-1482
Berry, Sheila & Richard/93 Warren, Arlington, MA	617-648-6734
Berstein, Steve/48 Arrandale Ave, Great Neck, NY	516-466-4730
Biggins, Wendy/185 Goodhill Rd, Weston, CT	203-226-7674
Bomzer Associates/66 Canal St, Boston, MA	617-227-5151
Booth, George/P O Box 8, Westport, CT	203-227-7806
Braman, Christi/42 Albermarle Ave, Lexington, MA	617-861-1814
Brandt, Joan/PO Box 861, Stratford, CT	203-377-6735
Brautigan, Don/29 Cona Ct, Haledon, NJ	201-956-7710
Breeden, Paul M/1503 Marker Rd, Middletown, MD	301-371-6817
Breiner, Joanne/11 Webster St, Medford, MA	617-395-0865
Brickman, Robin/381 Morris Ave, Providence, RI	401-273-7372
Brown, Michael David/932 Hungerford Dr Bldg 24, Rockville, MD	301-762-4474
Bullock, Wilbur/229 Berkeley #52, Boston, MA	617-266-3858
Burroughs, Miggs/Box 6, Westport, CT	203-227-9667
Burrows, Bill & Assoc/103 E Read St, Baltimore, MD	301-752-4615
Buschini, Maryanne/602 N 16th St #0, Philadelphia, PA	215-235-7838
Butcher, Jim/1357 E Macphail Rd, Belair, MD	301-879-6380

C
CABARGA, LESLIE/258 W TULPEHOCKEN, PHILADELPHIA, PA (P 67)	**215-438-9954**
Carpenter, Sheldon/9 Sparhank St, Brighton, MA	617-782-6827
Carson, Jim/58 Fayette, Cambridge, MA	617-661-3321
Casilla, Robert/36 Hamilton Ave, Yonkers, NY	914-963-8165
Chambless-Rigie, Jane/185 Goodhill Rd, Weston, CT	203-226-7674
Chandler, Jean/385 Oakwood Dr, Wyckoff, NJ	201-891-2381
Chang, Judith/8857 195th St, Hollis, NY	212-465-5598
Cheng, Judith/185 Goodhill Rd, Weston, CT	203-226-7674
CLINE, ROB/229 BERKELEY #52, BOSTON, MA (P 28)	**617-266-3858**
Cober, Alan/95 Croten Dam RD, Ossining, NY	914-941-8696
Cohen, Susan D/708 Willow St #3, Hoboken, NJ	201-659-5473
Collins & Lund Studios/11 S Meramec, Clayton, MO	314-725-0344
CONCEPT ONE/GIZMO/366 OXFORD ST, ROCHESTER, NY (P 126,127)	**716-461-4240**
Conge, Bob/28 Harper St, Rochester, NY	716-244-0183
Console, Carmen/2642 S Mildred St, Philadelphia, PA	215-463-6110
Cooper, Bob/311 Fern Dr, Atco Post Office, NJ	609-767-0967
Cosatt, Paulette/60 South St, Cresskill, NJ	201-568-1436
CRAFT, KINUKO/RFD #1 POB 167, NORFOLK, CT (P 66)	**203-542-5018**
Cramer, D L/17 Lake Dr. E, Wayne, NJ	201-628-8793
CROFUT, BOB/225 PEACEABLE ST, RIDGEFIELD, CT (P 25)	**203-431-4304**

D
Daily, Don/1007 Lombard St, Philadelphia, PA	215-922-1124
Daly, Tom/47 E Edsel Ave, Palisades Park, NJ	201-943-1837
Dan Bridy Visuals Inc/119 1st Ave, Pittsburgh, PA	412-288-9362
Daniel, Alan/185 Goodhill Rd, Weston, CT	203-226-7674
Darrow, Whitney/PO Box 8, Westport, CT	203-227-7806
DAVIDIAN, ANNA/229 BERKELEY #52, BOSTON, MA (P 29)	**617-266-3858**
Davis, Allen/185 Goodhill Rd, Weston, CT	203-226-7674
Davis, Paul/PO Box 360, Sag Harbor, NY	516-725-2248
Dedini, Eldon/PO Box 8, Westport, CT	203-227-7806
DeKiefte, Kees/185 Goodhill Rd, Weston, CT	203-226-7674
Demarest, Robert/87 Highview Terr, Hawthorne, NJ	201-427-9639
DeMuth, Roger Taze/2627 DeGroff Rd, Nunda, NY	716-468-2685
Devlin, Bill/3393 Lufberry, Wantagh, NY	516-785-0376
Dey, Lorraine/10 Highland Ave, Rumson, NJ	201-530-1480
Dior, Jerry/9 Old Hickory Ln, Edison, NJ	201-561-6536
Dodge, Paul/731 N 24th St, Philadelphia, PA	215-928-0918
Dodge, Plunkett/79A Atlantic Ave, Cohasset, MA	617-383-6951
Dougherty, Kevin/10 Highland Ave, Rumson, NJ	201-530-1480
Downey, William/21 Vista Pl, Red Bank, NJ	201-842-5965
Drescher, Joan/23 Cedar, Hingham, MA	617-749-5179

EF
Eagle, Mike/7 Captains Ln, Old Saybrook, CT	203-388-5654
Eberbach, Andrea/185 Goodhill Rd, Weston, CT	203-226-7674
Echevarria, Abe/Box 98-Anderson Rd, Sherman, CT	203-355-1254

Ed Parker Assoc/45 Newbury St, Boston, MA	617-437-7726
Einsel, Naiad/26 S Morningside Dr, Westport, CT	203-226-0709
Einsel, Walter/26 S Morningside Dr, Westport, CT	203-226-0709
Enos, Randall/11 Court of Oaks, Westport, CT	203-227-4785
Epstein, Dave/Dows Ln, Irvington-on-Hudson, NY	914-591-7470
Epstein, Len/720 Montgomery Ave, Narbeth, PA	215-664-4700
Estey, Peg/7 Garden Ct, Cambridge, MA	617-876-1142
Eucalyptus Tree Studio/2220 N Charles St, Baltimore, MD	301-243-0211
Farris, Joe/PO Box 8, Westport, CT	203-227-7806
Ford, Pam/49 Richmondville Ave, Westport, CT	203-226-3233
Frazee, Marla/185 Goodhill Rd, Weston, CT	203-226-7674
Frost, Ralph/Box 542 RD I, Forest Park, Wilkes Barre, PA	717-472-3600
Fuchs, Bernard/3 Tanglewood Ln, Westport, CT	203-227-4644
Fulkerson, Chuck/Box 7 North St, Roxbury, CT	203-354-1365

G

Gaadt, George/888 Thorn, Sewickley, PA	412-741-5161
Garland, Michael/78 Columbia Ave, Hartsdale, NY	914-946-4536
Gist, Linda E/224 Madison Ave, Fort Washington, PA	215-643-3757
Giuliani, Alfred/39 Belleview Ave, Leonardo, NJ	201-291-1751
Glanzman, Louis S/154 Handsome Ave, Sayville, NY	516-589-2613
Glessner, Marc/24 Evergreen Rd, Somerset, NJ	201-249-5038
Gnidziejko, Alex/37 Alexander Ave, Madison, NJ	201-377-2664
Golden, Elisa/330 Rahway, Edison, NJ	201-755-6580
Goldman, Marvin/RD 3 Gypsy Trail Rd, Carmel, NY	914-225-8611
Gordley, Scott/185 Goodhill Rd, Weston, CT	203-226-7674
Gove, Geoffrey/10 Highland Ave, Rumson, NJ	201-530-1480
Grashow, James/14 Diamond Hill Rd, West Redding, CT	203-938-9195
Gustavson, Dale/56 Fourbrooks Rd, Stamford, CT	203-322-5667

H

Haffner, Marilyn/5 Bridge St, Watertown, MA	617-924-5100
Hamilton, William/PO Box 8, Westport, CT	203-227-7806
Handelsman, Bud/PO Box 8, Westport, CT	203-227-7806
Handville, Robert T/99 Woodland Dr, Pleasantville, NY	914-769-3582
Hardy, Neil O/2 Woods Grove, Westport, CT	203-226-4446
Harris, Ellen/125 Pleasant St #602, Brookline, MA	617-739-1867
Harris, Peter/PO Box 412, Brookline, MA	617-524-3156
Harris, Sidney/8 Polo Rd, Great Neck, NY	516-466-6143
Harsh, Fred/185 Goodhill Rd, Weston, CT	203-226-7674
Hazelton, Betsey/106 Robbins Dr, Carlisle, MA	617-369-5309
Heath, R Mark/4338 Roland Springs Dr, Baltimore, MD	301-366-4633
Henderson, David/7 Clover Ln, Verona, NJ	201-783-5791
Herrick, George W/384 Farmington, Hartford, CT	203-527-1940
Hess, Richard/Southover Farms RT 67, Roxbury, CT	203-354-2921
Heyck, Edith/92 Water St, Newburyport, MA	617-462-9027
Hildebrandt, Greg/90 Park Ave, Verona, NJ	201-239-7088
Hildebrandt, Tim/10 Jackson Ave, Gladstone, NJ	201-234-2149
Hockerman, Dennis/185 Goodhill Rd, Weston, CT	203-226-7674
Hogan, Jamie/131 Pierce St, Malden, MA	617-254-2740
Huehnergarth, John/196 Snowden Ln, Princeton, NJ	609-921-3211
Huffaker, Sandy/375 Snowden Lane, Princeton, NJ	609-924-2883
Hulsey, John/Rte 9D, Garrison, NY	914-424-3544
Hunt, Stan/Box 8, Westport, CT	203-227-7806
Hurwitz, Joyce/7314 Burdette Ct, Bethesda, MD	301-365-0340

IJ

Iosa, Ann/185 Goodhill Rd, Weston, CT	203-226-7674
Irwin, Virginia/174 Chestnut Ave #2, Jamaica Plain, MA	617-522-0580
Jaeger Design Studio #622/2025 I St NW, Washington, DC	202-785-8434
Jean, Carole/45 Oriole Dr, Roslyn, NY	516-742-3322
Jim Deigen and Associates/625 Stanwick St, Pittsburgh, PA	412-391-1698
Johne, Garrett/84-35 Lander St #4F, Briarwood, NY	212-523-5558
JOHNSON, B E/366 OXFORD ST,	
ROCHESTER, NY (P 126,127)	**716-461-4240**
Johnson, David A/299 South Ave, New Canaan, CT	203-966-3269
Jones, George/52 Old Highway, Wilton, CT	203-762-7242
Jones, John R/75 Town St, East Haddam, CT	203-873-9950
Jones, Roger/15 Waldo Ave, Somerville, MA	617-628-1487
Jordan, Laurie/185 Goodhill Rd, Weston, CT	203-226-7674

K

Kalish, Lionel/Box 559, Woodstock, NY	914-679-8156
Katsin, Nancy/417 E 72nd St #3B, New York, NY	212-535-7786
Kidder, Harvey/Stillman Ln, Pleasantville, NY	914-769-6298

Kingham, Dave/17 Washington St, S Norwalk, CT	203-226-3106
Koeppel, Gary/368 Congress, Boston, MA	617-426-8887
Kossin, Sanford/143 Cowneck Rd, Port Washington, NY	516-883-3038
KOVALCIK, TERRY/88 UNION AVE, CLIFTON, NJ (P 131)	**201-478-1191**
Kovarsky, Anatol/PO Box 8, Westport, CT	203-227-7806

L

Laird, William/10 Highland Ave, Rumson, NJ	201-530-1480
Lambert, Saul/153 Carter Rd, Princeton, NJ	609-924-6518
Lane, Jack/177 San Juan Dr, Hauppauge, NY	516-361-6051
LANGDON, JOHN/106 S MARION AVE,	
WENONAH, NJ (P 134)	**609-468-7868**
Lanza, Barbara/PO Box 118, Pine Island, NY	914-258-4601
Laquatra, Jack/1221 Glencoe Ave, Pittsburgh, PA	412-279-6210
Layman, Linda J/35 Ware Rd, Auburndale, MA	617-965-0519
Lazarevich, Mila/185 Goodhill Rd, Weston, CT	203-226-7674
Leamon, Tom/18 Main St, Amherst, MA	413-256-8423
Lehew, Ron/17 Chestnut St, Salem, NJ	609-935-1422
Leibow, Paul/369 Lantana Ave, Englewood, NJ	201-567-7814
Levine, Ned/301 Frankel Blvd, Merrick, NY	516-378-8122
LEYONMARK, ROGER/229 BERKELEY #52,	
BOSTON, MA (P 28)	**617-266-3858**
Lidbeck, Karin/185 Goodhill Rd, Weston, CT	203-226-7674
Loccisano, Karen/185 Goodhill Rd, Weston, CT	203-226-7674
Locke, John A, III/Dept of Vis Arts Ulster County,	
Stone Ridge, NY	914-339-4872
Longacre, Jimmy/185 Goodhill Rd, Weston, CT	203-679-1358
Lorenz, Al/185 Goodhill Rd, Weston, CT	203-226-7674
Lorenz, Lee/Box 8, Westport, CT	203-227-7806
Lubey, Dick/726 Harvard, Rochester, NY	716-442-6075
Luce, Ben/52 Strathmore Rd, #32, Brookline, MA	617-277-9607
LUZAK, DENNIS/PO BOX 342, REDDING RIDGE, CT (P 144)	**212-938-3278**
Lynch, Don/532 N Broadway, Upper Nyack, NY	914-358-3939
Lyon, Lynne/9 Castleton St, Jamaica Plain, MA	617-522-4533

M

MacArthur, Dave/147-B Bradford Ave, Cedar Grove, NJ	201-857-1046
MacDonald, Susan/6 Holly Ave c/o J Riseman, Cambridge, MA	617-354-7935
Maffia, Daniel/44 N Dean St, Englewood, NJ	201-871-0435
Mahoney, Katherine/60 Hurd Rd, Belmont, MA	617-489-0406
Margerin, Bill/731 N 24th St, Philadelphia, PA	215-928-0918
Mariuzza, Pete/146 Hardscrabble Rd, Briarcliff Manor, NY	914-769-3310
Marmo, Brent/15A St Mary's Ct, Brookline, MA	617-491-6214
Martin, Henry/PO Box 8, Westport, CT	203-227-7806
MASCIO, TONY/4 TETON CT, VOORHEES, NJ (P 147)	**215-567-1585**
Mayforth, Hal/19 Irma Ave, Watertown, MA	617-923-4668
McCanlish, Joan/327A Highland Ave, Somerville, MA	617-666-4546
McCollum, Rick/5 Palmieri Ln, Westport, CT	203-255-2275
McGinnis, Robert/13 Arcadia Rd, Old Greenwich, CT	203-637-5055
McGuire, Arlene Phoebe/51 W Walnut La, Philadelphia, PA	215-844-0754
McIntosh, Jon C/268 Woodward St, Waban, MA	617-964-6292
Michael Gnatek Assoc/6642 Barbnaby St NW, Washington, DC	202-363-6803
Michaels, Ian/488 Main St, Fitchburg, MA	617-345-4476
Miles, Elizabeth/185 Goodhill, Weston, CT	203-226-7674
Miller, Warren/PO Box 8, Westport, CT	203-227-7806
Milnazik, Kim/210 Locust St, #3F, Philadelphia, PA	215-922-5440
Mistretta, Andrea/5 Bohnert Pl, Waldwick, NJ	201-652-5325
Mitchell & Company/1627 Connecticut Ave NW,	
Washington, DC	202-483-1301
Miyake, Yoshi/185 Goodhill Rd, Weston, CT	203-226-7674
Modell, Frank/PO Box 8, Westport, CT	203-227-7806
Munger, Nancy/185 Goodhill Rd, Weston, CT	203-226-7674
Myers, Lou/58 Lakeview Ave, Peekskill, NY	914-737-2307

NO

NEIBART, WALLY/1715 WALNUT ST,	
PHILADELPHIA, PA (P 33)	**215-564-5167**
Newman, Robert/570 W. Dekalb Pike #111,	
King of Prussia, PA	215-337-2745
Norman, Marty/5 Radcliff Blvd, Glen Head, NY	516-671-4482
Oh, Jeffrey/2635 Ebony Rd, Baltimore, MD	301-661-6064
Olsen, Jimmy/527 Rosewood Terr, Linden, NJ	201-486-5752
Olson, Victor/Santon Meadows, Weat Redding, CT	203-938-2868
Oni/3514 Tulip Dr, Yorktown Hts, NY	914-245-5862
Otnes, Fred/Chalburn Rd, West Redding, CT	203-938-2829

ILLUSTRATORS (side tab)

P

Paine, Larry & Assoc/4617 Edgefield Rd, Bethesda, MD	301-493-8445
Palulian, Dickran/18 McKinley St, Rowayton, CT	203-866-3734
Passalacqua, David/325 Versa Pl, Sayville, NY	516-589-1663
Pate, Rodney/185 Goodhill Rd, Weston, CT	203-226-7674
Payne, Thomas/11 Colonial Ave, Albany, NY	518-482-1756
Perina, Jim/33 Regent St, N Plainfield, NJ	201-757-3010
Pierson, Mary Louise/743 Bedford Rd, Tarrytown, NY	914-631-3711
Pinkney, Jerry/41 Furnace Dock Rd, Croton-on-Hudson, NY	914-271-5238
Pisano, Al/21 Skyline Dr, Upper Saddle River, NJ	201-327-6716
Plotkin, Barnett/126 Wooleys Ln, Great Neck, NY	516-487-7457
Plumridge Artworks Inc/10215 Fernwood Rd, Bethesda, MD	301-530-9624
POLLACK, SCOTT/11 TRINITY PL., HEWLETT, NY (P 56)	**516-295-4026**
Porzio, Ed/131 Bartlett Rd, Winthrop, MA	617-846-3875
Powell, Witney/20 Prescott St #34, Cambridge, MA	617-354-2570
Provensen, Alice/Meadowbrook Ln, Clinton Corners, NY	914-266-3245
Pruyn, Glen/7333A Rockwell Ave, Philadelphia, PA	215-722-1323
Puccio, Jim/32 Rugg Rd, Allston, MA	617-783-2719

R

Ramage, Alfred/29 Tewksbury St, Winthrop, MA	617-846-5955
Ramus, Michael/954 Kingston Rd, Princeton, NJ	609-924-4266
Raymo, Anne/RT 28A, West Shokan, NY	914-657-6405
Recchia, Dennis/191 Engle St., Englewood, NJ	201-871-1595
Recchia, Janet/191 Engle St., Englewood, NJ	201-569-6136
Richardson, Suzanne/185 Goodhill Rd, Weston, CT	203-226-7674
Richter, Mische/Box 8, Westport, CT	203-227-7806
RICKERD, DAVID/18 UNIVERSITY AVE,	
CHATHAM, NJ (P 164)	**201-635-9513**
RILEY, FRANK/108 BAMFORD AVE.,	
HAWTHORNE, NJ (P 52)	**201-423-2659**
Rogers, Howard/Walnut Ln, Weston, CT	203-227-2273
Roman, Irena/369 Thomas Clapp Rd., Scituate, MA	617-545-6514
Ross, Jeremy/26 Vautrinot Ave, Hull, MA	617-925-0176
Ross, Richard/71 Redbrook Rd, Great Neck, NY	516-466-3339
Roth, Gail/185 Goodhill Rd, Weston, CT	203-226-7674
Rutherford, Jenny/185 Goodhill Rd, Weston, CT	203-226-7674

S

Saint John, Bob/320 South St, Portsmouth, NH	603-431-7345
Sanderson, Ruth/185 Goodhill Rd, Weston, CT	203-226-7674
Santa, Monica/185 Goodhill Rd, Weston, CT	203-226-7674
Santore, Charles/138 S 20th St, Philadelphia, PA	215-563-0430
Saxon, Charles/Box 8, Westport, CT	203-227-7806
Schenker, Bob/731 N 24th St, Philadelphia, PA	215-928-0918
Schleinkofer, David/344 Crown St, Morrisville, PA	215-295-8622
Schneider, Rick/260 Montague Rd, Leverett, MA	413-549-0704
Sharpe, Jim/5 Side Hill Rd, Westport, CT	203-226-9984
Sherman, Whitney/702 N. Eutaw St., Baltimore, MD	301-685-3626
Shevins, Scott J./300 Anchor Ave, Oceanside, NY	516-764-9195
Sierra, Dorthea/5 Bridge St, Watertown, MA	617-924-5100
Sims, Blanche/185 Goodhill Rd, Weston, CT	203-226-7674
Skibinski, Ray/694 Harrell Ave, Woodbridge, NJ	201-634-3074
Smith, Douglas/405 Washington St. #2, Brookline, MA	617-566-3816
Smith, Elwood H./2 Locust Grove Rd, Rhinebeck, NY	914-876-2358
Smith, Gary/10 Highland Ave, Rumson, NJ	201-530-1480
Smith, Marcia/35 Bond St, Rochester, NY	716-275-9348
Smith, Susan B./22 Henchman St, Boston, MA	617-523-0593
Solomon, Shimon Josef/741 Dearborn St., Teaneck, NJ	201-836-7332
Soyka, Ed/231 Lafayette Ave, Peekskill, NY	914-737-2230
Spanfeller, Jim/Mustato Rd, Katonah, NY	914-232-3546
Sparkman, Gene/15 Bradley Lane, Sandy Hook, CT	203-426-0061
Sparks, Richard & Barbara/2 W Rocks Rd, Norwalk, CT	203-866-2002
Spence, Jim/185 Goodhill Rd, Weston, CT	203-226-7674
Spitzmiller, Walter/24 Lee Lane Rd 2, West Redding, CT	203-938-3551
Springer, Sally/185 Goodhill Rd, Weston, CT	203-226-7674
Stahl, Benjamin F/East Hill, Lichfield, CT	203-567-8005
Steig, William/Box 8, Westport, CT	203-227-7806
Steinberg, Herb/PO Box 65, Roosevelt, NJ	609-448-4724
Stevenson, James/Box 8, Wesport, CT	203-227-7806
Stirweis, Shannon/31 Fawn Pl, Wilton, CT	203-762-7058
Stump, Greg/2 Upton Hall, Newark, DE	302-737-0813
Syverson, Henry/Box 8, Westport, CT	203-227-7806

T V

Taktakajian, Asdur/17 Merlin Ave, North Tarrytown, NY	914-631-5553
Tandem Graphics/5313 Waneta Rd, Bethesda, MD	301-320-5008
Tauss, Herb/S Mountain Pass, Garrison, NY	914-424-3765
Thompson, John M/River Road, W Cornwall, CT	203-672-6163
TINKELMAN, MURRAY/75 LAKEVIEW AVE W,	
PEEKSKILL, NY (P 20)	**914-737-5960**
Todd, Kathleen/241 Upland Rd., Cambridge, MA	617-864-1818
Toulmin-Rothe, Ann/49 Richmondville Rd, Westport, CT	203-226-3011
Traub, Patricia/25-30 Aspen St, Philadelphia, PA	215-769-1378
TSUI, GEORGE/2250 ELLIOT ST, MERRICK, NY (P 175)	**516-223-8474**
Valeho, Boris/24 St Andrews Pl, Yonkers, NY	914-423-8694
VISKUPIC, GARY/7 WESTFIELD DR,	
CENTER PORT, NY (P 177)	**516-757-9021**
Vissichelli, Joe/34-40 Church St #21, Malverne, NY	516-599-2562

W

W.E. Duke Illustration/216 Walnut St, Holyoke, MA	413-536-8269
Waldman, Neil/12 Turner Rd, Pearl River, NY	914-735-6699
Warner, Sara/PO Box 1454-GMS, Boston, MA	617-451-5362
Watson, Karen/100 Churchill Ave, Arlington, MA	617-641-1420
WATTS, MARK/616 IVA LN., FAIRLESS HILLS, PA (P 180)	**215-945-9422**
Weber, Robert/Box 8, Westport, CT	203-227-7806
Weller, Linda Boehm/185 Goodhill Rd, Weston, CT	203-226-7674
Whelan, Michael/172 Candlewood Lake Rd, Brookfield, CT	203-775-4430
Williams, Frank/130 Bainbridge St, Philadelphia, PA	215-625-2408
Wilson, Rowland/PO Box 8, Westport, CT	203-227-7806
Windfall Arts Ltd/104 Charles St, Boston, MA	617-367-0810
Witschonke, Alan/40 Magnolia St., Arlington, MA	617-646-7549
Woodman, Bill/PO Box 8, Westport, CT	203-227-7806
The Wozniaks/15520 Clifton Blvd., Cleveland, OH	516-757-5609

Y Z

Young, Debby/185 Goodhill Rd, Weston, CT	203-226-7674
YOUNG, ROBERT ASSOC/78 NORTH UNION ST,	
ROCHESTER, NY (P 188)	**716-546-1973**
Ziegler, Bill/PO Box 8, Westport, CT	203-227-7806
Zimmerman, Jerry/287 Francis St, Teaneck, NJ	201-836-6469

SOUTHEAST

A B

A 1A/355 NE 79th St, Miami, FL	305-757-7164
Adams, Lisa/161 Aragon Ave, Coral Gables, FL	305-444-4080
Advertising Artists/880 W 53rd Terr, Hialeah, FL	305-557-4631
Andrew, Joan/9315 Glenbrook Rd, Fairfax, VA	703-385-0126
Aplin, Jim/124 N Forest Ave, Lookout Mt, TN	615-821-1295
Armstrong, Lynn/7325 Chatt. Bluff Dr, Atlanta, GA	404-396-0742
Art Directions/14875 NE 20th Ave, N Miami, FL	305-940-5355
Arunski, Joe & Assoc/8264 SW 184th Terro, Miami, FL	305-253-3337
Bailey, R.C./255 Westward Dr, Miami Springs, FL	305-888-6309
Boatright, John/PO Box 171382, Memphis, TN	901-683-1856
Boone, Joe/PO Box 99337, Louisville, KY	502-499-9220
Breakey, John/2909 Peachtree Rd NE #C8, Atlanta, GA	404-237-0788
Bull, Richard/785 Ponce De Leone Pl NE, Atlanta, GA	404-876-7835

C D F

Carey, Wayne/532 Hardendorp Ave, Atlanta, GA	404-378-0426
Chaisson, Brant/1420 Lee Ave, Houma, LA	504-868-7423
Cochran, Bobbye/213 W Institute Pl # 605, Chicago, IL	312-943-5912
Condak, Cliff/4104 S Ocean Blvd, #5, Highland Beach, FL	305-276-8342
Cooper-Copeland Inc./1151 W Peachtree St NW, Atlanta, GA	404-892-3472
Cosgrove, Dan/405 N Wabash #4307, Chicago, IL	312-527-0375
Davis, Mike/1461 Rockspring Cle #3, Atlanta, GA	404-872-5525
DeBro, James/2725 Hayden Dr, Eastpoint, GA	404-262-7380
Faure, Renee/600 Second St, Neptune Beach, FL	904-246-2781
Fleck, Tom/One Park Place #120 1900 E, Atlanta, GA	404-355-0729

G

Gaadt, David M/3656 Chestnut Ridge Ct, Marietta, GA	404-434-7322
George, Eugene/2905 Saint Anne St, New Orleans, LA	504 486 4312
Gordon, Jack/5716 S 2nd St, Arlington, VA	703-820-0145
Graphics Group/56 E Andrews Dr, Atlanta, GA	404-261-5146
GREATHEAD, IAN/2975 CHRISTOPHER'S COURT,	
MARIETTA, GA (P 115)	**404-952-5067**

ILLUSTRATORS CONT'D.

Please send us your additions and updates.

HIJ
Hamilton, Marcus/12225 Ranburne Rd, Charlotte, NC	704-545-3121
Havaway, Jane/806 Briarcliff Rd, Atlanta, GA	404-872-7284
Hicks, Richard Edward/3635 Pierce Dr. Ste 76, Chamblee, GA	404-457-8928
Hinojosa, Albino/2101 Mesa Dr, Ruston, LA	318-257-2532
Ison, Diana/4212 E Knob Oak Lane, Charlotte, NC	704-364-8138
Jones, Jack/104 Ardmore Pl #1, Atlanta, GA	404-355-6357

KL
Kerns, Jeffrey/48 Peach Tree Ave, Atlanta, GA	404-233-5158
King, Gregory N/3524 Clubhouse Dr, #F, Decatur, GA	813-461-2934
Lee, Kelly/3511 N 22nd St, Arlington, VA	703-527-4089
LESTER, MIKE/5218 CHAMBLEE DUNWOODY RD, ATLANTA, GA (P 138)	**404-399-5288**
Lewis, Chris/503 Ansley Villa Dr, Atlanta, GA	404-892-6303
LOVELL, RICK/745 KIRK RD, DECATUR, GA (P 143)	**404-371-0681**

MN
MacDonald, Richard/1144 Crescent Ave NE, Atlanta, GA	404-881-0212
MAYER, BILL/240 FORKNER DR, DECATUR, GA (P 75)	**404-378-0686**
McGary, Richard/180 NE 39th St #125, Miami, FL	305-573-0490
McGurren Weber Ink/104-C S Alfred St, Alexandria, VA	703-548-0003
MCKELVEY, DAVID/2702 FRONTIER COURT, ATLANTA, GA (P 150)	**404-457-3615**
McKinney,/21 W. Church St, Jacksonville, FL	904-358-4453
McKinney, Deborah/PO Box 2567, Jacksonville, FL	904-358-4453
Meyers, Bill/240 Faulkner Dr, Decatur, GA	404-378-0686
Nelson, Bill/1402 Wilmington Ave, Richmond, VA	804-358-9637

OPR
Olson, Linda/1 Charter Plaxa, Jacksonville, FL	904-358-4453
Overacre, Gary/RD 2, 3802 Vineyard Trace, Marietta, GA	404-973-8878
OVIES, JOE/1900 EMERY ST NW #120, ATLANTA, GA (P 42)	**404-355-0729**
PARDUE, JACK/2307 SHERWOOD HALL LN, ALEXANDRIA, VA (P 53)	**703-765-2622**
Pate, Martin/401 W Peachtree NW, Atlanta, GA	404-221-0700
Penca, Gary/3184 NW 39th Ct, Lauderdale Lakes, FL	305-733-5847
Richard Allyn Studios/369 NE 167 St, N Miami Beach, FL	305-945-1702
Richards, William E/9550 Regency Sq Blvd, PO 2567, Jacksonville, FL	904-358-4453
ROBINETTE, JOHN/1147 S PRESCOTT, MEMPHIS, TN (P 166)	**901-452-9853**

ST
Saffold, Joe/719 Martina Dr NE, Atlanta, GA	404-231-2168
Salmon, Paul/5826 Jackson's Oak Ct., Burke, VA	703-250-4943
Sams, B B/PO Box A, Social Circle, GA	404-464-2956
Santa Maria, Paul/5411 NW 23rd St, Buffalo, FL	305-434-0551
Shelly, Ron/6396 Manor La, S Miami, FL	305-667-0154
Spetseris, Steve/401 W Peachtree NW, Atlanta, GA	404-221-0700
Trevor, Irwin/2222B Lindmont Cle NE, Atlanta, GA	404-261-6639
Turner, Pete/938 Pamlico Dr, Cary, NC	919-467-8466

VWY
Vander Weg, Phil/Box 450 MTSU, Murfreesboro, TN	615-896-4239
Vaughn, Rob/PO Box 660706, Miami Springs, FL	305-885-1292
Wasiluck Associates/1333 Tierra Cir, Winter Park, FL	305-678-6964
Webber, Warren/401 W Peachtree NW, Atlanta, Ga	404-221-0700
Whitver, Harry K./208 Reidhurst Ave., Nashville, TN	615-320-1795
Whole Hog Studios. Ltd/1205 Spring St, Atlanta, GA	404-873-4021
Wooden Reps/503 Ansley Villa Dr, Atlanta, GA	404-892-6303
The Workshop, David Dobra/735 Bismark Rd NE, Atlanta, GA	404-875-0141
Young, Bruce/503 Ansley Villa Dr, Atlanta, GA	404-892-6303

MIDWEST

AB
AHEARN, JOHN D/151 S ELM, ST LOUIS, MO (P 76)	**314-721-3997**
Anastas, Nicolette/535 N Michigan Ave, Chicago, IL	312-943-1668
Art Staff Inc/1200 City National Bank Bldg, Detroit, MI	313-963-8240
Artist Studios/666 Euclid Ave, Cleveland, OH	216-241-5355
Blauchette, Dan/645 N. Michigan, Chicago, IL	312-787-6826
Bowman, Bob/163 Cedarwood Ct, Palatine, IL	312-966-2770
Busch, Lonnie/11 Meadow Dr., Fenton, MO	314-343-1330
Buttram, Andy/1636 Hickory Glen Dr, Miamisburg, OH	513-298-0566

CDE
Centaur Studios/10 Broadway, St Louis, MO	314-421-6485
Clyne, Dan/535 N Michigan Ave, #1416, Chicago, IL	312-943-1668
Collier, John/2309 Willow Creek Lane, Laurence, KS	215-928-0918
Collier, John/2309 Willow Creek Ln, Lawrence, KS	913-841-6442
COMMERCIAL ART STUDIO/151 S ELM, ST LOUIS, MO (P 76)	**314-721-3997**
CRAIG, JOHN/RT 2 BOX 81 TOWER RD, SOLDIERS GROVE, WI (P 94,95)	**608-872-2371**
Creative Source/360 N Michigan, Chicago, IL	312-649-9777
Csicsko, David/2350 N Cleveland, Chicago, IL	312-935-1707
DICIANNI, RON/340 THOMPSON BLVD, BUFFALO GROVE, IL (P 102)	**312-634-1848**
Duggan, Lee/405 N Wabash #4307, Chicago, IL	312-527-0375
Dye, Jim International/2228 Thornton Dr, Des Moines, IA	515-287-6050
EATON & IWEN/307 N MICHIGAN, CHICAGO, IL (P 28, 29)	**312-332-3256**
Elbie/PO Box 1225, St. Louis, MO	314-343-6568
English, Mark/5013 A Walnut St, Kansas City, MO	816-931-0366

FGH
Flood, Dick/2210 S Lynn, Urbana, IL	217-328-3642
Gardner, D B/1098 12th Ave SE, Minneapolis, MN	612-378-1995
Gates, Bruce/356 1/2 S Main St, Akron, OH	216-375-5282
Goldammer, Ken/405 N Wabash #3001, Chicago, IL	312-836-0143
Graham, Bill/2350 N Cleveland, Chicago, IL	312-935-1707
Groff, David/2204 S Patterson Blvd #1, Kettering, OH	513-294-2700
Handelan-Pedersen/333 N Michigan, Chicago, IL	312-782-6833
Hsi, Kai/160 E Illinois, Chicago, IL	312-642-9853

IJK
Izold, Donald/20475 Bunker Hill Dr., Fairview Park, OH	216-333-9988
Jacobsen, Bill/405 N Wabash #1801, Chicago, IL	312-321-9558
Jamerson, David/6332 N Guilford Ave, Indianapolis, IN	317-257-8752
Johnson, Larry A/2617 #rd Ave S #3, Minneapolis, MN	612-871-4783
Johnson, Rick/535 N Michigan, Chicago, IL	312-943-1668
Johnston, David McCall/26110 Carol St, Franklin, MI	313-626-9546
Juenger, Richard/411 N 7th, #1515, St Louis, MO	314-231-4069
Kahl, Konrad/26039 German Hill, Franklin, MI	313-851-7064
Kauffman, George/1232 W 70th Terr, Kansas City, MO	816-523-0223
Kocar, George/2141 W 98th St, Cleveland, OH	216-651-8171
Kock, Carl/311 N Desplaines Ave, Chicago, IL	312-559-0440
Kordic, Vladimar/3535 Grovewood Dr., East Lake, OH	216-946-6824

LM
Langeneckert, Donald/4939 Ringer Rd, St Louis, MO	314-487-2042
Langton, Bruce/53145 Kinglet, South Bend, IN	219-277-6137
Laurent, Richard/1132 W Columbia Ave, Chicago, IL	312-761-1436
LEE, JARED D/2942 OLD HAMILTON RD, LEBANON, OH (P 137)	**513-932-2154**
Lesh, David/6332 Guilford Ave, Indianapolis, IN	317-253-3141
MAGDICH, DENNIS/1914 N DAYTON, CHICAGO, IL (P 55)	**312-248-6492**
Mahan, Benton/PO Box 66, Chesterville, OH	419-768-2204
Mayes,Kevin/1414 Alturas, Wichita, KS	316-942-6210
McInturff, Steve/6174 Joyce La. #2, Cincinnati, OH	513-731-8017
McMahon, Mark/2620 Highland Ave, Evanston, IL	312-869-6491
Meents, Len/448 S 8th Ave, La Grange, IL	312-482-4674
Miller, Bill/1355 N Sandburg Terr Ste 2, Chicago, IL	312-787-4093
Miller, Doug/1180 Chambers Rd #103C, Columbus, OH	614-488-3987

NOP
Nighthawk Studio/1250 Riverbed Rd, Cleveland, OH	216-522-1809
Norcia, Ernest/3395 Houston Rd, Waynesville, OH	513-862-5761
Novack, Bob/6809 Mayfield Gates Mills Twrs, Mayfield Hts., OH	216-442-0456
O'Grady, Jack Graphics Inc/333 N Michigan #2200, Chicago, IL	312-726-9833
Pigalle Studios Inc/314 N Broadway, #1936, St Louis, MO	314-241-4398
Pitt Studios, Inc./1370 Ontario, Cleveland, OH	216-241-6720
Pope, Kevin/4540 Gifford Rd #44D, Bloomington, IN	812-332-1599

QRS
Quinn, Colleen/535 N Michigan, Chicago, IL	312-943-1668
Rybka, Stephen/535 N Michigan, Chicago, IL	312-943-1668
Sahratian, John/2100 W Big Beaver Rd, Troy, MI	313-643-6000
Schmelzer, J P/539 N Thatcher, River Forest, IL	312-366-5051
Schrier, Fred/9058 Little Mtn Rd, Kirtland Hills, OH	216-757-5609
Scibilia, Dom/2902 Franklin Blvd, Cleveland, OH	216-861-2561
Selfridge, Mary/3317 N Sheffield, Chicago, IL	516-757-5609

Shay, RJ/3301 S Jefferson, St Louis, MO — 314-773-9989
Skillicorn Associates, Inc/410 S Michigan Ave, Chicago, IL — 312-663-4313
Slack, Chuck/9 Cambridge Ln, Lincolnshire, IL — 312-948-9226
SMITH, RAYMOND/1546 WEST SHERWIN,
 CHICAGO, IL (P 171) — **312-973-2625**
Smithback, Jes/2013 E 7th St, PO Box 556, Wellington, KS — 316-326-8631
Stephens Biondi Decicco/230 E Ohio, Chicago, IL — 312-944-3340
Sumichrast, Joe/860 N Northwoods, Deerfield, IL — 312-945-6353

TV
TAYLOR, DAVID/1449 N PENNSYLVANIA ST,
 INDIANAPOLIS, IN (P 174) — **317-634-2728**
Thiewes, Sam/111 N Andover La, Geneva, IL — 312-232-0980
Thumbtac Studio/2013 E 7th St, PO Box 556, Wellington, KS — 316-326-8631
TOWNLEY, JON/61 SUNNYSIDE LANE,
 COLUMBUS, OH (P 54) — **614-888-1597**
Trusilo, Jim/535 N Michigan Ave, Chicago, IL — 312-943-1668
Vann, Bill Studio/1706 S 8th St, St Louis, MO — 314-231-2322
Vuksanovich, Bill/3224 N Nordica, Chicago, IL — 312-283-2138

WYZ
Watson, Richard/6007 W 61st St, Shawnee, KS — 913-262-9654
Weiss, Barbara/23856 Norcrest, Southfield, MI — 313-357-5985
Willson Graphics/100 E Ohio #314, Chicago, IL — 312-642-5328
WIMMER, CHUCK/5000 IRA AVE, CLEVELAND, OH (P 186) — **216-651-1724**
WOLF, LESLIE/2350 N CLEVELAND, CHICAGO, IL (P 187) — **312-935-1707**
YOUSSI, JOHN/RT #1, 220 POWERS RD,
 GILBERTS, IL (P 189) — **312-428-7398**
Zimnicki Design/798 Oregon Trail, Roselle, IL — 312-893-2666

SOUTHWEST

ABC
ANDREWS, CHRIS/1515 N. BEVERLY AVE,
 TUCSON, AZ (P 78) — **602-325-5126**
Bates, Al/7714 Rolling Fork Ln, Houston, TX — 713-466-4977
Brazeal, Lee Lee/9131 West View, Houston, TX — 713-668-0221
Collier, Steve/5512 Chaucer Dr, Houston, TX — 713-522-0205
Criswell, Ron/5016 McKinney Ave, Dallas, TX — 214-522-8582

DEF
Dean, Michael/5512 Chaucer, Houston, TX — 713-527-0295
Dewy, Jennifer/224 Carlisle Bl NE, Alberquerque, NM — 505-266-9772
Durbin, Mike/4034 Woodcraft, Houston, TX — 713-667-8129
Eagle, Bruce/4101 NW Expwy CB 16-188, Oklahoma City, OK — 405-751-9536
Escobedo, Louis/803 Arthur Dr., Arlington, TX — 817-261-8197
Falk, Rusty/707 E Alameda Dr., Tempe, AZ — 602-966-1626
Forbes, Bart/2706 Fairmount, Dallas, TX — 214-748-8436

GHK
Garns, Alan/3314 E El Moro, Mesa, AZ — 602-830-7224
Griffin, David/3000 Carlisle, #208, Dallas, TX — 214-742-6746
GRIMES, DON/3514 OAK GROVE, DALLAS, TX (P 116) — **214-526-0040**
Hall, Bill/1235-B Colorado Lane, Arlington, TX — 817-277-5981
HIGH,RICHARD 4500 MONTROSE,STE D, HOUSTON,TX(P121) — **713-521-2772**
KIRKMAN, RICK/313 E THOMAS RD #205,
 PHOENIX, AZ (P 70) — **602-279-0119**

LMP
Lapsley, Bob/3707 Nottingham, Houston, TX — 713-667-4393
Lewis, Maurice/3704 Harper St, Houston, TX — 713-664-1807
LINDLOF, ED/603 CAROLYN AVE, AUSTIN, TX (P 141) — **512-472-0195**
Loveless, Jim/4137 San Francisco, St Louis, MO — 314-533-7914
MACPHERSON, KEVIN/313 E THOMAS RD #205,
 PHOENIX, AZ (P 70) — **602-279-0119**
Payne, Chris F/1800 Lear St, Dallas, TX — 214-421-3993
PENDLETON, NANCY/313 E THOMAS RD #205,
 PHOENIX, AZ (P 70) — **602-279-0119**
Peters, Bob/313 E Thomas Rd #205, Phoenix, AZ — 602-279-0119
Punchatz, Don Ivan/2605 Westgate Dr, Arlington, TX — 817-460-7680

RS
Richardson, Ralph/949 Avenue B, Suite B, Yuma, AZ — 602-726-5411
Ricks, Thom/6511 Adair Dr, San Antonio, TX — 512-680-6540
Rogers, Sara/3929 Hawthorne, Dallas, TX — 214-526-3509
Schorre, Charles/2406 Tangley Rd, Houston, TX — 713-522-8628
Sketch Pad/2605 Westgate Dr, Arlington, TX — 817-469-8151
Skistimas, James/7701 N Stemmons Frwy., #85, Dallas, TX — 214-630-2574
Strand, David/603 W Garland Ave, #206, Garland, TX — 214-494-0095

Sundgren, Deborah/5222 E Windsor #8, Phoenix, AZ — 602-840-6286

UWZ
Unruh, Jack/333 7616 LBJ, Dallas, TX — 214-748-8145
WATFORD, WAYNE/313 E THOMAS RD, PHOENIX, AZ (P 70) — **602-279-0119**
Zapata, Deborah/5222 E Windsor Ave #8, Phoenix, AZ — 602-840-6286

WEST

A
Abrams, Edward/255 Portufino Way, Redondo Beach, CA — 213-372-6266
Abrams, Jodell Davidow/255 Portafino Way, Redondo, CA — 213-372-6266
Akimoto, George/621 Villa Mont Ave, Monterey Park, CA — 213-573-3930
Allaire, Michael/405 Union St, #2, San Francisco, CA — 415-982-5598
Allan, Gus/385 Millwood Dr, Millbrae, CA — 415-871-9034
Allison, Gene/1808 Stanley Ave, Placentia, CA — 714-524-5955
Alsina, Gustav/5103 Pico Blvd, Los Angeles, CA — 213-939-1900
Alt, Tim/2800 28th, #152, Santa Monica, CA — 213-392-4877
Alvin, John/15942 Londelius, Sepulveda, CA — 213-279-1775
Anderson, Jon/1465 Ellendale Ave, Logan, UT — 801-752-8936
Anderson, Terry/5902 W 85th Pl, Los Angeles, CA — 213-645-8469
Andreoli, Rick/5638-1 Etiwanda Ave, Tarzana, CA — 213-344-6998
ANKA/50 KINGS RD, BRISBANE, CA (P 79) — **415-467-8108**
Ansley, Frank/170 Lombard St, San Francisco, CA — 415-781-6681
Arkle's Art/133 A Nearglen Ave, Covina, CA — 213-967-8009
Arshawsky, David/9401 Alcott St, Los Angeles, CA — 213-276-6058
Artists in Print/Fort Mason, Bldg. D, San Francisco, CA — 415-673-6941
August, Bob/Los Angeles, CA — 213-656-6864

B
Baine, Vernon/114 Marshall Dr, Walnut Creek, CA — 415-933-5973
BANTHIEN, BARBARA/1535 MISSION ST,
 SAN FRANCISCO, CA (P 81) — **415-552-4252**
Banuelos, Art/1743 S Douglas Rd, Annaheim, CA — 714-978-1074
Banyai, Istvan/1241 9th St #3, Santa Monica, CA — 213-394-8035
Barbee, Joel/209 San Pablo, San Clemente, CA — 714-498-0067
Barry, Mike/8800 Venice Blvd, Los Angeles, CA — 213-870-6565
Batcheller, Keith/624 W Cypress Ave, Covina, CA — 213-331-0439
Beach, Lou/5312 W 8th St, Los Angeles, CA — 213-934-7335
Beersworth, Roger/618 S Western Ave, #201,
 Los Angeles, CA — 213-392-4877
Beigle, David/5632 Meinhardt Rd, Westminster, CA — 714-893-7749
Benemelis, Paul/655 Wesley Ave, #3, Oakland, CA — 415-465-6156
Bensen, Ben/8800 Venice Blvd, Los Angeles, CA — 213-870-6565
Bergendorff, Roger/12106 Sims St, Huntington Bch, CA — 213-279-1775
Bernstein, Sol/649 Encino Vista Dr, Thousand Oaks, CA — 805-497-7967
Berrett, Randy/2526 Van Ness #10, San Francisco, CA — 415-441-8568
Bettoli, Delana/737 Vernon Ave, Venice, CA — 213-396-0294
Bhang, Samuel Design Assoc/3030 W Sixth St #200,
 Los Angeles, CA — 213-382-1126
Bjorkman, Steve/1711 Langley, Irvine, CA — 714-540-4847
Blonder, Ellen/PO Box 53, Mill Valley, CA — 415-388-9158
Botello, Gerre/12203 Sundale Ave, Hawthorne, CA — 213-973-2440
Boyle, Neil/5455 Wilshire Blvd #1212, Los Angeles, CA — 213-937-4472
Bradbury, Jack/3725 Wood Valley Rd, Sonoma, CA — 707-938-2975
Bradley, Barbara/750 Wildcat Canyon Rd, Berkeley, CA — 415-525-5496
Brady, Elizabeth/3731 Tracy, Los Angeles, CA — 213-666-3952
Broad, David/100 Golden Hinde Blvd, San Rafael, CA — 415-479-5505
Brown, Charley/716 Montgomery St, San Francisco, CA — 415-433-1222
Broyles, Kathie/1838 El Cerrito Pl #3, Hollywood, CA — 213-874-1661
Buerge, Bill/2153 Charlemagne, Long Beach, CA — 213-597-9991
BULL, MICHAEL/75 WATER ST, SAN FRANCISCO, CA (P 89) — **415-776-7471**
Burnside, John E/4204 Los Feliz Blvd, Los Angeles, CA — 213-665-8913
Butte, Annie/PO Box 307, Jacksonville, OR — 503-899-1465

C
Cadd, Ray/8800 Venice Blvd, Los Angeles, CA — 213-870-6565
Calsbeek, Craig/704 Angelus, Venice, CA — 213-821-8839
Camozzi, Teresa/770 California St, San Francisco, CA — 415-392-1202
CARROLL, JUSTIN/2228 21ST ST,
 SANTA MONICA, CA (P 90) — **213-450-4197**
Carver, Steve/618 S Western Ave #205, Los Angeles, CA — 213-388-0938
Catom, Don/638 S Van Ness Ave, Los Angeles, CA — 213-382-6281
Chang, Warren/1283 Vicente Dr #217, Sunnyvale, CA — 415-964-1701
Chorney, Steven/5311 Saturn St, Los Angeles, CA — 213-985-8181

ILLUSTRATORS CONT'D.

Please send us your additions and updates.

Christensen, James C/656 West 550 South, Orem, UT	801-224-6237
Clark, Tim/8800 Venice Blvd, Los Angeles, CA	213-202-1044
CLENNEY, LINDA/SAN FRANCISCO, CA (P 91)	**415-641-4794**
CoConis, Ted/2244 Santa Ana, Palo Alto, CA	415-856-9055
Cockerill, Bruce/3169 Barbara Ct, #E, Los Angeles, CA	213-876-0960
THE COMMITTEE/15468 VENTURA BLVD,	
SHERMAN OAKS, CA (P 93)	**213-986-4420**
Coppock, Chuck/638 S Van Ness Ave, Los Angeles, CA	213-382-6281
Corey, Christopher/10616 Moorpark St, No Hollywood, CA	805-969-4285
Cornfield, Jim/4545 S LaBrea Ave, Los Angeles, CA	213-938-3553
Costelloe, Richard/14258 Aetna St, Van Nuys, CA	213-901-1077
Cotter, Debbie/San Francisco, CA	415-922-4304
Criss, Keith/4329 Piedmont Ave, Oakland, CA	415-655-2171
Critz, Carl/638 S Van Ness Ave, Los Angeles, CA	213-382-6281
Crop, Mark/672 S Lafayette Park Place, Los Angeles, CA	213-388-3142
Cummings, B D/3845 E Casselle, Orange, CA	714-633-3322
Curtis, Todd/2046 14th St #10, Santa Monica, CA	213-207-0788
D Daley, Joann/1317 Maltman Ave, Los Angeles, CA	213-655-0408
Daniels, Alan/3336 Tilden Ave, Los Angeles, CA	213-204-3230
Daniels, Stewart/961 Terrace Dr, Oakdale, CA	209-847-5596
Dann, Stan/1051 Fifth Ave, Oakland, CA	415-835-3571
Davis, Bill/5474 E Geoffrey Ave, Simi Valley, CA	805-527-9749
DAZZELAND STUDIOS/209 EDISON,	
SALT LAKE CITY, UT (P 98,99)	**801-355-8555**
Dean, Donald/2936 Domingo Ave #2, Berkeley, CA	415-644-1139
Deanda, Ruben/1744 6th Ave, San Diego, CA	619-231-4702
Deasy, Rosemary/2510 Jalmia Dr, Los Angeles, CA	213-874-4552
Dember, Sol/7309 Paso Robles, Van Nuys, CA	213-710-3681
Densham, Robert S/781 1/2 California Blvd,	
San Luis Obispo, CA	805-543-8394
Dietz, James/2203 13th Ave E, Seattle, WA	206-325-2857
Diffenderfer, Ed/32 Cabernet Ct, Lafayette, CA	415-254-8235
DISMUKES, JOHN TAYLOR/4844 VAN NOORD,	
SHERMAN OAKS, CA (P 23,24)	**213-907-9087**
Donrmann, Marsha J/144 Woodbine Dr, Mill Valley, CA	415-383-0188
Donato, Robert/2330 W 3rd, Los Angeles, CA	808-396-6544
Doody, Jim/6802 Skyview Dr, Huntington Beach, CA	714-851-3066
Drake, Bob/1510 Hi-Point, Los Angeles, CA	213-931-8690
Drayton, Richard/5018 Dumont Pl, Woodland Hills, CA	213-347-2227
Drennon, Tom/7770 Hollywood #1, Hollywood, CA	213-874-1276
Droy, Brad/2600 S St Paul, Denver, CO	303-694-3296
Dryden, Rod/8800 Venice Blvd, Los Angeles, CA	213-870-6565
Duell, Nancy/90 Corona, #508, Denver, CO	303-591-9309
Duffus, Bill/1745 Wagner, Pasadena, CA	213-792-7921
Duke, Lawrence W/Star Route Box 93, Woodside, CA	415-851-2705
Durfee, Tom/70 Broadway, San Francisco, CA	415-781-0527
Dvore, Sandy/9255 Sunset Blvd, Los Angeles, CA	213-278-4343
E **EASTMAN, BRYANT/11607 CLOVER AVE,**	
LOS ANGELES, CA (P 54)	**213-828-9653**
EDELSON, WENDY/85 S WASHINGTON,	
SEATTLE, WA (P 107)	**206-625-0109**
Ellescas, Richard/321 N Martel, Hollywood, CA	213-939-7396
Ellmore, Dennis/3245 Orange Ave, Long Beach, CA	213-424-9379
Emerson, Terry/505 Wyoming St, Pasadena, CA	213-791-3819
Endicott, James R/Rte 1, Box 27B, Newberg, OR	503-538-5466
Ente, Anke/50 Kings Rd, Brisbane, CA	415-467-8108
Ericksen, Mark/1045 Sansome, San Francisco, CA	415-362-1214
Erickson, Kernie/Box 2175, Mission Viejo, CA	714-831-2818
Etow, Carole/221 17th St #B, Manhattan Beach, CA	213-545-0795
Evans, Jan/20656 Pacific Coast Hwy, Malibu, CA	213-456-5195
Evans, Robert/1045 Sansome, San Francisco, CA	415-397-5322
Evenson, Stan/1830 S Robertson Blvd, #20, Los Angeles, CA	213-204-1995
F Ferrero, Felix/215 Liedesdorff, San Francisco, CA	415-981-1164
Fox, Ronald/2274 237th St, Torrance, CA	213-325-4970
Francuch, George/638 S Van Ness Ave, Los Angeles, CA	213-382-6281
Franks, Bill/638 S Van Ness Ave, Los Angeles, CA	213-382-6281
G Gaines, David/3805 Effie, Los Angeles, CA	213-663-8763

Gallon, Dale B/251 Shipyard Way, Bth A #9,	
Newport Beach, CA	714-673-4971
Galloway, Nixon/5455 Wilshire Blvd, Los Angeles, CA	213-937-4472
Garnett, Joe/638 S Van Ness Ave, Los Angeles, CA	213-382-6281
Garo, Harry/7738 E Allen Grove, Downey, CA	213-928-2768
Geary, Rick/2124 Froude St, San Diego, CA	619-222-2476
George, Jeff/2204 Matthews Ave #D, Redondo Beach, CA	213-370-1417
Germain, Frank/5455 Wilshire Blvd, Los Angeles, CA	213-937-4472
Gerrie, Dean/603 Kings Rd, Newport Beach, CA	714-646-8508
GIRVIN, TIM/911 WESTERN AVE, #408,	
SEATTLE, WA (P 114)	**206-623-7918**
Gisko, Max/San Francisco, CA	415-922-4304
Glad, Deanna/PO Box 3261, Santa Monica, CA	213-393-7464
Gleason, Bob/618 S Western Ave, #207, Los Angeles, CA	213-386-3721
Glusha, Laura/PO Box 665, Glendale, CA	213-241-2005
Gohata, Mark/1107 Magnolia Ave, Gardena, CA	213-327-6595
Goldstein, Howard/7031 Aldea Ave, Van Nuys, CA	213-987-2837
Gomez, Ignacio/812 Kenneth Rd, Glendale, CA	213-243-2838
Gordon, Duane/638 S Van Ness Ave, Los Angeles, CA	213-382-6281
Gordon, Roger/3111 4th St #202, Santa Monica, CA	213-396-2365
Gorham, Kimberly/11823 Bernardo Terr #108, San Diego, CA	619-451-1078
Graves, David/4735 Vesper Ave, Sherman Oaks, CA	213-935-6668
Greco, Peter/7250 Beverly Blvd #101, Los Angeles, CA	213-933-5186
Green, Peter/4433 Forman Ave, Toluca Lake, CA	213-760-1011
Gribbitt Ltd/5419 Sunset Blvd, Los Angeles, CA	213-462-7362
Grim, Elgas/638 S Van Ness Ave, Los Angeles, CA	213-382-6281
Grossman, Myron/8800 Venice Blvd, Los Angeles, CA	213-559-9344
Group West Inc/5455 Wilshire Blvd, #1212, Los Angeles, CA	213-937-4472
Grove, David/382 Union St, San Francisco, CA	415-433-2100
Guidice, Rick/9 Park Ave, Los Gatos, CA	408-354-7787
H **HAMAGAMI, JOHN/7822 CROYDON AVE,**	
LOS ANGELES, CA (P 117)	**213-641-1522**
Hamilton, Pamela/2956 S Robertson Blvd #9, Los Angeles, CA	213-838-7888
Hammond, Roger/5455 Wilshire Blvd, Los Angeles, CA	213-937-4472
Hanes, Marsha/7455 Collet Ave, Van Nuys, CA	213-994-2926
Hardiman, Miles/30 Village Dr, Littleton, CO	303-978-9143
Harris, Diane Teske/3646 Keystone, Hollywood, CA	213-838-6601
Harris, Ralph/Box 1091, Sun Valley, ID	208-726-8077
HASENBECK, GEORGE/3600 15TH AVE W. #201A,	
SEATTLE, WA (P 118)	**206-283-0980**
Hasselle, Bruce/2620 Segerstrom A, Santa Ana, CA	714-662-5731
Hatzer, Fred/5455 Wilshire Blvd, Los Angeles, CA	213-937-4472
Haydock, Robert/716 Montgomery St, San Francisco, CA	415-383-6986
Hays, Jim/3809 Sunnyside Blvd, Marysville, WA	206-334-7596
Hedstrom, Ingrid/24211 Via San Clemente, Mission Viejo, CA	714-645-6426
Heidrich, Tim/14824 Ibex Ave, Norwalk, CA	213-828-9653
Heimann, Jim/618 N Western Ave, Los Angeles, CA	213-828-9653
HEINER, JOE & KATHY/1612 SHERMAN AVE,	
SALT LAKE CITY, UT (P 120)	**801-581-1612**
Hendricks, Steve/1050 Elsiemae Dr, Boulder Creek, CA	408-338-6639
Henry, James/1744 Palisades Dr, Pacific Palisades, CA	213-459-7337
Herrero, Lowell/870 Harrison St, San Francisco, CA	415-543-6400
Hicks, Brad/2161 W 25th St, San Pedro, CA	213-519-9321
High, Richard/48 Second St, San Francisco, CA	415-777-5115
Hill, Glenn/325 Pasadena Ave, South Pasadena, CA	213-441-3297
Hilliard, Fred/5425 Crystal Springs Dr. N.E.,	
Bainbridge Island, WA	206-842-6003
Hinds, Joe/7615 Vance Dr, Arvada, CO	303-424-2067
Hinton, Hank/6118 W 6th St, Los Angeles, CA	213-938-9893
Hoburg, Maryanne Regal/1695 8th Ave, San Francisco, CA	415-731-1870
Hodges, Ken/12401 Bellwood, Los Alamitos, CA	213-431-4343
Hoff, Ken/8800 Venice Blvd, Los Angeles, CA	213-870-6565
HOPKINS/SISSON/3113 PICO BLVD,	
SANTA MONICA, CA (P 122)	**213-829-7216**
Hubbard, Roger/7461 Beverly Blvd, Los Angeles, CA	213-938-5177
Huhn, Tim/4718 Kester Ave #208, Sherman Oaks, CA	213-986-2352
HUNT, ROBERT/4376 21ST ST, SAN FRANCISCO, CA (P 123)	**415-824-1824**
I Ikkanda, Richard/2800 28th St, #152, Santa Monica, CA	213-450-4881
Ingalls, Betty/7 Crescent Dr, Orinda, CA	415-254-5036
Ingalls, Ed/7 Crescent Dr, Orinda, CA	415-254-5036

ILLUSTRATORS CONT'D.

Please send us your additions and updates.

Irvin, Fred/1702 Hillcrest Rd, Santa Barbara, CA — 805-965-2309
Irvine, Rex John/6026 Dovetail Dr, Agoura, CA — 213-991-2522

J
Jacobi, Kathryn/17830 Osborne St, Northridge, CA — 213-886-4482
Jenott, John/234 A Miller Ave, Mill Valley, CA — 415-383-2330
Johnson, Karen/1600 Beach St, #301, San Francisco, CA — 415-567-3089
Jones, Steve/1081 Nowita Pl, Venice, CA — 213-396-9111
Juckes, Geoff/3185 Durand Dr, Hollywood, CA — 213-465-6604
Judd, Jeff/827 1/2 N McCadden Pl, Los Angeles, CA — 213-469-0330
Jue, Tommy/812 Flores De Oro Ave, South Pasadena, CA — 213-255-8883

K
Kari, Morgan/3516 Sawtelle Blvd #226, Los Angeles, CA — 213-390-1343
Katayama, Mits/515 Lake Washington Blvd, Seattle, WA — 206-324-1199
Kaufman, Van/10290 Seabury Ln, Bel Air, CA — 213-279-1924
Keefer, Mel/847 5th St #108, Santa Monica, CA — 213-395-1147
Keeling, Greg/659 Boulevard Way, Oakland, CA — 415-444-8688
Kenton, Nelson/1900 E Warner Ste E, Santa Ana, CA — 714-546-9371
Kenyon, Chris/1537 Franklin St, #102, San Francisco, CA — 415-775-7276
Kimble, David/711 S Flower, Burbank, CA — 213-849-1576
King, Heather/2029 Pierce #3, San Francisco, CA — 415-563-1613
Kriss, Ron/6671 W Sunset, Los Angeles, CA — 213-462-5731
Krogle, Bob/11607 Clover Ave, Los Angeles, CA — 213-828-9653
Kuwahara, Sachi/5900 Wilshire Blvd #1420, Los Angeles, CA — 213-937-8360

L
Labadie, Ed/1012 San Rafael Ave, Glendale, CA — 213-240-0802
Lakich, Lili/1632 Lemoyne, Los Angeles, CA — 213-413-2404
Larson, Ron/940 N Highland Ave, Los Angeles, CA — 213-465-8451
Laycock, Dick/8800 Venice Blvd, Los Angeles, CA — 213-870-6565
Lecash, Lion/1736 Holly Vista Ave, Los Angeles, CA — 213-934-9819
Lediard, Francis A./2216 Kensington Ave, Salt Lake City, UT — 801-328-0573
LEE, BRYCE/427 N ADAMS #2, GLENDALE, CA (P 136) — 818-244-2310
Lee, Warren/88 Meadow Valley Rd, Corte Madera, CA — 415-924-0261
Leech, Richard & Associates/725 Filbert St, San Francisco, CA — 415-981-4840
Leech, Richard and Assoc/725 Filbert St, San Francisco, CA — 415-981-4840
Leedy, Jeff/209 North St, Sausalito, CA — 415-332-9100
LEVINE, BETTE/149 N. HAMILTON DR., BEVERLY HILLS, CA (P 19) — 213-653-9765
Lewis, Dennis/6671 Sunset #1519, Los Angeles, CA — 213-462-5731
Leynnwood, Jack/22932 Oxnard, Woodland Hills, CA — 213-883-6871
Lillard, Jill/2930 Lombardy Rd, Pasadena, CA — 213-792-5921
Livingston, Francis/1537 Franklin, #105, San Francisco, CA — 415-776-1531
Locke, Charles/PO Box 61986, Sunnyvale, CA — 408-734-5298
Locke, Margo/619 Benvenue Ave, Los Altos, CA — 415-948-3434
Lozano, Henry Jr/3650 Holdrege Ave, Los Angeles, CA — 213-836-5507
LYMAN, KENVIN/209 EDISON ST, SALT LAKE CITY, UT (P 98,99) — 801-355-8555
LYTLE, JOHN/PO BOX 5155, SONORA, CA (P 145) — 209-532-1115

M
Mahler, Jaef/11134 La Maida, North Hollywood, CA — 213-763-2994
Mahurin, Matt/4533 Sunnycrest Dr, Los Angeles, CA — 213-258-4058
Manoogian, Michael/7457 Beck Ave, North Hollywood, CA — 213-764-6114
Manzelman, Judy/9 1/2 Murray Ln, Larkspur, CA — 415-461-9685
Marsh, Cynthia/5805 Venice Blvd, Los Angeles, CA — 213-934-6892
Marshall, Craig/28 Abbey St, San Francisco, CA — 415-621-3644
Marshall, Patricia/816 NW 177th Pl, Seattle, WA — 206-542-3370
Masami/90 Corona #508, Denver, CO — 303-778-6016
Mattos, John/1546 Grant Ave, San Francisco, CA — 415-397-2138
Maughan, William/3182 Penview Dr, Vista, CA — 619-724-3340
Mayeda, Kaz/3847 Bentley Ave #2, Culver City, CA — 213-559-6839
McCandlish, Mark Edward/1334 W Foothill Blvd #8H, Upland, CA — 213-286-0517
McCargar, Lucy/563 Pilgrim Dr Ste A, Foster City, CA — 415-341-5450
McConnell, Jim/7789 Greenly Dr, Oakland, CA — 415-569-0852
MCDOUGALL, SCOTT/914 13TH AVE, SEATTLE, WA (P 149) — 206-324-8640
McGowan, Daniel/90 Corona, Denver, CO — 303-778-6016
McKee, Ron/5455 Wilshire Blvd, Los Angeles, CA — 213-937-4472
McKiernan, James E/346 Park Ave, Long Beach, CA — 213-438-0846
Mediate, Frank/514 Shatto Place, #335, Los Angeles, CA — 213-381-3977
Megowan, John/3114 1/2 Sherwood Ave, Alhambra, CA — 213-289-5826
Merritt, Norman/5455 Wilshire Blvd, Los Angeles, CA — 213-937-4472
MEYER, GARY/227 W CHANNEL RD, SANTA MONICA, CA (P 152,153) — 213-454-2174

Mikkelson, Linda S/1624 Vista Del Mar, Hollywood, CA — 213-463-3116
Miller, Chris/2124 Froude St, San Diego, CA — 619-222-2476
Miller, Steve/5929 Irvine Ave, North Hollywood, CA — 213-985-5610
Millsap, Darrel/1744 6th Ave, San Diego, CA — 619-232-4519
Mitchell, Kathy/828 21st St, #6, Santa Monica, CA — 213-828-6331
Mitoma, Tim/1200 Dale Ave, #97, Mountain View, CA — 415-965-9734
Monahan, Leo/1624 Vista Del Mar, Los Angeles, CA — 213-463-3116
Moreau, Alain/1461 1/2 S Beverly Dr, Los Angeles, CA — 213-553-8529
Morgan, Kari/3516 Sawtelle Blvd #226, Los Angeles, CA
Moyna, Nancy/8800 Venice Blvd, Los Angeles, CA — 213-870-6565
Mukai, Dennis/1838 El Cerrito, Hollywood, CA — 213-874-1661
Murphy, James/1824 4th St, Berkeley, CA — 415-276-2734
Murray, Mike/1622 Moulton Pkwy, Tustin, CA — 714-730-5793

N
Naganuma, Tony/1100 Montgomery, San Francisco, CA — 415-433-4484
Nagel, Pat/308 N Sycamore Ave, Los Angeles, CA — 213-936-6193
Nakamura, Tak/411 Benton Way, Los Angeles, CA — 213-383-6991
Nasser, Christine/Los Angeles, CA — 213-545-3583
Nay, Ben/8800 Venice Blvd, Los Angeles, CA — 213-870-6565
Neila, Anthony/450 Sansome St #555, San Francisco, CA — 415-398-1919
Nelson, Craig/6010 Graciosa Dr, Los Angeles, CA — 213-466-6483
Nelson, Mike/1836 Woodsdale Ct, Concord, CA — 415-686-9295
Nelson, Sue/1205 West St, Petaluma, CA — 707-778-1070
Nelson, Will/750 Warm Springs, Boise, ID — 208-342-7507
Nethery, Susan/618 S Western Ave, Los Angeles, CA — 213-383-5646
Nicholson, Norman/410 Pacific Ave, San Francisco, CA — 415-421-2555
Nikosey, Tom/7417 Melrose, Hollywood, CA — 213-655-2184
Nishiyama, Curtis/2719 Fourth St #C, Santa Monica, CA — 213-396-8628
Noble, Larry/10434 Corfu Ln, Los Angeles, CA — 213-279-1775
Nordell, Dale/515 Lake Washington Blvd, Seattle, WA — 206-324-1199
Nordell, Marilyn/515 Lake Washington Blvd, Seattle, WA — 206-324-1199
Norman, Gary/Los Angeles,, CA — 213-828-9653

O
Oden, Richard/1303 Avocado Ave, Newport Beach, CA — 714-760-0400
Odgers, Jayme/4121 Wilshire Blvd, Los Angeles, CA — 213-484-9965
Ohanian, Nancy/22234 Victory Blvd, #6303, Woodland Hills, CA — 213-247-0135
Olsen, Paul/1823 N Dillon, Los Angeles, CA — 213-666-6677
O'Meara, Janice/1341 Ocean Ave #154, Santa Monica, CA — 213-826-9155
O'Neil, Sharon/409 Alberto Way #6, Los Gatos, CA — 408-354-3816
Osborn, Stephen/535 Ramona St #3, Palo Alto, CA — 415-326-2276
Oshiro, David/Pier 33 North Embarcadero, San Francisco, CA — 415-956-5648

P Q
Page, Frank/10434 Corfu Ln, Los Angeles, CA — 213-279-1775
Pansini, Tom/16222 Howland La, Huntington Beach, CA — 714-847-9329
Passey, Kim/3336 Tilden Ave, Los Angeles, CA — 213-204-3230
Peck, Everett/728 Dewitt Ave, Encinitas, CA — 714-964-4225
Pederson, Sharleen/5685 Round Meadow Rd, Hidden Hills, CA — 213-887-0518
PERINGER, STEPHEN/6046 LAKESHORE DR SO, SEATTLE, WA (P 159) — 206-725-7779
Peterson, Eric/270 Termino Avenue, Long Beach, CA — 213-438-2785
Peterson, Julie/1717 Union, San Francisco, CA — 415-441-2195
Phillips, Barry/1318 1/2 S Beverly Glen, Los Angeles, CA — 213-275-6524
Phister, Suzanne/248 Alhambra, San Francisco, CA — 415-922-4304
Platz, Henry III/15922 118th Pl, NE, Bothell, WA — 206-488-9171
Platz, Rusty/515 Lake Washington Blvd, Seattle, WA — 206-324-1199
Podevin, J F/223 South Kenmore #4, Los Angeles, CA — 213-739-5083
Porter, Sophie/2620 Hyde St, San Francisco, CA — 415-776-6556
Pound, John/2124 Froude St, San Diego, CA — 619-222-2476
Putnam, Denise/7059-83 Park Mesa Way, San Diego, CA — 619-565-7568
Putnam, Jamie/10th and Parker, Berkeley, CA — 415-549-2200
Pyle, Chuck/146 10th Ave, San Francisco, CA — 415-751-8087
Quilez, Jose/17891 Ridgeway Rd, Grenada Hills, CA — 213-363-3716

R
Rand, Ted/515 Lake Washington Blvd, Seattle, WA — 206-324-1199
Rehag, Larry/353 Folsom St, San Francisco, CA — 415-543-7080
Released Imagination/132 W Front St, Missoula, MT — 406-549-3248
Rieser, Bill/11922 Kling, N Hollywood, CA — 213-763-7517
Robbins, George/2700 Neilson Way, #1423, Santa Monica, CA — 213-392-4439
Robles, Bill/5455 Wilshire Blvd #1212, Los Angeles, CA — 213-937-4472
Robley, Bryan/PO Box 2618, Sun Valley, ID — 208-788-2098
Rodriquez, Bob/618 S Western Ave, Los Angeles, CA — 213-384-4413

Rosenthal, Martin/PO Box 3452, Culver City, CA 213-397-6805
Ross, Deborah/10848 Ventura #B, Studio City, CA 213-985-5205
Rother, Sue/1537 Franklin St. #105, San Francisco, CA 415-441-8893
Rowe, Ken C./36325 Panorama Dr, Yucaipa, CA 714-797-7030
Ruben, Deanda/1744 6th Ave, San Diego, CA 619-231-4702
Rubin, Marvin/309 Main, Venice, CA 213-392-2226
Rutherford, John/55 Alvarado Ave, Mill Valley, CA 415-383-1788

S
Sakahara, Dick/28826 Cedar Bluff Dr,
 Rancho Palso Verdes, CA 213-541-8187
Salk, Larry/7461 Berverly Blvd, #405, Los Angeles, CA 213-938-5177
Sanford, James/1153 Oleander Rd, Lafayette, CA 415-284-9015
Sano, Kazu/729B Waller St, San Francisco, CA 415-863-1463
Sauter, Ron/2215 S Mississippi, Denver, CO 303-698-0073
Scanlon, Dave/2523 Valley Dr, Manhattan Beach, CA 213-545-0773
Schaar, Bob/23282 Morobe Cr, Laguna Niguel, CA 714-831-9845
Schields, Gretchen/1151 Leavenworth, San Francisco, CA 415-673-2539
Schilens, Tim/1372 Winston Ct, Upland, CA 714-982-4036
Schwering, James/Box 665, Stinson Beach, CA 415-868-1062
Scribner, Joanne L/N 3314 Lee, Spokane, WA 509-484-3208
Shannon, Tom/17291 Marken Ln, Huntington Beach, CA 714-842-1602
Shehorn, Gene/1672 Lynwood Dr, Concord, CA 415-687-4516
Shenon, Mike/522 Ramona St, Palo Alto, CA 415-326-4608
Shepherd, Roni/1 San Antonio Pl, San Antonio, CA 415-421-9764
Shields, Bill/70 Broadway, San Francisco, CA 415-346-0376
Shimokochi, Momoru/2260 Lakeshore Ave, Los Angeles, CA 213-660-4217
Siefried, Ken/8800 Venice Blvd, Los Angeles, CA 213-870-6565
Sigwart, Forrest/1033 S Orlando Ave, Los Angeles, CA
Siminger, Suzanne/3542 Broderick, San Francisco, CA 415-346-7314
Simmons, Russ/1555 South Brockton Ave #5, Los Angeles, CA 213-820-7477
Skirvin, William/5417 LaMaida Ave, Los Angeles, CA 213-466-5948
Smallbone, Norma/2905 Piedmont Ave, La Cresenta, CA 213-249-1823
Smith, Douglas R/3667 Irlanda Way, San Jose, CA 408-265-4811
Smith, J Peter/PO Box 69559, Los Angeles, CA 213-464-1163
Smith, Kenneth/3545 El Caminito St, La Crescenta, CA 213-248-2531
Snyder, Teresa/4291 Suzanne Dr, Pittsburg, CA 415-436-5661
Snyder, Wayne/4291 Suzanne Dr, Pittsburg, CA 415-439-5661
SOBEL, JUNE/1128 23RD ST, #2,
 SANTA MONICA, CA (P 172) **213-829-4882**
Solvang-Angell, Diane/515 lake Washington Blvd, Seattle, WA 206-324-1199
Spalenka, Greg/1427 Dixon #E, Glendale, CA 213-956-5190
Spear, Jeff/540 San Vincente #8, Santa Monica, CA 213-395-3939
Spear, Randy/5228 Vanderhill Rd, Torrance, CA 213-375-4640
Specht, Meredith/5228 Vanderhill Rd, Torrance, CA 213-375-4640
Specht/Watson Studio/1252 S LaCienega Blvd,
 Los Angeles, CA 213-652-2682
Spencer, Joe/11201 Valley Spring La, Studio City, CA 213-760-0216
Spira, David/90 Corona, #508, Denver, CO 303-778-6016
Spohn, Cliff/3216 Bruce Dr, Fremont, CA 415-651-4597
Sprattler, Rob/1947 El Arbolita Dr, Glendale, CA 213-935-4696
Starkweather, Teri/4633 Galendo St, Woodland Hills, CA 213-992-5938
Steele, Robert/1537 Franklin #104, San Francisco, CA 415-885-2611
Stermer, Dugald/515 Lake Washington Blvd, Seattle, WA 206-324-1199
Stevenson, Kay/410 S Griffith Park Dr, Burbank, CA 213-845-4069
Stewart, Walt/PO Box 621, Sausalito, CA 415-868-0481
Stout, William G/812 S LaBrea, Hollywood, CA 213-936-6342
Suvityasiri, Sarn/1811 Leavenworth St, San Francisco, CA 415-928-1602

T
Tanenbaum, Robert/5505 Corbin Ave, Tarzana, CA 213-345-6741
Taylor, C Winston/17008 Lisette St, Granada Hills, CA 213-363-5761
Terry, Emerson/505 Wyoming St, Pasadena, CA 213-791-3819
Timmons, Bonnie/90 Corona, #508, Denver, CO 303-778-6016
Tolone, Robert/8383 Grand View Dr, Los Angeles, CA 213-399-6398
Tompkins, Tish/1660 Redcliff St, Los Angeles, CA 213-662-1660
Triffet, Kurt/1041 N McCadden Pl, Los Angeles, CA 213-465-0268
Tyron-Tatonian, Leslie/5541 Biloxi Ave, North Hollywood, CA 213-769-4003

V
Vance, Jay/676 Lafayette Park Place, Los Angeles, CA 213-387-1171
Vandervoort, Gene/3201 S Ramona Dr, Santa Ana, CA 714-549-3194
Vanle, Jay/638 S Van Ness Ave, Los Angeles, CA 213-382-6281
Vigon-Nahas-Vigon/717 LaCienega Ave, Los Angeles, CA 213-659-7750
Vintson, Sharron/3035 S Plateau Dr, Salt Lake City, UT 801-487-2326
Vogelman, Jack H/1314 Dartmourth Dr, Glendale, CA 213-243-3204
Voss, Tom/525 W B St #G, San Diego, CA 619-238-1673

W
Wack, Jeff/40532 Kraft Ave, Studio City, CA 213-508-0348
Walden, Craig/515 Lake Washington Blvd, Seattle, WA 206-324-1199
Watts, Stan/3896 San Marcus Ct, Newbury Park, CA 805-499-4747
Webster, Ken/67 Brookwood Rd #6, Orinda, CA 415-254-1098
Wed Enterprise/1401 Flower St, Glendale, CA 213-956-6500
Weller, Don/2427 Park Oak Dr, Los Angeles, CA 213-467-4576
Westlund Design Assoc/5410 Wilshire Blvd 503,
 Los Angeles, CA 213-938-5218
Weston, Will/135 S. LaBrea, Los Angeles, CA 213-204-3230
WEXLER, ED/11668 KIOWA #8, LOS ANGELES, CA (P 181) **213-826-1968**
Whitesides, Kim/Cinemascope Illustrations/PO B, Park City, UT 801-277-9868
Wicks, Ren/5455 Wilshire Blvd, Los Angeles, CA 213-937-4472
Wickstrom, Shari/8800 Venice Blvd, Los Angeles, CA 213-870-6565
Wiegand, Chris/7106 Waring Ave, Los Angeles, CA 213-934-9088
Willardson & White Studio/8383 Grand View Dr,
 Los Angeles, CA 213-656-9461
Wilson, Dick/Los Angeles, CA 213-828-9653
Wilson, Rebecca/1001 B Guerrero St, San Francisco, CA 415-647-8421
Winborg, Larry/3336 Tilden Ave #105, Los Angeles, CA 213-204-3230
WOLFE, BRUCE/206 EL CERRITO AVE,
 PIEDMONT, CA (P 72,73) **415-655-7871**
Wolfe, Corey/15716 Menlo, Gardena, CA 213-327-0138
Wolin, Ron/3977 Oeste Ave, North Hollywood, CA 213-984-0733
Woodward, Teresa/544 Paseo Miramar, Pacific Palisades, CA 213-459-2317
Wright, Jonathan/1838 El Cerrito Pl, Hollywood, CA 213-874-1661

YZ
Yaco, Richard/4630 Nogales Ave, Atascadero, CA 805-466-8121
Yamada, Jane/1243 Westerly Terr, Los Angeles, CA 213-663-6264
Yamada, Tony/1243 Westerly Terr, Los Angeles, CA 213-663-6264
Yenne, Bill/576 Sacramento, San Francisco, CA 415-989-2450
Yousling, Jim/208 S Witmer St, Los Angeles, CA 213-977-0454
Zebot, George/307 1/2 36th St, Newport Beach, CA 714-499-5027
ZICK, BRIAN/ LOS ANGELES, CA (P 190) **213-855-8855**
Zippel, Arthur/2100 E McFadden, #D, Santa Ana, CA 714-541-3237
Zito, Andy/11607 Clover Ave, Los Angeles, CA 213-931-1181
Zitting, Joel/2404 Ocean Pk Blvd Ste A, Santa Monica, CA 213-452-7009
Zuckerman, Dorie/17205 Avenida de la Hurradura,
 Pacific Palisades, CA 213-459-4614

GRAPHIC DESIGNERS

NEW YORK CITY

A

AKM Associates	212-687-7636
Abramson, Michael R Studio	212-683-1271
Adams, Gaylord Design	212-684-4625
Album Graphics Inc	212-489-0793
Allied Graphic Arts	212-730-1414
American Express Publishing Co	212-399-2500
Anagraphics Inc	212-279-2370
Ancona Design Atelier	212-947-8287
Anspach Grossman Portugal	212-692-9000
Antler & Baldwin Graphics	212-751-2031
Antupit and Others Inc	212-686-2552
Appelbaum & Curtis	212-752-0679
Apple Design	212-752-1710
Appletree Ad Agencey	212-697-8746
Apteryx Ltd	212-838-9483
Art Department	212-391-1826
The Art Farm Inc	212-688-4555
Art Plus Studio	212-564-8258
Associated Industrial Design Inc	212-765-7693

B

BN Associates	212-684-7210
Bain, S Milo	212-947-1427
Balasas, Cora	212-633-7753
Balin & Veres Inc	212-684-7450
Bantam Books Inc	212-765-6500
Barmache, Leon Design Assoc Inc	212-752-6780
Barnett Design Group	212-677-8830
Barry Douglas Designs Ltd	212-734-4137
Barry, Jim	212-873-6787
Beau Gardner Assoc.	212-832-2426
Becker, Richard	212-475-1756
Bell, James Graphic Design Inc	212-929-8855
Berger, Barry David	212-734-4137
Besalel, Ely	212-759-7820
Bessen & Tully, Inc	212-838-6406
Betty Binns Graphic Design	212-679-9200
Biondo, Charles Design Assoc	212-867-0760
Birch, Colin Assoc Inc	212-223-0499
Bloch, Graulich & Whelan, Inc	212-687-8375
Boker Group	212-686-1132
Bonnell Design Associates Inc	212-921-5390
Bordnick & Assoc	212-777-1860
Botero, Samuel Assoc	212-935-5155
Bradford, Peter	212-982-2090
Branin, Max	212-254-9608
Braswell, Lynn	212-222-8761
Brier, David Design Works	212-362-7786
Brochure People	212-580-9177
Brodsky Graphics	212-684-2600
Brown, Alastair Assoc	212-221-3166
Buckley Designs Inc.	212-861-0626
Burdick, Joshua Assoc Inc	212-696-4440
Burns, Tom Assoc Inc	212-888-1855
By Design	212-684-0388
The Byrne Group	212-354-3996

C

C L Mauro Assoc Inc	212-391-1990
CCI Art Inc	212-687-1552
Cain, David	212-691-5783
Cannan, Bill & Co Inc	212-580-1700
Caravello Studios	212-661-5540
Carnase, Inc	212-679-9880
Cetta, Al	212-989-9696
Chajet Design Group Inc	212-684-3669
Chang, Ivan	212-777-6102
Charles W North Studio	212-686-5740
Charles, Irene Assoc	212-765-8000
Chermayeff & Geismar Assoc.	212-759-9433
Clarke, John	212-730-7026

Composto, Mario Assoc	212-922-1058
Condon, J & M Assoc	212-242-7811
Corchia Woliner	212-977-9778
Corpographics, Inc.	212-483-9065
Corporate Annual Reports Inc.	212-889-2450
Corporate Graphics Inc	212-599-1820
Corporate Images	212-686-5221
Cosgrove Assoc Inc	212-889-7202
Cotler, Sheldon Inc	212-719-9590
Cousins, Morison S & Assoc	212-751-3390
Crane, Susan Inc	212-260-0580
Csoka/Benato/Fleurant Inc	212-686-6741
Cuevas, Robert	212-661-7149
Curtis Design Inc.	212-685-0670

D

DMCD	212-682-9044
Daniel Design	212-889-0071
Danne & Blackburn Inc.	212-371-3250
Davis-Delaney-Arrow Inc	212-686-2500
DeCamps, Craig	212-564-2691
DeHarak, Rudolph	212-929-5445
Delphan Company	212-371-6700
Design Alliance	212-689-3503
Design Derivatives Inc	212-751-7650
Design Group Inc	212-475-2822
Design Influence Inc	212-840-2155
The Design Organization	212-661-1070
Designers 3 Inc.	212-986-5454
Designframe	212-924-2426
The Designing Women	212-864-0909
Diamond Art Studio Ltd.	212-355-5444
Dick Lopez Inc	212-599-2327
DiComo, Charles & Assoc	212-689-8670
DiFranza-Williamson Inc	212-832-2343
Displaycraft	212-784-8186
Domino, Bob	212-935-0139
Donovan & Green Inc	212-755-0477
DORET, MICHAEL (P 106)	**212-889-0490**
Draper Shreeve Design	212-675-7534
Dreyfuss, Henry Assoc	212-957-8600
Dubins, Milt Designer Inc	212-691-0232
Dubrow, Oscar Assoc	212-688-0698
Duffy, William R	212-682-6755
Dwyer, Tom	212-986-7108

E

E M Mitchell Inc	212-986-5595
Edelman Studios Inc	212-255-7250
Edge, Dennis Design	212-679-0927
Edward C Kozlowski Design Inc	212-988-9761
Eichinger, Inc	212-421-0544
Eisenman and Enock	212-431-1000
Ellies, Dave Industrial Design Inc	212-679-9305
Emerson, Wajdowicz	212-807-8144
Environetics Inc	212-759-3830
Environment Planning Inc	212-661-3744
Erikson Assoc.	212-688-0048
Eskil Ohlsson Assoc Inc	212-758-4412
Etheridge, Palombo, Sedewitz	212-944-2530
Eucalyptus Tree Studio	212-226-0331

F

FDC Planning & Design Corp	212-355-7200
Failing, Kendrick G Design	212-677-5764
Falkins, Richard Design	212-840-3045
Farmlett Barsanti Inc	212-691-9398
Farrell, Bill	212-562-8931
Feucht, Fred Design Group Inc	212-682-0040
Filicori, Mauro Visual Communications	212-677-0065
Fineberg Associates	212-734-1220
Florville, Patrick Design Research	212-271-3723
Flying Eye Graphics	212-725-0658
Foyster, Gerry	212-674-0259
Freelancenter Inc	212-683-6969

Please send us your additions and updates.

Freeman, Irving	212-674-6705
Friday Saturday Sunday Inc	212-260-8479
Friedlander, Ira	212-580-9800
Froma/Graphics	212-391-8399
Fulgoni, Louis	212-243-2959
Fulton & Partners	212-695-1625
G GL & C Advertising Design Inc.	212-683-5811
GALE, CYNTHIA (P 113)	**212-860-5429**
Gale, Robert A Inc	212-535-4791
Gardner, Beau Assoc	212-832-2426
Gatter Inc	212-687-4821
Geismar, Tom	212-759-9433
Gentile Studio	212-986-7743
George, Hershell	212-925-2505
Gerstman & Meyers Inc.	212-586-2535
Gianninoto Assoc, Inc.	212-759-5757
Giovanni Design Assoc.	212-725-8536
Gips & Balkind & Assoc	212-421-5940
Gladstein, Renee	212-873-0257
Gladych, Marianne	212-925-9712
Glaser, Milton	212-889-3161
Glusker Group	212-757-4438
Goetz Graphics	212-679-4250
Goldman, Neal Assoc	212-687-5058
GORDON, JOEL (P 95)	**212-989-9207**
Gorman, W Chris Assoc	212-696-9377
The Graphic Expression Inc.	212-759-7788
Graphic Workshop	212-759-4524
Graphics 60 Inc.	212-687-1292
Graphics Institute	212-887-8670
Graphics by Nostradamus	212-581-1362
Graphics for Industry	212-889-6202
Graphics to Go	212-889-9337
Gray, George	212-873-3607
Gregory & Clyburne	212-686-3338
Griffler Designs	212-794-2625
Grossberg, Manuel	212-532-3335
Grunfeld Graphics, Ltd	212-431-8700
Gucciardo & Shapokas	212-683-9378
Guy Marino Graphic Design	212-935-1141
H H.G. Assoc, Inc.	212-221-3070
H.L. Chu & Company Ltd.	212-889-4818
HBO Studio Productions Inc	212-889-4818
Haas, Arie	212-382-1677
Haines, John Design	212-254-2326
Halversen, Everett	212-438-4200
Hamid, Helen	212-752-2546
Handler Group Inc	212-391-0951
Harris-Gorbaty Assoc Inc	212-689-4295
Harry Moshier & Assoc	212-873-6130
Harvey Offenhartz Inc	212-421-2242
Haydee Design Studio	212-242-3110
Hecker, Mark Studio	212-620-9050
Heiney, John & Assoc	212-686-1121
Helio Design	212-532-3340
Heston, Charles Assoc	212-889-6400
Hnath, John	212-684-0388
Holzsager, Mel Assoc Inc	212-741-7373
Holzsager, Mel Assoc Inc	212-741-7373
Hooper, Ray Design	212-924-5480
Hopkins, Will	212-580-9800
Horvath & Assoc Studios Ltd	212-741-0300
Howard Mont Assoc Inc	212-683-4360
Hub Graphics	212-421-5807
Huerta, Gerard	212-753-2895
Human Factors/Industrial Design Inc	212-730-8010
I ISD Inc.	212-751-0800
Image Communications Inc	212-838-0713
Infield & D'Astolfo	212-924-9206

Inner Thoughts	212-674-1277
Intersight Design Inc	212-696-0700
Irving D Miller Inc.	212-755-4040
Isip Rey Design Assoc.	212-475-2822
J J P Maggio Design Assoc Inc	212-725-9660
Jaffe Communications, Inc	212-697-4310
Jarrin Design Inc	212-879-3767
Jass,Milton Assoc	212-874-0418
Johnson, Dwight	212-834-8529
Johnston, Shaun & Susan	212-663-4686
Jonson Pedersen Hinrichs & Shakery	212-889-9611
K KLN Publishing Services Inc	212-686-8200
Kacik Design	212-753-0031
Kaeser & Wilson Design	212-563-2400
Kahn, Al Group	212-580-3517
Kahn, Al Group	212-580-3517
Kallir Phillips Ross Inc.	212-878-3700
Katz, Marjorie L Design	212-751-3028
Kaye Graphics	212-889-8240
Keithley & Assoc	212-679-5317
Kleb Associates	212-246-2847
Ko Noda and Assoc International	212-759-4044
Kollman, Joady	212-586-3416
Koons, Irv Assoc	212-752-4130
Koons, Irv Assoc	212-752-4130
Kozlowski, Edward C Design Inc	212-988-9761
L LCL Design Assoc Inc	212-758-2604
The Lamplight Group	212-682-6270
Landi-Handler Design Inc	212-661-3630
Lassen, Robert	212-929-0017
Lee & Young Communications	212-689-4000
Lefkowith Inc.	212-758-8550
Legaspi Designs Inc	212-255-0015
Leo Art Studio	212-736-8785
Lesley-Hille Inc	212-421-2421
Lester & Butler	212-889-0578
Levine, Gerald	212-751-3645
Levine, William V & Assoc	212-683-7177
Lichtenberg, Al Graphic Art	212-679-5350
LIEBERMAN, RON (P 140)	**212-947-0653**
Liebert Studios Inc	212-686-4520
Lika Association	212-490-3660
Lind Brothers Inc.	212-924-9280
Lippincott & Margulies Inc	212-832-3000
Lopez, Dick Inc	212-599-2327
Loscalzo/Michaelson & Assoc	516-482-7677
Loukin, Serge Inc	212-685-6473
Lowel-Light	212-947-0950
Lubliner/Saltz	212-679-9810
Luckett Slover & Partners	212-620-9770
Luth & Katz Inc	212-644-5777
M M & Co A Design Group Inc	212-582-7050
Maddalone, John	212-807-6087
Maggio, Ben Assoc Inc	212-697-8600
Maggio, Ben Assoc Inc	212-697-8600
Maggio, J P Design Assoc Inc	212-725-9660
Maleter, Mari	212-726-7124
Marchese, Frank	212-988-6267
Marciuliano Inc.	212-697-0740
Marino, Guy Graphic Design	212-935-1141
Mauro, Frank Assoc	212-391-1990
Mayo-Infurna Design	212-757-3136
McDonald, B & Assoc	212-869-9717
McFarlane, John	212-935-4676
McGhie Assoc. Inc.	212-661-2990
McGovern & Pivoda	212-840-2912
Media Design Group	212-758-1116
Meier Adv	212-355-6460

GRAPHIC DESIGNERS

Mentkin, Robert	212-534-5101
Merrill, Abby Studio Inc	212-753-7565
Messling, Jack A	212-724-6445
The Midnight Oil	212-582-9071
Millenium Design	212-986-4540
The Miller Organization Inc	212-685-7700
Miller, David	212-274-4335
Milton Kass Assoc Inc	212-874-0418
Mirenburg, Barry	212-885-0835
Mitchell, E M Inc	212-986-5595
Mizerek Design	212-986-5702
Modular Marketing Inc.	212-581-4690
Mont, Howard Assoc Inc	212-683-4360
Montoya, Juan Design Corp	212-242-3622
Morning, John Design	212-689-0088
Morris, Dean	212-533-5039
MOSELEY, RICHIE (P 142)	**212-499-7045**
Moshier, Harry & Assoc	212-873-6130
Moskof & Assoc.	212-765-4810
Mossberg, Stuart Design Assoc	212-873-6130
Muir, Cornelius, Moore	212-687-4055
Murro, A & Assoc Inc	212-691-4220
Murtha Desola Finsilver Fiore	212-832-4770
N N B Assoc Inc	212-684-8074
National Imagemakers Inc	212-563-5000
National Photo Service	212-563-5000
Neal Goldman Assoc	212-687-5058
Nelson, George & Assoc	212-777-4300
Nelson, George & Co	212-777-4300
Nemser & Howard, Inc	212-832-9595
New American Graphics	212-661-6820
Newman, Harvey Assoc	212-391-8060
Newport, R L & Co	212-935-3920
Newport, R L & Co	212-935-3920
Nightingale Gordon	212-685-9263
Nobart-New York	212-475-5522
Noneman & Noneman Design	212-473-4090
Norman Gorbaty Design	212-684-1665
North, Charles W Studio	212-686-5740
Notovitz & Perrault Design Inc	212-686-3300
O Offenhartz, Harvey Inc	212-421-2242
Ohlsson, Eskil Assoc Inc	212-4412
On Target	212-840-0766
Ong & Assoc	212-355-4343
O'Reilly, Robert Graphic Studio	212-832-8992
Orlov, Christian	212-873-2381
Oz Communications Inc	212-686-8200
PQ Page, Arbitrio, Resen Ltd.	212-421-8190
Palladino, Tony	212-751-0068
Paragraphic Inc	212-421-3970
Parshall, C A Inc	212-685-6370
Parsons School of Design	212-741-8900
Patel, Harish Design Assoc	212-686-7425
Pellegrini & Assoc	212-686-4481
Pellegrini & Assoc	212-686-4481
Pellegrini & Assoc	212-686-4481
Pencils Portfolio Inc	212-683-3732
Penpoint Studio Inc.	212-243-5435
Penraat Jaap Assoc	212-873-4541
Performing Dogs	212-260-1880
Perlman, Richard Design	212-599-2380
Peters, Stan Assoc Inc	212-684-0315
Peterson & Blyth Assoc Inc	212-421-1769
Pettis, Valerie	212-683-7382
Pierre Dinand Inc	212-751-3086
Planning & Design Corp	212-355-7200
Plumb Design Group Inc	212-673-3490
Podob, Al	212-486-0024
Prendergast, J W & Assoc Inc	212-972-9000

Primary Design Group	212-977-5700
Profile Press Inc	212-675-4188
Progressive Designers	212-532-3693
Projection Systems International	212-682-0995
Push Pin Lubalin Pecolick	212-674-8080
Quon, Mike Graphic Design	212-226-6024
R RC Graphics	212-755-1383
RD Graphics	212-682-6734
Rafkin Rubin Inc	212-869-2540
Rapecis Assoc. Inc.	212-697-1760
Ratzkin, Lawrence	212-279-1314
Ray Hooper Design	212-924-5480
Regn-Califano Inc	212-239-0380
Richard Rogers Inc.	212-685-3666
Rosebud Studio	212-752-1144
Rosenthal, Herb & Assoc Inc	212-685-1814
Ross/Pento Inc.	212-757-5604
Royce Graphics	212-239-1990
Russell, Anthony Inc	2120255-0650
S SCR Design Organization	212-752-8496
Saiki Design	212-679-3523
Saks, Arnold	212-861-4300
Salisbury & Salisbury Inc.	212-575-0770
Salpeter, Paganucci, Inc	212-683-3310
The Mike Saltzman Group, Inc	212-929-4655
Sandgren Associates Inc	212-687-5060
Sant'Andrea, Jim	212-974-5400
Saunier, Fredric	212-307-5244
Saville Design	212-759-7002
Saxton Communications Group	212-953-1300
Say It In Neon	212-691-7977
Schaefer-Cassety Inc	212-840-0175
SchaefferBoehm, Ltd	212-947-4345
Schechter Group Inc.	212-752-4400
Schecterson, Jack Assoc Inc	212-889-3950
Schumach, Michael P	212-445-1587
Schwartz, Robert & Assoc	212-689-6482
Scott, Louis Assoc	212-674-0215
Serge Loukin Inc.	212-685-6473
Shapiro, Ellen Graphic Design	212-221-2625
Shareholders Reports	212-686-9099
Sherin & Matejka Inc	212-661-3232
Siegel & Gale Inc.	212-759-5246
Silberlicht, Ira	212-595-6252
Silverman, Bob Design	212-371-6472
Sloan, William	212-988-6267
Sobel, Phillip	212-476-3841
Sochynsky, Ilona	212-686-1275
Solay/Hunt	212-840-3313
Sorvino, Skip	212-580-9638
St Vincent Milone & McConnells	212-921-1414
Stonehill Studio	212-689-7074
Stuart Mossberg Design Assoc.	212-873-6130
Stuart, Gunn & Furuta	212-695-7770
Stuart, Neil	212-751-9275
Studio 42	212-354-7298
Styrowicz, Tom	212-582-2978
Systems Collaborative Inc	212-483-0585
T THe Sukon Group, Inc	212-986-2290
Tapa Graphics	212-243-0176
Tauss, Jack George	212-279-1658
Taylor & Ives	212-244-0750
Taylor, Stan	212-685-4741
Teague, Walter Dorwin Assoc	212-557-0920
Tercovich, Douglas Assoc Inc	212-838-4800
Theoharides Inc.	212-838-7760
Thompson Communications	212-986-3570
Three	212-988-6267
Tobias, William	212-741-1712

GRAPHIC DESIGNERS CONT'D.

Please send us your additions and updates.

Tower Graphics Arts Corp	212-421-0850
Tribich, Jay Design Assoc	212-679-6016
Tschantre, J Graphic Svcs Ltd	212-279-4040
Tscherny, George Design	212-734-3277
Tunstull Studio	212-834-8529
Turner/Miller	212-371-3035
Tusa, Philip Design Inc	212-753-2810
Type Trends	212-986-1783

UV
Ultra Arts Inc	212-679-7493
Viewpoint Graphics	212-685-0560
Vignelli Assoc.	212-593-1416
Visible Studio Inc	212-683-8530
Visual Accents Corp	212-777-7766
Visual Communications	212-677-0065
Visual Development Corp	212-532-3202

W
W Chris Gorman Assoc.	212-696-9377
Wajdowicz, Jurek	212-807-8144
Waldman, Veronica	212-260-3552
Wallace Church Assoc.	212-755-2903
Wardell-Berger Design	212-398-9355
Warren A Kass Graphics Inc.	212-868-3133
Waters, John Assoc Inc	212-807-0717
Waters, Pamela Studio Inc	212-677-2966
Webster, Robert Inc	212-677-2966
Weed, Eunice Assoc Inc	212-725-4933
Weeks & Toomey	212-564-8260
What have You Done For Me Lately Co	212-757-9210
Whelan Design Office	212-691-4404
The Whole Works	212-575-0765
Wijtvliet, Ine	212-684-4575
Wilke, Jerry	212-679-1318
Wilke/Davis Assoc Inc	212-532-5500
William V Levine & Assoc.	212-683-7177
Withers, Bruce Graphic Design	212-599-2388
Wizard Graphics Inc	212-686-8200
Wjdowiecz, Jurek	212-371-0699
Wolf, Henry Production Inc	212-472-2500
Wolff, Rudi Inc	212-873-5800
Wood, Alan	212-889-5195
Works	212-696-1666

Y Z
Yale Forman Designs Inc	212-799-1665
Yasumura & Assoc	212-953-2000
Yoshimura-Fisher Graphic Design	212-431-4776
Young Goldman Young Inc	212-697-7820
Zeitsoff, Elaine	212-580-1282
Zimmerman & Foyster	212-674-0259

NORTHEAST

A
Advertising Design Assoc Inc/Baltimore, MD	301-752-2181
Alber Associates/Philadelphia, PA	215-969-4293
Another Color Inc/Washington, DC	202-547-3430
Aries Graphics/Manchester, NH	603-668-0811
Art Service Assoc Inc/Pittsburgh, PA	412-391-0902
Art Services Inc/Washington, DC	202-526-5607
Art Staff & Co/Potomac, MD	301-983-0531
The Artery/Baltimore, MD	301-752-2979
Arts and Words/Washington, DC	202-463-4880
Artstyles Inc/Pittsburgh, PA	412-261-1601
Artwork Unlimited Inc/Washington, DC	202-638-6352
Ashley, Ellen Smith/Danbury, CT	
Autograph/Rockville, MD	301-770-0360
The Avit Corp/Fort Lee, NJ	201-886-1100

B
Baldwin Design/Salem, MA	617-745-6250
Bally Design Inc/Carnegie, PA	412-276-5454
Banks & Co/Boston, MA	617-262-0020
Bartlett, Morton & Associates/Boston, MA	617-536-8421

Barton-Gillet/Baltimore, MD	301-685-3626
Baskin & Assoc/Washington, DC	202-331-1098
BEDFORD PHOTO-GRAPHIC STUDIO/BEDFORD, NY (P 208)	**914-234-3123**
Bellows, Amelia/Bethesda, MD	202-337-0412
Belser, Burkey/Washington, DC	202-462-1482
Bennardo, Churik Design Inc/Pittsburgh, PA	412-366-3362
Berns & Kay Ltd/Washington DC,	202-387-7032
Beveridge and Associates, Inc/Washington, DC	202-223-4010
Blum, William Assoc/Boston, MA	617-232-1166
Bogus, Sidney A & Assoc/Melrose, MA	617-662-6660
Bookmakers/Westport, CT	203-226-4293
Boscobel Advertising, Inc/Laurel, MD	301-953-7294
Boulanger Associates Inc/Armonk, NY	914-273-5571
Bradick Design & Methods Inc/Guys Mills, PA	814-967-2332
Brady, John Design Consultants/Pittsburgh, PA	412-288-9300
Bressler, Peter Design Assoc/Philadelphia, PA	215-925-7100
Bridy, Dan/Pittsburgh, PA	412-288-9362
Brown Design Comm/Bethesda, MD	301-986-8872
Brown and Craig Inc/Baltimore, MD	301-837-2727
Brown, Michael David Inc/Rockville, MD	301-762-4474
Buckett, Bill Assoc/Rochester, NY	716-546-6580
Burke & Michael Inc/Pittsburgh, PA	412-321-2301
Byrne, Ford/Philadelphia, PA	215-564-0500

C
Cabot, Harold & Co Inc/Boston, MA	617-426-7600
Cameron Inc/Boston, MA	617-267-2667
Captain Graphics/Boston, MA	617-367-1008
Carmel, Abraham/Peekskill, NY	914-737-1439
Case/Washington, DC	202-328-5900
Chaparos Productions Limited/Washington, DC	202-289-4838
Charysyn & Charysyn/Westkill, NY	518-989-6720
Chase, David O Design Inc/Skaneateles, NY	315-685-5715
Colopy Dale Inc/Pittsburgh, PA	412-471-0522
Communications Design/Laurel Springs, NJ	609-627-6979
Concept Packaging Inc/Ft Lee, NJ	201-224-5762
Consolidated Visual Center Inc/Tuxedo, MD	301-772-7300
Cook & Shanosky Assoc/Princeton, NJ	609-921-0200
Creative Communications Center/Pennsauken, NJ	609-665-2058
The Creative Dept/Philadelphia, PA	215-988-0390
The Creative Group/Baltimore, MD	301-889-1404
Creative Presentations Inc/Washington, DC	202-737-7152
Curran & Connors Inc/Jericho, NY	516-433-6600

D
D.P.W Inc/Rochester, NY	716-325-6295
Dakota Design/King of Prussia, PA	215-265-1255
Daroff Design Inc/Philadelphia, PA	215-546-3440
D'Art Studio Inc/Boston, MA	617-482-4442
Dawson Designers Associates/Boston, MA	617-644-2940
DeCesare, John/Darien, CT	203-655-6057
DeMartin-Marona-Cranstoun-Downes/Wilmington, DE	302-654-5277
DeMartin-Marona-Cranstoun-Downes/Briarcliff Manor, NY	914-941-1634
Design Associates/Arlington, VA	703-243-7717
Design Center Inc/Boston, MA	617-536-6846
Design Communication Collaboration/Washington, DC	202-833-9087
Design Group of Boston/Boston, MA	617-437-1084
Design Plus/Schenectady, NY	518-377-1327
The Design Solution/Washington, DC	202-965-6040
Design Technology Corp/Burlington, MA	617-272-8890
Design for Medicine Inc/Philadelphia, PA	215-925-7100
Designworks Inc/Cambridge, MA	617-876-7035
DiFiore Associates/Pittsburgh, PA	412-471-0608
Dohanos, Steven/Westport, CT	203-227-3541
Downing, Allan/Needham, MA	617-449-4784
Drafting and Design Studio/Columbia, MD	301-730-5596
Duffy, Bill & Assoc/Washington, DC	202-965-2216

E
Edigraph Inc/Katonah, NY	914-232-3725
Educational Media/Graphics Division/Washington, DC	202-625-2211
Edwards, Joan & Assoc/Washington, DC	202-966-3365
Egress Concepts/Katonah, NY	914-232-8433
Environetics DC Inc/Washington, DC	202-466-7110
Eucalyptus Tree Studio/Baltimore, MD	301-243-0211

GRAPHIC DESIGNERS CONT'D.

Please send us your additions and updates.

Evans Garber & Paige/Utica, NY	315-733-2313
Evans, Timothy Graphics/Washington, DC	202-337-1608

F
Fader Jones & Zarkades/Boston, MA	617-267-7779
Falcone & Assoc/Chatham, NJ	201-635-2900
Fall, Dorothy Graphic Design/Washington, DC	202-338-2022
Fannell Studio/Boston, MA	617-267-0895
Fitzpatrick & Associates/Silver Springs, MD	301-946-4677
Forum Inc/Fairfield, CT	203-259-5686
Fossella, Gregory Assoc/Boston, MA	617-267-4940
Fresh Produce/Lutherville, MD	301-821-1815
Friday Design Group Inc/Washington, DC	202-965-9600
Froelich Advertising Service/Mahwah, NJ	201-529-1737

G
Gasser, Gene/Chatham, NJ	201-635-6020
Gateway Studios/Pittsburgh, PA	412-471-7224
Gene Galasso Assoc Inc/Washington, DC	202-223-5680
Geyer, Jackie/Pittsburgh, PA	412-261-1111
Gilliam Communications Inc/Washington, DC	202-232-6080
Glickman, Frank Inc/Boston, MA	617-524-2200
Good, Peter Graphic Design/Chester, CT	203-526-9597
Graham Associates Inc/Washington, DC	202-833-9657
Grant Marketing Assoc./Philadelphia, PA	215-985-9079
The Graphic Suite/Pittsburgh, PA	412-661-6699
Graphics By Gallo/Washington, DC	202-234-7700
Graphics, Communications Systems/Silver Spring, MD	301-587-1505
Graphicus Corp/Baltimore, MD	301-727-5553
Graphiti/Philadelphia, PA	215-925-0280
Grear, Malcolm Designers Inc/Providence, RI	401-331-5656
Groff-Long Associates/Bethesda, MD	301-654-0279
Group Four Inc/Avon, CT	203-678-1570
Gunn Associates/Boston, MA	617-267-0618

H
Hain, Robert Assoc/Scotch Plains, NJ	201-322-1717
Hallock, Robert/Newtown, CT	203-426-4751
Hammond Design Assoc/Milford, NH	603-673-5253
Hancock Gross/Philadelphia, PA	215-567-4000
Harish Patel Design Assoc/Boston, MA	617-423-3633
Harrington-Jackson/Boston, MA	617-536-6164
Hegemann Associates/Nyack, NY	914-358-7348
Herbick & Held/Pittsburgh, PA	412-321-7400
Herbst Lazar Design Inc/Lancaster, PA	717-291-9042
Herman & Lees/Cambridge, MA	617-876-6463
Hiestand Design Associates/Watertown, MA	617-923-8800
Hillmuth, James/Washington, DC	202-244-0465
The Hoyt Group/Waldwick, NJ	201-652-6300
Hrivnak, James/Silver Spring, MD	301-681-9090

IJ
Identitia Incorporated/Newburyport, MA	617-462-3146
Image Consultants/Burlington, MA	617-273-1010
Imarc Corporation/Newtown Square, PA	215-356-2000
Innovations & Development Inc/Ft Lee, NJ	201-944-9317
Inwil International Inc/Paterson, NJ	201-684-1024
J H Roth Inc/Peekskill, NY	914-737-6784
Jack Hough Inc/Stamford, CT	203-357-7077
Jaeger Design Studio/Washington, DC	202-785-8434
Jensen, R S/Baltimore, MD	301-727-3411
Johnson & Simpson Graphic Design/Newark, NJ	201-624-7788
Johnson, Karl Graphic Design/Acton, MA	617-263-5345
Jones, Tom & Jane Kearns/Washington, DC	202-232-1921

K
KBH Graphics/Baltimore, MD	301-539-7916
Kahana Associates/Jenkintown, PA	215-887-0422
Kaufman, Henry J & Assoc Inc/Washington, DC	202-333-0700
Keaton Design/Washington, DC	202-547-4422
Ketchum International/Pittsburgh, PA	412-456-3693
King-Casey Inc/New Canaan, CT	203-966-3581
Klim, Matt & Assoc/Avon, CT	203-678-1222
Knox, Harry & Assoc/Washington, DC	202-833-2305
Kostanecki, Andrew Inc/New Canaan, CT	203-966-1681
Kovanen, Erik/Wilton, CT	203-762-8961
Kramer/Miller/Lomden/Glossman/Philadelphia, PA	215-545-7077

Krone Graphic Design/Lemoyne, PA	717-774-7431

L
LAM Design Inc/White Plains, NY	914-948-4777
LANGDON, JOHN/WENONAH, NJ (P 134)	**609-468-7868**
Lange, Erwin G/Wenonah, NJ	609-468-7868
Lapham/Miller Assoc/Boston, MA	617-367-0110
Latham Brefka Associates/Boston, MA	617-227-3900
Lausch, David Graphics/Baltimore, MD	301-235-7453
Lebowitz, Mo/N Bellemore, NY	516-826-3397
Leeds, Judith K Studio/West Caldwell, NJ	201-226-3552
Leotta Designers Inc/Conshohocken, PA	215-828-8820
Lester Associates Inc/West Nyack, NY	914-358-6100
Levinson Zaprauskis Assoc/Philadelphia, PA	215-248-5242
Lewis, Hal Design/Philadelphia, PA	215-563-4461
Lion Hill Studio/Baltimore, MD	301-837-6218
Lizak, Matt/N Smithfield, RI	401-766-8885

M
M&M Graphics/Baltimore, MD	301-747-4555
MacIntosh, Rob Communication/Boston, MA	617-267-4912
Macey-Noyes/Ossining, NY	914-941-7120
Mahoney, Ron/Pittsburgh, PA	412-261-3824
Major Assoc/Baltimore, MD	301-752-6174
Malcolm R Mansfield Graphics/Boston, MA	617-437-1922
Mandala/Philadelphia, PA	215-923-6020
Marcus, Sarna/Amazing Graphic Design/Washington, DC	202-234-4592
Mariuzza, Pete/Briarcliff Manor, NY	914-769-3310
Martucci Studio/Boston, MA	617-266-6960
Mauro, Joseph & Miller, Ruthea/Wilmington, DE	302-762-5753
McDade Inc/Morristown, NJ	201-538-8133
Media Concepts/Boston, MA	617-437-1382
Media Graphics/Washington, DC	202-265-9259
Melancon, Joseph Studios/Wilmington, DE	302-762-5753
Melanson, Donya Assoc/Boston, MA	617-482-0421
Micolucci, Nicholas Assoc/King of Prussia, PA	215-265-3320
Miho, J Inc/Redding, CT	203-938-3214
Milcraft/Annandale, NJ	201-735-8632
Mitchell & Company/Washington, DC	202-483-1301
Mitchell & Webb Inc/Boston, MA	617-262-6980
Morlock Graphics/Tuson, MD	301-825-5080
Moss, John C/Chevy Chase, MD	301-320-3912
Mossman Art Studio/Baltimore, MD	301-243-1963
Mueller & Wister/Philadelphia, PA	215-568-7260
Muller-Munk, Peter Assoc/Pittsburgh, PA	412-261-5161
Myers, Gene Assoc/Pittsburgh, PA	412-661-6314
Myers, Patricia Inc/Chevy Chase, MD	202-657-2311

NO
Nason Design Assoc/Boston, MA	617-266-7286
Navratil Art Studio/Pittsburgh, PA	412-471-4322
Nimeck, Fran/South Brunswick, NJ	201-821-8741
Nolan & Assoc/Washington, DC	202-363-6553
North Charles Street Design Org./Baltimore, MD	301-539-4040
Odyssey Design Group, Inc/Washington, DC	202-783-6240
Ollio Studio/Pittsburgh, PA	412-281-4483
Omnigraphics/Cambridge, MA	617-354-7444
One Harvard Sq Design Assoc/Cambridge, MA	617-876-9673

P
Paganucci, Bob/Montvale, NJ	201-391-1752
Paine, Larry & Associates/Bethesda, MD	301-493-8445
Paragraphics Inc./White Plains, NY	914-948-4777
Parks, Franz & Cox, Inc/Washington, DC	202-797-7568
Pasinski, Irene Assoc/Pittsburgh, PA	412-683-0585
Patazian Design Inc/Boston, MA	617-262-7848
Pesanelli, David Assoc/Washington, DC	202-363-4760
Petco Design/Stamford, CT	203-348-3734
Phillips Design Assoc/Boston, MA	617-787-5757
Pilgrim Design Inc/Bloomfield, NJ	201-429-9449
Planert, Paul Design Assoc/Pittsburgh, PA	412-621-1275
Plataz, George/Pittsburgh, PA	412-322-3177
Porter, Al/Graphics Inc/Washington, DC	202-244-0403
Presentation Associates/Washington, DC	202-333-0080
Prestige Marking & Coating Co/Stamford, CT	203-329-0384
Production Studio/Port Washington, NY	516-944-6688

GRAPHIC DESIGNERS

GRAPHIC DESIGNERS CONT'D.

Please send us your additions and updates.

Publication Services Inc/Stamford, CT	203-348-7351

R
RSV/Boston, MA	617-262-9450
RZA Inc/Westwood, NJ	201-664-4543
Ralcon Inc/West Chester, PA	215-692-2840
Rand, Paul Inc/Weston, CT	203-227-5375
Redtree Associates/Washington, DC	202-628-2900
Research Planning Assoc/Philadelphia, PA	215-561-9700
Richard Ritter Design Inc/Berwyn, PA	215-296-0400
Rieb, Robert/Westport, CT	203-227-0061
Ringel, Leonard Lee Graphic Design/Kendall Park, NJ	201-297-9084
Romax Studio/Stamford, CT	203-324-4260
Ronald R. Miller & Co./Rockaway, NJ	201-625-9280
Rosborg Inc/Newton, CT	203-426-3171
Roth, J R/Peekskill, NY	914-737-6784

S
Sanchez/Philadelphia, PA	215-564-2223
Sanders & Noe Inc/Arlington, VA	703-524-0544
Schneider Design/Baltimore, MD	301-467-2611
Schoenfeld, Cal/Parsippany, NJ	201-334-6257
Schwartz, Adler Graphics Inc/Baltimore, MD	301-433-4400
Selame Design Associates/Newton Lower Falls, MA	617-969-6690
Shapiro, Deborah/Jersey City, NJ	201-432-5198
Simpson Booth Designers/Cambridge, MA	617-661-2630
Smith, Doug/Larchmont, NY	914-834-3997
Smith, Gail Hunter III/Barnegat Light, NJ	609-494-9136
Smith, Tyler Art Direction/Providence, RI	401-751-1220
Snowden Associates Inc/Washington, DC	202-362-8944
Sparkman & Bartholomew/Washington, DC	202-785-2414
Star Design Inc/Moorestown, NJ	609-235-8150
Steel Art Co Inc/Boston, MA	617-566-4079
Stettler, Wayne Design/Philadelphia, PA	215-235-1230
Stockman & Andrews Inc/E Providence, RI	401-438-0694
Stolt, Jill Design/Rochester, NY	716-461-2594
Studio Six Design/Springfield, NJ	201-379-5820
Studio Three/Philadelphia, PA	215-665-0141

T
Takajian, Asdur/N Tarrytown, NY	914-631-5553
Taylor, Ron V Assoc/Stratford, CT	203-378-3090
Team One/Pittsburgh, PA	412-471-1065
Telesis/Baltimore, MD	301-235-2000
Tetrad Inc/Annapolis, MD	301-268-8680
Thompson, Bradbury/Riverside, CT	203-637-3614
Thompson, George L/Reading, MA	617-944-6256
Torode, Barbara/Philadelphia, PA	215-732-6792
Totally Board/Boston, MA	617-437-1914
Town Studios Inc/Pittsburgh, PA	412-471-5353
Troller, Fred Assoc Inc/Rye, NY	914-698-1405

V
van der Sluys Graphics Inc/Washington, DC	202-265-3443
VanDine,Horton,McNamara,Manges/Pittsburgh, PA	412-261-4280
Vance Wright Adams & Assoc/Pittsburgh, PA	412-322-1800
Victoria Group/Natick, MA	617-235-2003
Vinick, Bernard Assoc Inc/Hartford, CT	203-525-4293
Viscom Inc/Baltimore, MD	301-727-6476
Vista Design Group/Pittsburgh, PA	412-441-8500
Visual Research & Design Corp/Boston, MA	617-536-2111
The Visualizers/Pittsburgh, PA	412-281-9387

W
Warkulwiz Design/Philadelphia, PA	215-546-0880
Wasserman's, Myron Graphic Design Group/Philadelphia, PA	215-922-4545
Weadock, Rutka/Baltimore, MD	301-358-3588
Weitzman & Assoc/Bethesda, MD	301-652-7035
Wetherell, Joseph J Industrial Design/Katonah, NY	914-232-8227
Weymouth Design/Boston, MA	617-542-2647
White, E James Co/Alexandria, VA	703-750-3680
Wickham & Assoc Inc/Washington, DC	202-296-4860
Wilke, Jerry Design/Croton-On-Hudson, NY	212-690-2644
Willard, Janet Design Assoc/Pittsburgh, PA	412-661-9100
William E Young & Co/Neptune, NJ	201-922-1234
Williams Associates/Lynnfield, MA	617-599-1818
Wills Group/Philadelphia, PA	215-985-1377

Wilson-Pirk/Washington, DC	202-244-5736
Wistrand,John Design/New Canaan, CT	203-966-9849
World Wide Agency/Baltimore, MD	301-385-0800
Worseldine Graphics/Washington, DC	202-965-4325
Wright, Kent M Assoc Inc/Sudbury, MA	617-443-9909

YZ
Yurdin, Carl Industrial Design Inc/Port Washington, NY	516-944-7811
Zeb Graphics/Washington, DC	202-293-1687
Zmiejko & Assoc Design Agcy/Freeland, PA	717-636-2304

SOUTHEAST

A
Ace Art/New Orleans, LA	504-861-2222
The Alderman Co/High Point, NC	919-889-6121
Allyn, Richar Studio/N Miami, FL	305-945-1702
Alphabet Group/Atlanta, GA	404-892-6500
Amberger, Michael/Miami, FL	305-531-4932
Archigraphics/Coral Gables, FL	
Art Services/Atlanta, GA	404-892-2105
Arts & Graphics/Annandale, VA	703-941-2560
Arunski, Joe & Assoc/Miami, FL	305-253-3337
Asi/Ft Lauderdale, FL	305-561-0551
The Associates Inc/Arlington, VA	703-534-3940

B
Blair, Inc/Baileys Cross Roads, VA	703-820-9011
Bodenhamer, William S Inc/Miami, FL	305-253-9284
Bonner Advertising Art/New Orleans, LA	504-895-7938
Brimm, Edward & Assoc/Palm Beach, FL	305-655-1059
Brothers Bogusky/Miami, FL	305-891-3642
Bugdal Group/Miami, FL	305-264-1860
Burch, Dan Associates/Louisville, KY	502-895-4881

C
Carlson Design/Gainesville, FL	904-373-3153
Chartmasters Inc/Atlanta, GA	404-262-7610
Communications Graphics Inc/Atlanta, GA	404-231-9039
Corporate Advertising & Graphics/Ft Lauderdale, Fl	305-776-4060
Creative Design Assoc/Palm Beach Garden, FL	305-694-2711
Creative Services Inc/New Orleans, LA	504-943-0842
Creative Services Unlimited/Naples, FL	813-262-0201

D E F
Deltacom/McLean, VA	703-790-4800
Design Consultants Inc/Falls Church, VA	703-241-2323
Design Workshop Inc/N Miami, FL	305-893-2820
Designcomp/Vienna, VA	202-938-1822
Emig, Paul E/Arlington, VA	703-522-5926
First Impressions/Tampa, FL	813-224-0454
Foster, Kim A/Miami, FL	305-642-1801
From Us Advertising & Design/Atlanta, GA	404-373-0373

G
Garrett Lewis Johnson/Atlanta, GA	404-221-0700
Garrett, Kenneth/Atlanta, GA	404-221-0700
Gerbino Advertising Inc/Ft Lauderdale, FL	305-776-5050
Gestalt Associates, Inc/Alexandria, VA	703-683-1126
Graphic Arts Inc/Alexandria, VA	703-683-4303
Graphics 4/Ft Lauderdale, FL	305-764-1470
Graphics Associates/Atlanta, GA	404-873-5858
Graphics Group/Atlanta, GA	404-261-5146
Graphicstudio/N Miami, FL	305-893-1015
Great Incorporated/Alexandria, VA	703-836-6020
Gregg, Bill Advertising Design/Miami, FL	305-854-7657

H
Hall Graphics/Miami, FL	305-856-6536
Hall, Stephen Design Office/Louisville, KY	502-584-5030
Hannau, Michael Ent. Inc/Hialeah, FL	305-887-1536
Hansen, James N/Orlando, FL	305-896-4240
Hauser, Sydney/Sarasota, FL	813-388-3021
Helms, John Graphic Design/Memphis, TN	901-363-6589

J
Jensen, Rupert & Assoc Inc/Atlanta, GA	404-892-6658
Johnson Design Group Inc/Arlington, VA	703-525-0808
Jordan Barrett & Assoc/Miami, FL	305-667-7051

Please send us your additions and updates.

GRAPHIC DESIGNERS (side tab)

K L

Kelly & Co Graphic Design Inc/St Petersburg, FL	813-327-1009
Kjeldsen, Howard Assoc Inc/Atlanta, GA	404-266-1897
Leisuregraphics Inc/Miami, FL	305-751-0266
Leonard, Dick Group/St Petersburg, FL	813-576-6723
Lollis & Turpin/Atlanta, GA	404-261-0705
Lowell, Shelley Design/Atlanta, GA	404-636-9149

M

Mabrey Design/Sarasota, FL	813-957-1063
Maxine, J & Martin Advertising/McLean, VA	703-356-5222
McGurren Weber Ink/Alexandria, VA	703-548-0003
Michael, Richard S/Knoxville, TN	615-584-3319
Miller, Hugh K/Orlando, FL	305-293-8220
Morgan-Burchette Assoc/Alexandria, VA	703-549-2393
Morris, Robert Assoc Inc/Ft Lauderdale, FL	305-973-4380
Muhlhausen, John Design Inc/Atlanta, GA	404-393-0743

P

P & W Inc/Louisville, KY	502-499-9220
PL&P Advertising Studio/Ft Lauderdale, FL	305-776-6505
PRB Design Studio/Winter Park, FL	305-671-7992
Parallel Group Inc/Atlanta, GA	404-261-0988
Pertuit, Jim & Assoc Inc/New Orleans, LA	504-581-7500
Piatti and Wolk Design Assoc/Coral Gable, FL	305-445-0553
Platt, Don Advertising Art/Hialeah, FL	305-888-3296
Point 6/Ft Lauderdale, FL	305-563-6939
Polizos, Arthur Assoc/Norfolk, VA	804-622-7033
Positively Main St Graphics/Sarasota, FL	813-366-4959
Promotion Graphics Inc/N Miami, FL	305-891-3941
Publications Studio/Arlington, VA	703-241-1980

R S

Rasor & Rasor/Cary, NC	919-362-7266
Rebeiz, Kathryn Dereki/Vienna, VA	703-560-7784
Rodriguez, Emilio Jr/Miami, FL	305-235-4700
Sager Assoc Inc/Sarasota, FL	813-366-4192
Salmon, Paul/Burke, VA	703-250-4943
Schulwolf, Frank/Coral Gables, FL	305-665-2129
Seay, Jack Design Group/Norcross, GA	404-447-4840
Showcraft Designworks/Clearwater, FL	813-461-4471
Sirrine, J E/Greenville, SC	803-298-6000
Supertype/Hialeah, FL	305-885-6241

T V W

Thayer, Dan Industrial Design/Monroe, VA	804-929-6359
Varisco, Tom Graphic Design Inc/New Orleans, LA	504-949-2888
Visualgraphics Design/Tampa, FL	813-877-3804
Wells Squire Assoc Inc/Ft Lauderdale, FL	305-763-8063
Whitver, Harry K Graphic Design/Nashville, TN	615-320-1795
Will and Assoc/Atlanta, GA	404-355-3194
Wilsonwork Graphic Design/Alexandrea, VA	703-836-8343
Winner, Stewart Inc/Louisville, KY	502-583-5502
Wood, Tom/Atlanta, GA	404-262-7424
The Workshop/Atlanta, GA	404-875-0141

MIDWEST

A

Ades, Leonards Graphic Design/Northbrook, IL	312-564-8863
Advertising Art Studios Inc/Milwaukee, WI	414-276-6306
Album Graphics/Melrose Park, IL	312-344-9100
Allan Aarons Design/Northbrook, IL	312-291-9800
Allied Design Group/Chicago, IL	312-743-3330
Alpha Designs Inc/Cincinnati, OH	513-579-8569
Anderson Studios/Chicago, IL	312-922-3039
Anderson, I K Studios/Chicago, IL	312-664-4536
Architectural Signing/Chicago, IL	312-871-0100
Art Forms Inc/Cleveland, OH	216-361-3855
Artform/Evanston, IL	312-864-2994
Arvind Khatkate Design/Chicago, IL	312-337-1478

B

Babcock & Schmid Assoc/Bath, OH	216-666-8826
Bailey Orner Makstaller Inc/Cincinnati, OH	513-281-1338
Bal Graphics Inc/Chicago, IL	312-337-0325
Banka Mango Design Inc/Chicago, IL	312-467-0059

Beck, Bruce Design Assoc/Evanston, IL	312-869-7100
Bieger, Walter Assoc/Arden Hills, MN	612-636-8500
Blake, Hayward & Co/Evanston, IL	312-864-9800
Blau-Bishop & Assoc/Chicago, IL	312-321-1420
Boelter Industries Inc/Minneapolis, MN	612-831-5338
Boller-Coates-Spadero/Chicao, IL	312-787-2798
Bowlby, Joseph A/Chicago, IL	312-782-1253
Bradford-Cout Graphic Design/Skokie, IL	312-539-5557
Bradick Design & Methods Inc/Cleveland, OH	216-531-1711
Broin, Steven/St Paul, MN	612-644-7314
Brooks Stevens Assoc Inc/Mequon, WI	414-241-3800
Burton E Benjamin Assoc/Highland Park, IL	312-432-8089
Busch, Lonnie/Fenton, MO	314-343-1330

C

CMO Graphics/Chicago, IL	312-527-0900
Campbell Art Studio/Cinncinati, OH	513-221-3600
Campbell Creative Group Inc/Milwaukee, WI	414-351-4150
Carol Naughton & Assoc/Chicago, IL	312-427-9800
Carter, Don W/ Industrial Design/Kansas City, MO	816-356-1874
Centaur Studios Inc/St Louis, MO	314-421-6485
Centermark Corp./Des Moines, IA	515-288-7000
Chartmaster Inc/Chicago, IL	312-787-9040
Chestnut House/Chicago, IL	312-822-9090
Chott & Janah Design, Inc./Chicago, IL	312-726-4560
Combined Services Inc/Minneapolis, MN	612-339-7770
Communications Network Sys Inc/Minneapolis, MN	612-341-2029
Container Corp of America/Chicago, IL	312-580-5500
Contours Consulting Design Group/Bartlett, IL	312-837-4100
Coons/Beirise Design Associate/Cincinnati, OH	513-751-7459
Creative Directions Inc/Milwaukee, WI	414-466-3910
Creative Environments/Glen Ellyn, IL	312-858-9222

D

David Day/Designer & Assoc/Cincinnati, OH	513-621-4060
David Doty Design/Chicago, IL	312-348-1200
DeBrey Design/Minneapolis, MN	612-935-2292
DeGoede & Others/Chicago, IL	312-828-0056
Dektas Eger Inc/Cincinnati, OH	513-621-7070
Design Alliance Inc/Cincinnati, OH	513-621-9373
Design Consultants/Chicago, IL	312-372-4670
Design Dynamics Inc/Union, IL	815-923-2221
Design Factory/Overland Park, KS	913-383-3085
The Design Group/Madison, WI	608-274-5393
Design Group Three/Chicago, IL	312-929-6313
Design House III/Cleveland, OH	216-621-7777
Design Mark Inc/Indianapolis, IN	317-872-3000
Design Marks Corp/Chicago, IL	312-327-3669
Design North Inc/Racine, WI	414-639-2080
The Design Partnership/Minneapolis, MN	612-338-8889
Design Planning Group/Chicago, IL	312-943-8400
Design Programs Inc/Milwaukee, WI	414-276-6505
Design Train/Cincinnati, OH	513-761-7099
Design Two Ltd/Chicago, IL	312-642-9888
Di Cristo & Slagle Design/Milwaukee, WI	414-273-0980
Dickens Design Group/Chicago, IL	312-222-1850
Dimensional Communications/Evanston, IL	312-492-1033
Dimensional Designs Inc/Indianapolis, IN	317-637-1353
Dresser, John Design/Libertyville, IL	312-362-4222
Dynamic Graphics/Ted Lane/Peoria, IL	309-688-8800

E

Eaton and Associates/Minneapolis, MN	612-871-1028
Eberle, Robert A & Assoc Inc/Kansas City, MO	816-931-2428
Ellies, Dave IndustrialDesign Inc/Columbus, OH	614-488-7995
Elyria Graphics/Elyria, OH	216-365-9384
Engelhardt Design/Minneapolis, MN	612-377-3389
Environmental Graphics Inc/Indianapolis, IN	317-634-1458
Epstein & Szilagyi/Cleveland, OH	216-421-1600
Evans, Cecil Jr Interiors/Chicago, IL	312-943-8974

F

Falk, Robert Design Group/St Louis, MO	314-531-1410
Feldkamp-Malloy/Chicago, IL	312-263-0633
Ficho & Corley Inc/Chicago, IL	312-787-1011
Final Draft Graphic Art/Cleveland, OH	216-861-3735

Fleishman-Hillard, Inc/St Louis, MO	314-982-1700
Flexo Design/Chicago, IL	312-321-1368
Ford & Earl Design Assoc Inc/Warren, MI	313-539-2280
Forsythe-French Inc/Kansas City, MO	816-561-6678
Frink, Chin, Casey Inc/Minneapolis, MN	612-333-6539

G

Gellman, Stan Graphic Design Studio/St Louis, MO	314-361-7676
Gerhardt and Clements/Chicago, IL	312-337-3443
The Glen Smith Co/Minneapolis, MN	612-871-1616
Glenbard Graphics Inc/Carol Stream, IL	312-653-4550
Goldsholl Assoc/Northfield, IL	312-446-8300
Goldsmith Yamasaki Specht Inc/Chicago, IL	312-266-8404
Goose Graphics/Minneapolis, MN	612-871-2671
Gournoe, M Ltd/Chicago, IL	312-787-5157
Graphic Corp/Des Moines, IA	515-247-8500
Graphic Corporation/Troy, MI	313-649-5050
Graphic House Inc/Dearborn, MI	313-336-8710
Graphic Specialties Inc/Minneapolis, MN	612-922-4000
Graphics Group/Chicago, IL	312-782-7421
Graphics-Cor Associates/Chicago, IL	312-332-3379
Greenberg, Jon Assoc Inc/Southfield, MI	313-559-2333
Greenlee-Hess Ind Design/Cleveland, OH	216-382-7570
Greiner, John & Assoc/Chicago, IL	312-644-2973
Grusin, Gerald Design/Chicago, IL	312-944-4945
Gulick & Henry Inc/Minneapolis, MN	612-341-4551

H

The Hanley Partnership/St Louis, MO	314-621-1400
Hans Design/Northbrook, IL	312-272-7980
Harley, Don E Associates/West St Paul, MN	612-455-1631
Herbst/Lazar Design Inc/Chicago, IL	312-822-9660
Higgins Hegner Genovese, Inc/Chicago, IL	
Hirsch, David Design Group Inc/Chicago, IL	312-329-1500
Hirsh Co/Skokie, IL	312-267-6777
Hoekstra, Grant Graphics/Chicago, IL	312-641-6940
Hoffman-York Inc/Minneapolis, MN	612-835-5313
Horvath, Steve Design/Milwaukee, WI	414-271-3992

I

IGS Design, Div of Smith H & G/Detroit, MI	313-964-3000
ISD Incorporated/Chicago, IL	312-467-1515
Imagemakers/Cincinnati/Cincinnati, OH	513-281-3511
Indiana Design Consortium/Lafayette, IN	317-423-5469
Industrial Technological Assoc/Cleveland, OH	216-771-4151
Ing, Victor Design/Morton Grove, IL	312-965-3459
Intelplex/Maryland Hts, MI	314-739-9996
Interdesign Inc/Minneapolis, MN	612-871-7979
Interface Design Group/Milwaukee, WI	414-276-6688

J

JMH Design Center/Indianapolis, IN	317-639-2535
James, Frank Direct Marketing/Clayton, MO	314-726-4600
Jansen, Ute/Chicago, IL	312-922-5048
Johnson, Stan Design Inc/Brookfield, WI	414-783-6510
Johnson, Stewart Design Studio/Milwaukee, WI	414-265-3377
Jones, Richmond Designer/Chicago, IL	312-935-6500
Joss Design Group/Chicago, IL	312-828-0055

K

KDA Industrial Design Consultants Inc/Addison, IL	312-495-9466
Kaleidoscope Art Inc/Cleveland, OH	216-932-4454
Kaulfuss Design/Chicago, IL	312-943-2161
Kearns, Marilyn/Chicago, IL	312-645-1888
Kosterman, Wayne/Schaumburg, IL	312-843-2378
Krupp, Merlin Studios/Minneapolis, MN	612-871-6611

L

LVK Associates Inc/St Louis, MO	314-367-4824
Lange, Jim Design/Chicago, IL	312-527-4260
Larson Design/Minneapolis, MN	612-835-2271
Lehrfeld/Ray Studio/Chicago, IL	312-944-0651
Lerdon, Wes Assoc/Columbus, OH	614-486-8188
Lesniewicz/Navarre/Toledo, OH	419-243-7131
Lipson & Jacobs Associates/Cincinnati, OH	513-961-6225
Lipson Associates Inc/Northbrook, IL	312-291-0500
Liska Design/Chicago, IL	312-943-5910
Loew, Dick & Assoc/Chicago, IL	312-787-9032

Lubell, Robert/Toledo, OH	419-531-2267

M

Maddox, Eva Assoc Inc/Chicago, IL	312-649-0092
Manning Studios Inc/Cincinnati, OH	513-621-6959
Market Design/Cleveland, OH	216-771-0300
Marsh, Richard Assoc Inc/Chicago, IL	312-236-1331
McCoy, Steven/Omaha, NB	402-554-1416
McDermott, Bill Graphic Design/St Louis, MO	314-862-6021
McGuire, Robert L Design/Kansas City, MO	816-523-9164
McMurray Design Inc./Chicago, IL	312-527-1555
Media Corporation/Columbus, OH	614-488-7767
Medialoft/Minneapolis, MN	612-831-0226
Meyer Seltzer Design/Illustration/Chicago, IL	312-348-2885
Mid-America Graphics/Omaha, NB	402-554-1416
Minnick, James Design/Chicago, IL	312-527-1864
Moonink Inc/Chicago, IL	312-565-0040
Murrie White Drummond Leinhart/Chicago, IL	312-943-5995

N O

Newcomb House Inc/St Louis, MO	314-997-7262
Nobart Inc/Chicago, IL	312-427-9800
Nottingham-Spirk Design Inc/Cleveland, OH	216-231-7830
Oak Brook Graphics, Inc/Elmhurst, IL	312-832-3200
Osborne-Tuttle/Chicago, IL	312-565-1910
Oskar Designs/Evanston, IL	312-328-1734
Our Gang Studios/Omaha, NB	402-341-4965
Overlock Howe & Co/St Louis, MO	314-241-8640

P

Pace Studios/Lincolnwood, IL	312-676-9770
Painter/Cesaroni Design, Inc/Glenview, IL	312-724-8840
Palmer Design Assoc/Wilmette, IL	312-256-7448
Paramount Technical Service Inc/Cleveland, OH	216-585-2550
Patrick Redmond Design/St Paul, MN	612-292-9851
Perception Inc/Chicago, IL	312-663-5040
Perman, Norman/Chicago, IL	312-642-1348
Phares Associates Inc/Birmingham, MI	313-645-9194
Pinzke, Herbert Design/Chicago, IL	312-528-2277
Pitt Studios/Cleveland, OH	216-241-6720
Podall, Robert Assoc Inc/Northbrook, IL	312-498-0230
Polivka-Logan Design/Minnetonka, MN	612-474-1124
Porter-Matjasich/Chicago, IL	312-670-4355
Powell/Kleinschmidt Inc/Chicago, IL	312-726-2208
Pride and Perfomance/St Paul, MN	612-646-4800
Prodesign Inc/Plymouth, MI	612-559-1884
Purviance, George Marketing Comm/Clayton, MO	314-721-2765
Pycha and Associates/Chicago, IL	312-944-3679

Q R

Quality Graphics/Akron, OH	216-375-5282
Quality Images/Akron, OH	216-375-5282
Richardson/Smith Inc/Worthington, OH	614-885-3453
Robertz, Webb and Co./Chicago, IL	312-861-0060
Ronald Kovach Design/Chicago, IL	312-461-9888
Ross & Harvey Inc./Chicago, IL	312-467-1290
Roth, Randall/Chicago, IL	312-467-0140
Rotheiser, Jordan I/Highland Park, IL	312-433-4288

S

Samata Design Group Ltd/West Dundee, IL	312-428-8600
Savlin Assoc/Evanston, IL	312-328-3366
Schlatter Group Inc/Battle Creek, MI	616-964-0898
Schmidt, Wm M Assoc/Harper Woods, MI	313-881-8075
Schrin, Janet Interiors/Chicago, IL	312-943-0010
Schultz, Ron Design/Chicago, IL	312-528-1853
Sherman, Roger Assoc Inc/Dearborn, MI	313-582-8844
Shipley, R W Assoc Inc/Elmhurst, IL	312-279-1212
Simanis, Vito/St Charles, IL	312-584-1683
Simons, I W Industrial Design/Columbus, OH	614-451-3796
Skolnick, Jerome/Chicago, IL	312-944-4568
Slavin Assoc Inc/Chicago, IL	312-944-2920
Source Inc/Chicago, IL	312-236-7620
Space Design International Inc/Cincinnati, OH	513-241-3000
Spatial Graphics Inc/Milwaukee, WI	414-545-4444
Stepan Design/Mt. Prospect, IL	312-364-4121
Stromberg, Gordon H Visual Design/Chicago, IL	312-275-9449

Please send us your additions and updates.

Studio 1/Milwaukee, WI	414-265-2565
Studio One Graphics/Livonia, MI	313-522-7505
Studio One Inc/Minneapolis, MN	612-831-6313
Swanson, Gladys Graphics/Chicago, IL	312-726-3381
Swoger Grafik/Chicago, IL	312-935-0755
Synthesis/Chicago, IL	312-787-1201

TU
T & Company/Chicago, IL	312-463-1336
Tassian, George Org/Cincinnati, OH	513-721-5566
Total Communications Inc./St Louis, MO	314-421-3800
Underwood, Muriel/Chicago, IL	312-236-8472
Unicom/Milwaukee, WI	414-354-5440
Unigraphics/Troy, MI	313-528-0370
Unimark International Corp/Schaumberg, IL	312-843-3394

V
Vallarta, Frederick Assoc Inc/Chicago, IL	312-944-7300
Vanides-Mlodock/Chicago, IL	312-663-0595
Vann, Bill Studio/St Louis, MO	314-231-2322
Venture Graphics/Chicago, IL	312-943-2900
Vista Three Design/Minneapolis, MN	612-920-5311
Visual Image/St Paul, MN	612-644-7314

W
Wallner Graphics/Chicago, IL	312-787-6787
Weiss, Jack Assoc/Evanston, IL	312-864-7480
Widmer, Stanley Assoc Inc/Staples, MI	218-894-3466
Wilkes, Jean/Chicago, IL	312-332-5168
Winbush Design/Chicago, IL	312-527-4478
Wise, Guinotte/Independence, MO	816-836-1362
Worrel, W Robert Design/Minneapolis, MN	612-933-0303

XZ
Xeno/Chicago, IL	312-327-1989
Zender and Associates/Cincinnati, OH	513-561-8496

SOUTHWEST

A
A Worthwhile Place Comm/Dallas, TX	214-946-1348
A&M Associates Inc/Phoenix, AZ	602-263-6504
Ackerman & McQueen/Oklahoma City, OK	405-843-9451
The Ad Department/Ft Worth, TX	817-335-4012
Ad-Art Studios/Ft Worth, TX	817-335-9603
Advertising Inc/Tulsa, OK	918-747-8871
Art Associates/Irving, TX	214-258-6001

BC
Beals Advertising Agency/Oklahoma City, OK	405-848-8513
The Belcher Group Inc/Houston, TX	713-271-2727
Brooks & Pollard Co/Little Rock, AR	501-375-5561
Cathey Graphics Group/Dallas, TX	214-638-0731
Central Advertising Agency/Fort Worth, TX	817-390-3011
Chesterfield Interiors Inc/Dallas, TX	214-747-2211
Clark, Betty & Assoc/Dallas, TX	214-980-1685
Coffee Design Co/Houston, TX	713-780-0571
Cranford-Johnson-Hunt & Assoc/Little Rock, AR	501-376-6251

DEF
Design Enterprises, Inc/El Paso, TX	915-594-7100
Designmark/Houston, TX	713-626-0953
Ellies, David Industrial Design Inc/Dallas, TX	214-742-8654
Fedele Creative Consulting/Dallas, TX	214-528-3501
First Marketing Group/Houston, TX	713-626-2500

G
GKD/Oklahoma City, OK	405-232-2333
The Goodwin Co/El Paso, TX	915-584-1176
Gore, Fred M & Assoc/Dallas, TX	214-521-5844
Graphic Designers Group Inc/Houston, TX	713-622-8680
Graphics Hardware Co/Phoenix, AZ	602-242-4687
Graphics Intern Adv & Des/Fort Worth, TX	817-731-9941
Graphics International Adv & Dsgn/Fort Worth, TX	817-731-9941
GRIMES, DON/DALLAS, TX (P 116)	**214-526-0040**
Grimm, Tom/Dallas, TX	214-526-0040

HIK
Harrison Allen Design/Houston, TX	713-771-9274
Hood Hope & Assoc/Tulsa, OK	918-749-4454

ISD Incorporated/Houston, TX	713-236-8232
KCBN/Dallas, TX	214-521-6400
Konig Design Group/San Antonio, TX	512-824-7387

LMNO
Lowe Runkle Co/Oklahoma City, OK	405-848-6800
Mantz & Associates/Dallas, TX	214-521-7432
McGrath, Michael Design/Dallas, TX	214-361-1337
Morales, Frahk Design/Dallas, TX	214-827-2101
Neumann, Steve & Friends/Houston, TX	713-629-7501
Newhall, Leslie/Phoenix, AZ	602-279-2933
Owens & Assoc Advertising Inc/Phoenix, AZ	602-264-5691

PRS
Pen'N'Inc Studio/Ft Worth, TX	817-332-7687
Pirtle, Woody Inc/Dallas, TX	214-522-7520
Portzmann Design Inc/Houston, TX	713-977-5700
Reed Melnichek Gentry/Dallas, TX	214-634-7337
The Richards Group/Dallas, TX	214-231-2500
Strickland, Michael & Co/Houston, TX	713-526-6654
Sullivan, Jack Design Group/Phoenix, AZ	602-271-0117
Sunstar Designs/Prescott, AZ	602-778-2714

TVW
3D/International/Houston, TX	713-871-7000
Total Designers/Houston, TX	713-688-7766
Varner, Charles/Dallas, TX	214-744-0148
Weekley & Penny Inc/Houston, TX	713-529-4861
Winius Brandon/Bellaire, TX	713-666-1765
Witherspoon & Assoc/Fort Worth, TX	817-335-1373

WEST

A
ADI/Los Angeles, CA	213-254-7131
AGI/Los Angeles, CA	213-462-0821
Ace Design/Sausalito, CA	415-332-9390
Ad-Venture/Denver, CO	303-771-6520
Addison & Assoc/Santa Barbara, CA	805-965-8188
Adfiliation/Eugene, OR	503-687-8262
Advertising Design & Production Service/San Diego, CA	714-483-1393
Advertising Dsgn & Prod Services/San Diego, CA	714-483-1393
Advertising/Design Assoc/Littleton, CA	415-421-7000
Albertazzi, Mark/San Diego, CA	704-452-9845
Allied Artists/San Francisco, CA	415-421-1919
American Now Inc/Denver, CO	303-573-1663
Ampersand Studios/Denver, CO	303-571-1446
Amstutz Design/Los Angeles, CA	213-652-7110
Anaconda Studio/Santa Monica, CA	213-454-2825
Antisdel Image Group/Santa Clara, CA	408-988-1010
Arnold Design Inc/Denver, CO	303-832-7156
The Art Directors Club of Denver/Denver, CO	303-837-1070
The Art Zone/Honolulu, HI	808-537-6647
Artists In Print/San Francisco, CA	415-673-6941
Artmaster Studios/San Fernando, CA	213-365-7188
Artworks/Los Angeles, CA	213-653-5683
Asbury Tucker & Assoc/Long Beach, CA	213-595-6481
Aurora Borealis/San Francisco, CA	415-392-2971

B
Baily, Robert Design Group/Portland, OR	503-228-1381
Banullos Design/Anaheim, CA	714-978-1074
Barnes, Herb Design/South Pasadena, CA	213-682-2420
Barnstorm Studios/Colorado Springs, CO	303-630-7200
Basic Designs Inc/Muir Beach, CA	415-388-5141
Bass, Yager and Assoc/Hollywood, CA	213-466-9701
Bean, Carolyn Associates Inc/San Francisco, CA	415-957-9573
Bennett, Douglas Design/Seattle, WA	206-324-9966
Bennett, Ralph Assoc/Van Nuys, CA	213-782-3224
Blanchard, D W & Assoc/Salt Lake City, UT	801-484-6344
Blazej, Rosalie Graphics/San Francisco, CA	415-586-3325
Bloch & Associates/Santa Monica, CA	213-450-8863
The Boardroom/Santa Monica, CA	213-450-8343
Boelter, Herbert A/Burbank, CA	213-845-5055
Boyd, Douglas Design/Los Angeles, CA	213-655-9642
Bright & Associates, Inc/Los Angeles, CA	213-658-8844

Briteday Inc/Mountain View, CA	415-968-5668
Brookins, Ed/Studio City, CA	213-766-7336
Brown, Bill & Assoc/Los Angeles, CA	213-386-2455
Brown, Steve/Northridge, CA	213-349-0785
Bruce, Joel Graphic Design/Santa Ana, CA	714-641-2905
Burns & Associates Inc/San Francisco, CA	415-567-4404
Burridge Design/Santa Barbara, CA	805-965-8023
Burridge, Robert/Santa Barbara, CA	805-964-2087
Business Graphics/Los Angeles, CA	213-467-0292
Busse and Cummins/San Francisco, CA	415-957-0300

C

CAG Graphics/Van Nuys, CA	213-901-1077
Carlson, Keith Advertising Art/San Francisco, CA	415-397-5130
Carre Design/Santa Monica, CA	213-395-1033
Cassidy & Associates/Santa Clara, CA	408-735-8443
Cassidy Design/Santa Clara, CA	408-735-8443
Catalog Design & Production Inc/San Francisco, CA	415-468-5500
Chan Design/Santa Monica, CA	213-393-3735
Chandler Media Productions/Irvine, CA	714-751-0880
Chapman Productions/Los Angeles, CA	213-460-4302
Chartmasters Inc/San Francisco, CA	415-421-6591
Clark, Tim/Los Angeles, CA	213-202-1044
Coak, Steve & Pamela Designers/Altadena, CA	213-797-5477
The Coakley Heagerty Co/Santa Clara, CA	408-249-6242
Coates Creates/Portland, OR	503-241-1124
Cognata Associates/San Francisco, CA	415-931-3800
Communicreations/Denver, CO	303-759-1155
Conber Creations/Portland, OR	503-288-2938
Consortium West/Concept Design/Salt Lake City, UT	801-278-4441
Conversano, Henry & Assoc/Oakland, CA	415-547-6890
Corporate Graphics/San Francisco, CA	415-474-2888
Crawshaw, Todd Design/San Francisco, CA	415-956-3169
Creative Consultant/Venice, CA	213-399-3875
Cronan, Michael Patrick/San Francisco, CA	415-398-2368
CropMark/Los Angeles, CA	213-388-3142
Crouch, Jim & Assoc/Delmar, CA	714-450-9200
Cuerden Advertising Design/Denver, CO	303-321-4163
Cullimore, Jack M/Spokane, WA	509-747-0905

D

DMR/Santa Clara, CA	408-496-5010
Danziger, Louis/Los Angeles, CA	213-935-1251
Dave Doane Studio/Newport Beach, CA	714-548-7285
Dellaporta Adv & Graphic/Santa Monica, CA	213-394-0023
DeMaio Graphics & Advertising/Van Nuys, CA	213-785-6551
Design & Direction/Torrance, CA	213-320-0822
Design Center/Salt Lake City, UT	801-532-6122
Design Corps/Los Angeles, CA	213-651-1422
Design Direction Group/Pasadena, CA	213-792-4765
Design Element/Los Angeles, CA	213-656-3293
Design Geometrics Inc/Santa Ana, CA	714-557-1168
Design Office/San Francisco, CA	415-543-4760
Design Projects Inc/Encino, CA	213-995-0303
Design Vectors/San Francisco, CA	415-391-0399
The Design Works/Los Angeles, CA	213-556-2021
Design/Graphics/Portland, OR	503-227-7247
Designamite/Santa Ana, CA	714-549-8210
The Designory Inc/Long Beach, CA	213-432-5707
Detanna Advertising Design/Los Angeles, CA	213-852-0808
Deutsch Design/Los Angeles, CA	213-937-3521
Dimensional Design/N Hollywood, CA	213-769-5694
Diniz, Carlos/Los Angeles, CA	213-387-1171
Dubow & Hutkin/Los Angeles, CA	213-938-5177
Dyer, Rod/Los Angeles, CA	213-937-4100
Dyna-Pac/San Diego, CA	714-560-0117

E F

Earnett McFall & Assoc/Seattle, WA	206-364-4956
Ehrig & Assoc/Seattle, WA	206-623-6666
Ellies, Dave Industrial Design Inc/Santa Clara, CA	408-727-0626
Engle, Ray/Los Angeles, CA	213-381-5001
Entercom/Denver, CO	303-393-0405
Environetics Inc./San Francisco, CA	415-392-7438
Exhibit Design Inc/Burlingame, CA	415-342-3060

Farber, Melvyn Design Group/Venice, CA	213-399-3242
Farber, Rose Graphic Design/Venice, CA	213-392-3049
Finger, Julie/Los Angeles, CA	213-653-0541
First Impressions Design Studio/San Diego, CA	714-226-1800
Five Penguins Design/Burbank, CA	213-841-5576
Floyd, Richard Graphics/Lafayette, CA	415-283-1735
Flying Colors/San Francisco, CA	415-563-0500
Follis, John & Assoc/Los Angeles, CA	213-735-1283
Fox, BD & Friends/Hollywood, CA	213-464-0131
Frazier Design Assoc/Los Angeles, CA	213-857-5500
Freelance Design/Seattle, WA	206-365-0065
Furniss, Stephanie Design/San Geronomo, CA	415-488-4692

G

Garner, Glenn Graphic Design/Seattle, WA	206-323-7788
Garnett, Joe Design/Illus/Los Angeles, CA	213-381-1787
General Graphics/Denver, CO	303-832-5258
Georgopoulos/Imada Design/Los Angeles, CA	213-933-6425
Gerber Advertising Agency/Portland, OR	503-221-0100
Gibby, John Design/Layton, UT	801-544-0736
Girvin, Tim Design/Seattle, WA	206-623-7918
Glickman, Abe Design/Van Nuys, CA	213-989-3223
The Gnu Group/Sausalito, CA	415-332-8010
Gohata, Mark/Gardena, CA	213-327-6595
Gould & Assoc/W Los Angeles, CA	213-208-5577
Graformation/N Hollywood, CA	213-985-1224
Graphic Concepts Inc/Salt Lake City, UT	801-359-2191
Graphic Data/Pacific Beach, CA	714-274-4511
Graphic Designers, Inc/Los Angeles, CA	213-381-3977
Graphic Designs by Joy/Newport Beach, CA	714-642-0271
Graphic Ideas/San Diego, CA	714-299-3433
Graphics One/Los Angeles, CA	213-483-1126
Greiman, April/Los Angeles, CA	213-462-1771

H

Hale, Dan Ad Design Co/Woodland Hills, CA	213-347-4021
Hardbarger, Dave Design/Oakland, CA	415-655-4928
Harper and Assoc/Bellevue, WA	206-885-0405
Harrington and Associates/Los Angeles, CA	213-876-5272
Harte/Yamashita/Harte/Los Angeles, CA	213-462-6486
Hauser, S G Assoc Inc/Woodland Hills, CA	213-884-1727
Head & Hamilton/Los Angeles, CA	213-937-8632
Helgesson, Ulf Ind Dsgn/Woodland Hills, CA	213-883-3772
Hornall, John/Seattle, WA	206-283-1856
Horner, Pat/Seattle, WA	
Hosick, Frank Design/Seattle, WA	206-789-5535
The Howard Group/Woodland Hills, CA	213-888-0505
Hubert, Laurent/Menlo Park CA, 94	5-321-5182
Human Graphic/San Diego, CA	714-299-0431
Hyde, Bill/Foster City, CA	415-345-6955

I J

Imag'Inez/San Francisco, CA	415-398-3203
Image Makers/Santa Barbara, CA	805-965-8546
Image Stream/Los Angeles, CA	213-933-9196
Imagination Creative Services/Santa Cruz, CA	408-988-8696
Industrial Design Affiliates/Beverly Hills, CA	213-878-0808
JFDO Design/Los Angeles, CA	213-653-0541
Jaciow Kelley Organization/Menlo Park, CA	415-327-8210
Jamieson, Tom Design/Claremont, CA	714-626-8338
The Jeff Dayne Studio/Portland, OR	503-222-7144
Jerde Partnership/Los Angeles, CA	213-413-0130
Johnson Rodger Design/Rolling Hills, CA	213-377-8860
Johnson, Jerry & Assoc/Burbank, CA	213-849-1444
Johnson, Paige Graphic Design/Palo Alto, CA	415-327-0488
Johnson, Scott Graphic Art/Emeryville, CA	415-655-9673
Joly Assoc/San Francisco, CA	415-641-1933
Jones, Steve/Venice, CA	213-396-9111
Jonson Pedersen Hinrichs & Shakery/San Francisco, CA	415-981-6612
Juett Dennis & Assoc/Los Angeles, CA	213-385-4373

K

K S Wilshire Inc/Los Angeles, CA	213-879-9595
KLAC Metro Media/Los Angeles, CA	213-462-5522
Kageyama, David Designer/Seattle, WA	206-622-7281
Kano & Company Inc/Playa Del Rey, CA	213-823-7772

Please send us your additions and updates.

Keating & Keating/San Francisco, CA	415-421-3350
Keser, Dennis/San Francisco, CA	415-387-6448
Kessler, David & Assoc/Hollywood, CA	213-462-6043
Keylin, Richard/Denver, CO	303-777-1300
Klein/Los Angeles, CA	213-278-5600
Klein, Larry Designer/San Carlos, CA	415-595-1332
Kleiner, John A/Marina Del Rey, CA	213-472-7442
Kramer, Gideon Assoc/Seattle, WA	206-623-0676
Kuey, Patty/Yorba Linda, CA	714-970-5286
L LaFleur Design/Sausalito, CA	415-332-3725
Lanberger, Roy Assoc/Campbell, CA	408-379-8822
Landes & Assoc/Torrance, CA	213-379-6817
Landor Associates/San Francisco, CA	415-955-1200
Larson, Ron/Los Angeles, CA	213-465-8451
Laurence-Deutsch Design/Los Angeles, CA	213-937-3521
Leipzig, Dale/Huntington Beach, CA	714-847-1240
Leong, Russel Design Group/Palo Alto, CA	415-321-2443
Lesser, Joan/Etcetera/Santa Monica, CA	213-450-3977
Levine & Company, Steve Levine/Venice, CA	213-399-9336
Lipson, Marty & Assoc/Santa Monica, CA	213-451-1421
Littles, Dolores/Los Angeles, CA	213-757-3622
Logan Carey & Rehag/San Francisco, CA	415-543-7080
Loveless, J R Design/Santa Ana, CA	714-754-0886
Lum, Darell/Monterey Park, CA	213-613-2538
Lumco/Monterey Park, CA	213-613-2538
Lumel-Whiteman Assoc/North Hollywood, CA	213-769-5332
Lumel-Whiteman Assoc/Monterey Park, CA	213-613-2538
M Maddus, Patrick & Co/San Diego, CA	714-238-1340
Magnussen Design Inc/Walnut, CA	714-595-2483
Malmberg, Gary Assoc/Denver, CO	303-777-5411
Manhattan Graphics/Manhattan Beach, CA	213-376-2778
Manwaring, Michael Office/San Francisco, CA	415-421-3595
Mar, Vic Designs/North Shore, CA	714-393-3968
Marra, Ann Graphic Design/Portland, OR	503-227-5207
Martino Design/Portland, OR	503-227-7247
Matrix Design Consultants/Los Angeles, CA	213-620-0828
Matrix Design Inc/Denver, CO	303-388-9353
Media Services Corp/San Francisco, CA	415-928-3033
Mediate, Frank/Los Angeles, CA	213-381-3977
Mikkelson, Linda S/Los Angeles, CA	213-937-8360
Miura Design/Torrance, CA	213-320-1957
Mize, Charlie Advertising Art/San Francisco, CA	415-421-1548
Mizrahi, Robert/Buena Park, CA	714-527-6182
Mobius Design Assoc/Los Angeles, CA	213-659-5330
Molly Designs Inc/Irvine, CA	714-751-6600
Monahan, Leo/Los Angeles, CA	213-463-3116
Mortensen, Gordon/Santa Barbara, CA	805-962-5315
Multi-Media Inc/Englewood, CO	303-741-4600
Murphy, Harry & Friends/Mill Valley, CA	415-383-8586
Murray/Bradley Inc/Seattle, WA	206-622-7082
N N Lee Lacy/Assoc Ltd/Los Angeles, CA	213-852-1414
Naganuma, Tony K Design/San Francisco, CA	415-433-4484
Nagel, William Design Group/Palo Alto, CA	415-328-0251
New Breath Productions/Los Angeles, CA	213-876-3491
New Concepts Industrial Design Corp/Seattle, WA	206-633-3111
Newman, Rich Graphic/San Francisco, CA	415-433-4977
Nicholson Design/San Diego, CA	714-235-9000
Nicolini Associates/Oakland, CA	415-531-5569
Niehaus, Don/Westwood, CA	213-279-1559
O O'Brien, Stephanie/Long Beach, CA	213-438-4367
Odgers, Jayme/Los Angeles, CA	213-484-9965
Okland Design Assoc/Salt Lake City, UT	801-484-7861
Olson & Assoc/San Diego, CA	714-235-9993
Omega Productions/Santa Ana, CA	714-547-5669
Orr, R & Associates Inc/El Toro, CA	714-770-1277
Orsan, Lou Design/Los Angeles, CA	213-413-5300
Osborn, Michael/San Francisco, CA	415-495-4292
Osborn, Stephen/San Francisco, CA	415-495-4292

Oshima, Carol/Covina, CA	213-966-0796
Overby, Robert/Santa Barbara, CA	805-966-2359
Overton, Chuck Designer/San Francisco, CA	415-552-7090
P Q Pacif Graphic Assoc/City of Industry, CA	213-336-6958
Pease, Robert & Co/San Francisco, CA	415-775-4667
Peddicord & Assoc/Santa Clara, CA	408-727-7800
Persechini & Moss/Los Angeles, CA	213-559-0864
Petzold & Assoc/Portland, OR	503-221-1800
Pilas Schmidt Westerdahl Co/Portland, OR	503-228-4000
Popovich, Mike c/o Pacific Graphic Assoc/City of Industry, CA	213-336-6958
Powers Design International/Newport Beach, CA	714-645-2265
Primo Angeli Graphics/San Francisco, CA	415-974-6100
Quatro Graphics Publishing Co/Seattle, WA	206-881-7711
The Quorum/Clinton, WA	206-321-5868
R RJL Design Graphics/Fremont, CA	415-657-2038
Radetsky Design Associates/Denver, CO	303-629-7375
Rainbow Graphics & Printing/San Diego, CA	714-296-8242
Regis McKenna Inc/Palo Alto, CA	415-494-2030
Rehag, Larry/San Francisco, CA	415-543-7080
Reid, Scott/Santa Barbara, CA	805-963-8926
Reineck & Reineck/San Francisco, CA	415-566-3614
Reis, Gerald & Co/San Francisco, CA	415-543-1344
Richard Reineman Industrial Design/Newport Beach, CA	714-673-2485
Richard Runyan Design/West Los Angeles, CA	213-477-8878
Rickabaugh Design/Portland, OR	503-223-2191
Ricks Ehrig Inc/Seattle, WA	206-623-6666
Robinson, David & Assoc/San Diego, CA	714-298-2021
Rogow & Bernstein/Los Angeles, CA	213-936-9916
Rolandesign/Woodland Hills, CA	213-346-9752
Ross, Deborah/Studio City, CA	213-985-5205
Roy Ritola Inc/San Francisco, CA	415-788-7010
Rubin, Marvin/Venice, CA	213-392-2226
Runyan, Robert Miles & Assoc/Playa Del Rey, CA	213-823-0975
Rupert, Paul Designer/San Francisco, CA	415-391-2966
S Sackheim, Morton Enterprises/Beverly Hills, CA	213-652-0220
Sanchez, Michael Assoc/Pasadena, CA	213-793-4017
Sandvick, John Studios/Los Angeles, CA	213-685-7148
Sant'Andrea, Jim/Compton, CA	213-979-9100
Saunders, Britt Design/Irvine, CA	714-549-1274
Schaefer, Robert Television Art/Hollywood, CA	213-462-7877
Schorer, R Thomas/Palos Verdes, CA	213-377-0207
Schulz, Margi Design Inc/Los Angeles, CA	213-386-5261
Schwab, Michael/San Francisco, CA	415-546-7559
Schwartz, Clem & Bonnie Graphic Design/San Diego, CA	714-291-8878
Schwartz, Daniel & Assoc/Santa Ana, CA	714-633-1170
Scroggin & Fischer Advertising/San Francisco, CA	415-391-2694
See Design & Production Inc/Salem, OR	503-393-1733
Seigle Rolfs & Wood Inc/Honolulu, HI	808-531-6211
Seiniger & Assoc/Los Angeles, CA	213-653-8665
Sellers, Michael Advertising/San Francisco, CA	415-781-7200
Sharon Shuman, Designer/Los Angeles, CA	213-837-6998
Shaw, Michael Design/Manhattan Beach, CA	213-545-0516
Shenon, Mike/Palo Alto, CA	415-326-4608
Shoji Graphics/Los Angeles, CA	213-384-3091
Shook & Assoc/Glendale, CA	213-504-9623
Sidjakov, Nicholas/San Francisco, CA	415-543-9962
Signworks Inc/Seattle, WA	206-525-2718
Smidt, Sam/Palo Alto, CA	415-327-0707
The Smith Group/Portland, OR	503-224-1905
Sorensen, Hugh E Industrail Design/Brea, CA	714-529-8493
Soyster & Ohrenschall Inc/San Francisco, CA	415-956-7575
Spangler Leonhardt & Hornall Inc./Seattle, WA	206-624-0551
Spear Design Associates/Santa Monica, CA	213-395-3939
Spivey, William Design/Newport Beach, CA	714-752-1203
The Stansbury Company/Beverly Hills, CA	213-273-1138
STEINBERG, BRUCE/SAN FRANCISCO, CA (P 391)	**415-864-0739**
Stine, Kym E/Seal Beach, CA	213-431-9464
Stockton, James & Assoc/San Francisco, CA	415-929-7900
Strong, David Design Group/Seattle, WA	206-447-9160

GRAPHIC DESIGNERS CONT'D.

Please send us your additions and updates.

The Studio/San Francisco, CA	415-928-4400
Studio Artists Inc/Los Angeles, CA	213-382-6281
Sugi, Richard Design & Assoc/Los Angeles, CA	213-385-4169
Sullivan & Assoc/Los Angeles, CA	213-384-3331
Superior Graphic Systems/Long Beach, CA	213-433-7421
Sussman & Prejza/Santa Monica, CA	213-829-3337

T

TOPS Talent Agency/Honolulu, HI	808-537-6647
Tamburello, Michael Graphic Design/Littleton, CO	303-773-0128
Tanner Laffitte Advertising Inc/Irvine, CA	714-957-8591
Tartak Libera Design/Los Angeles, CA	213-477-3571
Taylor, Robert W Design Inc/Boulder, CO	303-494-8479
Teitelbaum, William/Los Angeles, CA	213-277-0597
Thomas & Assoc/Santa Monica, CA	213-451-8502
Thomas, Keith M Inc/Santa Ana, CA	714-979-3051
Thompson, Larry Ltd/San Bernardino, CA	714-885-4976
Trade Marx/Seattle, WA	206-623-7676
Tribotte Design/Los Angeles, CA	213-466-6514
Trygg Stefanic Advertising/Los Altos, CA	415-948-3493
Tycer Fultz Bellack/Palo Alto, CA	415-328-6300

UV

Unigraphics/San Francisco, CA	415-398-8232
Valentino Graphic Design/Los Angeles, CA	213-386-9444
Van Hamersveld Design/Los Angeles, CA	213-656-3815
Van Noy & Co Inc/Los Angeles, CA	213-386-7312
Vanderbyl Design/San Francisco, CA	415-397-4583
Vantage Advertising & Marketing Assoc/San Leandro, CA	415-352-3640
Vicom Associates/San Francisco, CA	415-391-8700
Village Design/Irvine, CA	714-857-9048
Visual Images Inc/Denver, CO	303-388-5366
Visual Resources Inc/Los Angeles, CA	213-851-6688
Voltec Associates/Los Angeles, CA	213-467-2106

W

Walker Design Associates/Denver, CO	303-773-0426
Warner Design/Berkeley, CA	415-658-0733
Weideman and Associates/North Hollywood, CA	213-769-8488
West End Studios/Westwood, CA	213-279-1539
West End Studios/San Francisco, CA	415-434-0380
West, Suzanne Design/Palo Alto, CA	415-324-8068
White, Ken Design/Los Angeles, CA	213-467-4681
Whitely, Mitchell Assoc/San Francisco, CA	415-398-2920
Wilkerson, Haines/Manhattan Beach, CA	213-372-3325
Wilkins & Peterson Graphic Design/Seattle, WA	206-624-1695
Wilkins, Doug/Seattle, WA	
WILLARDSON & WHITE/LOS ANGELES, CA (P 184,185)	**213-656-9461**
Williams, Leslie/Norwalk, CA	213-864-4135
Williamson Clave Inc/Los Angeles, CA	213-836-0143
Wilton Coombs & Colnett Inc/San Francisco, CA	415-981-6250
Winters, Clyde Design/San Francisco, CA	415-391-5643
Woodard Racing Graphics Ltd/Boulder, CO	303-443-1986
Woodward Design Assoc/Hollywood, CA	213-461-4141
Woodward, Teresa/Pacific Palisades, CA	213-459-2317
Workshop West/Beverly Hills, CA	213-278-1370
Worthington, Carl A Partnership/Boulder, CO	303-443-7271

YZ

Yamaguma & Assoc/San Jose, CA	408-279-0500
Yanez, Maurice & Assoc/Los Angeles, CA	213-938-3846
Young & Roehr Adv/Portland, OR	503-297-4501
Yuguchi Krogstad/Los Angeles, CA	213-383-6915
Zamparelli Design/Pasadena, CA	213-577-7292
Zolotow, Milton/Westwood, CA	213-279-1789

NOTES:

NOTES:

NOTES:

INDEX

continued

INDEX